Great British Paintings
from American Collections

HOLBEIN TO HOCKNEY

Malcolm Warner and Robyn Asleson

With contributions by
Julia Marciari Alexander
Brian Allen
Patrick McCaughey

YALE CENTER FOR BRITISH ART

Published on the occasion of the exhibition
Great British Paintings from American Collections: Holbein to Hockney

Yale Center for British Art,
New Haven, Connecticut
September 27 to December 30, 2001

Huntington Library, Art Collections, and Botanical Gardens
San Marino, California
February 3 to May 5, 2002

Copyright 2001
Yale University Press
ISBN 0-300-09222-9

Design and production by Lyn Bell Rose
Assisted by Emily Wright
Printed by Thames Printing Company, Norwich, Connecticut

Front cover: NO. 37
Back cover: NO. 81

Exhibition sponsored by **bp**

Contents

Sponsor's Foreword

BP IS DELIGHTED TO SUPPORT *Great British Paintings from American Collections: Holbein to Hockney.* The exhibition stands as a testament to American collectors and philanthropists, such as Paul Mellon and Henry E. Huntington, whose enthusiasm and generosity have contributed so much to our enjoyment of the arts in the United States. Seeing this diverse range of paintings, from private collections as well as national and regional museums in the US, demonstrates how closely American and British cultures have been woven together over the centuries.

BP is one of the largest integrated energy companies in the world. Starting from British roots, now nearly half of all our assets and staff are American. Here in the US, and in all the places in which we operate, our aim is to generate economic benefit and to be a source of progress for individuals and for the community as a whole. Our support for this fascinating exhibition is just one part of that effort. I hope you will find it enjoyable and inspiring.

JOHN BROWNE
Group Chief Executive
BP p. l. c.

Foreword

The Yale Center for British Art takes enormous pride in presenting *Great British Paintings from American Collections: Holbein to Hockney*. It is the most comprehensive exhibition of masterpieces of British painting ever assembled in this country and the Center's chief contribution to the Yale Tercentennial celebrations.

Earlier this year the Center paid homage to the final gifts of its great founder, Paul Mellon, in the exhibition *The Paul Mellon Bequest: Treasures of a Lifetime*. In *The Line of Beauty: British Drawings and Watercolors of the Eighteenth Century*, drawn largely from the thousands of works on paper given by Paul Mellon to the Center, we highlighted one enchanting aspect of his extraordinary British collection. Now we present him and his collection as part of a broader picture, showing how he fits into—and indeed stands out from—patterns in the collecting of British art in the United States.

Americans have been the most avid collectors of British art outside Britain. There have been large numbers of British paintings in America since colonial times, and the interest in British painting of the highest quality shown by American collectors and museums since around 1900 is a remarkable and continuing phenomenon in the history of taste. The present exhibition includes some of the most familiar images of British art— Fuseli's *The Nightmare*, for instance—but also important works that are less well known than they deserve, largely because previous exhibitions and books on British art have tended, naturally enough, to draw upon British collections.

The examples of British painting we have selected from American collections offer a fresh and beautiful account of the subject from the sixteenth century to the 1990s. As Malcolm Warner discusses in his introductory essay, they also tell us something about the nature of American Anglophilia. British art has appealed to American collectors as, among other things, a connection to the "mother country" and a nostalgic escape into a more gracious, pre-industrial world. At a time when the nature of "Britishness" is the subject of much discussion in Britain itself, it may be especially interesting to look at the image of Britain created by Americans through their collecting of British painting.

Apart from Paul Mellon, the most important collector of British art in the United States was Henry E. Huntington, founder of The Huntington Library, Art Collections, and Botanical Gardens in San Marino, California. It is natural that the Yale Center for British Art and the Huntington are the chief contributors of paintings to the exhibition, and we are delighted that the exhibition travels to the Huntington—

in slightly reduced form—after its showing at Yale. It has been a pleasure to collaborate on this project with our colleagues there, especially Ed Nygren and Shelley Bennett.

As ever, BP has been the perfect sponsor, supporting the exhibition at both venues. We thank Ian Fowler for his unstinting faith in the idea of the exhibition from the outset. The lenders to the exhibition include private collectors and public institutions large and small. Some are celebrated for their British holdings; some have just one or two British works of outstanding quality. We thank them all heartily for their generosity.

CONSTANCE CLEMENT
Acting Director, Yale Center for British Art

Acknowledgments

Great British Paintings: Holbein to Hockney could not have taken place without the vision, leadership, and support of Patrick McCaughey, former director of the Yale Center for British Art. Patrick was quick to realize the appropriateness of the exhibition as a contribution to Yale's tercentennial celebrations. He played a vital part in shaping its content and contributed entries on some of the modern British paintings to the catalogue. His achievements as director were many and enduring, and the Center owes him a huge debt of gratitude.

Robyn Asleson, Research Associate at the Huntington Library, Art Collections, and Botanical Gardens, has been an invaluable colleague and indefatigable collaborator in the writing of the catalogue, to which she has contributed an essay and the majority of the entries. Julia Marciari Alexander, Associate Curator of Paintings and Sculpture at the Center, wrote a number of the entries, particularly on the earlier paintings, and also played an integral role in the selection and organization of the exhibition. Brian Allen, Director of Studies at the Paul Mellon Centre in London, gamely undertook the writing of entries for the paintings by Hogarth. The catalogue was skillfully edited by Julie Lavorgna and designed with customary elegance by Lyn Bell Rose, assisted by Emily Wright.

Among the other members of the Center's staff who have worked with diligence and good cheer toward the realization of the exhibition, the following deserve particular thanks: Jane Nowosadko, Coordinator of Programs, and former Curatorial Assistant in the Department of Paintings and Sculpture; Timothy Goodhue, Registrar; Rick Johnson, Exhibition Designer and Installer; Beth Miller, Assistant Director for Development; and Senja Foster, Manager of Public Relations.

For their various kindnesses during the planning of the exhibition and the writing of the catalogue, thanks are also due to Patricia Asleson, Katharine Baetjer, Fred Bancroft, Graham Beal, Shelley Bennett, Ivor Braka, Stephen Bruni, Nicolai Cikovsky, Michael Conforti, Malcolm Cormack, David Park Curry, Sabine Eckmann, John Elderfield, Everett Fahy, Richard Feigen, Christopher Forbes, Angela Gill, Peter Goulds, Nicholas Hall, Franklin Kelly, Ian Kennedy, George Keyes, Dorothy Kosinski, Brian Lang, Louise Lippincott, Mr. and Mrs. Herbert L. Lucas, Nicholas Maclean, Christopher Makins, DeCourcy McIntosh, Aimée Marcereau, Patrice Marandel, Elaine and Melvin Merians, Ellen Miles, Sir Oliver Millar, Larry Nichols, Ed Nygren, Timothy Potts, Jules Prown, Richard Rand, Jock Reynolds, Timothy Riggs, Joseph Rishel, Malcolm Rogers, Cynthia Roman, Andrew Rose, Timothy Rub, Scott Schaefer, Charlie Scheips, Douglas Schultz, Kate Sellers, George Shackelford, John Sondheim, Allen and Etheleen Staley, Susan Strickler, Susan Kasen Summer and Robert D. Summer, Kurt Sundstrom, Adrian Turner, Giles Waterfield, and George Weiss.

MALCOLM WARNER
Senior Curator of Paintings and Sculpture, Yale Center for British Art

Lenders to the Exhibition

Anglophilia into Art

Malcolm Warner

There is a clear pattern to the collecting of British art outside Britain. In the rest of the Continent of Europe, to begin with the country's most immediate neighbors, the sight of a British painting is almost as rare as that of a game of cricket. However passionate British artists, art lovers, collectors, and museums have been about the art of the Continent, the Continent has remained largely indifferent to British art. There have been British paintings of some note in French collections, and recently the stirrings of renewed interest in British art among museums across the Continent. Still, one need only compare the spectacular holdings in French, Italian, Spanish, and Dutch painting at the National Gallery in London to the British works at the Louvre in Paris, the Uffizi in Florence, the Prado in Madrid, or the Rijksmuseum in Amsterdam to get a sense of how one-sided, as a general rule, the artistic relationship has been. In the rest of the Western world, British art has fared more strongly, and this is tied to the long history of British political and economic activity overseas. Like the prevalence of the English language, the spread of British art in the world at large is colonial in origin. It has been collected almost entirely in English-speaking, strongly Protestant countries that were once British colonies: Australia, New Zealand, Canada, South Africa, and, above all, the United States. Nowadays impressive collections of British art exist all across the Midwest and West of the country, most remarkably at The Huntington in California, but the greatest concentration remains along the eastern seaboard, in the former British colonies—where the most obviously anglicizing examples of American architecture and decorative arts, from the colonial to the neo-colonial, are also to be found. From New England into the South, from Boston to Philadelphia to Richmond, most of the outstanding American collections of British art have grown in places that were once British themselves.

The American relationship to Britain and British culture, sometimes compared to that of a child to a parent, sometimes to that of the Romans to the Greeks, has been landscape-forming for both countries. The importance to Americans of coming to terms with Britain emerges, for instance, in the sheer quantity of American writings on the "mother country," which overwhelmingly outnumber those on any other part of the world. As Henry Steele Commager remarked in the introduction to his anthology of these, "it was in the approximation to or departure from things British that the Americans discovered their character."[1] Certainly there has been a strain of Anglophobia in the American mentality. In his classic study *Conflict and Concord*, H. C. Allen traced the low point of Anglo-American relations to the period from the War of 1812, following which a heightened American nationalism finally severed the States' British moorings, to the middle years of the nineteenth century.[2] On the one side, the British outdid themselves in the sneering assumption of superiority in morals, language, and culture generally. In 1845, when asked if he would let Americans buy his work, the painter J. M. W. Turner replied curtly, "No, they

1. Henry Steele Commager, ed. *Britain through American Eyes* (New York, 1974), xxxii.
2. H. C. Allen, *Conflict and Concord: The Anglo-American Relationship since 1783* (New York, 1959).

won't come up to the scratch" (see no. 51). On the American side there was much resentment at British superciliousness and a feeling that, although the States had separated themselves politically from Britain, they remained in "a state of colonization of intellect."[3] The bad feeling comes through in the over-the-top description of the state of art in Britain published by the American journalist Henry Tuckerman in 1853:

> In Paris and Rome we seem to inhale an atmosphere of art; it is a portion of existence, a familiar necessity; in London it must be painfully sought, and when found, often affects us like the sight of an eastern prince, with silken robe and pearly coronet, dragged along in a triumphal procession of northern invaders.[4]

The antagonistic aspects of the Anglo-American relationship have persisted to a degree, in one form or another, to the present day. On the whole, however, Americans have been far more generous and good-natured in their appraisals of Britain than the British in theirs of the States, and Anglophobia less in evidence in the States than Anglophilia.

The growth of warm feelings among Americans toward Britain and British culture in the later nineteenth and early twentieth century was a sign of the country's maturing sense of national identity and self-confidence as it rose to be a major power in the world. This was the background to the great surge in the collecting of British art that took place from about 1900 to 1930. As the States took over Britain's position of political and industrial preeminence, wealthy American collectors bought British art as never before or since. It was as if, having won out over Britain in everything else, America was now happy to concede culture, at least high culture. Of course, the great American collectors acquired works of art not just from Britain but from all over the world. Nevertheless, Britain enjoyed a special cultural status: almost synonymous with culture itself, it came to serve, in one way or another, as the port of entry through which other cultural traffic passed. As the eminent art historian Bernard Berenson observed, the most powerful selling point for a painting in the States, of whatever nationality or quality, was that it had come from the collection of an English nobleman.[5] Even when great American collections of this period contained largely Continental Old Masters, the presence of some British portraits made for the kind of ensemble one would find in an English country house or the Wallace Collection in London. Joseph Duveen, the supreme art dealer of the age, not only sold large numbers of British paintings but maintained an impeccably British tone at his New York gallery. "The members of his staff, in the words of a former associate, were invariably 'dressed like Englishmen—cutaways and striped trousers' . . . You could drop an 'h' there with impunity, but under no circumstances pick up an Americanism. One day, a Duveen employee, throwing caution to the winds, said, 'O. K.' Duveen was severe."[6]

The American response to British art has been fostered by bonds of history and language, and also by common religious beliefs. Since the sixteenth century, when the Protestant Reformation in Britain swept away the religious images that were the mainstay of art in the Middle Ages, British art has been dominated by the secular artistic genres of portraiture and landscape. This has made British art more readily palatable to the mostly Protestant collectors who have dominated American collecting. Although Protestant beliefs have rarely stopped any collectors, British or American, from collecting Roman Catholic devotional images when they are great works of art—especially Madonna and child subjects—the absence of any

3. J. B. McMaster, *A History of the People of the United States, from the Revolution to the Civil War* (New York, 1903), 5:287, quoted in Allen, 130.
4. Henry Tuckerman, *A Month in England* (1853), quoted in Commager, 316.
5. See S. N. Behrman, *Duveen* (New York, 1952), 98.
6. Behrman, 40.

even slightly idolatrous elements from most British art has undeniably worked in its favor. Those giants of American collecting Henry Clay Frick and Andrew W. Mellon began their great Old Master collections with paintings from Protestant Britain and the Protestant Netherlands, moving on to the art of Roman Catholic Europe later; among American collectors the taste for British art has often gone together with a taste for Dutch art in this way. At the time when Frick and Mellon were collecting, the growth of Roman Catholic and Jewish immigration into the States brought about a heightened sense of religious and racial identity among the country's white, Anglo-Saxon, Protestant elite. One of the means by which the wealthiest Americans could affirm their "WASP" allegiance was the collecting of British art.

In general, collectors in the States have found British paintings to be fairly readily available for export. This is, at least in part, because the cosmopolitan patrons, collectors, museums, and critics of Britain have tended to undervalue the artists of their own country. As Nikolaus Pevsner remarked, "None of the other nations of Europe has so abject an inferiority complex about its own aesthetic capabilities as England."[7] A common line has been that the British are "a literary people" with little aptitude for the visual.[8] The Victorian period saw a growing pride among the British in their own national school of painters, and by the end of the nineteenth century there was a national museum of British art in the shape of the Tate Gallery; in the early decades of the twentieth century, however, the tide of interest in British art ebbed on the British side of the Atlantic just as it flowed on the American. Ellis Waterhouse, the distinguished historian of British art, recalled the dismal plight of the Tate, and of British art in London's public collections generally, when he began his career in 1929: "There was no government grant for the purchase of pictures to the Tate Gallery: and the National Gallery allotted one of its lesser funds (amounting to the princely sum of £576) to the Tate Gallery for the purchase of British pictures. There was no serious policy for the development of a historic collection of British painting, there was then practically no library at the Tate, and the gentleman who became its director at about this time was an alcoholic."[9] As late as 1959, when Paul Mellon began his great British collection, his impression was that "the directors and curators of the national collections seemed to have turned their backs on British art."[10] The quality of the collection Mellon formed, largely in the 1960s, bears witness to the extraordinary level of availability of British works on the art market at the time and, it must be said, the continuing low regard of the British for their national artistic heritage.

In their collecting of British painting, Americans have shown a clear preference for the period from about 1700 to about 1850. Painting in Britain before 1700 is represented in the States by a relatively small number of choice examples, notably portraits painted by Hans Holbein at the court of Henry VIII and Anthony van Dyck at the court of Charles I. The outstanding works by Holbein, who set British art on a new, portrait-based, Protestant course after the Reformation, include the portrait of Edward VI as a boy at the National Gallery of Art in Washington, that of Sir Thomas More in the Frick Collection,

FIG. 1:
Hans Holbein the Younger, *Mary, Lady Guildford*, 1527. St. Louis Art Museum, St. Louis. Purchase, 1943

7. Nikolaus Pevsner, *The Englishness of English Art* (Harmondsworth, 1956; repr. 1978), 25.
8. On the "self-directed racism" of the British when it comes to British art, see Andrew Graham-Dixon, *A History of British Art* (London, 1996), 9–11.
9. *British Art and British Studies: Remarks by Ellis Waterhouse at the Inauguration of the Yale Center for British Art*, 16 April 1977 (New Haven, 1979), 10–11.
10. Paul Mellon, with John Baskett, *Reflections in a Silver Spoon: A Memoir* (New York, 1992), 279.

and that of Lady Guildford at St. Louis (fig. 1). Van Dyck's celebrated portrait of Queen Henrietta Maria with her dwarf Sir Jeffrey Hudson (no. 3) is the most brilliant among several important examples of his British portraits in the States. As the fountain-head of the tradition in British portraiture that reached its height in the later eighteenth century—a tradition much beloved of American collectors—van Dyck has been undoubtedly the most sought-after figure in British art before 1700. As for the less well known painters of this early period, whose work would, if nothing else, provide a setting for the glories of Holbein and van Dyck, they are little represented in American collections. One might have expected the similarity of Tudor and Stuart portraiture to some of the stylized portraits painted in eighteenth- and nineteenth-century America to have recommended it to American taste, but this seems not to have been the case. Perhaps its often esoteric symbolism has not traveled well. For whatever reason, it is represented by groups of works in the Yale Center for British Art, the Metropolitan Museum in New York, and the Berger Collection (on loan to the Denver Art Museum), but elsewhere only scantily at best.

Neither Holbein nor van Dyck was British by birth. They are among the many non-native artists who have worked in Britain, some of whom have played integral parts in the history of British art; the others include Peter Lely, Canaletto, Johann Zoffany, and Henry Fuseli. The success of these immigrants has been the source of some anxiety among native talents. In the eighteenth century William Hogarth campaigned fiercely against what he saw as the blind prejudice of British patrons in favor of artists from Continental Europe, and in paintings such as *The Beggar's Opera* (no. 7) promoted a forthright, anti-pretentious realism that he felt to be British as

opposed to Continental. On the other hand, Joshua Reynolds sought to assimilate British art, as much as possible given its basis in the "low" genre of portraiture, to the great Continental tradition of art stemming from the Italian Renaissance. In their different ways Hogarth and Reynolds were moved by an acute self-consciousness about their national artistic identity, a self-consciousness that has been so prevalent in Britain as to be a defining feature of its artistic life. Despite the concerns of Hogarth, however, and the continuing bad habit among the British of underrating British artists and overrating foreign ones, the inter-nationalism of British art—its openness to stimulation of one kind or another from other cultures—has been one of its strengths. The tradition continues: among the most prominent artists working in Britain today, Lucian Freud was born German and Paula Rego Portuguese.

What makes the issue especially relevant here is that works created in Britain by Holbein, van Dyck, and the other foreign artists have so often been col-lected and catalogued in the States under the "German School," "Flemish School," and so on. In this way some of the greatest paintings made in Britain have been written out of the story of British art. It should be said that this is by no means entirely an American tendency: the Louvre has never regarded its greatest British painting, van Dyck's portrait of Charles I in hunting dress, as anything but Flemish, and one could probably find similar cases even in British col-lections. But the problem seems more acute in the States because so many of the best foreign artists working in Britain have been American: Benjamin West, John Singleton Copley, Gilbert Stuart, J. A. M. Whistler, and John Singer Sargent. For obvious patriotic reasons the many paintings made by these artists in Britain that are in American collections are

considered American rather than British. In the States the idea that an established masterpiece of American art such as Copley's *Brook Watson and the Shark* (fig. 2), though painted in London for a Lon-

FIG 2: John Singleton Copley, *Brook Watson and the Shark*, 1778. National Gallery of Art, Washington. Ferdinand Lammot Belin Fund, 1963

don patron and exhibited at the Royal Academy, could be considered at least as British as American has almost the air of heresy about it. The Holbein portrait of Edward VI, van Dyck's portrait of Queen Henrietta Maria, Copley's *Brook Watson and the Shark*, Gilbert Stuart's *The Skater* (no. 35), and Whistler's *Wapping* (no. 60) are all in the collection of the National Gallery of Art in Washington; although the gallery has recently taken the enlightened step of hanging Stuart's *The Skater* in its British rooms, none of the above works appears in the British paintings volume of its systematic catalogue.[11]

The tendency to think of British art as a thing apart, into which non-British geniuses sometimes drop for a spell but without painting British pictures, may stem from common American ideas about Britishness. For most Americans the idea of Britain as part of an international scene seems far less appealing than that of a nation of individualists, even eccentrics, tending toward the insular. When they have compared homegrown British art to that of Continental Europe, some have found its distinguishing marks to be touches of the naïve and untutored. As Henry James said of the work of Thomas Gainsborough, "The merit is not at all school-merit, and you take very much the same sort of affectionate interest in it as you do in the success of a superior *amateur*."[12] The impression of British art as pleasantly unprofessional and quirky was enhanced in the twentieth century by the rise of art history as a discipline, with its tendency to regard art as more or less important according to its influence on other art. In this scheme of things, the serious developments in Western painting happen in Italy with the Renaissance, in France from about 1750, then, triumphantly, in the States from about 1950. Sometimes in an American collection British art does come across as part of the broad art-historical picture: at the Art Institute of Chicago, Reynolds's portrait of Lady Sarah Bunbury sacrificing to the Graces (fig. 3) forms the centerpiece of a room dedicated to the Neo-Classical movement. But more often it seems to exist off to the side from the rest of the world, home of the "superior *amateur*" and fascinating oddball rather than the influential master, admired not so much for its artistic quality as for its Britishness and nostalgic associations.

When the taste for British art was at its height in the States, from about 1900 to 1930, it centered on the eighteenth and early nineteenth centuries, the so-called "Golden Age" of British art, and in particular on portraits in the van Dyckian tradition. For the best portraits by Reynolds, Gainsborough, George Romney, Henry Raeburn, John Hoppner, William Beechey, and Thomas Lawrence, American collectors of that time would pay as much as for the Old

FIG 3: Joshua Reynolds, *Lady Sarah Bunbury Sacrificing to the Graces*, 1763-5. Art Institute of Chicago. Mr. and Mrs. W. W. Kimball Collection, 1922

11. John Hayes, *British Paintings of the Sixteenth through Nineteenth Centuries (The Collections of the National Gallery of Art Systematic Catalogue)* (National Gallery of Art, Washington, D.C., 1992).
12. Remarks on the Wallace Collection, *Atlantic Monthly*, January 1873, in *The Painter's Eye: Notes and Essays on the Pictorial Arts by Henry James*, ed. John L. Sweeney (Cambridge, Massachusetts, 1956), 69.

FIG 4:
Joshua Reynolds,
*Charles Stanhope, 3rd
Earl of Harrington*, 1782.
Yale Center for British
Art, Paul Mellon
Collection

Masters of any of the other national "schools" of Europe. Of the 111 works in Esther Singleton's general anthology of *Old World Masters in New World Collections*, published in 1929, no less than eighteen were portraits by these artists.[13] In 1933 the more scholarly C. H. Collins Baker, then Head of Research in Art History at The Huntington, published a book on British painting that contained a "List of Some of the Principal British Paintings in American Collections."[14] Collins Baker included a good number of landscapes in his list, and even a handful of genre and subject pictures. But still he confined his selection almost entirely to paintings of 1700 to 1850, and of the 463 items listed, 298 were portraits. Seven of the eight works by William Hogarth included in the list were portraits, with only one "Modern Moral Subject" (no. 9) to represent the kind of work for which he is best known in Britain.

Of all the branches of painting, portraiture is the most functional, and the most responsive to the specific needs of patrons—the patrons and their relatives being, usually, the very subject matter that the artist must address. The vast majority of portraits have been made for family purposes, to record the likenesses of family members for future generations, to proclaim a noble lineage; they have been made to hang with other family portraits in the family home, which, in the case of the kind of British portrait most

collected in the States, has normally meant the ancestral seat, often a country house. They began life as commissioned works; when they have changed hands and been collected, whether into a private art collection or into a museum, they have become—more than, say, landscapes or still lifes—displaced persons. Most collectors and museums do some matchmaking in the way in which they arrange British portraits, hanging similar-sized portraits of men and women as pairs, as though they were husbands and wives, when in life the people concerned may never even have met. Such pseudo-marital unions are typical of the way in which the collected portrait looses so much of its original meaning, and of the slight strangeness that enters our experience of all British portraits in American collections when we think of them in this light—as mock families, related neither to their owners nor to one another.

The massive importation of British portraits of the Golden Age into American collections seems stranger still when we remember that the people they depict are that British ruling class whose colonial dominion the United States overthrew in the War of Independence. Owned and displayed by an American museum, a work such as Reynolds's portrait of Charles Stanhope, 3rd Earl of Harrington (fig. 4)—who served under General Burgoyne in the campaign leading to the British surrender at Saratoga in 1777—might appear almost in the light of a trophy of victory. Certainly the fact that Reynolds shows the man as a cross between a medieval knight and a Greek god seems a little ridiculous in the circumstances. As Americans, American collectors have looked upon British colonialism and the British class system with a critical, democratic eye. It is tempting to think that there may be a touch of Schadenfreude about the collecting of portraits of the British

13. Esther Singleton, *Old World Masters in New World Collections* (New York, 1929).
14. C. H. Collins Baker, *British Painting* (London, 1933), 276–88.

aristocracy in the States—images of a class defeated by America in the eighteenth century and, in later generations, forced by hard times to sell off their family heirlooms. But in fact the idea of the British as an old enemy seems hardly to have entered into the thinking of American collectors at all; on the contrary, their response to British aristocratic portraiture has been rosy and sentimental.

The British portrait of the Golden Age was an essential ingredient of what W. G. Constable, in his study of American collecting, called "the Great Master collection."[15] The Great Master collections were formed largely in the early decades of the twentieth century by immensely wealthy men, among them Henry Clay Frick, J. Pierpont Morgan, Andrew W. Mellon, and Henry E. Huntington. Most were advised and assisted in building their collections by Joseph Duveen. These were typically collections of grand masterpieces by the most celebrated names of European art, in which there was little room for the interesting minor work, for American art, or for anything more recent in date than around 1850. One can recapture the heady atmosphere of this phase of American collecting, especially the choiceness and exquisiteness conferred upon each work by its richly decorative setting, by visiting the Frick Collection in New York or The Huntington in California. No doubt the Great Master collector responded in different ways to each national school of painting that he liked and collected; if any given work of art appealed to him in part for its beauty and in part for its associations, however, surely the British portrait scored above average with its associations. The world of luxury that it evoked was one that he could readily enter into. The British themselves had collected art on a spectacular scale, bringing great works from the Continent to decorate their homes, rather as he was

bringing great works from all over Europe to decorate his; he may even have made his own form of the Grand Tour, as they had done in the eighteenth century. More than a self-portrait by Rembrandt, or a Bellini of St. Francis receiving the stigmata—masterpieces though they were—the British portrait showed him people with whom he, his wife, and his family could identify, models of the glamour of wealth.

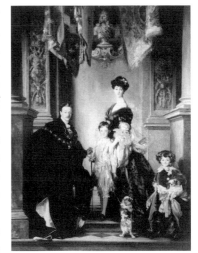

The richest Americans had as much money as the sitters in the British portraits they bought, and in many cases a great deal more. What they were buying into when they bought British was an idea of Old-World "stock," social prestige, and that complicated, supposedly quintessential European quality of "class." In all these respects there was an interesting parallel in the increase in marriages between American heiresses and titled Englishmen. According to H. C. Allen, there were 130 such cases by 1914.[16] The *locus classicus* of the Anglo-American marriage was that of Consuelo Vanderbilt, daughter of the railroad magnate William K. Vanderbilt, to Charles Richard John Spencer-Churchill, 9th Duke of Marlborough. In 1905 Consuelo completed her entry into the British aristocracy by entering British aristocratic portraiture, appearing with her husband and their children in a full-dress, eighteenth-century-style portrait by Sargent (fig. 5). The artist designed the work as a pair to Reynolds's portrait of the family of the 4th Duke, and showed Consuelo wearing a dress derived from a van Dyck that was also in the family collection at Blenheim.

If there was a certain kinship of wealth that drew

15. See W. G. Constable, *Art Collecting in the United States of America: An Outline of a History* (London, 1964), Chapter VIII, "Great Masters."
16. Allen, 111.

the early twentieth-century titans of American collecting to the elegant company represented in British portraits, there was also a fundamental difference as far as the origins of their wealth were concerned. The collectors were rich not through the hereditary ownership of land but through modern business and industry. Frick was a Pittsburgh iron and steel man; Morgan and Andrew Mellon were financiers; Huntington was another railroad man. For them collecting was no doubt an affirmation of the power and prestige they achieved in their careers, but it was also the creation of a refuge from the mundane, vexatious, sometimes ugly world of moneymaking. As his biographer observed, Morgan had "a romantic reverence for the archaic, the traditional, the remote, for things whose beauty took him far away from prosaic industrial America."[17] Portraits of the British Golden Age were especially attractive in this respect because they suggested an idyllic, leisured, pre-industrial society in which one could escape the present.

There were models for this kind of nostalgic, nouveau-riche collecting in Britain itself. The wealthy brewer Edward Cecil Guinness (created Earl of Iveagh), for instance, assembled a brilliant collection of British portraits in the 1880s and 1890s, and in 1925 bought an eighteenth-century house, Kenwood in Hampstead, in which to display them. Another case in point would be the Rothschild collection at Waddesdon Manor. In Britain the collecting of Golden-Age portraits was part of a general eighteenth-century revival that affected art, architecture, design, and fashion alike; contemporary British artists found a ready market for paintings that looked back romantically to eighteenth-century life—scenes featuring young women in mob-caps, "souvenirs" of Reynolds and Gainsborough, illustrations to Oliver Goldsmith's *The Vicar of Wakefield*. In their taste for

eighteenth-century British portraiture the American collectors were, in this sense, followers rather than leaders. What the portraits they collected meant to them and their compatriots, however, was something different from what they meant to the British. From Fifth Avenue to southern California, the appeal of British art was part of a deep-seated historical and cultural relationship to Britain; the nostalgia was not just for another time, but for another place.

For Esther Singleton, introducing the British section of *Old World Masters in New World Collections*, British portraits were a means of transport to another world:

> The Eighteenth Century was one of those periods in the world's history when Society reached its peak, when Society was the goal of all things and of every one . . . There was a chic and dainty grace with which the Eighteenth Century belle wore her large hat, tied her sash, and pointed the toe of her high-heeled satin slipper on the polished floor of the ball-room, or the greensward of the garden or lawn; and there was a corresponding chic and dashing elegance with which the Eighteenth Century beau made his bow, tapped his snuff-box, or handed the 'ladies of St. James's' in and out of their sedan-chairs. This sparkling, iridescent age, with its taste, grace, and wit can never come again—for our world has travelled far along another path—but if the Eighteenth Century cannot return to us, we can return to it by means of its literature, its music, and its art.[18]

Much to the amusement of the British, the picture of Britain as a land of well-mannered ladies and gentlemen, given seductive form by the costume dramas broadcast on *Masterpiece Theatre*, remains popular in the States to this day.[19]

For most Americans of the twentieth century the quintessential painter of British *chic* was Gainsborough, and his work is richly represented in American

17. F. L. Allen, *The Great Pierpont Morgan* (New York, 1949), 147.
18. Singleton, 329.
19. For some brilliant and entertaining reflections on "Brit Kitsch" and other manifestations of Anglophilia in the States, see Christopher Hitchens, *Blood, Class, and Nostalgia: Anglo-American Ironies* (New York, 1990).

collections. His fame was boosted by the case of the "Lost Duchess." In 1901 Gainsborough's portrait of the beautiful Georgiana, Duchess of Devonshire (fig. 6) was recovered in Chicago after having been missing for some twenty-five years, stolen from the London art dealer Agnew's. Shortly after its recovery it

FIG 6: Thomas Gainsborough, *Georgiana, Duchess of Devonshire*, c. 1787-89. Devonshire Collection, Chatsworth House

was bought from Agnew's for $150,000 by J. Pierpont Morgan. The elements of glamour, intrigue, and wealth in the story attracted so much coverage in the media that the portrait became, for a time, a familiar public icon. (Most of Morgan's art collection was later dispersed, and the Duchess has returned home to Chatsworth House.) Further masterpieces followed: in 1911 Mary M. Emery of Cincinnati bought *Ann Ford, later Mrs. Philip Thicknesse* (no. 14) and in 1916 Henry Clay Frick bought *The Mall in St. James's Park* (fig. 7). The canonical acquisition, however, was Henry E. Huntington's purchase of *The Blue Boy* (no. 17) for the enormous sum of £182,200 ($728,000) in 1921—at that time the highest price ever paid for a painting. Esther Singleton referred to this work as "without doubt the most famous picture in the world,"[20] and it remains the most famous British picture in the United States. Like many other British works in American collections, *The Blue Boy* seems curiously at odds, in some ways, with its adoptive country. Gainsborough painted it within

a few years of the American Revolution and, to suggest the continuity of British portraiture and the British ruling class, clothed the boy in cavalier costume harking back to the era of van Dyck and absolute monarchy. There is an ironic justice to this, however, in that the boy, Jonathan Buttall, was

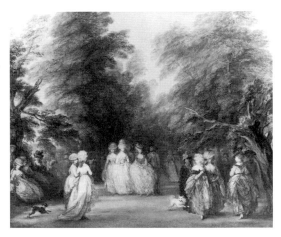

FIG 7: Thomas Gainsborough, *The Mall in St. James's Park*, 1783. Frick Collection, New York.

no titled gentleman but the son of a London ironmonger, his satin and lace a flight of nostalgic fancy.

The man who bought *The Blue Boy*, Henry E. Huntington, was unique among the Great Master collectors of the early decades of the twentieth century in the degree of emphasis he placed upon British art, but in the kind of British art he favored he was quite typical. He bought largely from Duveen, and the core of his collection was a group of full-length, roughly life-sized British portraits by Gainsborough, Reynolds, Romney, and Lawrence. After his death in 1927 his collection opened to the public and immediately became the principal museum of British art outside Britain, a position it held until the opening of the Yale Center for British Art some fifty years later. In 1936 C. H. Collins Baker published a catalogue of the British collection and at that time it contained fifty-eight paintings, of which forty-seven were portraits. The heart of the collection remains

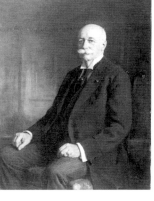

FIG 8: Oswald Birley, *Henry Edwards Huntington*, 1924. Huntington Library, Art Collections, and Botanical Gardens, San Marino, California.

20. Singleton, 378.

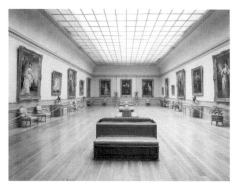

FIG 9: Huntington Art Gallery, San Marino, California: Main Gallery

the Main Gallery (fig. 9), which is undoubtedly the most impressive assemblage of British full-lengths existing anywhere in one room, a testament to Huntington's belief in collecting nothing but the best. Looking around the glamorous company of sitters there, one can hardly fail to be struck by the predominance of attractive women and children: the usual line-up features fourteen women, four children, and only two men. This is representative of the taste of Henry E. Huntington and most American collectors of British portraiture. The spectacular American holdings of portraits by Thomas Lawrence, for instance, revolve unashamedly around the young and the beautiful, from the popular *"Pinkie"* at the Huntington (no. 39) to *Arthur Atherley* in Los Angeles (no. 38), *Mrs. Jens Wolff* at the Art Institute of Chicago, and *Elizabeth Farren* and *The Calmady Children* in New York (nos. 37 and 40). Another important selling-point has been the celebrity sitter, whether an actress, a society beauty, a famous mistress, or a viscountess with an exciting private life.

The Depression of the 1930s brought the end of the Great-Master type of collecting in the States and a massive slump in the market for British paintings. The period from the 1930s to the 1950s was a low point for the reputation of British art generally. On the other hand, although there was little private collecting, some considerable advances were made—as at The Huntington—in making British art available to the public at large. This was a formative stage in the growth of the American civic museum as an institution, and much of the art in the Great Master collections, including most of the best British

paintings, became publicly accessible in one way or another. Indeed, the moving force in the story of British painting in the States was, for a while at least, the museum rather than the collector. A landmark in this development was the Gainsborough exhibition held at the Cincinnati Art Museum in 1931, which drew upon the remarkable group of Gainsboroughs collected in that city by Mary M. Emery and Charles and Anna Taft. The Frick Collection, with its choice holdings in British painting, opened to the public in

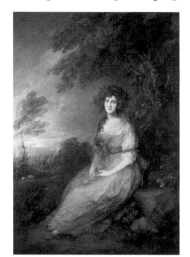

FIG 10: Thomas Gainsborough, *Mrs. Richard Brinsley Sheridan*, 1785-87 National Gallery of Art, Washington. Andrew W. Mellon Collection, 1937

1935. Of the 110 paintings presented by Andrew W. Mellon to the National Gallery of Art as his founding gift in 1937, no less than twenty were British, including that early masterpiece of Romantic portraiture, Gainsborough's *Mrs. Richard Brinsley Sheridan* (fig. 10). In the same years some whole interiors from British houses were installed in American museums as "period rooms": the drawing-room from Robert Adam's Lansdowne House was recreated at the Philadelphia Museum of Art and the dining-room at the Metropolitan Museum in New York.

Since the 1960s a resurgence of interest in British art has taken place among American collectors, critics, and museums, and this was put in motion almost single-handedly by Andrew W. Mellon's son, Paul

Mellon—the greatest ever collector and champion of British art on either side of the Atlantic. Paul Mellon began his British collection in earnest in 1959. With the help and advice of the British art historian Basil Taylor, he built the collection rapidly; by 1963, when he brought it before the public for the first time in an exhibition at the Virginia Museum of Fine Arts, Richmond, it already contained over three hundred paintings.[21] In 1966 he announced his intention of giving the collection to his *alma mater*, Yale University, together with a building and an endowment, and the Yale Center for British Art opened in 1977. By this time the Paul Mellon Collection contained about 1,700 British paintings, as well as thousands of drawings, watercolors, prints, and rare books. First as founding gifts, in batches over the succeeding years, and finally in a large bequest at his death in 1999, Mellon gave the Center the bulk of these, creating the largest and most comprehensive public collection of British art outside Britain.

As the main showcases for British art in the States today, the collection of Henry E. Huntington in San Marino and the Paul Mellon Collection at Yale are a study in the different interpretations that collectors can place upon the same national school of painting. To mention the similarities first, both focus on the Golden Age of British art—the period roughly from 1700 to 1850—although at the Huntington this preference is seen in more pronounced form. Henry E. Huntington anticipated Paul Mellon in collecting works on paper and rare books as well as paintings, and both collections contain rich holdings in William Blake, Thomas Rowlandson, and other British draftsmen, watercolorists, and printmakers. Both exist in a scholarly setting, one in conjunction with the Huntington Library, which is the country's premier library of Anglo-American civilization, the other as part of a prestigious university. Huntington and Mellon both began their careers as collectors of books rather than art, and the settings of the institutions they founded seem to invite a literary and historical approach to British art as well as an aesthetic one. They were both conservative, nostalgic Anglophiles for whom Britain—or rather a certain vision of British life in the eighteenth and early nineteenth centuries—represented a better alternative to the modern world.

The most obvious difference between the collections is that Paul Mellon's is much larger. This is not merely a reflection of the fact that British paintings were a great deal more expensive in Huntington's day than in Paul Mellon's, although it was undoubtedly a factor. More significantly, Mellon was not building his collection on the Great Master pattern: he ranged widely across British art—by no means ignoring the established big names, but making his own discoveries, pursuing an interest in certain kinds of subject matter, buying the works of interesting forgotten figures when they appealed to him. He cared little for the grandeur and glamour of the classic British full-length portrait beloved of Huntington, preferring works of a certain informality and quiet lyricism: smaller-scale portraits, conversation pieces, scenes of leisure and sport. When buying a portrait he looked for a sense of character in a sitter, for signs of intelligence or humor. Quite unlike Huntington, he preferred male portraits to female, with the result that

FIG 11: Paul Mellon at the Yale Center for British Art. Photograph by William B. Carter, 1977.

21. See *Painting in England 1700–1850: Collection of Mr and Mrs Paul Mellon*, exh. cat. (Virginia Museum of Fine Arts, Richmond, 1963). The exhibition was shown in modified form at the Royal Academy in London and the Yale University Art Gallery in 1964–65.

FIG 12: Huntington Art Gallery, San Marino, California: south front

FIG 13: Yale Center for British Art, New Haven

22. Editorial, *Burlington Magazine* 107 (February 1965): 57.

the definitive Huntington type of painting, the eighteenth-century full-length female portrait, is represented at the Yale Center for British Art by only one example, a Reynolds studio work. "Since he was born immensely rich," observed the British art historian Benedict Nicolson when the Paul Mellon Collection was shown at the Royal Academy in London in 1964–5, "he is not glamorized by riches as other men are who acquire them, and for this reason he disregarded the glamorous side of British art, the side that appealed to an earlier generation of American collectors."[22] The earlier generation included, of course, Paul Mellon's own father; in some ways the Yale Center for British Art stands as a complement or corrective to the taste that still dominates the representation of British art at the National Gallery of Art thanks to Andrew W. Mellon's founding gifts.

The collection at the Huntington is set in a small world of immaculate gardens in the styles of various countries; as you approach the galleries, built in the heavily revivalist style of "beaux-arts" classicism, you pass the grand North Vista, with its tall palm trees, azaleas, and seventeenth-century Italian sculptures, looking toward the San Gabriel Mountains.

The impression is that of a collage pieced together from the best of everything in creation, the best of culture being understood to be British. At Yale, breathing in the Anglophile air of the campus, catching glimpses into quadrangles modeled on Oxford and Cambridge, first-time visitors might expect the Yale Center for British Art, of all places, to chime in with the theme. Instead, they find an insistently modern, concrete and steel building by Louis Kahn that suggests only subtle points of comparison to any building of the past, British or otherwise. The Paul Mellon Collection was originally housed in the Brick House, on the Mellon estate in Virginia, a dignified neo-Georgian mansion that emphasized the collection's nostalgic quality. Its modern quarters at Yale bring out an element of modernity in Paul Mellon's taste: his emphasis on the informal and the natural, as opposed to the fashionable and courtly, comes across as part of seeing British art afresh, untraditionally, through modern eyes. Each of these leading British collections in the States, in its various and different ways, offers a distinctly American experience of British art.

Not surprisingly, since his own enjoyment of the outdoor and sporting life in Britain was a large part of what moved him to collect, Paul Mellon placed a greater emphasis than Huntington on landscape painting. This is not to say that Huntington's generation of collectors, the Great Master collectors, were uninterested in British landscape. In the list of British paintings in the States published by C. H. Collins Baker in 1933, 143 of the 165 that were not portraits were landscapes. The outstanding names, as one might expect, were J. M. W. Turner and John Constable. Landscape of the Golden Age was appealing for some of the same reasons as portraiture: it offered an escape into an Edenic, pre-industrial

world. Most of the British landscapes in American collections have taken on a particular inflection of meaning—the country scene as an oasis of nature—from the fact that the collectors and museums have been situated in large, modern cities. For Americans of British descent, moreover, the landscape of Britain can be a sentimental homeland even if they have never been there. Nathaniel Hawthorne wrote of "the deep yearning which a sensitive American, his mind full of English thoughts, his imagination of English poetry, his heart of English character and sentiment—cannot fail to be influenced by, the yearning of the blood within his veins for that from which it has been estranged, the half-fanciful regret that he should ever have been separated from these woods, these fields, these natural features of scenery to which his nature was moulded."[23] A painting by Constable might move Hawthorne's sensitive American just as readily as the actual scenery of Britain and perhaps even more. Like British place-names in the States, British landscapes in American collections can serve as reminders of the "mother country." The fact that there is a suburb of Boston named Dedham and the Museum of Fine Arts in Boston owns Constable's painting of *The Stour Valley and Dedham Church* (no. 43) is not entirely a coincidence.

Far more than the taste for British portraiture, the taste for British Romantic landscape painting was fostered in the States by American painters working under British influence. From an early date the visionary and apocalyptic landscapes of John Martin were admired by American artists such as Thomas Cole and Frederick Church. For all his disdain for the artistic scene in Britain, even Henry Tuckerman approved of Martin, writing that "the vague and sublime effects of Martin are among the few specimens of modern English art that seem born of original

inspiration."[24] There were already a number of important Constables and Turners in the States by 1900—including Constable's *The Stour Valley and Dedham Church* and *The White Horse* (fig. 33), and Turner's *Staffa* (no. 51) and *The Slave Ship* (fig. 14)—and the early decades of the twentieth century brought further landmark acquisitions. The impressive British collection formed by the Philadelphia cotton king John McFadden between 1900 and 1913 included Turner's *The Burning of the Houses of Lords and Commons* (fig. 15), and in 1914 Henry Clay Frick bought his two great Turners, *Harbour of Dieppe* and *Cologne, the Arrival of a Packet Boat*. The eighteen British paintings that entered the National Gallery of Art as part of the Widener Collection in 1942 included Constable's full-scale sketch for *The White Horse*, along with his *Wivenhoe Park*, and three Turners, including *Keelmen Heaving in Coals by Night*.

For Paul Mellon, the outstanding American collector of British landscape paintings, the pleasures of the landscape were inseparable from the pleasures of sport; his favorite British artist was George Stubbs,

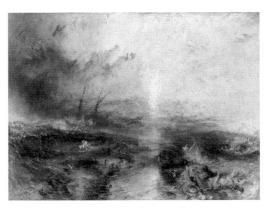

FIG 14: J. M. W. Turner, *The Slave Ship (Slavers Throwing Overboard the Dead and Dying – Typhon Coming On)*, 1839-40. Museum of Fine Arts, Boston. Henry Lillie Pierce Fund

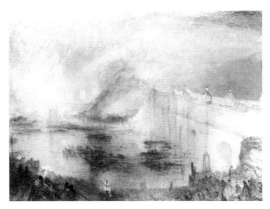

FIG 15: J. M. W. Turner, *The Burning of the Houses of Lords and Commons*, 1834-5. Philadelphia Museum of Art, The John Howard McFadden Collection

23. *Doctor Grimshawe's Secret* (c. 1861), quoted in Commager, xxii.
24. Quoted in Commager, 316.

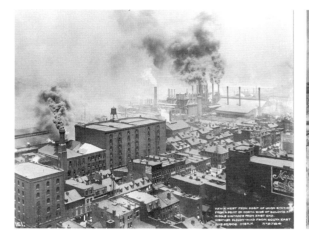

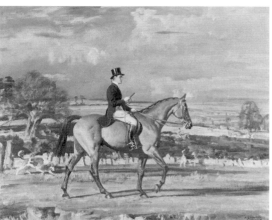

FIG 16: Pittsburgh: The Strip District. Photograph by Abram M. Brown, 1906. Carnegie Library, Pittsburgh

FIG 17: Alfred Munnings, *Paul Mellon on Dublin*, 1932–33. Yale Center for British Art, Paul Mellon Collection

in whose work the green fields of England appear so often as an idyllic setting for horseracing, hunting, or shooting. He collected in a spirit of nostalgia that was both historical and personal: through British art he looked back longingly to pre-industrial Britain, and at the same time to the happiest moments of his own childhood. In both these respects his Anglophilia and his collection were a reaction against his early home in industrial Pittsburgh, where his father created the Mellon fortune. He wrote in his autobiography of "the hellish quality of smoky old Pittsburgh with its mills belching fire (shades of William Blake's dark satanic mills)."[25] The young Paul Mellon escaped Pittsburgh almost every summer for a holiday in England—his mother was English—and this was the brightest moment of his year. Later, with his knowledge of the English poets and admiration for Blake in particular, he came to see England as Innocence to Pittsburgh's Experience, a green and pleasant land to set against those dark, satanic mills.

Like Wordsworth, Paul Mellon cherished his recollections of boyhood happiness, and none more intensely than those of Down Place, Windsor, where he stayed at the age of six: "England had a stillness and deep serenity in those last few years before the First World War. It is impossible to describe the atmosphere and feeling of that long-lost summer of 1913 . . . To me it had the color and feeling of childhood itself, a most beautiful and peaceful interlude."[26] The element of nostalgia in his response to British landscape art, the urge to regain a lost paradise, drew him especially to the paintings of Constable, for whom painting was in large part a Wordsworthian recollection of childhood joys; he found particular pleasure in the feeling of intimacy and freshness about Constable's oil sketches. Unlike his father, and indeed most of the older generation of American collectors, Paul Mellon pursued the English rural idyll in life as well as art; he lived in some ways like an English country gentleman on his estate in Virginia, owned and bred racehorses, and rode to hounds in both Virginia and England.

25. Mellon, 372.
26. Mellon, 72.

Though intensely nostalgic to Paul Mellon, and to most Americans, British landscape painting has appeared to some in a different light, as protomodern. Perhaps because it seems more "abstract" than portraiture, being more independent of patronage and lending itself more readily to free brushwork, landscape—especially the work of Turner and Constable—has been seen as part of the progressive, Modernist version of the story of nineteenth- and twentieth-century art. Both those artists are represented, for instance, in the Phillips Collection in Washington, a museum devoted to modern art and its sources. The great critic and champion of American Abstract Expressionism, Clement Greenberg, regarded most British art as too pretty by far. "Prettiness," he once wrote, "has been the besetting sin of English pictorial art."[27] But he reserved a special place for the Romantic landscapists. He saw a kinship between the Abstract Expressionists and Turner in particular, and placed both Turner and Constable in the noble lineage of protomodern artists, going back to the Venetian Renaissance, who delighted in the qualities of paint as paint: "The entelechy of oil painting on canvas is Turner, Constable, Géricault, Delacroix, Corot, Courbet, Daumier, the Impressionists and Post-Impressionists. This is the Venetian line," he wrote.[28] One of the most spectacular private collections of modern painting in New York today includes Turner's *Seascape: Folkestone* (fig. 18) as its historical cornerstone. In such a setting Turner appears quite a different artist from the stately Old Master he appears to be at the Frick Collection, another object lesson in the variety of ways in which American collectors have inflected the meaning of British art.

When C. H. Collins Baker compiled his "List of Some of the Principal British Paintings in American Collections" in the early 1930s, the only artist of relatively recent times whom he included was, curiously, Whistler. Presumably there were no other Victorian or early twentieth-century artists in American collections whose works he felt could be called "Principal British Paintings." No doubt Collins Baker was biased toward the Golden Age—but so were most American collectors, and the near absence of any more recent British art in his list is not such a misrepresentation as one might have hoped. Whereas Victorian and twentieth-century British painting have been collected with enthusiasm and discernment in Australia, Canada, and other formerly British parts of the world, the American taste for British art has tended to fade out around 1850. Given that so much of Victorian painting, in particular, was designed for the pleasure of collectors who were wealthy industrialists and businessmen, one might expect it to appeal to the wealthy industrialists and businessmen who collected British art in the States in the early decades of the twentieth century. But this would be to underestimate the conservatism of the Great Master collectors, who seldom bought recent art of any nationality, and also the importance of nostalgia in the American imaginative response to Britain.

Though offering any number of variations on the idea of the painting as a dream of another world, even the most "idealist" British painters of the

FIG 18:
J. M. W. Turner,
Seascape: Folkestone,
c. 1845.
Private Collection,
New York

27. *The Nation*, April 16, 1949, in *Clement Greenberg: The Collected Essays and Criticism*, ed. John O'Brian, 4 vols. (Chicago, 1986–93), 2:299.
28. *Partisan Review*, April 1950, in O'Brian, 3:33.

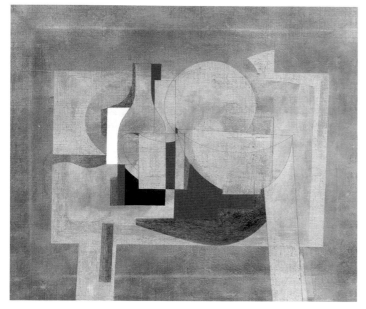

Victorian period could not compete with Gainsborough and Constable. This was because the great American collectors were less interested in the escapist visions of British artists than in an idea of Britain—its glamorous high society, its idyllic landscape—as an escape in itself. The Britain that produced Victorian painting, the modern, highly industrialized country in which most British people have actually lived, held no romance for them. They might be tempted by a later-nineteenth-century work of especially sympathetic subject matter: Lawrence Alma-Tadema's meticulous, marble-fixated vision of life among the affluent in ancient Rome enjoyed considerable currency in the States. But for the most part, the more serious they became as collectors, the more they were drawn to blue-chip artists of the past. Henry Clay Frick bought an Alma-Tadema in 1897 and sold it in 1906 to buy an Aelbert Cuyp. Those American collectors who have been interested in post-1850 European art as a specialty have been a different breed from the Great Master collectors who favored the British, and their taste, in some major instances under the encouragement of Mary Cassatt, has tended to center on the French Impressionist and Post-Impressionist painters. Today this taste has become so dominant among American art-lovers of all levels as to seem part of the natural order of things.

Nevertheless, though still very much a minority interest, the taste for post-Golden Age British art has shown some signs of growth among American collectors and museums. Some of the finest of the few Pre-Raphaelite paintings to enter American collections in the later nineteenth and early twentieth centuries became publicly accessible with the gift of the Bancroft Collection to what is now the Delaware Art Museum in 1935 and Grenville L. Winthrop's bequest to the Fogg Art Museum at Harvard University in 1943. Another landmark, important for both Victorian and twentieth-century British art in the States, was Andrew Carnduff Ritchie's splendid exhibition *Masters of British Painting, 1800–1950*, shown at the Museum of Modern Art in New York, the City Art Museum of St. Louis, and the California Palace of the Legion of Honor in San Francisco in 1956–57. By that time Huntington Hartford was already assembling the remarkable, now dispersed collection of Victorian art featured at his Gallery of Modern Art in New York. The 1960s saw a revival of interest in Victorian painting in Britain; this traveled in reduced form across the Atlantic and has continued to the present. The FORBES Magazine Collection in particular has done much, through touring exhibitions, to promote the cause. It is not unusual nowadays to find Victorian art taught in American universities, especially in art history departments

that lean toward the social history of art; certainly it receives more attention in the academic world than any other period of art in Britain.

When it comes to British painting of the twentieth century, the signs of growing interest are more difficult to discern, even with the most hopeful eye. As far as most American collectors, critics, museums, and universities are concerned, modern painting begins in Paris and moves to New York with no British stopovers; they regard modern British art as a poor man's version, first of the School of Paris, then of the School of New York. The Bloomsbury Group has enjoyed an American following, perhaps as much for its literary and biographical as for its artistic interest. The meditative calm of Ben Nicholson's paintings appealed to Paul Mellon, and, as in a few other instances, he broke with his preference for the Golden Age and bought a number of them (see fig. 19). Nicholson is well represented at the Yale Center for British Art and also at the Phillips Collection in Washington. In 1956 Andrew Carnduff Ritchie wrote bravely in support of modern British art in the catalogue of the *Masters of British Painting* exhibition: "Whatever the future of British art may be, and whatever its heights and depths have been over the past century and a half, it can be said that within the past twenty years its leading artists came of age and once more joined the company of Constable and Turner on an international rather than an insular stage."[29] Ritchie's statement has proved to be largely wishful thinking, however. Only one of the recent painters in his exhibition, Francis Bacon, could truly be said to have joined the company of Constable and Turner on an international stage. Nicholson is something of a name—and perhaps Stanley Spencer, inasmuch as the unmodern narrative and religious aspects of his work allow. But the others, Ivon

FIG 20: David Hockney, *American Collectors (Fred and Marcia Weisman)*, 1968. Art Institute of Chicago. Restricted Gift of Mr. and Mrs. Frederic G. Pick, 1984

Hitchens, Paul Nash, Graham Sutherland, and Victor Pasmore, hover uneasily between the off-beat and the unknown. Sutherland is perhaps the most poignantly representative figure: he was highly acclaimed in Britain during his lifetime and remains a familiar name there; his work is even represented by important examples in the States—at the Phillips Collection in Washington, the Museum of Modern Art in New York, and the Wadsworth Atheneum Museum of Art in Hartford. Yet he has virtually no American reputation.

The exceptions to the rule have been those few modern British artists who, like Bacon, and of course the sculptor Henry Moore, have managed to transcend nationality and the stigma of provincialism to become part of the canon of international modern artists. The others who have risen to this charmed status are Lucian Freud, David Hockney, and to a lesser degree Howard Hodgkin. These are artists whose works are standard ingredients of the American modern art collection, in which the fact that they are British is incidental. The most important British

29. Andrew Carnduff Ritchie, *Masters of British Painting, 1800–1950*, exh. cat. (Museum of Modern Art, New York, 1956), 11.

artist to follow his paintings across the Atlantic in person and settle in the States, Hockney is in a sense a key figure in the story of British art in American collections. On the other hand, his work is seldom collected in a particularly British setting; it may even be collected more often as American than as British, and perhaps rightly so. What the international modern collection tends to take away from paintings is their historical resonance. Although many of the figure paintings of Bacon, Freud, and Hockney relate in significant ways to the British portrait tradition so well represented in American collections, it is rarely that they appear in the kind of setting that would bring out this aspect of their meaning.

There is no Henry E. Huntington or Paul Mellon of modern British art, but it does have its dedicated supporters. William S. Lieberman has staged exhibitions and made impressive acquisitions in this area for the Metropolitan Museum of Art in New York, and there are fine private collections on both coasts. When American collectors do respond to something they feel is specifically British about modern British art, they do so with passion, and the something tends to be figuration combined with a certain intensity of feeling. This is the case with Elaine and Melvin Merians, probably the leading collectors on either side of the Atlantic of the School of London painters. "For me, I love figurative art," Melvin Merians has said in an interview. "That great school of Abstract Expressionism that came up in the United States just never spoke to either Elaine or me, though it is great art and they were great artists. So we searched for a great school or a great group of artists . . . that would fulfill the kind of aesthetics that we liked, and we found that the School of London did that for us."[30] When the collection of Susan Kasen Summer and Robert D. Summer was shown in Glasgow and

London in the exhibition *An American Passion*, Andrew Gibbon Williams described its dominant theme as "the courageous return to imaginative figuration with which the younger generation of British artists—those born in the late fifties and early sixties—stormed the citadels of the international contemporary art world during the early eighties."[31] The idea of contemporary British art as more gutsy and human, less hermetic than its American counterpart—even to the point of offensiveness—reached a mass American audience through the scandal surrounding the *Sensation* exhibition at the Brooklyn Museum of Art in 1999.

The paintings in the present exhibition are resident aliens, existing out of their national element. The artists who created them had altogether different kinds of setting in mind for them, mostly the walls of English country houses and mansions in London. If they imagined their works acquired by great art collectors and museums of the future, few of them can have imagined the collectors and museums would be on the other side of the Atlantic. Seeing works of art in their original, intended settings may be the ideal. But this does not make the inflections of meaning that other settings may bring to them a mere distraction. Like people, works of art change in interesting ways when they become expatriates. The life of paintings in the imaginations of the people who see them is always affected by *where* they see them. In the American setting British paintings may come across as Americanized or more British than ever, both of those things at the same time, or infused with some other quality that was never as apparent when they were on their home territory. They are part of the story of American Anglophilia, and the story is part of them.

30. *The School of London and Their Friends: The Collection of Elaine and Melvin Merians*, exh. cat. (Yale Center for British Art, New Haven, 2000), 26.
31. *An American Passion: The Susan Kasen Summer and Robert D. Summer Collection of Contemporary British Painting*, exh. cat. (Glasgow Museums and the Royal College of Art, London, 1994), 12–13.

Atlantic Crossings: British Paintings in America, 1630–1930

Robyn Asleson

The story of British painting in America parallels America's evolving relationship with Britain itself. It begins with a period of dependence on the mother country during the seventeenth and eighteenth centuries, when British (and particularly English) paintings were purchased, copied, and slavishly imitated as a matter of course. The early nineteenth century ushered in a struggle for independence, during which many American collectors, patrons, and artists widened their cultural perspective beyond Britain, forging ties with Continental Europe, while simultaneously developing indigenous artistic traditions at home. In the late nineteenth and early twentieth centuries, as burgeoning wealth raised the United States to a new position of dominance, American collectors began to capture artistic trophies that had once been perquisites of Britain's ruling classes.

Over the course of those three centuries, from the 1630s to the 1930s, American acquisition of British paintings shifted from an importation remarkable for its great quantity to one that was truly astonishing in its superb quality. The composition of *Great British Paintings from American Collections* reflects that historical trend, for the exhibition is dominated by works that entered the United States during the early twentieth century, when American collectors had the most money to spend and British owners were most eager to sell. A vivid impression of that heady period may be gleaned from the individual entries in this catalogue, where the circumstances that brought each of the paintings to the United States are detailed. The following essay sets the stage for the twentieth-century spending spree, examining the kinds of paintings that came to America earlier in the country's history, as well as the way those paintings functioned on their arrival and the motivations that fueled collecting. It must be admitted at the outset that the overall quality of works acquired during the seventeenth, eighteenth, and nineteenth centuries ranks well below that of twentieth-century acquisitions. Nevertheless, the paintings that crossed the Atlantic during the first three hundred years of this country's history provide fascinating insights into the evolving taste for British painting in America.

The Colonial Period, 1630–1776

Fleets of English colonists came to the American colonies in the seventeenth century, and in their wake followed a steady stream of paintings by English artists.[1] The vast majority of those early imported works were portraits. Indeed, in the first decades of colonization, scarcely any other type of painting appears to have been deemed worthy of the long trip across the Atlantic. The imbalance is scarcely surprising, as portraits were the predominant art form in seventeenth-century England as well—for reasons that were, if anything, more acute in the New World than in the Old.

1. I am grateful to Patricia Asleson and Ellen Miles for providing much valuable information about the presence of British paintings in the American colonies.

Among other functions, portraits gratified and reinforced the emotional bonds between family members and friends. After taking leave of their native land with "breast-breaking sobs" and "bowel-breaking affections,"[2] many American colonists turned to portraiture as a means of assuaging the pain of separation from distant loved ones. For example, when his daughter Elizabeth emigrated to America following her marriage in 1669 to Samuel Shrimpton (a councillor of the province of Massachusetts Bay), the London merchant Nicholas Roberts commissioned a series of family portraits specifically for her. In a letter of July 1671, Roberts announced that he had sat for his own portrait and was encouraging his wife to do the same. "I have not forgot my promise," he assured his son-in-law.[3] The parents' portraits were shipped in September 1674, and in the following year Roberts sent six additional portraits, representing Elizabeth's three sisters, her maternal grandmother, and pendant portraits of herself and her husband.

Like most English paintings imported into the American colonies in the seventeenth century, the series commissioned by Roberts for the Shrimptons was executed by an unknown artist from the middle ranks of his profession, whose principal concern was to provide a convincing likeness. In the portrait of Roberts's wife (fig. 21), the sensitively rendered face and eloquent hand convey an intimate sense of psychological connection, enhancing the portrait's ability to function as a surrogate for an absent loved one. There is scant evidence of the lustrous sensuality and courtly elegance cultivated by fashionable painters such as Peter Lely during the same period (see no. 4). Rather, the portrait reflects the conservative taste and modest means of the middle-class Roberts and Shrimpton families. The same old-fashioned, somewhat naive

appearance characterizes most of the British portraits that found their way to the American colonies during the seventeenth century.

The strong family feelings that made separation a painful ordeal for colonists also engendered a proud sense of dynastic tradition. Many of America's early settlers retained a loyal devotion to family heritage, while others were conscious of initiating fresh traditions in a new world. Both sentiments fueled the desire to create comprehensive displays of family portraits as a legacy for future generations. John Winthrop, the principal organizer and first governor of the Massachusetts Bay Company, never returned to England after coming to America in 1630. His portrait by an early seventeenth-century English painter (American Antiquarian Society, Worcester) either accompanied him across the Atlantic as part of his minimal household effects, or was brought over for reasons of familial pride by one of his sons or grandsons, several of whom sat for their own portraits during visits to England.[4] The 1671 inventory of William Moseley of Virginia lists twelve pictures in his study—most of them evidently family portraits brought from England twenty-two years earlier.[5] The Huguenot physician Paul Micou

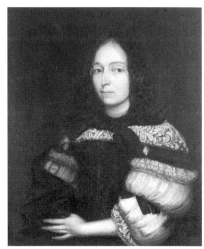

2. Quoted in Michael Zuckerman, "The Fabrication of Identity in Early America," *William and Mary Quarterly* 34 [3rd ser.] (April 1977): 197.
3. Quoted in Andrew Oliver, Ann Millspaugh Huff, and Edward W. Hanson, *Portraits in the Massachusetts Historical Society* (Boston, 1988), 13.
4. Rodger D. Parker, *Wellsprings of a Nation: America before 1801* (Worcester, 1977), 19; Oliver, Huff, and Hanson, 125–28.
5. "Virginia Council Journals, 1727–1753," *Virginia Magazine of History and Biography* 35 (January 1927): 49–54.

FIG. 21: Artist unknown, *Mrs. Nicholas Roberts (Elizabeth Roberts)*, c.1674. Massachusetts Historical Society, Boston

also carried "a large number of pictures" from England to Virginia in 1695,[6] and a group of "family pictures drawn by Sir Godfrey Kneller" evidently accompanied the English botanist John Clayton when he came to Virginia in 1705.[7] Numerous other examples confirm that sentimental and dynastic concerns (rather than an abstract appreciation of fine art) were of overriding importance in bringing the first English paintings to the American colonies.

Some of these imported paintings were clearly intended to serve a quasi-public function as symbols of status. Increase Mather, the eminent Boston divine, took time from his duties as London agent for the Massachusetts Bay Colony in order to sit for a half-length portrait, painted in 1688 by a minor artist who generally worked as a mezzotint engraver, Jan van der Spriett (fig. 22).[8] Although the choice of painter could scarcely be more humble, the portrait itself is unusually ambitious. In keeping with his public role as a spiritual leader, Mather is shown pointing to a passage in one of several hefty theological tomes. The impressive size and imagery indicate that the painting (which presumably accompanied Mather on his return to Boston in 1692) was intended for public consumption rather than as an intimate glimpse of Mather's private self.

Another native Bostonian, Jonathan Belcher, sat to the London artist Franz Lippoldt in 1729, the same year that he returned to America after an absence of twenty-five years (Massachusetts Historical Society). The last-minute commission suggests the importance attached to displaying one's portrait in the New World, especially if that portrait was executed by an Old World artist. Presumably the same motive lies behind the impressive series of family portraits commissioned by Edward Jaquelin, who had become one of the wealthiest men in Virginia after emigrating to

the colony around 1697. On a return visit to England in the 1720s, Jaquelin reportedly secured the services of "an artist of the greatest merit he could find" to paint his wife, five children, and himself.[9] Artists were active in Virginia by that date, but Jaquelin evidently considered the English hallmark more in keeping with his eminent social status. In the decades that followed, Americans would continue to view English portraiture as a means of lending prestige to their personal image.

A large number of the portraits sent from England to America in the seventeenth and eighteenth centuries served yet another purpose—a political one—by providing visual symbols of English authority. Pictures of the monarch and of official representatives of the Crown flowed to the American colonies and were displayed prominently in town halls, legislative meeting rooms, and governors' residences. Initially, these portraits appear to have crossed the Atlantic as propagandistic "gifts." In 1732, when Maryland's disputed boundaries threatened the tax revenues of Charles Calvert, 5th Lord Baltimore, he took the unusual step of traveling to the province himself. To ensure that his authoritative presence endured long after he had returned to England, Lord Baltimore endowed the colony with a commanding full-length portrait of himself, painted in London c. 1732 by Herman Van der Mijn (City Life Museums/The

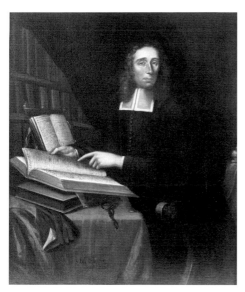

FIG. 22: Jan van der Spriett, *Increase Mather*, 1688. Massachusetts Historical Society, Boston

6. Philip Slaughter, *Memoir of Col. Joshua Fry* (Richmond, 1880), 16–17; Paul Micou, "Paul Micou, Huguenot Physician and His Descendants," *Virginia Magazine of History and Biography* 46 (October, 1938), 362–63.
7. "Historical and Genealogical Notes," *William and Mary College Quarterly* 4 [1st ser.] (January 1896): 200.
8. Samuel Abbott Green, *Remarks on an Original Portrait of the Rev. Increase Mather*, D.D. (Cambridge, 1893), 5–6.
9. "Smiths of Virginia," *William and Mary College Quarterly* 5 (July 1896): 51. Photographs of several Jaquelin portraits are in the Virginia Historical Society, Richmond.

10. Richard Saunders and Ellen G. Miles, *American Colonial Portraits, 1700–1776* (Washington, 1987), 149–50.

11. Michael Quick, "Princely Images in the Wilderness, 1720–1775," in Michael Quick et al., *American Portraiture in the Grand Manner: 1720–1920* (Los Angeles, 1981), 13.

12. George Francis Dow, *The Arts & Crafts in New England, 1704–1775* (Topsfield, Massachusetts, 1927), 5.

13. Jacob Simon, "Allan Ramsay and Picture Frames," *Burlington Magazine* 136 (1994): 452.

14. *Boston News-Letter* (October 8/15, 1730, quoted in Dow, 5.

15. *Virginia Magazine of History and Biography* 35 (July and October 1927): 277, 407.

16. James L. Yarnall and William H. Gerdts, *The National Museum of American Art's Index to American Art Exhibition Catalogues*, 5 vols. (Boston, 1986), 3:2044.

Peale Museum, Baltimore). Reinforcing the impact of the portrait, the succeeding Lord Baltimore sent his own full-length likeness to Annapolis in 1766, to "be plac'd in the Council-Room near that of his Noble Father."[10] These impressive paintings served an important aesthetic role by fostering the development of grand, full-length portraiture by American artists. Their primary function was as icons of political authority, however, rather than as works of art. As a result, state portraits became irresistible targets for republican wrath during the revolutionary war, so that today few examples survive of the scores of state portraits that once hung along the eastern seaboard (although efforts have been made in recent decades to acquire equivalent examples; see, for example, no. 5).

Written accounts provide glimpses of the once-formidable impact that state portraits once had in the New World. Within two years of Queen Anne's succession in 1702, her imposing full-length portrait hung in the new Virginia Capitol at Williamsburg. Equally magisterial representations of the queen hung in Maryland's Capitol in Annapolis. From the walls of the armory ballroom, she gazed down imperiously on meetings of the council, while in the main hall of the second statehouse, she was depicted at full length, presenting the city with its charter.[11] When the town hall in Boston caught fire in 1711, it was the queen's portrait that was rescued from the blaze.[12] The magnificent proliferation of royal portraiture in the colonies resulted from the Crown's official distribution system, whereby each colonial governor received, as a right of office, a copy of the monarch's official portrait, paid for by the Lord Chamberlain's Office.[13] The portraits of George II and Queen Caroline that hung in the council chamber of Boston in 1730 bore inscriptions identifying them as "the Gift of His Majesty,

to His Province of the Massachusetts Bay."[14] Similar inscriptions presumably appeared on the pair of royal portraits acquired by Virginia that same year.[15]

Many of those paintings were probably supplied by the studio of Godfrey Kneller, who had produced defining images of Queen Anne's predecessors, Charles II, James II, and William and Mary. Kneller also secured the favor of George I, who succeeded Anne in 1714. His portrait of the new king was one of Yale College's earliest art acquisitions, presented in 1718 by Elihu Yale (fig. 23). Like so many other state portraits, Yale's suffered its share of violence during the revolutionary war; according to a nineteenth-century source, "some over-zealous patriot" destroyed the painting's royal crest, which presumably had ornamented the frame.[16]

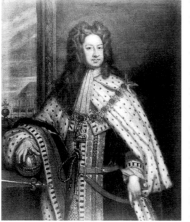

FIG. 23: Godfrey Kneller, *George I*, c. 1717. Yale University Art Gallery, New Haven. Gift of Governor Elihu Yale, 1718

In light of their propagandistic function, it is not surprising that the most extensive colonial importations of English state portraits occurred in the decade preceding American independence. Having produced two masterful state portraits of George III and Queen Charlotte shortly after their coronation in September 1761, Allan Ramsay devoted the last two decades of his career to supplying an unprecedented number of replicas to dignitaries and courtiers, including successive governors of Massachusetts Bay, New York,

New Jersey, Virginia, North and South Carolina, and East and West Florida.[17] A visitor to Ramsay's London studio later remembered it as "crowded with portraits of His Majesty in every stage of their operation. The ardour with which these beloved objects were sought for by distant corporations and transmarine colonies was astonishing; the painter with all the assistance he could procure could by no means satisfy the diurnal demands that were made . . . upon his talents and industry."[18] This assessment is supported by the persistence with which William Franklin (son of Benjamin), governor of New Jersey, issued pleas for Ramsay's state portraits of the newly crowned George III and Queen Charlotte. "I wish the King and Queen's pictures were finished," he wrote toward the end of December 1763, "as there is no picture of either of them (except the prints) yet sent to N. America." On February 18, 1765, he wrote again, "Pray hasten Mr. Ramsay with the King & Queen's picture."[19] As Franklin's powers derived from the Crown, it is no wonder that he was eager to buttress his authority through the symbolic presence of the new monarch and his consort.

The steady flow of royal portraits to the colonies gave rise to the earliest true "collections" of English painting in America. By the mid-eighteenth century, colonial governors and other locally prominent men had begun to assemble comprehensive sets of portraits representing past and present English monarchs. Groups spanning the reigns of Charles II through George III were displayed at the Governor's Mansion in New York and at the State House in Boston. Similar assemblages were given to universities and collected privately.[20] The creation of such portrait series presumably required the assistance of agents in London, who either scouted for existing portraits of historic monarchs or commissioned new copies.

Such an arrangement is suggested by the *Boston Gazette*'s report of 1740 (thirty-eight years and three monarchs after the death of William III) that "the Pictures of their late Majesty's [sic] King William and Queen Mary of blessed memory, at full length, which were done in London by the best Hands, at the charge of the Province, are come over in Capt. Jones. They are reckoned to be fine Pieces, and on Saturday last they were put up in the council Chamber."[21] Portraits of British monarchs and statesmen of still greater antiquity (such as Mary Queen of Scots, Elizabeth I, Charles I, and Francis Bacon) were presumably acquired as historical curiosities some time after their deaths.[22]

Colonists who chafed under royal authority imported English portraits for propagandistic purposes of their own—as counterweights to the icons of authority that hung in the official seats of government. On numerous occasions portraits of English advocates of American liberties were commissioned and displayed publicly for political effect. In 1765 a group of Boston citizens voted to commission portraits of Col. Isaac Barré and the Hon. Henry Seymour Conway, who had supported American interests during the recent Stamp Act controversy. The two portraits were duly commissioned and shipped from England to Boston, to be exhibited publicly at Faneuil Hall. The arrival of the paintings in January and May 1767 was reported by the *Boston Gazette* as a matter of public interest. In 1768 a group of citizens from Westmoreland County, Virginia, commissioned portraits of two other opponents of the Stamp Act.[23]

Less contentious tributes to overseas benefactors were erected in America's early colleges and institutions. In 1722 Harvard College commissioned the London artist Joseph Highmore to paint a full-length

17. Simon, 453–54; Alastair Smart, *Allan Ramsay: A Complete Catalogue of his Paintings*, ed. John Ingamells (New Haven, 1999), 112–18.
18. Quoted in Smart, 112.
19. Ellen G. Miles, "The Portrait in America," in Saunders and Miles, 53.
20. Miles, 52, 55; Quick, 12.
21. *Boston Gazette* (December 1/8, 1740), quoted in Dow, 5.
22. "Historical Notes and Queries," *William and Mary College Quarterly* 9 [1st ser.] (July 1900): 64 and 12 (October 1903): 129; Quick, 13; John K. Howat, "Private Collectors and Public Spirit: A Selective View," in Catherine Hoover Voorsanger and John K. Howat, eds. *Art and the Empire City: New York, 1825–1861* (New Haven and London, 2000), 89.
23. Quick, 12–14; Miles, 55–56.

24. Laura M. Huntsinger, *Harvard Portraits* (Cambridge, 1936), 75; Dow, 35; Saunders and Miles, no. 30.

25. Colonial Dames of America in the State of Georgia, *Early Georgia Portraits, 1715–1870* (Athens, Georgia, 1975), 94.

26. Kenneth A. Lockridge, *The Diary, and Life, of William Byrd II of Virginia, 1674–1744* (Chapel Hill and London, 1987), 20–23.

27. Virginius Cormick Hall, Jr., *Portraits in the Collection of the Virginia Historical Society* (Charlottesville, 1981), 41–42.

28. "Letters of the Byrd Family," *Virginia Magazine of History and Biography* 35 (October 1927): 374; R. A. Brock, "Portraits of Colonial Virginians," *William and Mary College Quarterly* 1 [1st ser.] (October 1892): 124.

29. "The Will of Mrs. Mary Willing Byrd, of Westover, 1813," *Virginia Magazine of History and Biography* 6 (April 1899): 346–58; "Letters of the Byrd Family," *Virginia Magazine of History and Biography* 36 (July 1828): 219–20, and 38 (April 1930): 147–52; W. S. Morton, "The Portraits of Lower Brandon and Upper Brandon, Virginia," *William and Mary Quarterly* 10 [2nd ser.] (October 1930): 338–40.

portrait of Thomas Hollis, a wealthy London merchant who had enlarged the library and endowed a number of Harvard professorships and scholarships. When Highmore's painting was destroyed by fire in 1764, a copy of another English portrait was immediately commissioned for the college.[24] A more unusual commission was carried out by John Russell in 1772: an allegorical portrait of the Methodist leader Selina Hastings, Dowager Countess of Huntingdon, painted for the Bethesda Orphanage in Georgia (Bethesda Home for Boys, Savannah).[25] The full-length portrait shows Lady Huntingdon veiled and dressed in a brown nun's habit, holding a crown of thorns in one hand and, with the other, lifting her skirt to reveal a sandaled foot resting on the temporal crown of a monarch.

In private contexts, too, English portraits enabled American colonists to commemorate the social alliances, political allegiances, and commercial partnerships that connected them with the mother country. Portraits of well-known (especially titled) English sitters, executed by technically sophisticated English painters, possessed a distinctive cachet, even while demonstrations of Anglophilia were arousing increasing suspicion in pre-revolutionary America. Like other sons of well-to-do colonial families, Virginia-born William Byrd II was sent at an early age to be educated in England. To commemorate his acquisition of the manners, dress, and deportment of an English gentleman, he sat for two elegant portraits shortly before coming into his inheritance in 1704.[26] One of these remained in Byrd's London house until 1725, when he gave it to a distinguished friend, the natural philosopher Charles Boyle, 4th Earl of Orrery (Virginia Historical Society, Richmond).[27] The other painting (fig. 24) evidently accompanied Byrd on his return to America and hung at his Virginia

FIG. 24: Godfrey Kneller (attrib.), *William Byrd II*, c. 1704 Colonial Williamsburg Foundation

estate, Westover, where he was accumulating the colony's largest private library and a collection of pictures that included works attributed to Titian and Rubens.[28]

Byrd's long and frequent periods of residence in London and his intimacy with a number of politically prominent English aristocrats burnished his reputation as one of the most cultivated men in Virginia. Proud of his transatlantic connections, he acquired Kneller's portrait of his former tutor, the diplomat Sir Robert Southwell (Virginia Historical Society), together with those of a dozen other eminent English friends and associates. Some of these were evidently acquired long after Byrd's final London sojourn in 1726, when affection for distant friends (mingled, no doubt, with a desire to advertise his prestigious connections) provided a spur to collecting.[29] Most appear to have been painted by Godfrey Kneller and his

closest rivals, attesting to the high expectation of artistic quality that led Byrd to disparage another English artist as lacking "the Masterly Hand of a Lilly [Lely], or a Kneller."[30] The combined firepower of so many titled English luminaries could not fail to impress visitors to Westover, although some of Byrd's Virginia neighbors evidently took offense. A Mr. Waltham of Williamsburg bequeathed a diamond ring to Byrd on the condition that his own portrait (which showed him wearing a hat) be hung in the same room with those of Byrd's aristocratic English friends.[31]

Travel and communication between Britain and the American colonies became even more prevalent in the latter half of the eighteenth century. Civil officials and merchants crossed the ocean in the course of their business; the wealthy made trips for pleasure or health; and young people were sent out in pursuit of education and genteel "finishing." In the bustling marketplace of London, American visitors shopped for fine items to send home, and works of art were among the treasures that most frequently caught their eye. In a letter of 1764 accompanying some landscape prints that he had bought in London at the request of his brother-in-law in Charleston, Barnard Elliott described the splendid paintings that he would have preferred:

> Had I but fifty guineas to spend I would bring over such a collection of Hunting Pieces etc. as would charm you beyond everything but they are painted in oil, and are too dear for me to purchase, the least being priced at ten guineas, but What is that to three hundred, which I saw given the other day for a noble piece of Lord Grosvenor, and his Company with every Dog, Horse, and Servant taken from life on a full chase . . . Some fine historical pieces also valued at five hundred guineas but you could have no sort of idea of them without seeing them yourself, for they are beyond description fine![32]

Elliott's letter attests to the American interest in English painting other than portraiture—but also exposes the lack of financial wherewithal that prevented colonials abroad from indulging in such temptations.

Modest collectors such as Elliott were far more likely to spread their limited resources thinly, dabbling in minor landscapes, still lifes, and genre scenes. Such paintings did not have to be acquired abroad but could be purchased in major American cities, where whole cargoes of luxury goods were sent from England as commercial speculations. In southern cities such as Baltimore and Charleston, well-to-do planters traded tobacco for imported household items, and the earliest art exhibitions in those cities featured landscapes, hunting scenes, and genre subjects by minor English and Scottish artists.[33] By the 1740s Philadelphia and Boston newspapers were regularly advertising assorted oil paintings imported from London and Bristol, featuring themes such as "[the] seasons, months, Monemy's sea pieces, sieges, the views of Venice, England and French views, with a variety of other humours."[34] As the list of subject matter suggests, most of the paintings were of a generic, decorative nature, serviceable as elements of domestic furnishing rather than as rarefied works of fine art. Particularly accomplished examples are the allegorical representations of the Four Seasons, painted by Philippe Mercier and given in the 1740s to Samuel Ogle, Governor of Maryland, by Lord Baltimore, Proprietor of the colony (The Belair Mansion, City of Bowie Museums). Painted in soft, pastel colors, the youthful figures personifying Spring, Summer, and Fall would have added a charming decorative accent to any room. Even elderly Winter, warming his hands

30. Quoted in "Letters of the Byrd Family," (July 1928), 212. See also "Meade Family History," *William and Mary College Quarterly* 13 (October 1904): 91.

31. Morton, 340.

32. Anna Wells Rutledge, "Artists in the Life of Charleston through Colony and State from Restoration to Reconstruction," *Transactions of the American Philosophical Society* 39 n.s. (November 1949): 116.

33. *A Century of Baltimore Collecting, 1840–1940,* exh. cat. (The Baltimore Museum of Art, Baltimore, 1941), 7; Paul Staiti, "The 1823 Exhibition of the South Carolina Academy of Fine Arts: A Paradigm of Charleston Taste?" in David Moltke-Hansen, ed., *Art in the Lives of South Carolinians* (Charleston, 1979), PSb-4, 9–14.

34. *The Pennsylvania Gazette* (May 11, 1749); for Boston papers, see Dow, 18–25, 32, 36–37.

FIG. 25: Philippe Mercier, *Winter*, from *The Four Seasons*, c. 1740. Belair Mansion, Bowie, Maryland

35. Robert G. Stewart, *Robert Edge Pine: A British Portrait Painter in America, 1784–1788* (Washington, 1979), 13, 19–20, 23–25, 38, 110–14.
36. Helmut von Erffa and Allen Staley, *The Paintings of Benjamin West* (New Haven and London, 1986), 15, 24, 571.

by the fire, appears cheerfully benign (fig. 25).

In their acquisition of art, as in so many other social patterns, American colonists essentially replicated the attitudes and customs that characterized the middle classes of Britain and continental Europe. Paintings were valued chiefly as biographical documents (portraits) and as home furnishings (landscapes and genre scenes) and in every instance were required to blend unobtrusively into a cozy domestic environment. There was even less support in the colonies than in England for the large-scale and dramatic imagery of "high art"—imaginative scenes from history, literature, and mythology that ambitious artists struggled to promote in England. On immigrating to Philadelphia in 1784, Robert Edge Pine carried with him a large selection of the theatrical and historical paintings that he had failed to sell in England. Yet, like many other European artists who pursued their fortunes in the colonies, he soon found that there was little choice but to support himself as a portrait painter.[35]

Indeed, despite the growing market for other subject matter, portraiture remained the most sought-after type of English painting in eighteenth-century America. From mid-century sitting for one's portrait while on a visit overseas became standard practice. This was especially the case among young men sent to England to be educated, either in schools and universities or through an ambitious course of European travel known as the Grand Tour. After completing his education at the College of William and Mary in Virginia, Robert Carter received additional polish through a two-year sojourn in England. He crystallized his newly acquired sophistication through an elegant portrait probably painted by Thomas Hudson, one of London's most successful artists during the 1740s and 1750s (fig. 26). The portrait shows Carter in a jaunty pose and rich satin costume, both of which were modeled on the aristocratic seventeenth-century style of Anthony van Dyck. In mid-eighteenth century London such costumes were frequently worn at fashionable masquerades, so that the portrait alludes to Carter's acceptance into well-heeled English social circles, as well as his acquisition of the grace and confidence of an English gentleman.

FIG. 26: Thomas Hudson (attrib.), *Robert Carter*, c. 1750. Virginia Historical Society, Richmond

English affectations of a different kind color a group portrait of 1763–64 by Benjamin West representing five young Americans who had recently completed their studies at Cambridge and the Middle Temple, London (private collection).[36] West, another American in pursuit of sophistication abroad, pictured the men wielding cricket bats before a riverine landscape intended to recall Cambridge. In years to

FIG. 27: Joshua Reynolds, *Charles Caroll of Carrollton*, 1763
Yale Center for British Art, Paul Mellon Collection

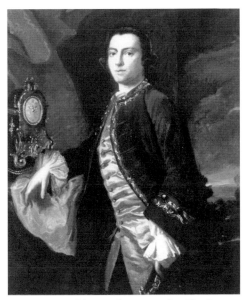

FIG. 28: Margaret Owen, copy after Allan Ramsay,
Peter Manigault, 1751. The Charleston Museum,
Charleston, South Carolina

come West would carry out commissions for many Americans, as would John Singleton Copley, Gilbert Stuart, and other Americans working in London. However, such painters by no means monopolized American patronage. The South Carolinian Ralph Izard, who commissioned West's group portrait, had sat to the London painter Johann Zoffany while at Cambridge, and a few years later he commissioned Thomas Gainsborough to paint his wife.[37] Another sitter in West's painting, the Virginian Ralph Wormeley of Rosegill, sat to Robert Edge Pine for an impressive half-length portrait that represents him in academic robes before the backdrop of Trinity Hall, Cambridge (Virginia Historical Society).[38] Significantly, Wormeley commissioned the painting in 1763, the year that Pine triumphed for the second time in a prestigious annual art competition.[39] An equally ambitious choice of painter was made by Charles Carroll of Carrollton, a Maryland-born student of law at the Middle Temple, London, who like the others sat for his portrait in 1763 before returning to America in 1765 (fig. 27). Carroll's father initiated the commission, writing on April 8, 1762: "I desire you will get your picture drawn by ye best hand in London … let it be put in a genteel gilt frame and sent me by ye next fleet carefully cased and packed." Carroll sagely selected Joshua Reynolds, future president of the Royal Academy of Arts, as his portraitist, but warned his father that the twenty-five guineas Reynolds charged was "an extravagant price but you desired it should be done by the best hand."[40]

Increasingly during the eighteenth century American visitors to England resembled the young men described above in targeting London's finest painters as their chosen portraitists. The elevated expectation of artistic quality emerges clearly in a letter of 1751, sent by twenty-one-year-old Peter Manigault to his mother in Charleston, along with his portrait by Allan Ramsay (unlocated; for a copy, see fig. 28). "Tis done by one of the best Hands in England," Manigault wrote, "& is accounted by all Judges here, not only an Exceedingly good Likeness, but a very good Piece of Painting." Manigault appears to have been Ramsay's only American patron, and consciousness of his daring prompted him to beg an assessment of the finished picture from the South Carolina painter

37. Rutledge, November 1949, 116.
38. Benjamin Ogle Tayloe, "American Gentlemen of the Olden Time, Especially in Maryland and Virginia," *Tyler's Quarterly Historical and Genealogical Magazine* 2 (October 1920): 89.
39. Stewart, 13, 15.
40. Quoted in Saunders and Miles, no. 84.

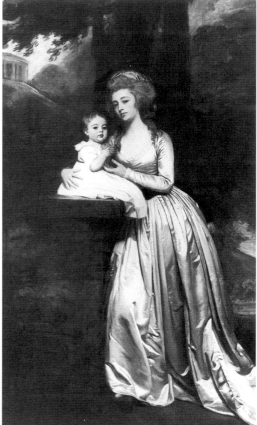

41. Rutledge, November 1949, 116; see also Miles, 48.
42. George C. Rogers, Jr., "Preliminary Thoughts on Joseph Allen Smith as the United States' First Art Collector," and Sallie Doscher, "Art Exhibitions in Nineteenth-Century Charleston," in Moltke-Hansen, GR-5, SD-4, 7, 12, 14.

Jeremiah Theüs. In the letter to his mother, Manigault accounted for his unusual choice of portraitist on the basis of artistic quality rather than representational value:

I was advised to have it drawn by one Keble [William Keeble], that drew Tom Smith, & several others that went over to Carolina, but upon seeing his Paintings, I found that though his Likenesses, (which are the easiest Part in doing a Picture,) were some of them very good, yet his Paint seemed to be laid on with a Trowel, and looked more like Plaistering than Painting.[41]

Ramsay, by contrast, was noted for the exquisite polish of his paint surface (see no. 10)—a mode that perfectly embodied the refinement Manigault was cultivating in England through lessons in dancing, fencing, and drawing. Alluding to the elegant ways he had acquired, Manigault informed his mother with pride:

The Drapery is all taken from my own Clothes, & the very Flowers in the lace, upon the Hat, are taken from a Hat of my own. . .Tell me if you think any Part of it too gay, the Ruffles are done charmingly,

and exactly like the Ruffles I had on when I was drawn, you see my Taste in Dress by the Picture, for everything there, is what I have had the Pleasure of wearing often.

From the choice of painter to the choice of dress, every feature of Manigault's portrait (and others of its kind) was calculated to flaunt the sophistication that the American sitter had achieved abroad. Indeed, when his mother first broached the subject of his portrait, Manigault had tried to persuade her to commission a full-length—a rare extravagance among colonial American patrons that she evidently refused.

Three and a half decades later another Charleston native, Lt. Col. Roger Smith, did commission a grand full-length portrait of his wife and infant child (fig. 29). Carried out in 1786 by one of London's most fashionable portraitists, George Romney, the painting shows Mary Rutledge Smith in a glamorous gown of shimmering satin, posed before a cultivated, park-like setting intended to convey intimations of wealth and landownership. The painting arrived in Charleston in 1788 and for many years remained the most magnificent private portrait in the city as well as the only major Romney in America. It became a standard feature of Charleston exhibitions, providing a stunning contrast to the innumerable head-and-shoulders portraits of male sitters that Americans tended to bring back from England.[42] By the end of the nineteenth century, full-length female portraits in the grand manner (particularly those by Romney) figured among the most highly coveted paintings on the American market.

Despite the rising spirit of independence in eighteenth-century America, England remained the ultimate source of ideals of sophistication and refinement. As touchstones of the elegance and gentility that colonists continued to associate with the Old World,

portraits painted in England possessed a patina of distinction that American artists were unable to rival until the late nineteenth century. Moreover, although capturing a convincing likeness remained the most important consideration in the success of a portrait, American patrons were becoming steadily more concerned with artistic quality. When viewed alongside the works of local artists such as Theüs, with their propensity for strong colors and stark highlights, the suffused modeling and subtle color schemes favored by painters such as Hudson, Ramsay, and Reynolds presented a distinctively English appearance that redoubled a portrait's capacity to impress.

The Nineteenth Century

As American society grew increasingly nationalistic in the decades that followed independence, civic and cultural leaders in Boston, New York, Philadelphia, Baltimore, and Charleston began to organize art exhibitions and academies as a means of promoting indigenous traditions in the fine arts. Private collectors proudly turned over paintings they considered models of artistic excellence: chiefly works attributed to esteemed European "Old Masters" such as Titian, Raphael, Rubens, Rembrandt, and the founders of the English school, van Dyck, Lely, and Kneller.[43] Emulating the practice of recent London exhibitions, "Old Master" status was also extended to illustrious English painters of the late eighteenth century, such as Gainsborough and Reynolds.[44] The majority of these paintings were very likely unauthentic, for the tendency to "consider nothing excellent unless it be old and come from abroad" (as Philadelphia's *Port Folio* magazine observed wryly in 1814)[45] made America's inexperienced connoisseurs easy targets for cunning salesmen. A particularly notorious example was the group of Old Master paintings

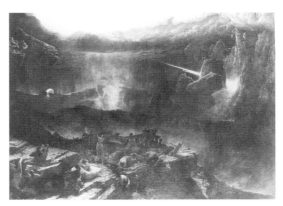

FIG. 30 Francis Danby, *The Opening of the Sixth Seal*, 1828
National Gallery of Ireland, Dublin

spirited to New York in 1830 by the unscrupulous London picture cleaner and dealer Richard Abraham. His collection was dominated by European Old Masters and a hodgepodge of English pictures, ranging from a portrait of Charles I by William Dobson to an Italian landscape by Richard Wilson. When it was discovered that Abraham's cargo actually belonged to a string of hoodwinked English clients, he was arrested. Nevertheless, the paintings remained in New York and attracted over 15,000 curious spectators to the American Academy of Fine Arts, where they were exhibited prior to being sold at auction.[46]

Americans were on firmer ground when securing paintings by living British artists. Contemporary paintings brought to the United States for exhibition and potential sale in the first decades of the nineteenth century ran the gamut from a group of animal paintings by James Ward, exhibited at New York's National Academy of Design in 1831, to Francis Danby's monumental *The Opening of the Sixth Seal* (fig. 30), which toured Philadelphia, Washington, and New York in 1833.[47] The American Academy of Fine Arts in New York forged particularly close links with the contemporary British art world. In addition

43. Yarnall and Gerdts, 3:1760–61, 2043–44, 2169–70, 5.3641–48.
44. Yarnall and Gerdts, 4:2930–32; Carrie Rebora, "The American Academy of Fine Art, New York, 1802–1842," Ph.D. dissertation, City University of New York, 1990, 403–04.
45. Quoted in Neil Harris, *The Artist in American Society: The Formative Years, 1790–1860* (Chicago and London, 1982), 104.
46. Carrie Rebora, "Mapping the Venues" in Voorsanger and Howat, (2000), 53; and Rebora, 1990, 83, 99 n. 93, 392–93.
47. Rebora, 2000, 55, 75; Rebora, 1990, 72–73, 391, 404, 410–11, 417–18.

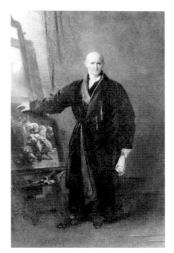

FIG. 31: Thomas Lawrence, *Benjamin West*, 1818-21. Wadsworth Atheneum Museum of Art, Hartford, Connecticut.

48. Rebora, 1990, 163.
49. Raeburn was also elected an honorary member of the Academy of Art in South Carolina in 1821 (Allan Cunningham, *The Lives of the Most Eminent British Painters and Sculptors*, 4 vols. [New York, 1868], 4:196; Rebora, 1990, 71–72).
50. *Catalogue of American Portraits in The New-York Historical Society*, 2 vols. (New Haven and London, 1974), 1:477.
51. See Rebora, 1990, 72–73, 159–216.
52. Yarnall and Gerdts, 3:2135–37; Rebora, 1990, 182–83.
53. Anna Wells Rutledge, "Robert Gilmor, Jr., Baltimore Collector," *The Journal of the Walters Art Gallery* 12 (1949): 26; *A Century of Baltimore Collecting*, 27.
54. *The Taste of Maryland: Art Collecting in Maryland, 1800–1934*, exh. cat. (The Walters Art Gallery, Baltimore, 1984), vi, 1–2.
55. Quoted in Rutledge, 1949, 20.
56. Rutledge, 1949, 21–22, 32.
57. *A Century of Baltimore Collecting*, 27–28, 30; Yarnall and Gerdts, 3:1756; 4:2482; 5:3951.

to using the Royal Academy of Arts as an institutional model, the Academy sought practical assistance from British artists and collectors. Two of the leading portraitists of the day, Henry Raeburn and Thomas Lawrence, were invited in 1817 to become honorary members—with the stipulation that each should provide "a specimen of his talents" as an object of study.[48] Raeburn complied with a portrait of Peter Van Brugh Livingston painted in 1819 while the New Yorker was visiting Edinburgh on his return from the Grand Tour (Wadsworth Atheneum Museum of Art, Hartford).[49] First exhibited at the American Academy in 1820, the portrait was eagerly copied by a number of local artists, including Thomas Sully in 1828.[50] Lawrence produced a far more ambitious painting for the Academy: a full-length portrait of the expatriate American artist Benjamin West (fig. 31), who reigned over the British art world as president of the Royal Academy from 1792 until his death in 1820, when Lawrence succeeded him. Eager to honor their illustrious compatriot and to possess a major work by Lawrence as "a principal Ornament of our Gallery, and an excellent Study for the Pupils of our infant institution," the Academy commissioned West's portrait for the extravagant price of £420.[51]

Although Americans would later prove themselves voracious collectors of Lawrence's glamorous society portraits and sentimental pictures of children (see nos. 37–40), very few of his paintings had crossed the Atlantic at the time of the West commission.[52] Rare exceptions were the pair of portraits he painted in 1817 for Mr. and Mrs. Robert Gilmor, Jr. of Baltimore, who were then beginning a three-year sojourn in London.[53] The son of a Scottish immigrant who amassed a large fortune through maritime commerce with Russia and the Far East, Gilmor had indulged his precocious taste for Old Master paintings, drawings, and prints while completing his education in Amsterdam and making the Grand Tour (1799–1801).[54] He became one of the first Americans to buy historic and contemporary art on a grand scale, but his collection was more remarkable for quantity than quality. After admiring a drawing in a Dutch collection that had cost the equivalent of $5,600, he reflected ruefully, "What would be thought in America, of a man who gave such an enormous sum for one poor drawing, shut up in a portfolio?"[55] Gilmor's own purchases seldom cost more than $100, and he once admitted that although his collection was superior to most in the United States, "yet one good picture of a London cabinet would be worth the whole."[56]

Dutch and Flemish paintings dominated Gilmor's collection, but he also had a penchant for British depictions of rural life. In addition to numerous English watercolors, he owned landscape paintings by Richard Wilson, sporting pictures by Benjamin Marshall, genre subjects by William Hogarth, and rustic scenes by Thomas Barker of Bath and George Morland.[57] Such paintings were already so prevalent in the United States that Gilmor merely consolidated what others had brought into the country, without importing many from abroad. In 1806, for example,

he purchased a version of Richard Wilson's *Lake Nemi* from the American landscape painter William Groombridge, whom he commissioned in the same year to paint a Baltimore landscape.[58] Gilmor encouraged American artists such as Groombridge not to copy the artificial conventions of English landscapes but to paint what they actually saw before them. "Nature, *nature*, after all is the great *Master* in landscape painting," he reminded the American painter Thomas Cole in 1826.[59] Expanding on the subject in a subsequent letter to the artist, Gilmor observed, "The English school of landscape painting is as you say not a strict adherence to nature. There is too much artificial effect, . . . and the consequence is a slovenly unfinished style of execution merely to produce it—[J.M.W.] Turner was the best."[60]

Gilmor's contemporaries sustained a flourishing market for the type of eighteenth-century British landscapes that he faulted as "artificial." A dozen of Richard Wilson's classicizing views of Italy and Britain were exhibited in Baltimore, Boston, Pittsburgh, Philadelphia, and New York between 1821 and 1874. During the same period an equal number of Dutch-influenced rustic scenes ascribed to Thomas Gainsborough (and just three or four of the artist's portraits) were displayed in cities as far-flung as Buffalo, St. Louis, and Louisville.[61] His charming early landscape *Rest by the Way* (1747) was one of the first works by Gainsborough to be purchased by an American public institution, bought in 1895 from the English collector Charles Fairfax Murray by the Pennsylvania Museum of Fine Art (fig. 32). Most popular of all were George Morland's paintings of rural life, which combined the influences of Gainsborough and the Dutch landscapists with an earthiness that was all Morland's own. Four of his sporting pictures and a copy after the seventeenth-century

Dutch artist David Teniers were offered for sale by Doggett's Repository of Arts in Boston in 1821, and one of his paintings of farm animals was in Peale's Baltimore Museum by 1822. Thereafter several dozen of Morland's paintings were acquired by wealthy Americans, including the New York grocery wholesaler Luman Reed; the former U.S. minister to Great Britain, Senator Rufus King of Albany; the wealthy Cincinnati landowner Joseph Longworth; and the writer and Congressman John Pendleton Kennedy of Baltimore.[62]

FIG. 32: Thomas Gainsborough, *Rest by the Way*, 1747. Philadelphia Museum of Art. The W.P. Wilstach Collection

In his passion for naturalistic fidelity and his high praise of Turner as "the best" of the British school, Gilmor was ahead of his time, anticipating opinions that would later be advanced by the influential English art critic John Ruskin. In the first volume of his seminal work *Modern Painters* (1843–60), Ruskin rallied artists to approach nature in the acutely receptive manner that he attributed to Turner. Ruskin's passionate endorsement of naturalism had a profound impact on American attitudes to landscape art, but his enthusiasm for Turner did not immediately catch fire among the country's collectors. The paltry sum offered by an American in the early 1840s for *The Fighting "Temeraire"* (1839)—a work singled out for praise by Ruskin—only insulted Turner and convinced him that Americans were a money-grubbing lot who lacked refinement and knew nothing of art.[63]

It was only through the agency of Charles Robert

58. Rutledge, 1949, 26; *A Century of Baltimore Collecting*, 10–11.
59. Quoted in Rutledge, 1949, 31.
60. Quoted in Rutledge, 1949, 26.
61. Yarnall and Gerdts, 2:1367–68, 5:3951–52.
62. Yarnall and Gerdts, 4:2482–84.
63. Henry Stevens, *Recollections of James Lenox and the Formation of His Library* (New York, 1951), 40; Charles Robert Leslie, *Autobiographical Recollections*, 2 vols. (Wakefield, England, 1978), 1: 205–06.

Leslie, an English painter who had spent his youth in the United States, that Col. James Lenox succeeded in becoming the first American to own an oil painting by Turner. On the death of his father in 1839, Lenox had inherited a large mercantile fortune, which he continued to augment through real estate transactions.[64] Five years later he was able to offer Turner the generous sum of £500 for any of the unsold paintings that remained in his studio. The offer is all the more remarkable in light of the fact that at that time Lenox reportedly had seen only engravings after Turner's paintings, which do not seem to have reached the United States prior to mid-century.[65] Lenox bought the painting, *Staffa, Fingal's Cave*, sight unseen, entrusting its selection to Leslie (see no. 51). The transaction hints at the tendency for which American collectors would increasingly be criticized, that of expending great sums of money on art valued for the prestige of the artist's name rather than the aesthetic qualities of the object itself.

Lenox's collecting practices initially threatened to follow that philistine pattern. He formed the core of his collection (which ultimately included American, French, German, and Netherlandish as well as British paintings) through bulk purchases made at London auctions in 1848 and 1850. As in earlier American collections, quantity triumphed over quality, with a superabundance of minor works by major artists attesting to his lack of personal vision. Nevertheless, Lenox demonstrated considerable initiative in supplementing the usual assortment of eighteenth-century English masters (Reynolds, Gainsborough, Raeburn, and Morland, for example) with celebrated contemporary artists who were then little represented in the United States, including the genre painters David Wilkie and William Mulready, the Orientalist David Roberts, the animal painter Edwin Landseer,

and the fashionable portraitist (and future Royal Academy president) Francis Grant.[66] Moreover, Lenox was sufficiently interested in Turner to visit him in London in 1848 and to purchase an additional painting by the artist that year.[67] Although Turner drawings, watercolors, and engravings came to the United States by the dozens,[68] Lenox's two paintings remained the only Turner oils until 1872, when John Ruskin sold *The Slave Ship (Slavers Throwing Overboard the Dead and Dying—Typhon Coming On)* (fig 14), an example of the artist's late pyrotechnical style, to John Taylor Johnston, the New York railroad magnate and first president of the recently founded Metropolitan Museum of Art.[69] Before the close of the nineteenth century, an additional twelve paintings by Turner were purchased by Americans, and more than twice that many were acquired in the first two decades of the twentieth century.[70]

American acquisition of landscapes by the pioneering naturalist John Constable followed a similar pattern. In 1843, the same year that Ruskin first championed Turner in *Modern Painters*, C. R. Leslie published a celebratory biography of Constable, who had died in 1837. Immersed in the artist's work, Leslie was in an excellent position to advise James Lenox in 1848 on his acquisition of Constable's *Cottage on a River: "The Valley Farm"*—the first painting by the artist to reach the United States.[71] American collectors were as slow in following Lenox's lead in the matter of Constable as they were with Turner. Not until the 1890s and early 1900s did the Philadelphia attorney John Graver Johnson begin to amass a collection of twenty-one small oils by (or attributed to) Constable.[72] Thereafter other Americans began to snatch up important examples of the artist's work. The transportation tycoon Peter A. B. Widener bought the full-scale oil sketch for *The White Horse* in 1893 (National

64. Stevens, 3–10.
65. Leslie, 1:205.
66. New York Public Library, *Catalogue of the Paintings in the Lenox Gallery* (New York, 1900).
67. Martin Butlin and Evelyn Joll, *The Paintings of J. M .W. Turner*, rev. ed. (New Haven and London, 1984), 192–93, no. 341.
68. Yarnall and Gerdts, 5:3607–11; Howat, 84–85, 88, 92, 99.
69. William Smallwood Ayres, "The Domestic Museum in Manhattan: Major Private Art Installations in New York City, 1870–1920," Ph.D. dissertation, University of Delaware, 1993, 22, 24.
70. Data compiled from Butlin and Joll.
71. Leslie Parris and Ian Fleming-Williams, *Constable* (London, 1991), 66.
72. Ian Fleming-Williams and Leslie Parris, *The Discovery of Constable* (New York, 1984), 92–93, 114–15, 119, 129.

Gallery of Art), New York financier John Pierpont Morgan bought *The White Horse* itself in 1894 (fig. 33), Philadelphia cotton king John H. McFadden bought the full-scale oil sketch for *A Boat Passing a Lock* in 1901 (Philadelphia Museum of Art), and Pittsburgh coke and steel industrialist Henry Clay Frick bought a version of *Salisbury Cathedral from the Bishop's Grounds* in 1908 (Frick Collection; see also no. 47). The pace of acquisition accelerated dramatically in succeeding decades.[73]

Back in the mid-nineteenth century, however, the lagging interest in Constable, Turner, and other contemporary English artists was symptomatic of a pronounced shift in America's artistic loyalties. During the preceding two centuries British art, both contemporary and historic, had dominated American collections and exercised a formative influence on American artists. The schools of Holland, France, Italy, and Germany were represented almost exclusively by dubious Old Masters, while contemporary artists from those countries were scarcely known. Britain's cultural domination of its former colonies was a source of considerable satisfaction on the other side of the Atlantic. In 1819 a writer for London's *Annals of the Fine Arts* noted with patriarchal pride: "We are quite convinced that the great proportion of American people look with respect and admiration towards England, and are happy to take her advice and imitate her example in art, in preference to the erroneous and meretriciously labored schools of the Continent."[74] Such a statement became unthinkable a few decades later, as cosmopolitan American collectors and artists began to associate England and its Royal Academy with the past, while turning to fresh developments in Germany and France as the wave of the future. Instead of emulating James Lenox in his pioneering acquisition of landscape paintings

FIG. 33: John Constable, *The White Horse*, 1819
Frick Collection, New York

by Turner and Constable, American collectors of the 1850–80 period focused on landscapes by the German Düsseldorf and French Barbizon schools.

From the mid-nineteenth century America's cultural perspective expanded further under the influence of international exhibitions, which showcased contemporary art from around the globe. As the world became America's marketplace, British painting dwindled in importance. A mere four decades after the *Annals of the Fine Arts* had gloated over Britain's cultural hegemony in the United States, a writer for New York's *Evening Post* described an art world virtually bereft of modern English painting. "A stray picture by Landseer or Herring or Maclise has occasionally found its way to our shores," the writer observed, "but what do we know of their contemporaries and compeers, whose works crowd every annual exhibition in England? . . . German, French, Italian paintings, old masters and copies innumerable have filled our galleries, auction-rooms, and dwellings: the artists of the mother country are alone unknown."[75]

With the goal of introducing American audiences to modern English art, a few hundred oil paintings

73. Yarnall and Gerdts, 1: 803-4.
74. "New York Academy Exhibition, with Remarks on their Newspaper Criticism, &c.," *Annals of the Fine Arts* 3 (1819): 489.
75. Quoted in Susan P. Casteras, *English Pre-Raphaelitism and Its Reception in America in the Nineteenth Century* (Rutherford, New Jersey, 1990), 43.

and watercolors were sent to the United States in 1857 in an exhibition that traveled to New York, Philadelphia, and Boston. The exhibition included several pictures by members and associates of the Pre-Raphaelite Brotherhood, a youthful band formed in 1848 with the aim of combating the stagnant Old Master conventions advocated by the Royal Academy through a fresh interpretation of nature. The British art establishment loathed what it perceived as ugliness and crudity in the young revolutionaries' work, but John Ruskin lauded their rigorous truth to nature. Having followed the war of words from the sidelines, many Americans were eager for their first glimpse of the controversial Pre-Raphaelites. But the quickly assembled exhibition lacked major works by important painters, and some Americans interpreted the second-rate quality as evidence of the organizers' "presumption of ignorance or bad taste on our part."[76]

If the exhibition's organizers had indeed harbored doubts about the artistic sophistication of American viewers, these were surely confirmed when two classical nudes, *Pan* and *Venus and Cupid* by Frederic Leighton were hidden away in a closet for fear of causing offense.[77] To make matters worse, a financial crash hit New York just as the exhibition opened, all but extinguishing the possibility of sales. "We could not have undertaken our enterprise at a more unfortunate, I may say, disastrous time," one of the organizers commented.[78] The New York industrial tycoon John Wolfe, who was then assembling an extensive group of contemporary English, French, Flemish, and German pictures, apologized for his ability to pay only £300 for the most discussed painting in the exhibition, a version of *The Light of the World* by the Pre-Raphaelite William Holman Hunt (fig. 34).[79] Despite all these calamities many of the

paintings found purchasers when the exhibition traveled on to Philadelphia in April 1858. Joseph Harrison, a wealthy industrialist with a taste for "high art," paid £400 for Leighton's magisterial *Reconciliation of the Montagues and the Capulets* (which, the artist was told, would otherwise have been purchased by the Pennsylvania Academy of Fine Arts). Harrison also paid £400 for Charles Lucy's *Lord and Lady William Russell*.[80] In all, twenty-eight pictures sold in Philadelphia, and others found purchasers in Boston.[81]

The modest commercial success of the exhibition convinced one of the organizers, the enterprising London art dealer Ernest Gambart, to bring a second assortment of contemporary British art to New York during the autumn of 1859.[82] He repeated the experiment on subsequent occasions, and other dealers joined in his efforts to cultivate an American market for modern British painting. Their selection of pictures showed a propensity for genre subjects whose anecdotal detail and sentimental themes made for entertaining "reading." Most of the paintings were of a fairly trivial nature, however; and, as with the 1857–58 exhibition, they often failed to find

76. Quoted in David Howard Dickason, *The Daring Young Men: The Story of the American Pre-Raphaelites* (Bloomington, 1953), 68–69; see also Casteras, 45–51.
77. Emilie Isabel Barrington, *The Life, Letters, and Work of Frederic Leighton*, 2 vols. (London, 1906), 1:300, 2:45–46. See also Yarnall and Gerdts, 3:2165.
78. Quoted in Dickason, 66.
79. Casteras, 59–63.
80. Casteras, 67.
81. Ibid.
82. Thomas Seir Cummings, *Historic Annals of the National Academy of Design* (New York, 1969), 276; Rebora, 2000, 80; Casteras, 86.

FIG. 35: Dante Gabriel Rossetti, *Lady Lilith*, 1864-76 Delaware Art Museum, Wilmington. Samuel and Mary R. Bancroft Memorial, 1935

contemporary English art, particularly that of the Pre-Raphaelites. Charles Eliot Norton, Harvard's first professor of fine arts, developed an admiring friendship with John Ruskin in the late 1850s and through him met Dante Gabriel Rossetti, one of the original founders of the Pre-Raphaelite Brotherhood, and Edward Burne-Jones, a younger member of Rossetti's clique. In later years Norton acquired numerous works by both artists. His intimate knowledge of Ruskin and the Pre-Raphaelites made a profound impression on his students. The most important from the point of view of collecting was the New York attorney Grenville L. Winthrop, a descendant of the eminent Massachusetts family discussed earlier in this essay. During the 1920s and 1930s Winthrop assembled a highly eclectic collection, encompassing Chaldean, Egyptian, Chinese, and European art. The English component (which included Gainsborough, Lawrence, and Turner) was dominated by works of the Pre-Raphaelites and their contemporaries. Among the paintings were Rossetti's sensuous tribute to feminine beauty *The Blessed Damozel* (1871–77), a version of William Holman Hunt's visionary *The Triumph of the Innocents* (1870–76), and George Frederic Watts's *Sir Galahad* (1862) and *The Genius of Greek Poetry* (1878), all of which Winthrop bequeathed to Harvard's Fogg Art Museum in 1943.[84]

Many of the same artists had fascinated Samuel Bancroft, Jr., a self-educated Delaware mill-owner who began to acquire works by Rossetti, Burne-Jones, and their circle in the early 1880s. In 1892 Bancroft purchased Rossetti's *Lady Lilith* (fig. 35) and several other pictures from the collection of the recently deceased Liverpool shipping magnate, Frederic Richards Leyland.[85] Bancroft's acquisitions enabled him to contribute to an 1892 exhibition of Pre-Raphaelite art held in Philadelphia and New York,

purchasers. Americans who read of the glittering London art world in newspapers and magazines were aware that more important work was being produced across the Atlantic, and they occasionally expressed exasperation that nothing but the dregs found its way to the United States. In 1865 a writer for the *Round Table* demanded: "Will not someone, whose pride in his countrymen outweighs his desire for pecuniary benefit, take pains to let … [us] 'barbarians' see one or two first-rate works by such men as Dante Gabriel Rossetti, Millais, Holman Hunt, J. F. Lewis, Leighton, J. C. Hook, Wallis, Arthur Hughes, Brett, and a few others, whose names are much better known among us than their works."[83]

It was not until the last decades of the nineteenth century that a few dedicated American collectors actively sought out important examples of

83. Quoted in Casteras, 94.
84. Dickason, 253–56.
85. Dickason, 199–215; Rowland Elzea, "Samuel Bancroft: Pre-Raphaelite Collector," in Margaretta Frederick Watson, ed., *Collecting the Pre-Raphaelites: The Anglo-American Enchantment* (Aldershot, 1997), 28, 30.

which included loans from Charles Eliot Norton and Charles L. Hutchinson, president of the Art Institute of Chicago, who had purchased a version of Rossetti's *Beata Beatrix* in 1886 (Art Institute of Chicago).[86] Another American who acquired a Rossetti painting during the late nineteenth century was Isabella Stewart Gardner (another former student of Norton), who celebrated her inheritance of nearly three million dollars in 1891 by purchasing a Rossetti from the Leyland sale. The example of wealthy Victorian industrialists such as Leyland (who had been a leading patron of Rossetti and other "advanced" English artists during the 1860s and 1870s) very likely provided a model for progressive American collectors and particularly for Bancroft, who further emulated Leyland by extensively remodeling his house to accommodate his growing art collection. Among the most important objects in the "treasure trove of Pre-Raphaelitism" that Bancroft assembled in Wilmington were Burne-Jones's *The Council Chamber* (1872–92), Rossetti's *La Bella Mano* (1875), and Millais's *Waterfall at Glenfinlas* (no. 59).[87] Following Bancroft's death in 1915, his wife and children continued to add to his Pre-Raphaelite collection, ultimately presenting it to the Wilmington Society of Fine Arts (now the Delaware Art Museum) in 1934.[88]

As the richest Americans grew steadily wealthier during the prosperous decades that followed the Civil War, many began to rely on consultants (usually professional dealers) to oversee the building of ever-more ambitious art collections. Bancroft was unusual in working with an English adviser, Charles Fairfax Murray, who assisted in locating and acquiring paintings. Most Americans employed men whose sympathies lay with French art and who reinforced their own Francophile tendencies.[89] In the eight years preceding his death in 1885, the New York railway and ship-ping tycoon William Henry Vanderbilt went on an astonishing spending spree, assembling a collection of art and artifacts that rivaled in scale—for the first time in American history—the treasure houses of European aristocracy. To house his collection Vanderbilt erected a marble palace on Fifth Avenue that included a purpose-designed art gallery, a remarkable innovation that signaled the elevated pretensions of his approach to art.[90] Vanderbilt's principal art dealer and adviser Samuel P. Avery specialized in contemporary French paintings, and he brought the same taste to Vanderbilt's collection. Only a smattering of contemporary British paintings was included: among them Frederic Leighton's *Odalisque*, John Everett Millais's *The Bride of Lammermoor*, Edwin Landseer's *After the Chase*, John Linnell's *The Monarch Oak*, Thomas Faed's *Rest by the Stile*, and Turner's *Castle of Indolence*, the latter purchased in 1882.[91]

Another major American collector working with a Francophile advisor was William Thompson Walters of Baltimore, who had made a fortune through international trade in liquors. By the late 1850s he had established himself as a major patron of American artists, but he sold off his American collection during the Civil War in order to pursue European landscapes and academic genre subjects. Walters was then living in Paris and collecting under the guidance of George A. Lucas, a Baltimore native who had become a fixture of the Paris art world. Walters's painting collection was understandably dominated by contemporary French and Continental art, but, like Vanderbilt, he ensured that nineteenth-century English painters (ranging from Turner, to Millais, to Briton Riviere) were represented as well.[92]

The only nineteenth-century British artist who succeeded in crossing over sharply drawn national boundaries was Lawrence Alma-Tadema, a Dutch

86. Casteras, 144; Samuel Bancroft, *The Correspondence between Samuel Bancroft, Jr., and Charles Fairfax Murray, 1892–1916*, ed. Rowland Elzea (Wilmington, 1980), 10–11.
87. Elzea, 26–31.
88. Bancroft, 1–2.
89. Ayres, 49.
90. Ayres, 32, 55–58; Robert King, *The Vanderbilt Homes* (New York, 1989), 18–27.
91. Edward Strahan, *Mr. Vanderbilt's House and Collection*, 4 vols. (Boston, 1883–84), 3:12, 30, 34, 39, 40, 4:40, 45, 50, 54, 61, 62.
92. William R. Johnston, *William and Henry Walters: The Reticent Collectors* (Baltimore, 1999), 11, 26–27, 32–40, 55–67, 79–85.

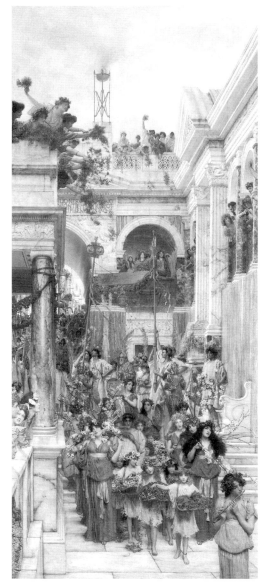

FIG. 36: Lawrence Alma-Tadema, *Spring*, 1894
J. Paul Getty Museum, Los Angeles

artist who settled in London in 1869 and was naturalized as an English citizen in 1875. Keen international demand spurred Alma-Tadema to produce a prodigious number of paintings and watercolors in which he reconstructed, in fastidious archaeological detail, everyday life in ancient Greece and Rome. From the mid-1860s Ernest Gambart and Goupil & Co. brought Alma-Tadema's paintings to New York and sold them to collectors along the East Coast and as far west as Kentucky.[93] The artist's stature in the United States was firmly established by the inclusion of six of his paintings in the Centennial Exhibition in Philadelphia in 1876. Thereafter his art sold steadily to some of the most important collectors in the States. Paintings by Alma-Tadema were among the first art purchases Vanderbilt made in 1877, the year he inherited his father's colossal fortune. Within three or four years, he had acquired at least six pictures by the artist.[94] Walters also acquired numerous works by Alma-Tadema over a very short period: six paintings and two watercolors between 1880 and 1885.[95] Henry Clay Frick visited the artist's London studio in August 1895 and returned two years later, when he purchased his painting *Watching and Waiting* from Arthur Tooth & Sons of New York (Fort Lauderdale Museum of Art, Florida).[96] A painting by Alma-Tadema was one of only two modern English works recorded in 1895 in the collection of the Chicago transportation tycoon Charles T. Yerkes (which consisted chiefly of French Barbizon and modern Flemish paintings).[97] Six years later, Yerkes acquired *Spring* (fig. 36), one of the artist's largest and most densely detailed compositions, which passed through a variety of American collections before being purchased for $55,000 in 1972 by J. Paul Getty. It now figures among the most popular paintings in the Getty Museum in Los Angeles.[98] Twentieth-century

93. See, for example, Vern Swanson, *Biography and Catalogue Raisonné of the Paintings of Sir Lawrence Alma-Tadema* (London, 1990), nos. 62, 63, 71, 75, 77, 105, 107; Dianne Sachko Macleod, "The New Centurions: Alma-Tadema's International Patrons," in Edwin Becker et al., eds., *Sir Lawrence Alma-Tadema*, exh. cat. (Van Gogh Museum, Amsterdam, 1997), 91–98.

94. See Swanson, nos. 74, 157, 163, 193, 247. He also bought a watercolor in 1877, *After the Bath*, formerly owned by James L. Claghorn of Philadelphia.

95. See Swanson, nos. 66, 131, 140, 255, 266, 307. The two watercolors were *Xanthe and Phaon* and *Between Venus and Bacchus*.

96. DeCourcy E. McIntosh, "Demand and Supply: the Pittsburgh Trade of M. Knoedler & Co.," in Gabriel P. Weisberg et al., *Collecting in the Gilded Age: Art Patronage in Pittsburgh, 1890–1910* (Frick Art and Historical Center, Pittsburgh, 1997), 143–44.

97. F. G. Stephens, "Mr. Yerkes' Collection at Chicago.—III. The Modern Masters," *Magazine of Art* [1895]: 165–71.

98. Louise Lippincott, *Lawrence Alma Tadema: Spring* (Malibu, 1990).

American collectors of Alma-Tadema's work are too numerous to mention, but they have included Andy Warhol, Jack Nicholson, and Allen Funt, who exhibited thirty-five Alma-Tadema paintings at the Metropolitan Museum of Art in 1973 prior to selling them.[99]

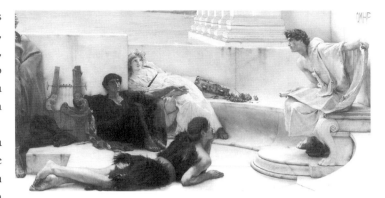

FIG. 37: Lawrence Alma-Tadema, *A Reading from Homer*, 1885. Philadelphia Museum of Art. The George W. Elkins Collection

Admiration for Alma-Tadema inspired one of the most remarkable commissions for contemporary British art in nineteenth-century America. In 1881 the New York financier Henry Gurdon Marquand purchased one of the artist's paintings of ancient romance, *Amo Te Ama Me* (1881; unlocated). Marquand, who made his fortune through investment in the St. Louis Iron Mountain & Southern Railroad, was a founder of the Metropolitan Museum of Art, serving as the museum's treasurer during 1882–89 and as its president from 1889.[100] Around 1882 he commissioned Alma-Tadema to paint *A Reading from Homer* (fig. 37) for the music room of his new residence on Madison Avenue.[101] To complement the painting's classical theme, Alma-Tadema designed eighteen items of furniture, including a Steinway piano constructed of ebony and sandalwood with classical ornaments of ivory, coral, mother-of-pearl, and other precious materials (Sterling and Francine Clark Art Institute, Williamstown).[102] Marquand's great wealth enabled Alma-Tadema to solicit assistance from illustrious British colleagues. The interior panel of the piano's keyboard cover was painted by Edward John Poynter, future director of London's National Gallery. The president of the Royal Academy, Frederic Leighton, helped select the Greek vases, ancient marble busts, and copies of antique bronzes displayed in the music room, and also painted an elaborate ceiling triptych representing three classical muses with attendant figures.[103]

The vast sums that Marquand spent on art and furnishings deeply impressed British observers, some of whom hoped that his example would improve the prospects for British art in the United States. Citing the American tendency to doubt that "any good thing [could] come out of London or anywhere else but Paris," the *Art Journal* expressed gratitude to Marquand for his "princely commission" and to Alma-Tadema for "showing what our workshops can produce."[104] Feverish reports of the astonishing magnificence of Marquand's house contributed to the emerging image of America's obscenely rich industrialists. A few months after the completion of his work for Marquand, Leighton wrote a young protégé visiting New York, "You will, like everybody who crosses the water, bring back a very pleasant recollection of American kindness and hospitality, and, I am glad to think, also a good pocketful of money."[105]

As it happened, few Americans followed Marquand in employing England's premier painters as interior decorators. Nevertheless, he set the tone for collectors of the early twentieth century, not only

99. *Victorians in Togas: Paintings by Sir Lawrence Alma-Tadema from the Collection of Allen Funt*, exh. cat. (Metropolitan Museum of Art, New York, 1973).
100. E.A. Alexander, "Mr. Henry S. Marquand and the Marquand Gallery, Metropolitan Museum of Art, New York," *Harper's Magazine* 33 (March 1897): 560–71.
101. Jennifer Gordon Lovett and William R. Johnston, *Empires Restored, Elysium Revisited: The Art of Sir Lawrence Alma-Tadema*, exh. cat. (Sterling and Francine Clark Art Institute, Williamstown, 1991), 90–91.
102. See Christie's sale catalogue, November 7, 1997 (86).
103. Barrington, 1:277, 2:259.
104. *Art Journal* 49 (1887): 256.
105. Quoted in Barrington, 1: 77.

through the huge sums he lavished on art but also by his conscious acquisition of British and European Old Masters that he judged to be of "museum quality."[106] His collection included van Dyck's *James Stuart, Duke of Richmond and Lennox* (fig. 38) and works by Gainsborough, Turner, and John Crome.[107] The paintings were never intended for Marquand's home but were acquired (along with pictures by Vermeer, Rembrandt, and Rubens) for the specific purpose of establishing a historically representative collection at the Metropolitan Museum of Art, to which he donated fifty items in 1889. For the same purpose in 1887 the American financier Junius Spencer Morgan purchased Reynolds's portrait *The Hon. Henry Fane with His Guardians, Inigo Jones and Charles Blair* for the substantial sum of £13,500 and immediately presented it to the Metropolitan, where it became the museum's first important British painting.[108]

In addition to the museum-quality works that he intended for the Metropolitan, Marquand formed an extensive personal collection that was sold at auction in 1903. The sale provides a convenient means of gauging the relative values assigned to paintings that collectors of Marquand's generation deemed worthy of domestic display. Most of the eighteenth- and early-nineteenth-century British paintings commanded prices of only a few thousand dollars each, as did works by modern American and French Barbizon painters. Higher prices were brought by Reynolds's *The Hon. Mrs. Stanhope* ($7,900), Romney's *Mrs. Wells* ($15,500) and *The Sly Child* ($7,800), Hoppner's *Catherine Horneck* ($22,200), Crome's *Old Mill on the Yare* ($8,800), and Constable's *Dedham Vale* ($13,750). Contemporary British art was valued even more highly. Alma-Tadema's *A Reading from Homer* sold for $30,300, his tiny *Amo Te Ama Me* (measuring just 7 x 15 inches) brought $10,600, and Leighton's

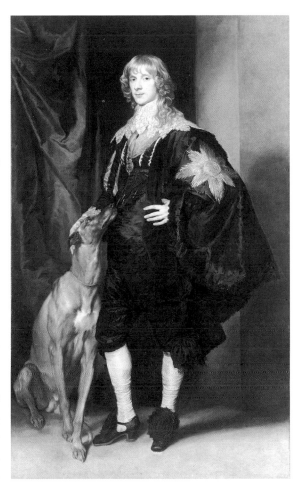

FIG. 38: Anthony van Dyck, *James Stuart, Duke of Richmond and Lennox*, 1633. Metropolitan Museum of Art, New York. Gift of Henry G. Marquand, 1889

ceiling triptych fetched $16,000.[109] But all of these prices were negligible in comparison with the enormous sums that a new generation of American collector had begun to pay for British Old Masters. Over the next two decades the upper echelons of American society pursued such paintings with enormous enthusiasm while largely neglecting the work of recent British artists.[110]

106. Ayres, 37, 50, 103–4, 116.
107. Katharine Baetjer, *European Paintings in The Metropolitan Museum of Art* (New York, 1995), 184, 189, 200, 202; Calvin Tomkins, *Merchants and Masterpieces: The Story of the Metropolitan Museum of Art* (New York, 1970), 73–75.
108. Jean Strouse, *Morgan: American Financier* (New York, 1999), 264–65.
109. Prices recorded in the *Art Amateur* 48 (March 1903): 102; see also December 1902: 3; January 1903: 32; February 1903: 64–66.
110. When the Leighton triptych appeared again at auction in 1927, it sold for only £315.

The Early Twentieth Century

A variety of circumstances combined to make historic British art particularly attractive to collectors at the turn of the twentieth century. Old Master exhibitions held regularly in London from 1813 had generated new interest in the glamorous full-length portraits of Gainsborough, Reynolds, and Romney and in the stunning landscapes of Constable and Turner. Their imagery fueled burgeoning nostalgia for what was perceived as the greater simplicity, elegance, and charm of life during the pre-industrial age.[111] Reproduction by engraving and photogravure made such paintings widely familiar, adding to the popular perception that they were "masterpieces" hailing from a "Golden Age" of British art.[112] Elevated stature translated directly into high monetary values, as cash-rich British bankers, industrialists, and art dealers paid increasingly extravagant prices for historic British paintings. The pace quickened in the last quarter of the nineteenth century, as an agricultural depression beginning in the 1870s and the introduction of death duties in the 1880s placed many of Britain's landed families in desperate financial straits, with little alternative but to raise funds by selling off works of art. The opportunity to acquire famous portraits and landscapes of the 1750–1825 period engendered an intensely competitive market.

The fashion for British Old Masters swiftly caught on across the Atlantic. The paintings' aura of patrician elegance lent itself perfectly to the opulent way of life funded by expanding American fortunes in transportation, manufacture, and banking. The high prices only enhanced the allure of such paintings, and with almost boundless financial resources at their disposal, wealthy Americans ensured that those prices continued to climb to ever dizzier heights.

A foretaste of things to come occurred in 1876, when the Bond Street dealers Thos. Agnew & Sons fought their way to a new auction record with a successful bid of £10,000 for a portrait of the Duchess of Devonshire attributed (some said mistakenly) to Gainsborough (fig. 6). After the dust had settled, it was a wealthy American financier, Junius Spencer Morgan, who stepped forward to purchase the painting, reportedly intending it as a gift for his son, John Pierpont Morgan.[113] Before the transaction could be completed, however, thieves stole the painting from Agnew's showroom and held it for ransom, a perverse but effective reinforcement of the work's perceived value. Not until 1901 would Pinkerton detectives recover the portrait in a Chicago hotel, whereupon J. P. Morgan finally closed the deal for the stunning price of $150,000. A year or two earlier he had purchased Reynolds's *Lady Elizabeth Delmé* (fig. 39), a painting that had set a record at auction in 1894 when the London art dealer and collector Charles J. Wertheimer purchased it for £11,555. Morgan reportedly paid Wertheimer more than double that price.[114] In subsequent purchases Morgan sustained a decided preference for famous paintings of beguiling female beauties, including Gainsborough's *Mrs. Tennant*, bought from Wertheimer for $150,000 in 1902, and Lawrence's *Elizabeth Farren* (no. 37), purchased from Agnew's in 1906 for $200,000.[115] Morgan's taste resembled that of the English branch of the Rothschild family, heirs to an enormous banking fortune, whose nineteenth-century art acquisitions combined European Old Masters with grand-manner English portraits of beautiful women.[116]

By the early twentieth century Americans no longer needed to travel abroad to seek out British and European Old Masters; the art treasures of the world came to them. Foreign art dealers had been

111. Laurel Ellen Bradley, "Evocations of the Eighteenth Century in Victorian Art," Ph.D. dissertation, New York University, 1986, 218–67.

112. The endurance of this construction into the present day is attested to by William Vaughan's recent survey, *British Painting: The Golden Age* (London, 1999).

113. Strouse, 162, 264, 383, 412.

114. "Death of J. C. Wertheimer, Famous Art Collector," *Daily Telegraph*, April 26, 1911.

115. William Roberts, "Mr. J. Pierpont Morgan's Pictures: The Early English School," *Connoisseur* 16 (October 1906): 68.

116. Bradley, 242.

establishing offices in New York since the 1880s, lured by the phenomenal fortunes accumulating in the United States. The most successful and influential among them was Duveen Bros., which aggressively marketed paintings to American clients from the turn of the twentieth century. The venture began somewhat inauspiciously in 1901, when Duveen set a new auction record of £14,750 for John Hoppner's *Louisa, Lady Manners*, a purchase reportedly authorized by the New York department store millionaire Benjamin Altman. When the painting arrived from London, however, Altman allegedly reneged on the deal, deeming the sitter too old and plump for his taste.[117] Duveen proved far more successful in future transactions. Through the firm's agency many paintings that had already passed from the nobility and landed gentry to British collectors such as the Rothschilds and Charles J. Wertheimer ultimately found their way to the palaces of American plutocrats (for example, nos. 14, 18, 32, 36). As more and more of these paintings crossed the Atlantic to the United States, critics complained that conspicuous consumption by nouveau riche Americans was robbing Britain of its cultural patrimony. Once again, however, Americans were merely emulating collecting patterns established in Britain. The difference was that rather than imitating the bourgeoisie, the richest Americans were now rivaling the upper classes in their time-honored prerogative of stockpiling masterpieces of art.

The enormous art purchases made by J. P. Morgan were largely responsible for triggering fears of an American takeover of Britain's artistic heritage. Morgan had been a founding patron of the Metropolitan in 1870 and began dabbling in art acquisition around the same time, but he did not focus his energies on collecting until 1890, when his father's death provided

the capital he required. From then on Morgan devoted nearly half of his fortune to art acquisitions, transforming his small assortment of mostly contemporary European and American art into a large collection of important Old Master paintings, in which British works held a prominent place.[118] Like many Americans in London, Morgan had been deeply impressed by the collection of British and European Old Masters assembled by the 4th Marquess of Hertford and his son Sir Richard Wallace, which opened to the public in 1900 as the

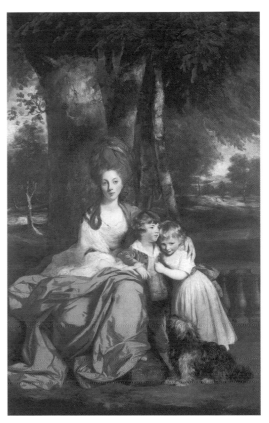

FIG. 39: Joshua Reynolds, *Lady Elizabeth Delmé and Her Children*, 1777-79. National Gallery of Art, Washington. Andrew W. Mellon Collection, 1937

Wallace Collection.[119] In 1900 Morgan began planning his own art gallery and library along similar lines, to be built adjacent to his house in New York (now the Pierpont Morgan Library). His aggressive acquisition of art treasures from that date reflects his intention of making exemplary works of art available in the United States. Yet Morgan's British paintings evidently held considerable personal significance. He resisted tempting offers to part with some of them (see no. 16) and later encouraged his children to select favorite works for their own keeping. While crates of

117. Malcolm Goldstein, *Landscape with Figures: A History of Art Dealing in the United States* (Oxford, 2000), 82.
118. Strouse, xii; Tomkins, 97.
119. Strouse, 486.

his acquisitions lay in storage facilities around the globe, it was his British paintings that Morgan chose to live with at home.

In just twenty years of collecting Morgan purchased more works of art than a single institution could feasibly exhibit or store. He succeeded in rivaling the splendor of the Wallace Collection, but not its concentrated selectivity. That goal would be achieved by Henry Clay Frick, who signaled his lofty aspirations in 1903 by choosing William Vanderbilt's palatial former residence on Fifth Avenue (complete with purpose-built art gallery) as a suitable New York home for his family and collections. Frick had begun collecting art fairly modestly in Pittsburgh during the 1880s, adhering to the contemporary taste for French Barbizon and academic paintings. He acquired his first important English portrait, Romney's *Mary Finch-Hatton*, for just $10,000 in 1898 and his first English landscape, a Turner, two years later. The combination of female portrait and Turner landscape set the tone for the British collection that Frick began to build on an ambitious scale from 1903. In just sixteen years he transformed a collection dominated by French art into an assemblage notable for important examples of British painting, including Romney's delightful *Lady Hamilton as Nature* (fig. 40), van Dyck's *Earl of Derby*, and a bevy of pictures by Gainsborough, ranging from the sensational full-length portrait *The Hon. Mrs. Frances Duncombe* to the elegant conversation piece *The Mall in St. James's Park* (fig. 7).[120] Frick's collection might have been still more magnificent had J. P. Morgan's heir accepted his offer of $500,000 for *Lady Elizabeth Delmé* and *Elizabeth Farren*, which Frick wished to hang in his dining room.[121]

Like Morgan, Frick acquired much of his collection after he had formed the intention of one day making

FIG. 40: George Romney, *Lady Hamilton as Nature*, 1782
Frick Collection, New York

it publicly accessible. The idea was reportedly inspired by his visit to Europe in 1880, when he toured great galleries of art, such as the future Wallace Collection. Between 1911 and 1913 Frick erected a domestic museum to house his treasures, located on the former site of James Lenox's library, opposite Central Park. Although his stated intention in creating the gallery (now The Frick Collection) was to enrich the lives of the American people, his daughter also recalled his saying near the end of his life, "I want this collection to be my monument."[122] Frick had good reason to take pride in his array of British, Italian, French, Netherlandish, and Spanish art. Although he worked closely with the New York firm M. Knoedler & Co. and, after 1910, with Duveen Bros., the superb level of quality sustained throughout the collection

120. McIntosh, 145; *The Frick Collection: An Illustrated Catalogue*, 8 vols. (New York, 1968), 1:passim.
121. A similar offer was made by John D. Rockefeller; see Strouse, 688.
122. Edgar Munhall, *Masterpieces of the Frick Collection* (New York, 1968), 8.

reflects the unified vision and astute judgment of the man himself.

Andrew W. Mellon had accompanied Frick to Europe in 1880, and he subsequently emulated his friend's development as an art collector. From tentative beginnings he leaped suddenly to far more important acquisitions. The slight female portraits by Henry Singleton, Reynolds, and Raeburn that he bought from Knoedler for a few thousand dollars each in 1899 and 1900 were followed by Gainsborough's *Mrs. John Taylor*, purchased in 1906 for a reported $115,000, Romney's *Miss Juliana Willoughby*, acquired for $50,000 in 1907 (both National Gallery of Art), and Turner's *Mortlake Terrace: Early Summer Morning*, purchased in 1908 for $70,902 (The Frick Collection).[123] Like Frick, Mellon eventually formed the idea of making his collection publicly accessible, with the ambitious goal of founding an American version of the National Gallery in London. In 1937 he presented 110 paintings as the core collection of what is now the National Gallery of Art in Washington, D.C. Mellon does not seem to have formulated his plan for the gallery until about 1927, very late in his history as a collector (eleven years after Frick's death and ten years before his own).[124] Prior to that date he had acquired thirteen of the twenty British paintings that ultimately formed part of his gift to the nation. He presumably acquired those paintings not with the idea of their one day becoming a public legacy, but as objects suitable to hang in his own private house. For the most part Mellon chose to ornament his domestic environment with stately portraits of lovely young women, as did Morgan and Frick as well as the Rothschilds and other English collectors before them.

The most specialized and successful of all the early twentieth-century collections of British paintings was that formed by the railroad titan Henry Edwards Huntington. His interest in art developed fairly late in life, but he had previous experience as a collector of books, having assembled more than one extensive library while still a young man. Like other American art collectors of his day, Huntington began by purchasing a large number of relatively inexpensive nineteenth-century French Barbizon and Salon paintings, but a hint of his loftier ambitions is evident from 1901, when he started buying colored prints in gilt frames depicting famous English Old Master paintings, including Gainsborough's *The Blue Boy*, Lawrence's *Pinkie*, and Reynolds's *Sarah Siddons as the Tragic Muse* (nos. 17, 39; fig. 41).[125] Remarkably, within just twenty-six years Huntington would own all three of those icons of British art and others as well.

In 1911, the year in which Joseph Duveen sold him three Gainsborough full-length portraits from the estate of Charles J. Wertheimer, Huntington began to focus his efforts on assembling a gallery of truly great British paintings to ornament his newly erected house in San Marino, California.[126] Like Frick, Huntington endeavored to buy only paintings of the highest quality, and he paid top dollar for them. As prices for British pictures continued to rise and Duveen offered increasingly significant works, Huntington's expenditures skyrocketed. For the three Wertheimer portraits that he bought in 1911, he had paid Duveen a total of $775,000. Ten years later he paid nearly as much ($728,000) for a single full-length by Gainsborough: the renowned portrait of Jonathan Buttall, known as *The Blue Boy* (no. 17).

Arguably the most famous British painting of any period, *The Blue Boy* had become the consummate trophy for collectors of artistic big game. Isabella Stewart Gardner's failure to acquire the painting in the late 1890s is said to have extinguished her desire to

123. McIntosh, 159, 161, 167.
124. Paul Mellon, with John Baskett, *Reflections in a Silver Spoon: A Memoir* (London, 1992), 140, 152–54.
125. Shelley M. Bennett, "The Formation of Henry E. Huntington's Collection of British Paintings," in Robyn Asleson, *British Paintings at The Huntington*, gen. ed. Shelley M. Bennett (New Haven and London, 2001), 2.
126. Bennett, 1–9.

FIG. 41: Joshua Reynolds, *Sarah Siddons as the Tragic Muse*, 1784. Huntington Library, Art Collections, and Botanical Gardens, San Marino, California

had always hung in private houses and had appeared in only eight public exhibitions in England since 1770. Nevertheless, it did not help matters that Huntington simultaneously purchased a second iconic painting from the Duke of Westminster's collection, Reynolds's monumental depiction of the greatest actress of his day, *Sarah Siddons as the Tragic Muse* (fig. 41). In all, Huntington would purchase thirty-eight important British paintings from the Duveen firm, creating in the process what was then the finest collection of British art outside the United Kingdom. Like Frick, Mellon, and others, Huntington devoted his last years to planning an institution that would ensure public access to the cultural legacy he had built, the institution that has grown to become The Huntington Library, Art Collections, and Botanical Gardens.

Huntington certainly would have purchased British paintings without the assistance of the Duveen firm, but the ambition and concentrated scope of his collection unquestionably reflects the influence of Joseph Duveen, who orchestrated all of Huntington's greatest acquisitions. In addition to possessing an acute eye for quality, Duveen proved a master of persuasion in spurring collectors such as Huntington to buy more pieces and at higher prices than they might otherwise have done. Surviving correspondence illustrates his cunning efforts to play one client off another, appealing to their vanity and competitiveness. His letters to Huntington in California are peppered with references not only to Frick and Mellon but to rival collectors throughout the country, including George Jay Gould in New York, Charles P. Taft in Cincinnati, and Jacob Epstein in Baltimore.[129] Moreover, the Duveen firm was deeply engaged in the business of creating an alluring mystique around British paintings of the so-called Golden Age. When Huntington hesitated over the purchase of one picture in 1923, Duveen

127. Rollin van N. Hadley, ed., *The Letters of Bernard Berenson and Isabella Stewart Gardner* (Boston, 1987), 50–56.
128. Francis Haskell, *Patrons and Painting* (London, 1963), 205
129. Duveen's letters to Henry E. Huntington, September 13, 1916, and May 23, 1925, Huntington Art Collection files.

form a collection of eighteenth-century English portraits.[127] Benjamin Altman also investigated the possibility of obtaining the painting, as did many British collectors.[128] *The Blue Boy*'s ultimate acquisition by Huntington in 1921 elicited an outcry of unparalleled fervor in England. It was the symbolism of the icon's departure for American shores that proved so upsetting, rather than any measurable loss to the British public, for in the 150 years of its existence, the painting

instructed him that it was just as "beautiful as *Blue Boy*, and by the time Sir Joseph Duveen has finished with [it], will be as famous."[130] It is little wonder that the heady early twentieth-century period of art collecting is popularly known as "the Duveen era."

As early as 1891 a member of the Colnaghi art firm in London had complained of being "bewildered" by the "idiotic" prices that British pictures were then fetching at auction.[131] The bubble was bound to burst, and it did with the financial crash of 1929. Although Americans continued to admire and purchase British paintings during the 1930s, acquisitions were severely curtailed and the inflated prices fell drastically. For example, Peter and Joseph Widener had spent between twenty and twenty-five million dollars for their collections during the first two decades of the twentieth century, but by 1940 the appraised value had fallen to between four and eight million.[132] Twenty years after that the depressed prices of British art created excellent acquisition opportunities for a new breed of collector. As Malcolm Warner's essay and several of the entries in this catalogue make clear, the greatest of the later twentieth-century collectors of British art was to be Andrew W. Mellon's son, Paul Mellon.

Over the last few decades the market for British paintings has reestablished itself on a sounder footing and with greater historical breadth than it possessed during "the Duveen era." Individuals and institutions in the United States have steadily broken free of the narrow parameters of the Grand Manner and the Golden Age, ranging more widely through the chronology and subject matter of British art. Taken as a whole, the British paintings in America today provide a rich survey of several hundred years of art, amply illustrating the achievements of successive generations of British painters from Holbein to Hockney, and beyond.

130. Quoted in Bennett, 8.
131. Nicholas H. J. Hall, *Colnaghi in America* (New York, 1992), 21.
132. John Walker, *National Gallery of Art*, new and rev. ed. (New York, 1984), 34.

Hans Holbein
the Younger

🪱 1497–1543

Portrait painter, draftsman, and designer, best known for his portraits of the English King Henry VIII. He was born in Augsburg, Germany, but established his career in Basel, Switzerland, where he worked primarily as a religious and portrait painter but also as a woodcut designer. In 1526 he left for England, armed with introductions from his great patron, the philosopher and theologian Erasmus. His connections with the circle of English humanists—foremost among them Sir Thomas More—provided the artist with an influential group of patrons close to the Crown. The artist's first visit to England lasted only two years (1526–28), but during that time he made a reputation as an insightful portraitist. In 1528 he returned to Basel but by 1532 he had settled in England, a country then divided by the Protestant Reformation. In 1536 he was described as "The King's Painter," and payments of the following year indicate that he had become a court painter with an annual income of £30. Although he did not limit his work for the English court to portrait painting—he completed large-scale decorative projects for the royal palaces at Greenwich and Whitehall (none of which survive) and also made designs for jewelry and metalwork—his international fame was cemented by his powerful likenesses of Henry VIII and other members of the English elite that circulated throughout the courts of Europe. Holbein's mastery of detailed realism and his gift for composition gave his portraits an arresting individuality well suited to sitters seeking to be portrayed for eternity according to Renaissance tenets of grace, restraint, learning, and grandeur. Holbein died in London in 1543, probably a victim of plague.

I Although from 1532 until his death Holbein worked primarily for the court, he did, in his second sojourn in England, broaden his clientele to include prominent London merchants and members of the growing middle class. Especially in the first years after his return to England from Basel, he painted some of his fellow countrymen, wealthy merchants of the Hanseatic League who did business in the steelyards of London. This unidentified sitter (aged thirty-three according to the inscription) may well have been one of them, although he is identified neither by name nor by epigrammatic symbols—as was customary in most of Holbein's portraits of the Hanseatic merchants. Alternatively, he could be a member of the growing body of bureaucrats associated with the apparatus of the English court.

In contrast to his almost ornate portraits from the earlier years of the decade, in which complex objects and symbols provided intricate and intriguing clues as to the sitter's social, political, and intellectual identity (see fig. 1), Holbein's later portraits feature few accessories and show his sitters surrounded by stark, solid-colored backgrounds. These later portraits of his second English period are almost iconic in their simplicity, their power emanating from the sheer economy of line as well as from the delicate juxtaposition of finely rendered textures, fabrics and surfaces. In this portrait the sharp cut of the man's hair is countered by the unruly hair of his beard, while the lush silks and fur of his cloak serve as a foil

1 *Portrait of a Man*, 1538

Oil on panel, 19 ½ x 15 ⅜ in.
Yale University Art Gallery. Gift of Charles S. Payson, B.A. 1921

REFERENCE:
John Rowlands,
*Holbein: The Paintings
of Hans Holbein
the Younger, Complete
Edition* (Oxford,
1985), 145, no. 65.

to his crisp white linen chemise. The immediacy of his pose is intensified by the blue-green background, which seems to thrust the sitter forward into the viewer's space although he remains distant through his averted gaze; combined with Holbein's naturalistic treatment of the man's facial features, the composition and coloring create a portrait whose tactile intimacy is more characteristic of miniature painting (an art in which Holbein himself excelled) than full-scale, bombastic portraiture.

In 1538, the year in which this portrait was painted, the artist was twice sent by Henry VIII to the Continent, each time to capture the likeness of a potential royal bride. (His third wife, Jane Seymour, had died of complications from childbirth on October 24, 1537.) In March Holbein traveled to Brussels to paint Christina of Sweden, a visit which resulted in a full-length portrait that is among his masterpieces (National Gallery, London); in August he was sent to the Duchy of Cleves, on the Dutch and German border, where he painted a finely sensitive portrait of Anne of Cleves. Famously, Henry VIII found Holbein's portrait much more beautiful than the woman, whom he called a "fat Flanders mare." In praising Holbein's ability to capture nature's details in paint, his biographer Karel van Mander praised the painter as a "bold liar,"[1] but what the critics saw as admirable painterly virtuosity may have ultimately cost Holbein the King's favor, since his flattering portrait of the young princess of Cleves contributed to the monarch's great disappointment in his bride.

For a time in the Royal Polish Picture Gallery, the *Portrait of a Man* passed through various hands until Joseph Duveen acquired it from a private collection in Paris in 1925. Two years later the work was purchased by Dr. A. Hamilton Rice of New York, from whom Charles Payson presumably acquired it. Payson, who graduated from Yale College in 1921, presented the work to the Yale University Art Gallery in 1977, and it is the crown jewel in Yale's collection of Tudor portraits.

JMA

1. Quoted in Oskar
Bätschmann and Pascal
Griener, *Hans Holbein*
(London, 1997), 220.

Robert Peake
the Elder

⌘ c. 1551–1619

Among the finest portraitists in Elizabethan and Jacobean Eng-
land, Peake was active by 1576, when his name appears in a list
of six artists employed by the Office of Revels to prepare decora-
tions for the court's Christmas festivities. His earliest documented
work is signed and dated 1583, but his most ambitious and
famous paintings depict the children of James I (reigned
1603–25). In 1604 Peake became Principal Picture Maker to
Henry, Prince of Wales and, three years later, Sergeant Painter,
a post he shared with John de Critz. His early training was as a
goldsmith, and his full-scale portraits often reflect the vivid jewel-
like colors, patterns, and textures found in miniature painting, a
form of art that came within the purview of the goldsmith trade.
His court style depended on the complex language of emblematic
painting that had become so popular in Elizabethan England;
within this ornate pictorial language, all aspects of a painting,
from overall composition to the details of gesture and clothing,
were conveyors of meaning. Peake's artistic legacy extended well
beyond his own paintings: subsequent generations of his family
produced some of the finest artists of their day (among them his
grandson, Robert Peake the Younger) and they, in turn, trained
other influential artists, such as the printmaker and publisher
William Faithorne.

2 The earliest among a group of Peake's por-
traits of the children of King James I, this
work signals the outset of an enduring
relationship between the artist and the young Henry,
Prince of Wales (1594–1612). The painting was
most likely commissioned not by the royal family but
by Lord and Lady Harington of Exton, whose son
appears here kneeling beside the prince. Lord Har-
ington had hosted a visit of James VI of Scotland and
his wife Anne of Denmark as they made their way to
London for his coronation as James I of England in
the spring of 1603, following Queen Elizabeth I's
death. After the coronation Princess Elizabeth, the
king's eldest daughter, was placed in the Haringtons'
care at Combe Abbey, where she would remain until
1608. The present portrait and its pendant, an
enchanting image of the young Elizabeth at age six
(National Maritime Museum, London), were likely
to have been commissioned by and painted for Eliza-
beth's guardians as tokens of their close political and
emotional bonds with the family of James I; it was
probably through them that Peake came to the notice
of the royal family.

Peake situated both portraits in lavish outdoor set-
tings. Whereas his sister stands stiffly in a parkland,
Prince Henry and his companion Sir John Haring-
ton (1592–1612) have ventured further afield, hunt-
ing for deer. Prince Henry towers above the animal
he has apparently just killed, unsheathing his sword
and about to "cut a slyt . . . to see the goodnesse of the
flesh and howe thicke it is" while Sir John, the "chiefe
huntsman (kneeling, if it be to a prince) doth holde
the Deare." These instructions were published in
Turbervile's Booke of Hunting (1676) and demonstrate
the precise rituals and protocol of the royal hunt.[1]
The figures are poised for action, the young prince's
power seemingly about to burst from his taut and

REFERENCES:
E. E. Gardner, "A British Hunting Portrait," *Metropolitan Museum of Art Bulletin* 3, no. 5 (1944): 113–17; Oliver Millar, *The Tudor, Stuart, and Early Georgian Pictures in the Royal Collection* (London, 1963), 79; Mary Edmond, "New Light on Jacobean Painters," *Burlington Magazine* 118 (1976): 74–83; *Dynasties: Painting in Tudor and Jacobean England, 1530–1630*, exh. cat. (Tate Gallery, London, 1995), 186; Katharine Baetjer, *British Portraits in the Metropolitan Museum of Art* (New York, 1999), 9–10; Roy Strong, *The English Icon: Elizabethan & Jacobean Portraiture* (London, 1999), 234–5, no. 201.

confident body. By setting Prince Henry against the dark and majestic horse—so tall it obscures almost completely the servant behind—and by fixing the easy, yet knowing gaze of the prince (and that of his horse) directly out of the picture, Peake engages his audience, impressing upon them the prince's power and control. As if to reinforce the magnitude of the event, each sitter is clearly identified, both by his coat of arms dangling above him and by the carvings in the trees, which designate, at the upper right, the prince as aged nine in 1603 and, at the lower left, Sir John (later 2nd Lord Harington) as aged 11. Although it may record an actual hunt that took place at Burley-on-the-Hill, where the Haringtons entertained the monarch and his family, the composition conveys more generally the beauty, confidence, and power of the heir to the throne.

This composition sealed Peake's artistic fortune, and shortly thereafter he was put in charge of the prince's imagery, first as his Picture Maker and later as Sergeant Painter. A later expanded adaptation of the composition exists (c. 1606, possibly by a different hand; now Royal Collection but first recorded there only during George III's reign), in which the kneeling figure is transformed into Robert Devereux, 3rd Earl of Essex, the son of Elizabeth I's notorious lover. The present picture is without question the original of the two.

Had Prince Henry lived to become king (he died tragically of typhoid fever at eighteen), Peake might have enjoyed more recognition by subsequent generations. Covered by later restorations, many of his works are only now emerging after centuries of obscurity; his ambitious life-size equestrian portrait of Prince Henry (c. 1611, Parham Park), for instance, remained almost completely hidden by layers of restoration until recently, while his spectacular portraits of Elizabeth of Bohemia were for many years almost all wrongly attributed to another Jacobean painter of note, Marcus Gheerhaerts the Younger.

This portrayal of the Prince of Wales and Sir John Harington passed from the collection of the 1st Lord Harington at his death to his sister Lucy, Countess of Bedford. She seems to have sold it almost immediately to William Pope, 1st Earl of Downe, of Wroxton Abbey. The Wroxton portraits passed in 1671 to Sir Frances North, and the present picture remained in his family until 1916 when it was acquired by Henry P. Davison. At a time when few public institutions were seeking to acquire the idiosyncratic portraits of Jacobean England, the Metropolitan Museum bought the painting, with funds from the Joseph Pulitzer Bequest, in 1944.

JMA

1. Quoted in Baetjer, 10.

2 *Henry, Prince of Wales, and Sir John Harington*, 1603

Oil on canvas, 79 ½ x 58 in.
The Metropolitan Museum of Art, New York. Purchase, Joseph Pulitzer Bequest, 1944

Anthony van Dyck

❧ 1599–1641

Painter whose greatest works include the portraits he made for the court of Charles 1. Born to a prosperous family of cloth merchants in Antwerp, he was working in the studio of Peter Paul Rubens by 1618 and soon acquired a reputation as the most gifted among that painter's assistants. During the 1620s he divided his time between England—where he found much favor at James 1's court—Italy, and his native Antwerp, painting some of the most influential members of the international aristocracy as well as significant religious commissions. In the late 1620s he began working with engravers and printers to produce his Iconography, a series of prints after his portraits of great philosophers, statesmen, artists, and collectors, many of whom were his friends and patrons. Only in 1632 did he return to England, where he was to stay, more or less permanently, until his death in 1641. Shortly after his arrival in England, Charles 1 knighted him and made him "Principal Painter in Ordinary to their Majesties," the annual stipend for which was £200. Almost single-handedly van Dyck transformed the conventions of aristocratic portraiture in England, adding life and vigor to the stiff and decorative art that had dominated Tudor and early Stuart tastes. His virtuoso likenesses perfectly suited and amply contributed to the aura of easy glamour that surrounded the Caroline court, especially its king and queen. From his death until the nineteenth century, van Dyck's elegant portraits were the standard against which all British portraiture was judged.

3 This portrait of Charles 1's queen, Henrietta Maria (1609–69), with one of her favorites, the dwarf Jeffrey Hudson (1619–82), is among van Dyck's most spectacular portraits of the Caroline court. Painted in the same year as the artist's life-size equestrian portrait of the king with Monsieur de Saint Antoine (Royal Collection), this depiction of the young queen, aged twenty-four, is more informal than that monumental image of the king. Wearing a sumptuous riding costume, she appears ready to embark on a hunt. Although it predates the artist's famous portrait of the king "à la chasse" (c. 1635; Louvre, Paris), it is a harbinger of that work in which the artist so ably captured the nonchalant air of Stuart majesty. Hunting portraits had been popular among the Tudor and Stuart monarchs. The hunt was seen as the most noble of aristocratic pastimes, and painters of the Jacobean era, such as Robert Peake the Elder (see no. 2) and Paul van Somer, had used hunting compositions to advantage in their portraits of members of the royal family. Such royal hunting compositions established not only the dominion of the Stuart monarchy over the lands and animals of England but also acted as pictorial reinforcements of their dynasty.

Shortly before van Dyck painted this portrait of Henrietta Maria and Jeffrey Hudson, Daniel Mytens—whose favor as court painter van Dyck usurped on his arrival in England—had created a double portrait of the king and queen ready for the hunt (c. 1630–32, Royal Collection). Mytens's composition also featured the dwarf Jeffrey Hudson, as a tiny figure in the corner of the picture. Perhaps to show that he could beat his competitor at his own game, van Dyck made this and at least one other portrait of the royal couple that reconfigured and outdid Mytens's designs.

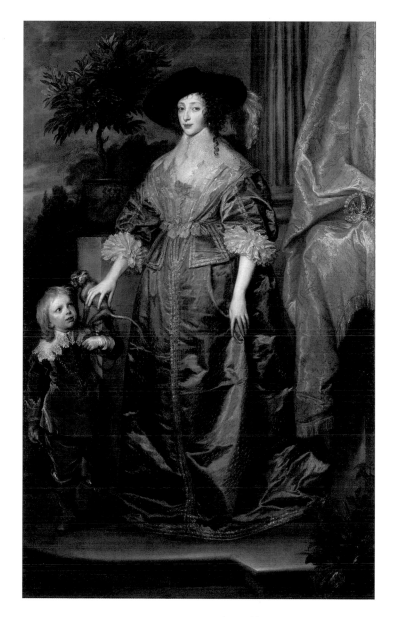

3 *Queen Henrietta Maria with Jeffrey Hudson,* 1633

Oil on canvas, 86 ¼ x 53 ⅛ in.
National Gallery of Art, Washington. Samuel H. Kress Collection, 1952

REFERENCES:

W. R. Valentiner et al., *Unknown Masterpieces in Public and Private Collections* (New York, 1930), 1:47; George Vertue, "Note Books," *Walpole Society* 5 (London, 1930–46): 25, 78–79; Colin Eisler, *Paintings from the Samuel H. Kress Collection: European Schools excluding Italian* (Oxford, 1977), 116–18; Erik Larsen, *The Paintings of Anthony Van Dyck* (Freren, Germany, 1988), 2:339, no. 864; Arthur K. Wheelock, Susan J. Barnes, and Julius S. Held, *Anthony Van Dyck*, exh. cat., (National Gallery of Art, Washington, 1991), 262–65, no. 67; Christopher Brown and Hans Vlieghe, *Van Dyck, 1599–1641*, exh. cat. (Koninklijk Museum voor Shone Kunsten, Antwerp, and Royal Academy, London, 1999), 246–47, no. 67.

1. Quoted in Oliver Millar, *Van Dyck in England*, exh. cat. (National Portrait Gallery, London, 1979), 27.

Whereas Mytens's portraits of the king and queen unwittingly continued the stiff traditions of Tudor portraiture, van Dyck's easy, flickering touch gives a vibrancy and life to his sitters and the trappings of wealth and grandeur around them. His juxtaposition of fabrics emphasizes their delicacy while demonstrating his painterly prowess. This is particularly evident in the transparent, gauze lawn that covers the silks of the queen's blue dress. Although the symbols of monarchy are few, the portrait is nonetheless filled with allusions to the sitter's royal status: the crown behind the queen, her exquisite silks and fashionable dress, and, most importantly, her two subservient companions, a monkey and a dwarf.

The monkey was intended not only to indicate the queen's wealth—she maintained a menagerie of exotic animals—but also to personify physical lust; by lightly placing her hand over the beast, the queen effortlessly curtails its power. Such an emblematic gesture reflected the Neoplatonic ideals that Henrietta Maria promoted in her circles at court, ideals that considered earthly beauty and desire indicators of purity in heart and soul. The dwarf, Jeffrey Hudson, was presented to the queen by the Duke of Buckingham, in whose service his father worked. Legend had it that Hudson was served up in a pie during a dinner party Buckingham gave for the king and queen; whatever his introduction to the royal couple, he quickly became a court favorite, especially with the queen. In 1649, in a duel, he killed a man who had insulted him about his stature and as punishment was exiled from England. His ship was captured at sea by Turks, who sold him into slavery in Barbary, but he managed to escape, returning to England by 1660. He quietly lived out the rest of his life in the country.

Not only was van Dyck adept at depicting the essence of Henrietta Maria's Neoplatonic beliefs and her friendship with Hudson, he also captured her individual and recognizable likeness. Nonetheless, his portraits necessarily flattered and, in her case, notoriously so. Charles I's niece, having seen only paintings of her aunt, recalled being shocked when she met the queen in person: whereas the queen looked ravishingly beautiful in her portraits, Princess Sophia found Henrietta Maria "a little woman with long lean arms, crooked shoulders and teeth protruding from her mouth like guns from a fort."[1] Similarly, van Dyck adds inches to Jeffrey Hudson's height. Born to parents of normal stature, Hudson was said not to have exceeded eighteen inches until his thirtieth year, when he grew to nearly four feet.

Increasing his customary fee for a full-length painting (between £50 and £60 in the early 1630s), van Dyck charged £80 for this portrait. It is unknown how it came to be in the collection of the Earls of Bradford, but it passed down in their extended family until 1881, when it was part of an exchange made between Henry Dawson, later 3rd Earl of Portarlington, and Francis George Baring, 2nd Earl of Northbrook. Joseph Duveen bought the portrait from Northbrook in 1927 and sold it immediately to the American media tycoon William Randolph Hearst, who probably wanted it to decorate the halls of his neo-Moorish castle, San Simeon, in northern California. Through M. Knoedler & Co. Hearst attempted to sell the painting several times but was unsuccessful until 1952, when the Samuel H. Kress Foundation purchased it. The Kress Foundation immediately presented it to the National Gallery of Art as part of a significant augmentation and nationwide redistribution of the Kress Collection. One of the few early modern royal portraits of quality in America, the work epitomizes both the quirkiness of William Randolph Hearst's little-known collection of British art (see nos. 5, 38) and the Kress Foundation's monumental contribution to American museums.

JMA

Peter Lely

ɔ̴ 1618–80

Portrait painter who assumed the mantle of van Dyck in England. Born in Soest, Westphalia, Lely trained in Haarlem where he became skilled in portraits and mythological subjects. By 1643—and perhaps as early as 1641—he had left the Netherlands for England, where he quickly filled the void left by van Dyck's death. Throughout the Civil War and ensuing Commonwealth Lely's portrait practice was hugely successful. His patrons included Royalists and Parliamentarians alike, and his portrait of the leader of the Commonwealth, Oliver Cromwell, "warts and all," is among the best known of his works from that period. Almost immediately after Charles II returned to the throne in May of 1660, Lely was granted the title of "Principal Painter" to the king and awarded the same annual stipend as van Dyck. Certainly the monarch, newly restored to his kingdom, was eager to have his Principal Painter create images of his court that rivaled van Dyck's of his father's; he would not be disappointed. Like van Dyck's before him, Lely's reputation eclipsed those of all other artists during his lifetime. Highly keyed in color and deeply sensual in their appeal, his portraits eloquently captured the exuberance of the Restoration court and its courtiers. In 1680 Charles II granted Lely a knighthood, but shortly thereafter the artist died. The sale of the works in his studio and of his vast art collection, among the finest in seventeenth-century Europe—upon which he drew extensively in the creation of his own paintings—prompted international attention.

4 This is one of a set of family portraits commissioned from Lely by Arthur, Lord Capel, who was created Earl of Essex by Charles II shortly after 1660 in honor of his father's sacrifice—he was beheaded in 1649—for the Royalist cause during the Civil War and Interegnum. The portrait depicts Essex's two sisters, Mary (1630–1715) and Elizabeth (1633–1718), and pays tribute to the bond between the two women. Lely's most likely source for the composition was one of the masterpieces of the genre that put siblings or friends together in a double portrait: van Dyck's *Dorothy Savage, Viscountess Andover, and her sister Elizabeth, Lady Thimbleby* (c. 1637; National Gallery, London), which Lely himself owned.

The picture displays both the affectionate unity of the sisters and their individual interests. It has been suggested that the laurel wreath that Mary holds, and to which she also points, alludes to poetry. In fact, it is more likely that she proffers it as emblematic praise of her younger sister's artistic achievements, represented by the small flower painting inscribed "E. Carnarvon/fec" that Elizabeth, an amateur painter, props on her knee. Perhaps the wreath also alludes to Mary's lifelong interest in botany and gardening. The women's father had maintained an elaborate garden at Little Hadham Hall, his estate in Essex, and each of the children in some way continued the family's avid interest in horticulture. Mary, in particular, was to create impressive gardens on her husband's estates at Beaufort and Badminton. Her large exotic plant collection was partially housed in a conservatory that she dubbed her "infirmary," and in 1703 she commissioned a set of drawings as a record of her plants. Whatever its particular meanings for either sitter, the wreath associates both women with the virtuous Muses of laurel-covered Mount Parnassus.

4 *Mary, later Duchess of Beaufort, and Elizabeth, Countess of Carnarvon,*
 c. 1660

Oil on canvas, 51 ¼ x 67 in.
The Metropolitan Museum of Art, New York. Bequest of Jacob Ruppert, 1939

It is not surprising that Lely would wish to immortalize the Capel sisters as his Muses. Their immediate and extended family had been among the greatest patrons of his early career. The Earl of Essex, the sisters' older brother, had married into the family of the Dukes of Northumberland, through whose patronage Lely's artistic fortunes had skyrocketed in the early 1640s. At about the same time Elizabeth had married Charles Dormer, 2nd Earl of Carnarvon, who was the grandson of Lely's other great early patron, Philip Herbert, Earl of Pembroke. Lely owed much of his continued fortune—and later royal favor—to the ardent patronage and possible friendship of these interconnected Royalist families.

This portrait epitomizes the best of Lely's work from the 1650s and early 1660s. His ability as a colorist and his training as a draftsman in the tradition of van Dyck give to his sitters a radiant elegance. The sparkling whiteness of their unblemished skin contrasts sharply with the rich coffee and gold tones of their shimmering silk dresses, while their graceful gestures and glances convey their aristocratic lineage. Lely's sensuous portrait speaks not only to the fashions of the time, but also to the individuality of his sitters: his confident and calligraphic brushstrokes fully capture the idiosyncratic beauty of the Countess of Carnarvon in particular, giving the lie to the protestations of his contemporaries, and posterity alike, that his portraits were never "like" their sitters.

The painting originally hung, along with five other Lelys of family members, in the Great Library at Cassiobury, the palatial house that the Earl of Essex built after the Restoration; its spectacular frame is original. The Lelys remained at Cassiobury until 1922, when they were sold at public auction. *Mary, later Duchess of Beaufort, and Elizabeth, Countess of Carnarvon* was bought at that time by the dealer Scott & Fowles, New York, from whom Jacob Ruppert acquired it. Along with sixty-five other objects, this painting and the single portrait of the women's brother were deemed by the curators of the Metropolitan Museum of Art as fulfilling the terms of Ruppert's bequest to that institution, which stipulated that the works chosen from his collection should have enough "exhibition value" to be "retained permanently in the exhibitions of the Museum."[1] This is one of the finest Lelys currently in an American collection.

JMA

REFERENCES:
Alan Priest, "The Bequest of Jacob Ruppert," *Bulletin of the Metropolitan Museum of Art* 34, no. 7 (July 1939): 166; Katharine Baetjer, *British Portraits in the Metropolitan Museum of Art*, independent issue of the *Bulletin of the Metropolitan Museum of Art* (Summer 1999): 17–21; Sir Oliver Millar, *Sir Peter Lely, 1618–1680*, exh. cat. (National Portrait Gallery, London, 1978), 50–51, no. 27; Sue Bennett, *Five Centuries of Women and Gardens*, exh. cat. (National Portrait Gallery, London, 2000), 34–37.

1. Priest, 166.

Gerard Soest

જ c. 1600–81

Portrait painter. Probably Dutch by birth, and certainly by train-
ing, Soest was in England by the early 1640s; his earliest dated
work is from 1646. Although he did not find much favor among
court figures, he maintained a prosperous portrait practice until
his death, and in 1658 his name appears in a published list of
the best painters working in England. In 1706 Bainbrigg
Buckeridge included a biography of Soest in his Essay towards
an English School of Painting, *in which he praised the*
artist's male portraits, calling them "admirable, having in them a
just bold Draft"; conversely, he noted that Soest did not always
execute his female portraits "with a due regard to Grace." Despite
his general success as a portrait painter, Soest never enjoyed a
reputation that equaled that of his great competitor Lely, perhaps
in part because of his penchant for unusual color schemes and
unconventional compositions. Often introspective, serious, and
even eerie, Soest's works are little known today, but they are
among the most arresting and inventive portraits created in early
modern England.

1. George Vertue, "Note
Books," *Walpole Society*
18 (1929–30):32.

5 When he saw this picture in the eighteenth
century, the antiquarian George Vertue
called it "an extraordinary piece of Zoust
highly finished."[1] Though little known today except
to scholars of Stuart portraiture and citizens of Bal-
timore, the work is one of Soest's most ambitious por-
traits and a forgotten masterpiece of British art.

During the 1620s the 2nd Lord Baltimore's father
—George Calvert, 1st Lord Baltimore, a prominent
statesman during the reign of James I—had tried to
establish a colony in Newfoundland. Finding the
weather there too severe, he and his men moved down
the coast of North America and hoped to settle in
Virginia. His Roman Catholic faith, however, led him
to refuse to take the oaths of allegiance and supremacy
required by the members of the Virginia Company,
who in turn refused to grant him lands. Shortly after
his death in 1632 Charles I granted his family a char-
ter to establish a settlement north of Virginia, in the
region north and east of the Potomac River. The 2nd
Lord Baltimore, seen here, established that colony
according to his father's wishes, calling it Maryland in
honor of Charles I's queen, Henrietta Maria. A
Catholic like his father, he hoped to encourage free-
dom of religion for its settlers despite a clause in the
charter stipulating that all churches be consecrated
according to the rites of the Church of England. In
order to represent the colony's interests most easily to
the Crown, Lord Baltimore remained in England but
sent his brother Leonard as Governor along with
more than 200 men and women to settle the Ameri-
can wilderness.

Soest's portrait shows Cecil (or Cecilius) Calvert,
2nd Lord Baltimore (1606–75) with his grandson
and namesake (1669–81). As the founder and first
"Proprietary" of the Maryland Colony, Lord Balti-
more joins his grandson here in proudly displaying a
map of the territory granted to their family. The map
may be that published in 1635 by T. Cecill as part of
his "A Relation of Maryland," which Lord Baltimore
probably used to publicize the settlement of the
colony. On the other hand it may be the new map of
the colony drawn by Augustine Hermann that
reached England in 1670. Certainly it predates John
Ogilby's map of Maryland, which was published in

5 *Cecil Calvert, 2nd Lord Baltimore, with his Grandson*
Cecil Calvert and an Unidentified Servant, c. 1670

Oil on canvas, 85 x 60 in.
Collection of The Enoch Pratt Free Library, Baltimore (Mayor and City Council of Baltimore)

REFERENCE:
"The Lords Baltimore: An Account of the Portraits of the Founder and the Five Proprietaries of the Colony of Maryland," brochure published by The Enoch Pratt Free Library (revised printing, 1961).

1671 in his *America: Being the Latest and Most Accurate Description of the New World*; unlike the map in the present work, this named the colony's counties. The map held by the sitters here, inscribed "Noua Terrae-Mariae Tabula," is a Portolan map, the kind used by ship captains, which mirrored the actual orientation of a ship's approach to land; here, for instance, North is shown at the right and not at the top of the page, so that a ship approaching the north-south Chesapeake Bay from the East would see the land exactly as it appeared without having to change the orientation of the paper.

Prominently displayed on Lord Baltimore's map is his family's coat-of-arms, literally and symbolically imprinting his family's dominion onto those territories. Soest dresses Lord Baltimore in the colors of his coat-of-arms, reinforcing the connection between the man and his family's powerful lineage. The type of tunic that he wears was a derivation of a style made popular by Charles II and his courtiers in the late 1660s, a fanciful adaptation of what they considered "Persian Dress." Although elegant and fashionable, Lord Baltimore's attire displays the sobriety of a man advanced in years. By contrast, the bright and beribboned outfit of the child mimics the exuberance of court fashions at the time, inasmuch as they could be adapted to the dress of a toddler. The boy must be younger than five, the age at which boys were first "breeched" (put into trousers) and when, more generally, they began to wear miniature versions of adult male attire. The boy's father, Charles Calvert, had gone to Maryland as Governor in 1661. He and little Cecil, then two, returned to England for a brief visit in 1669–70, and this portrait was probably commissioned to record that visit.

Soest's ability to capture the stern individuality of Lord Baltimore's likeness gives to this painting an immediacy lacking in most full-length portraits painted by his contemporaries. The serious bearing of the grandfather is countered, however, by the childlike gesture of his grandson, who uses the whole of his pudgy hand to point to the map. The inclusion of the unidentified servant in the background, who bows deferentially as he presents a feathered hat, not only emphasizes the power and dominion of Lord Baltimore and his grandson but also indicates Soest's desire to create an image to rival the full-scale baroque portraits of the best artists of his time. Artists like van Dyck and Lely often included in their compositions servants of color (especially Africans and Indians) to demonstrate their sitters' status as wealthy property owners as well as their own artistic prowess.

One of a set of individual full-length portraits of the six Lords Baltimore by various artists, Soest's painting remained in the family collection until Sir Timothy Calvert Eden put the group up for auction at Sotheby's, London, in 1933. Only two portraits sold at that time: that of the fifth Lord Baltimore was purchased by an American from Maryland who had inherited the English title of Lord Fairfax of Cameron, and the present portrait went to Joseph Duveen. Dr. Hugh Hampton Young, a prominent Baltimore surgeon, reunited five of the six portraits when he bought the four unsold pictures from Sir Timothy and persuaded Lord Fairfax to give him the portrait of the fifth Lord Baltimore. The group was exhibited first as part of the celebrations surrounding the tercentenary of Maryland's founding. Subsequently Dr. Young presented them on long-term loan to the Enoch Pratt Free Library in downtown Baltimore, where they were hung prominently in the Central Hall. In the meantime, Joseph Duveen had sold Soest's portrait to his American client William Randolph Hearst (see also nos. 3, 38). Eventually

GERARD SOEST

Dr. Young encouraged the Library to purchase the Soest on the promise that he would then give the institution his five portraits. In 1940 the Library bought the painting from Hearst—"for a song," as one official declared in a contemporary newspaper—and Dr. Young proudly donated the five other pictures to the Library, where they remain on permanent display.

JMA

Jan Siberechts

c. 1627–c. 1703

Flemish landscape painter active in England. Siberechts spent his early career in Antwerp, where he was made a master of the Guild of St. Luke in 1648. He was invited to England by George Villiers, 2nd Duke of Buckingham, and helped decorate the Duke's residence at Cliveden, Buckinghamshire, in 1672–73. After this he traveled widely and rapidly established himself as a painter of topographical "prospects" for the owners of English country houses and estates; some of the best known are the views of Longleat in Wiltshire that he painted in 1675–76, which remain at the house. Siberechts lived and worked in England for the rest of his career and played an important part in the development of British landscape painting.

6 Wollaton Hall, a few miles west of Nottingham, is one of the most important Elizabethan houses in Britain. It dates from the 1580s, and the architect was probably Robert Smythson. The most striking and unusual feature of the architecture is the raised central hall, with its tall proportions and medievalizing window tracery and turrets. The house was designed as a grand showpiece, proclaiming the success and status of its owner, Sir Francis Willoughby, a coal magnate-cum-entrepreneur. In 1688 Wollaton passed to Sir Thomas Willoughby, Bart., Sir Francis's great-great-grandson, and it was he who commissioned Siberechts to paint this and other views of the estate and neighboring countryside.

Though still in his twenties, Sir Thomas was already a considerable figure in the area, having served as High Sheriff of Nottinghamshire in 1695–96. He was elected Tory Member of Parliament for Nottingham in 1698, later represented Newark, and in 1712 was created 1st Baron Middleton by Queen Anne. He clearly took great pride in Wollaton. He remodeled parts of the interior of the house, commissioned mural decorations, and installed French-style formal gardens in the park. Having inherited some of the scientific interests of his father, who was a famous naturalist, he also created a garden of botanical specimens. (Wollaton is now owned by the Corporation of Nottingham and houses the city's natural-history museum.)

Siberechts's painting shows the view from the southeast and gives a fairly faithful account of the appearance of Wollaton—though with the house shown on lower ground, perhaps to lend drama to the hills that rise up in the distance. Like most country-house "prospects," it records improvements to the estate made by its owner—some of which may have been prospective rather than actual—as well as the pleasures he could offer his guests. Fashionably dressed people stroll across the grounds, and a game of bowls is in progress on the lawn at lower right. In the foreground the coach-and-six with escort shows the formal approach to the house, leads the viewer into the scene, and indicates further luxuries of Wollaton life: traveling in style and being attended by an ample household of servants. Elsewhere we see more of the daily workings of the place: to the south of the house, staff at work in the vegetable garden and a man rolling the path of the parterre; to the west a cabbage patch, a bleaching field, and some barns; to the north, between the house and the village of Wollaton, a maid milking a cow in the middle of a field.

6 *Wollaton Hall and Park, Nottinghamshire,* 1697

Oil on canvas, 75 ½ x 54 ½ in.
Yale Center for British Art, Paul Mellon Collection

REFERENCES:
Country Houses in Great Britain, exh. cat. (Yale Center for British Art, New Haven, 1979), 22–23, no. 3; Malcolm Warner and Julia Marciari Alexander, with an introduction by Patrick McCaughey, *This Other Eden: Paintings from the Yale Center for British Art* (New Haven, 1998), 36–37, no. 7.

The country-house prospect was a view that tended toward the map, showing more of the layout and workings of a place than any actual vantage point would reveal, often with different parts seen from different angles. The form was developed by artists of the Low Countries and flourished in Britain from the later seventeenth to the mid-eighteenth centuries. With its comprehensive, God-like perspective, it offered the landowner the pleasure of seeing his property and realm laid out before him as a whole. He might hang a prospect of his estate in the country house itself or perhaps in his London residence, where it would serve the additional purpose of impressing upon visitors the important fact of his owning land. More generally, it gave delightfully clear expression to the idea of mankind creating order within nature, from the symmetry of the house architecture to the rational planning of the pleasure grounds and gardens, to the careful husbandry apparent in the farmlands beyond.

Wollaton Hall and Park, Nottinghamshire was bought by Paul Mellon at a Sotheby's sale in London in 1962 but only granted an export license some twelve years later.

MW

William Hogarth

❧ 1697–1764

Hogarth was the dominant artistic personality in England in the first half of the eighteenth century. The son of a bankrupt author and schoolmaster, he was initially apprenticed to a silver engraver. Although in his youth he received very little formal tuition in painting he learnt enough from his father-in-law Sir James Thornhill to make rapid strides on his own with pictures like The Beggar's Opera *(no. 7). He made his name initially by painting small-scale group portraits (conversation pieces) but the success of his "Modern Moral Subjects," a new genre he created in which a story from contemporary life is told in a series of paintings designed to be engraved, liberated him from the drudgery of portrait painting. By the 1740s, however, Hogarth was determined to answer the charge that he was merely a comic painter; he proclaimed himself a "Comic History Painter" and in so doing disassociated himself from "low" genres such as caricature. During this decade he also painted numerous portraits, mostly of friends and associates, which demonstrate his extraordinary ability to reveal the character of his sitters in a most humane way. By the 1750s he became the target of caricature himself and his morbid depression about national decline became increasingly evident. At the end of his life he was overtaken by a new generation of artists led by Joshua Reynolds. His great achievement was to have helped liberate his generation of artists from the constraints of a system of patronage that, all too often, had left them dependent on a narrow group of patrons.*

7 In his influential *Essay on the Theory of Painting*, first published in 1715, Jonathan Richardson drew a perceptive analogy between painting and theater, noting that in the latter "we see a sort of moving, speaking Pictures, but these are Transient; whereas Painting remains, and is always at hand."[1] Reminiscing at the end of his life, Hogarth was also to state rather revealingly: "Subjects I consider'd as writers do . . . my Picture was my Stage and men and women my actors who were by Means of certain Actions and express[ions] to Exhibit a dumb shew."[2] Significantly, one of Hogarth's earliest surviving paintings is *Falstaff Examining His Recruits* (private collection), based on Shakespeare's *Henry IV, Part 2* and probably painted about a year before he began this picture.[3]

John Gay's *The Beggar's Opera* was first performed at John Rich's Theatre Royal, Lincoln's Inn Fields, on January 29, 1728, and it ran for an unprecedented sixty-two nights during the first season, making it the most celebrated and commercially successful theatrical production of the period. The setting was the seamy London underworld, with the climactic scene shown here (Act III, Scene XI) set in Newgate Prison. Gay's hugely popular work was an extraordinary mixture of ballad and burlesque, awash with slang, jokes, satire, and symbolism. It offered precisely the kind of satiric comparisons between the manners of "high" and "low" society that Hogarth was to explore in the genre he effectively invented a few years later, the Modern Moral Subject. The central conceit is that of the world turned upside down, so that the so-called respectable classes speak and behave like murderous thieves, while the leader of the gang of thieves declares himself "a man of honour" and has the manners of a gentleman.

REFERENCES:
A. P. Oppé, *The Drawings of William Hogarth* (London, 1948), 32–33; Frederick Antal, *Hogarth and His Place in European Art* (London, 1962), 65–67; Ronald Paulson, *Hogarth, His Life, Art and Times*, 2 vols. (New Haven and London, 1971), 1:180–92; David Bindman, *Hogarth* (London, 1980), 32–36; John Walker, "Hogarth's Painting *The Beggar's Opera*: Cast and Audience at the First Night," in John Wilmerding, ed., *Essays in Honor of Paul Mellon, Collector and Benefactor* (Washington, 1986), 363–79; David Bindman and Scott Wilcox, ed., *"Among the Whores and Thieves": William Hogarth and "The Beggar's Opera,"* exh. cat. (Yale Center for British Art, 1997), 17, 20–22, 92; Jenny Uglow, *Hogarth: A Life and a World* (London, 1997), 136–42; Malcolm Warner and Julia Marciari Alexander, with an introduction by Patrick McCaughey, *This Other Eden: Paintings from the Yale Center for British Art* (New Haven, 1998), 40–41, no. 8; Mark Hallett, *Hogarth* (London, 2001), 44–54.

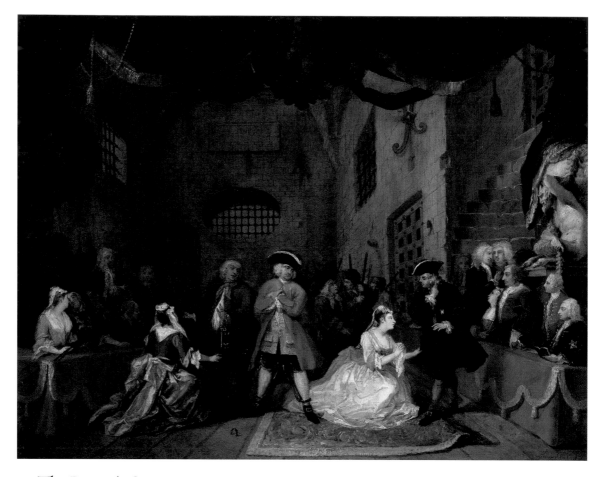

7 *The Beggar's Opera*, 1729

Oil on canvas, 23 ¼ x 30 in.
Yale Center for British Art, Paul Mellon Collection

WILLIAM HOGARTH

The Beggar's Opera may also have appealed enormously to Hogarth because it parodied the kind of high-brow Italian opera, with its mythological and historical settings, that was the preserve of his artistic enemies (the coterie around Lord Burlington and William Kent) in favor of the kind of unpretentious "Englishness" that Hogarth would champion throughout his life.[4] But it also would have struck a personal chord: not only had he grown up within a stone's throw of Newgate but, during his formative teenage years, he had experienced with his family the deprivations of the Fleet Prison after his father's bankruptcy.[5]

Ostensibly the work of a beggar who introduces the action, Gay's play tells the story of Macheath, a philandering highwayman. When Peachum, a thief-taker and receiver of stolen goods, hears that his daughter Polly has married Macheath, he takes his revenge by informing on his son-in-law, who is arrested and imprisoned in Newgate. To complicate matters, Lucy, the daughter of the gaoler Lockit, also claims Macheath as her husband. The two women fight over Macheath, and in the scene depicted here we see both beseeching their respective fathers to save him from the gallows. Peachum and Lockit remain unmoved, and the highwayman's execution seems inevitable until he is saved by the beggar's authorial intervention. Hogarth here introduces a theme—a parody of the Choice of Hercules between Virtue (Polly) and Pleasure (Lucy)—that recurs in several of his paintings. In his song the shackled Macheath's dilemma is plain:

Which way shall I turn me?—How can I decide
Wives, the Day of our Death, are as fond as a Bride.
One Wife is too much for most Husbands to hear,
But two at a time there's no Mortal can bear.[6]

The scene chosen by Hogarth contained all the main characters in the play, with portraits of Mrs. Egleton (Lucy), John Hall (Lockit), Tom Walker (Macheath), Lavinia Fenton (Polly), and John Hippisley (Peachum), but was especially topical because of the presence, in the box on the extreme right of the stage, of the middle-aged man wearing on his breast a star—the insignia of the most noble order of the Garter. This is the Duke of Bolton, who became so enamored of the twenty-year-old actress Lavinia Fenton that he returned night after night until he eventually swept her off the stage at the end of the season to become his mistress. Significantly, by the time this version of the painting was executed in 1729, the actress had become notorious, and, unlike in the earlier versions, Hogarth painted her turned away from Macheath with her gaze fixed firmly on the Duke.

During the three years that followed its initial success, Hogarth painted five versions of the subject, of which this appears to be the penultimate. Another version, which belonged to John Rich and later to Horace Walpole, is also among Yale University's holdings (The Lewis Walpole Library, Farmington, Connecticut); despite its illustrious provenance, however, that version was palpably not painted by Hogarth and is almost certainly an early copy by another hand of the version now in the Birmingham Museum and Art Gallery.[7]

The first three versions seem to have their compositional origin in a chalk sketch (Royal Collection, Windsor Castle) made by Hogarth at an actual performance, perhaps the first drawing of its kind.[8] In the drawing and the versions derived from it, the composition is much more cramped, with the central five actors occupying a much greater part of the picture plane. In common with the picture now in the Tate, painted two years later, the present version significantly enlarges the scene, reducing the scale of

1. Jonathan Richardson, *An Essay on the Theory of Painting,* 2nd ed. (London, 1725), 4.
2. William Hogarth, *The Analysis of Beauty, with the Rejected Passages from the Manuscript Drafts and Autobiographical Notes,* ed. Joseph Burke (Oxford, 1955), 209.
3. See Bindman, 32, pl. 22.
4. See Hogarth's engraving *The Taste of the Town or Masquerades and Operas* ("The Bad Taste of the Town") of 1724; see Ronald Paulson, *Hogarth's Graphic Works* (London, 1991), 47–49, pl. 44; also Diane Waggoner, "Hogarth's *Beggar's Opera* Paintings and Italian Opera," in Bindman and Wilcox, eds., 41–55.
5. See Paulson, 1971, 1:40–54.
6. *The Beggar's Opera,* III, xi: see John Gay, *Dramatic Works,* ed. John Fuller, 2 vols. (Oxford, 1983), 1:58.
7. For a full discussion see Bindman and Wilcox, eds., 6, 17–18.
8. See Oppé, 32–33, no. 23, pl. 20.

the central figures and enhancing the role of the audience by placing them within a much grander setting, in which the claustrophobic prison walls have receded to create an altogether less sinister setting.[9]

In this and the Tate version Hogarth included two sculpted satyrs, similar to actual sculptures on the proscenium arch in John Rich's theater, who hold up the stage curtain at the extremities and, by virtue of their classical allusions, serve to elevate the setting in these more "genteel" versions. The banderole on the great curtain is inscribed with two epigrams, "Velute in speculum" ("even as in a mirror") and, from Horace's *Ars Poetica*, "Utile dulce" ("useful and sweet")—the former inviting the audience to reflect on Gay's play, the latter alluding to the artist's duty to instruct through entertainment. By means of these visual and verbal devices we are invited to reflect on the idea of satire lifting the curtain on the follies and vices of the world, reflected here by both actors and audience.

At the time of its production, *The Beggar's Opera* was seen as a thinly veiled attack on the burgeoning commercial society and corrupt government of the Prime Minister, Sir Robert Walpole. Although Walpole and members of his government are reputed to have seen and enjoyed performances, his government significantly had the Lord Chamberlain ban the play's hastily produced sequel *Polly*, which appeared in December 1728. Like his friends Alexander Pope and Jonathan Swift, John Gay seems to have belonged to the "Country" opposition, who believed that the monarchy had been usurped by a clique driven by financial and political self-advancement rather than by true public spirit.[10]

Although this youthful work falls far short of the dazzling painterliness of *The Lady's Last Stake* executed thirty years later (no. 9), Hogarth was certainly beginning to find his feet as a painter at this date. The many small "converation pieces" painted in the years that followed were a natural progression from works like *The Beggar's Opera*. Perhaps surprisingly, the picture was not the subject of a print in Hogarth's lifetime, but it was eventually engraved by William Blake in 1790.[11]

This version of the subject was painted for John Rich, possibly to hang in the Lincoln's Inn Fields Theatre. It was purchased by the Duke of Leeds at the Rich sale at Langford's auction house in London in 1762. It remained in the same family until the 11th Duke of Leeds consigned it for sale at Sotheby's in 1961, when it was purchased by the London art dealers Thomas Agnew & Sons, who sold it to Paul Mellon.

BA

8 Although Hogarth had been active as a portraitist early in his career, by the end of the 1730s the success of his immensely popular Modern Moral Subjects provided sufficient means to liberate him from the comparative drudgery of portrait painting. Hogarth never considered himself a portrait painter in the conventional sense of the term and he even derided portrait painting in the scrappy "Autobiographical Notes," scribbled towards the end of his life, as a branch of art dependent only on "much practice and an exact Eye . . . by men of very midling natural parts."[12] Hogarth's small-scale, highly-animated group portraits (conversation pieces), which had attracted the attention of wealthy patrons in the early to mid 1730s had, with their meticulous attention to detail, been so time-consuming to produce—and not especially lucrative—that

9. See Bindman and Wilcox, eds., 17–24, and for the Tate version see Elizabeth Einberg and Judy Egerton, *Tate Gallery Collections: Volume Two—The Age of Hogarth, British Painters born 1675–1709* (London, 1988), 74–81, no. 87.

10. In Bindman and Wilcox, eds., see David Bindman's introduction, 9–10, and especially Andrew Jacobson, "Hogarth's *The Beggar's Opera* and the Ideology of the Country Party," 69–79.

11. See Wilmarth S. Lewis and Philip Hofer, *"The Beggar's Opera" by Hogarth and Blake* (New Haven, 1965).

12. Hogarth, 216.

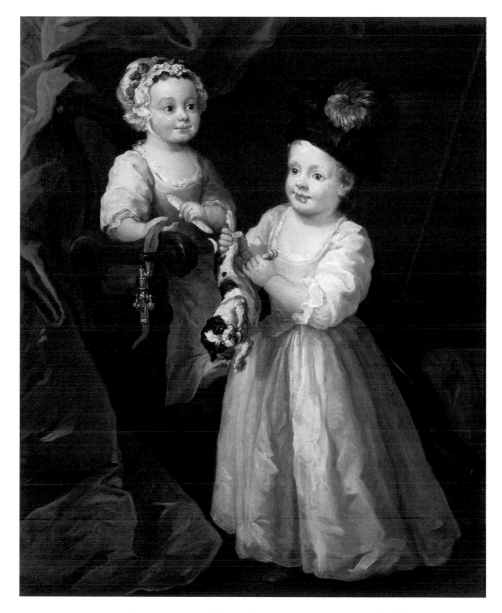

8 *Lord George and Lady Mary Grey as Children*, c. 1740

Oil on canvas, 42 x 35 ⅜ in.
Washington University Gallery of Art, Saint Louis, Missouri. University Purchase, Parsons Fund, 1936

REFERENCES:
R. B. Beckett, "Famous Hogarths in America," *Art in America* 36 (October 1948): 168; R. B. Beckett, *Hogarth* (London, 1949), 43; Paulson, 1:448, 458; Mary Webster, *Hogarth* (London, 1979), 118, 126; Bindman, 141–42; Uglow, 353.

by the end of that decade he had more or less abandoned the genre. However, around 1740, the xenophobic Hogarth became acutely aware that the presence in London of French and Italian portrait painters such as Jean-Baptiste Van Loo, Andrea Soldi, Carlo Rusca, and Andrea Casali (to name but a few) provided a serious, but by no means unprecedented, challenge to the supremacy of the native painters. Hogarth responded to this challenge with his grandest and most celebrated public portrait, that of Captain Thomas Coram, painted for the Foundling Hospital in London in 1740 and now in the Foundling Museum.[13]

This portrait of the Grey children was also painted c. 1740. Although it retains some of the narrative elements common to the earlier conversation pieces, the significant development here is that the figures are much larger in scale, reflecting the artist's burgeoning, albeit short-lived, interest in full-size portraiture.

Lord George Grey (1737–1819) and his sister Lady Mary (1739–1783) were the children of the 4th Earl of Stamford, an anti-Walpole Whig. The little boy, aged about two and still in long clothes, suspends a tiny squirming spaniel puppy by the legs while his younger sister, seated in a high chair, clutches a biscuit in her left hand and a coral—a common form of teething toy at this time—suspended from a blue ribbon in her right. The deep red, silver, and blue of the coral forms the kind of spectacular virtuoso still-life accent with which, as his painterly powers developed, Hogarth increasingly enlivened his pictures from about this time.

Typically, Hogarth leaves us with little doubt that there is only a thin dividing line between childhood innocence and thoughtless cruelty. From early pictures such as *Gerard Anne Hamilton in his Cradle* of

13. See Benedict Nicolson, *The Treasures of the Foundling Hospital* (Oxford, 1972), 68–69, no. 40. See also Brian Allen, "The Age of Hogarth, 1720–1760," in *The British Portrait, 1660–1960* (Woodbridge, 1991), 144–47.
14. Hogarth, 140.
15. Hogarth, 219–20.

1732–33 (The National Trust, Bearsted Collection, Upton House), he had shown great sensitivity to the particularities of childhood, and his perceptive statement in his much-derided *Analysis of Beauty* (1753) that "children in infancy have movements in the muscles of their faces peculiar to their age, as an uninformed and unmeaning stare, an open mouth, and simple grin" seems particularly apt here.[14]

The portrait of the Grey children remained with descendants of the family until 1928, when it was sold at Christie's in London. It was briefly owned by Leonard Gow, who lent it to the influential exhibition *English Conversation Pieces* at Sir Philip Sassoon's house in London in 1930. It soon reappeared on the art market in New York with M. Knoedler & Co. and the Howard Young Gallery, and was purchased from that source by Washington University in 1936.

BA

9 By the later 1750s Hogarth was an increasingly isolated figure, whose paintings were often the subject of criticism and whose theories on art, expounded in his book *The Analysis of Beauty* (1753), had been ridiculed. In the *London Evening Post* for February 24–26, 1757, he announced publicly that he would paint only portraits for the remainder of his career, and this may have been the impetus for the Irish peer James Caulfield, 1st Earl of Charlemont, to commission this remarkable painting.

As Hogarth remembered events, Charlemont urged him before he "entirely quitted the pencil to paint him a pickture leaving the subject to me and any price I asked."[15] Reminiscing over twenty years

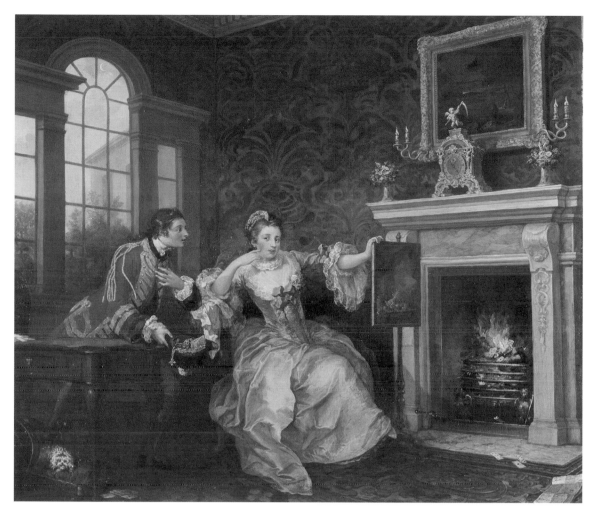

9 *The Lady's Last Stake* (also known as *Piquet, or Virtue in Danger*), 1758–59

Oil on canvas, 36 x 41½ in.
Albright-Knox Art Gallery, Buffalo, New York. Gift of Seymour H. Knox, 1945

REFERENCES:
Sixty lines of couplets by S. Hosmer explaining the meaning of the picture in *The Public Advertiser*, May 27–29, 1761, under the heading "Picquet, or Virtue in Danger, Occasioned by seeing a Picture of Mr Hogarth's (so called) at the Exhibition of the Artists of Great Britain"; Paulson, 2:267–69, 278–80, 460–1; Steven A. Nash, *Albright-Knox Art Gallery: Painting and Sculpture from Antiquity to 1942* (New York, 1979), 177–79; Webster, 169–76; Bindman, 199–200; Uglow, 608–15; Hallett, 301–10; Marcia Pointon, *William Hogarth's Sigismunda in Focus* (London, 2000), 10, 18, 35, no. 2; Judy Egerton, "Lord Charlemont and William Hogarth," in *Lord Charlemont and His Circle: Essays in Honour of Michael Wynne*, ed. Michael McCarthy (Dublin, 2001), 91–102.

later, Charlemont could not remember the exact year the picture was painted but suggested that it could "be probably ascertained from the records of the Haymarket Theatre, as the dog therein introduced is the portrait of the lap-dog belonging to the signora Mingotti, then first singer at the opera." Since Signora Regina Mingotti sang at the King's Theatre in the Haymarket during the 1755–56 and 1756–57 seasons and returned again in 1758–59 to John Rich's Covent Garden theater, it is possible that Charlemont approached Hogarth soon after his announcement in the *London Evening Post*.[16]

As their correspondence attests, Hogarth enjoyed especially cordial relations with Lord Charlemont, who went as far as to claim that his artist friend had been one of the educative forces of his early life. While *The Lady's Last Stake* was still with Hogarth, the young Irish peer also sat to him for the unfinished portrait that is now at Smith College, Northampton, Massachusetts. In August 1759 Hogarth finally finished the subject picture and asked his patron to name his price. Somewhat embarrassed, Charlemont replied: "having wrong calculated my expenses, I find myself unable for the present even to attempt paying you—However, if you be in any present need of Money, let me know it, and as soon as I get to Ireland, I will send you, not the Price of your Picture, for that is inestimable, but as much as I can afford to give for it." On January 29, 1760, he finally sent Hogarth £100, claiming to be "much ashamed to offer such a Trifle in recompense for the Pains you have taken, and the Pleasure your picture has afforded me. I beg you wou'd think that I by no means attempt to pay you according to your Merrit, but according to my own Abilities."[17]

In his "Autobiographical Notes" Hogarth tells us that the subject of the picture was "a virtuous married lady that had lost all at cards to a young officer, wavering at his suit whether she should part with her Hon[ou]r or no to regain the Loss which was afforded to her."[18] In a fashionable Palladian interior swathed in green damask, Hogarth shows a young woman in a rich yellow satin dress seated beside a gaming table. Her pose, with her left hand resting on the firescreen and the other raised to her flushed cheek and half-open mouth in an expression of pensiveness and indecision, is sexually highly-charged. The young officer in his scarlet coat is seen pressing his offer of absolving her debts at the price of her virtue and fidelity to her husband. In despair the young woman has hurled her losing cards towards the fire, some burning in the fireplace grate, which is supported by Harpies. Surmounting the clock is a cupid with a scythe, and on the pedestal can be read the ambiguous inscription "NUNC N.U.N.C." ("NOW N.O.W."). The clock itself registers 4:55 with "Set" replacing "Rise" on the half-circle that records sunrise and sunset, and through the window the moon is rising. The vanitas still life on the fire screen, with its exotic fruits of pineapple, grapes, melon, and cherries, seems to reinforce the message that time is running out, while the lapdog on its cushioned stool is too tame and pampered to defend its mistress. Charlemont recalled that the husband's letter, which lies on the floor, was supposed to say: "My dearest Charlotte, . . . your affectionate Townly.—I will send the remainder of the note by next post." The note in the hat on the floor reads "four hund[red]." Charlemont also tells us that the picture over the chimney represents a "'virtuoso landscape,' such as, decorated by a long Dutch name, the connoisseurs of those times eagerly and dearly purchased at auctions," although Ronald Paulson is more specific, if not entirely convincing, given the surviving visual

evidence, in suggesting that it represents a penitent Magdalen in a desert.[19]

As Paulson has pointed out, the painting is "less an admonitory warning than a celebration of the piquancy of the lady's situation: husband and honour on one side, flying time, youth, and chance on the other."[20] Hogarth was of course painting the kind of classic moment of choice witnessed in many of his subject paintings from *The Beggar's Opera* (no. 7) onwards, and he was well aware that his audience would enjoy this heightened moment of tension and indecision.

It has been suggested that the subject matter of the picture was at least partly inspired by the dramatist Colley Cibber's comedy of high manners *The Lady's Last Stake*, which was revived in 1756. In the play the card-obsessed Lady Gentle agrees to one last game of picquet with Lord George Brilliant. The latter is tricked by Mrs. Conquest, who arrives dressed as her brother, pays the debt, challenges him to a duel, and finally emerges as his real love. The subject may (as Judy Egerton has noted) have had some poignancy for Charlemont himself, since he had been warned by Edward Murphy to forsake his "love of cards and sitting up late hours" some ten years before at the start of his Grand Tour.[21] Marcia Pointon has recently proposed, less convincingly, that a more topical source than Cibber's play (which had been around for half a century) was the fashionable genre of courtesan memoirs such as the *Memoirs of the Celebrated Miss Fanny Murray* (1758, reprinted 1759). The same author also has much to say about the very prominent presence of jewelry, noting that, although the young officer has the bulk of the woman's jewelry in his tricorne hat, she has not yet yielded up all her treasures, since there are pearls in her hair and she is wearing at least one earring. A woman's jewelry, Pointon argues, "as distinct from heirlooms, which she merely had the right to use during her lifetime, often constituted her sole individually controlled wealth."[22]

The sharp compositional diagonals and high-key coloring show Hogarth at the peak of his painterly powers, and the result surpasses both in wit and sheer quality the celebrated series of six paintings from fifteen years earlier entitled *Marriage à la Mode* (National Gallery, London). Here we see more than a hint of recent French painting of the kind made popular by artists like Jean-François de Troy in works like *The Garter*, exhibited at the Paris Salon in 1725 (Metropolitan Museum of Art, Wrightsman Collection). If they were not already familiar to him, Hogarth would certainly have seen pictures of this kind during his first visit to Paris in 1743, and similar works had inspired his contemporary Joseph Highmore in his painted illustrations to Samuel Richardson's *Pamela*.[23]

Lord Charlemont lent the picture back to Hogarth for the exhibition at the newly-established Society of Artists in London in 1761, where he gave it the less risqué title *Picquet, or Virtue in Danger*. When Lord Charlemont finally received the picture it was hung in a bedchamber in Charlemont House in Dublin. It remained in the Charlemont family until sold anonymously at Christie's in 1874. The London dealer Thomas Agnew & Sons acquired it in 1899 and sold it to J. Pierpont Morgan. Morgan sold it on through Knoedler & Co. in 1911, from whom it was acquired by Seymour Knox. The latter presented it to the Albright-Knox Gallery in 1945.

BA

16. See P. H. Highfill, K. A. Burnim, and E. A. Langhans, *A Biographical Dictionary of Actors, Actresses, Musicians . . . and other Stage Personnel in London, 1660–1800* (Carbondale, 1984), 10: 263–66.
17. Charlemont's letters to Hogarth are in the British Library (Add. MSS.22, 394, ff.33,35). They were first published by the Historical Manuscripts Commission, 12th Report, Appendix, Part X [1891], 364, 385, and later by Paulson, 2:278.
18. Hogarth, 219.
19. Paulson, 2:268.
20. Ibid.
21. Edward Murphy to Charlemont, April 4, 1747, HMC *Charlemont*, 1:178.
22. Pointon, 18.
23. Einberg and Egerton, 50–59.

Allan Ramsay

1713–84

Painter of elegant society portraits and official images of the king and queen. Ramsay began his artistic training in 1729 at the Academy of St. Luke in his native Edinburgh. In 1732 he studied in London with the Swedish portraitist Hans Hysing, and during a 1736–38 sojourn in Italy he studied with Francesco Imperiali in Rome and Francesco Solimena in Naples. On his return to London, he set up a lucrative portraiture practice, producing sensitive likenesses notable for their quiet intimacy and refreshing candor. Ramsay's admiration of contemporary French art is evident in the delicate palette and decorative elegance of many of his paintings. Following a second trip to Italy in 1754–57, Ramsay established himself as the favorite portraitist of George III, who appointed him Serjeant Painter in 1767. Thereafter, he devoted himself almost entirely to royal commissions. Although a serious accident in 1773 made it all but impossible for him to paint, his studio continued to produce replicas of official portraits. During his last years Ramsay turned to literary endeavors and political pamphleteering.

REFERENCES:
Alastair Smart, *Allan Ramsay: A Complete Catalogue of His Paintings*, ed. John Ingamells (New Haven and London, 1999), 198, no. 553; Robyn Asleson, *British Paintings at The Huntington*, gen. ed. Shelley M. Bennett (New Haven and London, 2001), 318–24, no. 70.

10 Eighteenth-century British portraitists often represented women and children with pet birds. The demonstrable tameness of these formerly wild creatures was intended to reflect favorably on the civilizing influence of the birds' human keepers, accentuating the patient nurturing skills of women or the maturity and responsibility of children. Ramsay makes similar claims for the unknown girl in this portrait, who has so completely tamed her pet parrot that, even when released into the landscape, the obedient bird prefers to remain near its mistress.

Parrots had been kept as pets in Britain since the sixteenth century, and by the time Ramsay painted this portrait in 1744, they were fairly widely and cheaply available. The artist has so meticulously described the bird that it is possible to identify it as a white-headed parrot, now known as the Cuban Amazon (*Amazona leucocephala*), one of the first American parrots brought to Europe, and fairly prevalent in Britain during the mid-eighteenth century.

Ramsay's fresh, intelligent reinterpretation of standard portrait conventions yielded a series of innovative paintings during the 1740s. Here, his sensitive and dignified characterization of the young girl highlights his gift for portraying children with disarming candor and sympathetic understanding, anticipating the deliberately "natural" approach to portraiture that he would develop in the mid-1750s. Rather than adopting a static, frontal pose, Ramsay has placed the girl in a relaxed, fully three-dimensional position, with her weight shifted convincingly to one side.

Ramsay's eloquent treatment of the girl's hands reinforces the naturalism of his depiction. He had become fascinated with the expressive capacity of hands during his first trip to Italy in 1736–38, and thereafter he made meticulous drawings of hands and other isolated features as a means of perfecting the details of his portraits. Ramsay's careful preparatory process distinguished his practice from the impromptu techniques of other British portraitists. Equally uncharacteristic of British practice was the highly polished paint surface that he learned to

cultivate in Italy. Ramsay's smooth, tightly controlled brushwork differed markedly from the looser, more textured handling favored in England, leading one of his countrymen to complain that his paintings appeared "rather lick't than pencilled."[1]

By family descent, this portrait entered a private collection in New Zealand in 1876 and remained there until the late twentieth century. It was little known in Europe or America until 1999, when it was purchased at auction in London by The Huntington.

RA

1. George Vertue quoted in Alastair Smart, *Allan Ramsay: Painter, Essayist and Man of the Enlightenment* (New Haven and London, 1992), 59.

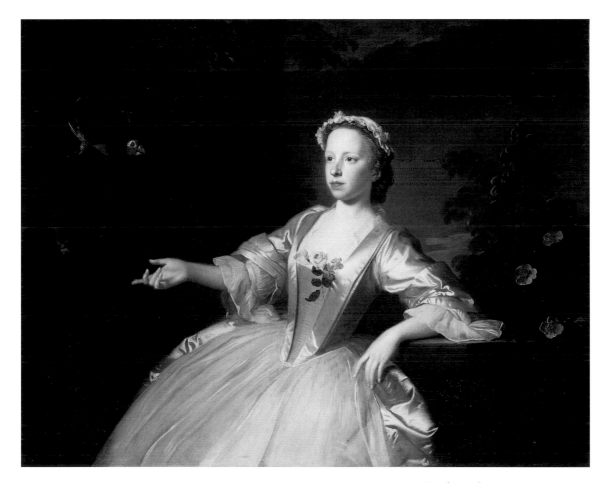

10 *Girl with a Parrot,* 1744

Oil on canvas, 38 x 48 ½ in.
The Huntington Library, Art Collections, and Botanical Gardens

Giovanni Antonio Canal, called Canaletto

❧ 1697–1768

Italian draftsman, printmaker, and painter best known for his views of Venice and London. Trained as a painter of theatrical scenery, Canaletto made his reputation through his sparkling images of his native Venice, often seen from a bird's-eye view. Rendered with a characteristic calligraphic brushstroke and often depicting the festive side of Venetian life, these Italian views (or vedute) became hugely popular among British aristocrats, many of whom were introduced to his work while on the Grand Tour and sought—through the artist's English agent in Venice, Joseph Smith—to bring his paintings back as souvenirs of their travels. Prompted by his success with the Grand Tourists, Canaletto came to England in May 1746 and, as he had hoped, quickly found patronage among the most prominent of London society. Although he has often been criticized—most famously by John Constable—for making his English vedute shimmer in the light of an Italian sun, his visions of England and its topography aptly capture the atmosphere of optimism and prosperity of mid-century Britain. During his nine years in England, Canaletto almost single-handedly transformed the traditions of cityscape and landscape painting as practiced in Britain, as van Dyck had done for portraiture a century before. The Italian painter inspired countless British-born followers, foremost among them Samuel Scott. He returned to Italy in 1755.

II Westminster Bridge, only the second bridge to span the River Thames, was among Canaletto's most often painted London subjects. This view was intended not only as a commemoration of the inauguration of the bridge but also as a record of the festivities celebrating the official swearing-in ceremony of the Lord Mayor of London. Until 1752, when the festival's date was changed to November 9, Lord Mayor's Day was celebrated annually on October 29: the Lord Mayor would make his way in a lavish procession up the Thames from the City to Westminster, where he would be sworn into office by the Barons of the Exchequer and presented to the king.

Shown from a bird's-eye view, the scene is more or less faithful in its depiction of the London skyline. In the background at the left, one can make out the turrets and towers of Lambeth Palace, the medieval structure that served as the London residence of the Archbishops of Canterbury. At the right, the congested quarter of Westminster is fully described: from left to right, the four spires of St. John-the-Evangelist in Smith Square, the double towers of St. Stephen's (then the seat of the House of Commons), and the majestic Westminster Abbey itself, directly in front of which is the smaller St. Margaret's, Westminster, proudly flying the Union Jack from its spire.

Less accurate, however, is Canaletto's pictorial description of the bridge itself. Westminster Bridge had proved one of the most controversial and monumental projects in London's history. Since their business was to transport people and commodities across the Thames, the watermen of London feared for their livelihood and had waged war against those sponsoring and building the bridge; joining them in this battle was the City Corporation, the members of which believed westward expansion would shift trade

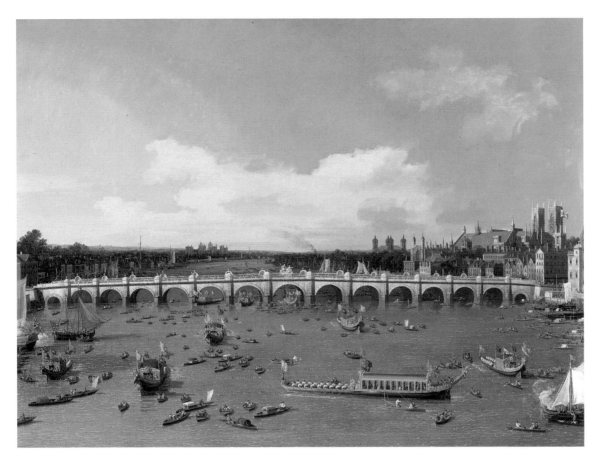

11　*Westminster Bridge with the Lord Mayor's Procession on the Thames*, 1747

Oil on canvas, 37 ¾ x 50 ¼ in.
Yale Center for British Art, Paul Mellon Collection

REFERENCES:
W. G. Constable and J. G. Links, *Canaletto: Giovanni Antonio Canal, 1697–1768*, 2nd rev. ed., 2 vols. (Oxford, 1976), 1:141, 2:423, no. 435; Malcolm Warner and Julia Marciari Alexander, with an introduction by Patrick McCaughey, *This Other Eden: Paintings from the Yale Center for British Art* (New Haven, 1998), 70–71, no. 22.

and commerce from their enclave in the center of London. When one of the piers on the Westminster side of the bridge began to settle shortly before its scheduled inauguration in 1747, rumors of sabotage plagued both the watermen and the City Corporation. Probably merely the result of poor engineering, the sinkage in the structure necessitated repairs that took over three years to complete. The absence of any sign of such troubles in the painting shows that Canaletto did not paint the bridge as it appeared at that time but rather as it might have appeared had it opened as scheduled. Other details of the scene corroborate this: only six of the pairs of octagonal half-domed alcoves he places above each pier were ever built, two pairs at each end and two over the bridge's middle section; furthermore, the statues of Isis and the Thames that he shows at the center of the bridge were never executed nor do they appear to have been part of the original architectural plan.

Similarly, Canaletto's treatment of the fluvial procession evokes but does not record the event as it actually happened. Designating the Lord Mayor's ceremonial barge by painting it broadside, he displays the grandeur of the boat, complete with eighteen oarsmen and various attendants; the blazon on the flag is indistinguishable, however, making it impossible to determine the guild to which the Lord Mayor belonged. A print after the painting, engraved by Remegius Parr in 1747, names the boats in its caption as the following: from left to right, the Skinners, the Goldsmiths, the Clockworkers, the Fishmongers, the Vintners, the Taylors, the Mercers, and, at the far right, the Drapers. On the basis of this print, art historians have assumed that the painting's flags designate accurately the flags of those guilds. Yet close inspection reveals that none of these ships has a recognizable flag. Nor do any of the people watching

from the bridge or from the windows of the riverside houses have distinguishing features. All these aspects of the painting demonstrate the artist's virtuoso ability to render an impression of accuracy and detail through carefully placed strokes and dabs of paint.

Nothing is known about the painting's commission. In fact, it is possible that Canaletto may have painted it to keep in his London studio as an example of his work for potential clients to see; the existence of Parr's print, which was sold by John Brindley, suggests that the artist may well have hoped to capitalize on the inauguration of the bridge and the Lord Mayor's Day parade to advertise his recent arrival in London. Although the painting's early history is largely obscure, it is certain that J. Carpenter owned the painting in the nineteenth century; it was sold from his collection through Christie's in July 1895 and bought by the dealer Colnaghi. The Duke of Buccleuch owned *Westminster Bridge with the Lord Mayor's Procession on the Thames* until 1962, when Paul Mellon bought it through Edward Speelman. It is one of six magnificent Canaletto canvases given by Mellon to the Yale Center for British Art.

JMA

Arthur Devis

1712–87

Portrait painter best known as a pioneer in the genre of the "conversation piece," a type of portrait, usually of small scale, in which family members or friends converse or engage in leisure activities in domestic settings. One of the first artists to practice this genre almost exclusively, Devis was trained in the studio of the Flemish landscape and sporting painter Peter Tillemans in London. In the 1730s he lived and worked in his native Lancashire, returning to London in 1742 to establish a successful portrait practice. The 1750s marked the apogee of his career, and his portraits from that time attest to his ability to capture his sitters' individuality while emphasizing their fashionable tastes and impeccable decorum. Although perhaps not as technically proficient as some of his competitors in the genre, among them Johann Zoffany and Francis Wheatley, Devis was its most prolific practitioner.

12 Sir Joshua Vanneck was of Dutch birth; his father had been Paymaster of the Land Forces of the United Provinces at The Hague. He came to England in 1722 to join his elder brother Gerard, who had emigrated in 1718 to seek his fortune. The brothers became prosperous merchants, and on December 14, 1751 Joshua was created a baronet, an event this portrait may have been commissioned to celebrate.

Sir Joshua is shown here with his extended family. Although there is no documentation to identify the sitters precisely, they are most likely, from left to right: Sir Joshua; Mrs. De La Mont (probably his sister); Henry Uhthoff, who married Vanneck's daughter Anna Maria in 1752 and was probably, like his father-in-law, a Dutch merchant; Vanneck's eldest son Gerard, who would become M.P. for Dunwich from 1768 to 1790 and succeed to his father's title in 1777; his daughter Gertrude, looking through a telescope; his son Joshua, in the middle seated on the ground, who inherited the family title from his brother in 1791, later becoming Baron Huntingfield of Heveningham Hall; his youngest daughter Margaret, on the ground wearing a yellow dress; his daughter Anna Maria; and, seated on the bench to the right, his eldest child Elizabeth and her husband the Hon. Thomas Walpole, a Whig M.P. and cousin of the antiquarian Horace Walpole. Missing from the group are Sir Joshua's wife Marianne and his brother Gerard, both of whom had died in 1750.

Although certainly a record of Sir Joshua's newfound social standing, this portrait probably was intended also to celebrate the marriage of his daughter Anna Maria to Henry Uhthoff in March 1752. Although it has been suggested that Anna Maria is the woman looking through the telescope, it is more likely that she is the sitter wearing the pink dress and hat. Displayed frontally and looking contentedly at her future or recent husband (who gazes happily back at her), she immediately draws the viewer's eye in her shimmering dress, while her gesture, pointing across the river and away from her father's estate, suggests both the beauty of the view and her imminent departure from her father's household. At mid-century, pink was frequently donned by young women in portraits that celebrated their marriage; furthermore, unlike her aunt and younger unmarried sisters, she

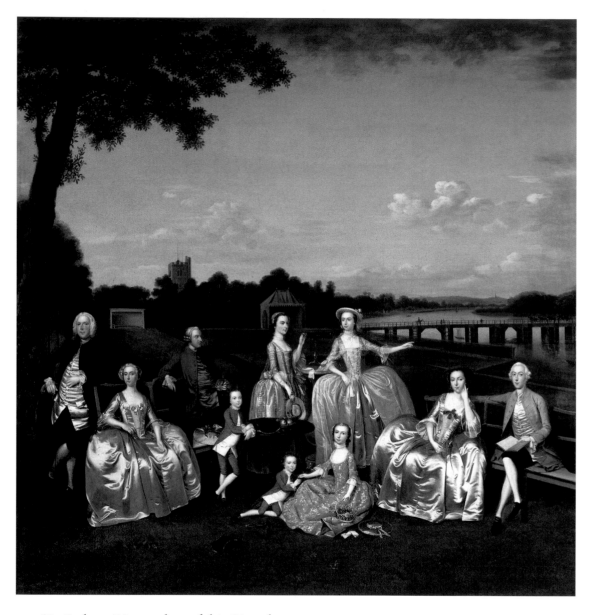

12　*Sir Joshua Vanneck and his Family*, 1752

Oil on canvas, 57 ½ x 55 in.
The Frick Art and Historical Center, Pittsburgh

　　ARTHUR DEVIS

and her married sister both wear their hats, suggesting a common familial status.

One of his most complex compositions, Devis's portrait of the Vannecks traditionally has been thought to represent them at their family estate, Roehampton House, along the River Thames in Putney. Certainly, his depiction of Putney Church in the background and of the Old Putney Bridge locate the scene with accuracy, and it is likely that Devis has captured at least the atmosphere, if not the topography, of what Horace Walpole described in 1778 as Vanneck's "beautiful terrace on the Thames with forty acres of ground."[1] The Vanneck estate at Roehampton was later refurbished by the young Gerard and renamed Roehampton Grove. Here Devis shows the fashionable garden as it existed at mid-century, elaborately delineated with terraced levels holding garden pavilions and viewing stations from which to admire to advantage the fluvial prospect. Devis had been trained as a landscape painter, and his portraits in exterior settings far outshine his interior groups, many of which betray his use of stock architectural features and props.

In this portrait, rather unusually, Devis's figures display little of the doll-like features for which he is best known. (His dependence on the lay-figure, a wooden doll that could be dressed up and posed in the studio, is frequently all too evident in his compositions). The likenesses of the sitters, if somewhat stylized, are rendered with delicacy, and family resemblances are everywhere apparent. For instance, each of the sons-in-law has features that distinguish him from his new family; indeed, it is not surprising that Thomas Walpole was long identified as his more famous cousin Horace, since their facial resemblance is striking. The artist also excels here in his depiction of glistening and lustrous fabrics and costume; the silks, satins, and cotton lawns serve to highlight their wearers' features and display the family's wealth and fashionable tastes. The group's conviviality is evident not only in their affectionate gestures but also in the well-placed accidents of familiar social interaction interrupted: a discarded glove hangs off the telescope perch; an upturned hat is absent-mindedly put down next to its owner, the matronly Mrs. De La Mont; floral sprigs have strayed from their basket into young Margaret's lap; and Mr. Walpole has momentarily looked up from the book poised delicately on his knee.

The portrait remained in the possession of the heirs of the youngest Vanneck daughter, Margaret, who married Richard Walpole in 1757. In 1913 it was bought by the dealer M. Knoedler & Co. at the sale of the collection of Lady Dorothy Nevill, wife of Margaret's grandson, Reginald Henry Nevill. Henry Clay Frick purchased the work in 1916, at which time it went to Clayton, the Frick family's Pittsburgh mansion. The only conversation piece among the important collection of British art assembled by Frick, this painting—almost like a snapshot in its immediacy—attests to Devis's mastery of the genre and is certainly among the finest of his works in America today.

JMA

REFERENCES:
Sydney H. Pavière, *The Devis Family of Painters* (Leigh-on-Sea, 1950), 58, no. 138; Ellen D'Oench, *The Conversation Piece: Arthur Devis & His Contemporaries*, exh. cat. (Yale Center for British Art, New Haven, 1980), 58–59, no. 29.

1. From a letter of June 26, 1778, quoted in D'Oench, 59.

Thomas Gainsborough

✣ 1727–88

Portrait and landscape painter. The dazzling brushwork and suave informality of Gainsborough's portraits won him favor among aristocratic and fashionable patrons, raising him to the pinnacle of his profession. Yet his true passion was for landscape painting, a mode of art that attracted few buyers during his lifetime. After leaving rural Sudbury, Suffolk, for London in 1740, Gainsborough assimilated the French rococo style while training under the engraver Hubert-François Gravelot. Chasing after patronage, he returned in 1748 to Sudbury; he moved on to the seaport of Ipswich in 1752, and finally to the resort town of Bath in 1759. Meanwhile his small-scale, realistic portraits evolved into sophisticated confections on the scale of life, rivaling the work of Joshua Reynolds. Gainsborough became a founding member of the Royal Academy in 1768 and resettled in London six years later. He amused his idle hours by playing musical instruments and painting landscapes and "fancy pictures" (subject pictures drawn from the artist's imagination, or "fancy"). Stubborn and independent, he exhibited only privately after quarreling with the Academy over the hanging of an important painting in 1784.

13 Provincial middle-class families such as the Gravenors provided Gainsborough with crucial patronage while he was struggling to establish his career and form his painting style in the 1750s. Having failed to attract an adequate number of portrait commissions in his native Sudbury, he moved on to Ipswich in 1752 and completed this group portrait there a few years later. It was undoubtedly an important commission for the artist. John Gravenor (1700–78), an Ipswich apothecary, became prominent as a local political figure around 1754. He may have wished to mark his growing public stature with a portrait, which was a conventional means of marking important occasions in life. Gravenor is shown with his second wife, Ann Colman, whom he married in 1739, and his two daughters, Ann (baptized January 1740) and Elizabeth Broke Gravenor (c. 1742–1819).

The curious appearance of the figures is one of the most striking features of the portrait for modern viewers. The anatomical improbabilities of the females owe something to the artificial fashions of the day. Rigid corsets and long, pointed waistlines exaggerated the length and flatness of the torso, while square hoops lent a boxy shape to the skirts. However, the awkwardness of the figures also reflects Gainsborough's reliance on a lay-figure in his studio practice. Like many other artists, he employed small, malleable dolls as convenient substitutes for the live model. The limitations of the method are evident in the curious tilting pose in which Gainsborough represents both Mrs. Gravenor and her younger daughter. The position was evidently intended to suggest a relaxed informality but fails to provide a convincing sense of torsion and shifting weight. With his hand tucked into his vest and his feet placed in a neat perpendicular arrangement, John Gravenor assumes the sort of decorous pose advocated by dancing masters and illustrated in courtesy literature.

The twisting trees that rise up behind the figures reflect similar artistic manipulation. In addition to exemplifying the serpentine lines beloved of the

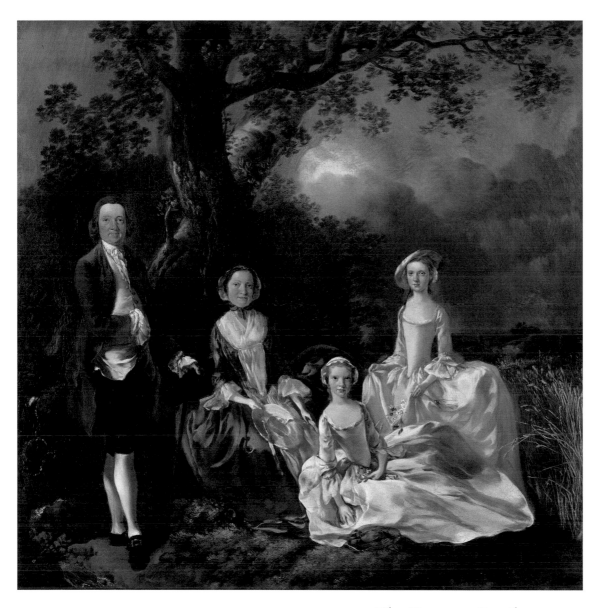

13 *The Gravenor Family*, c. 1754

Oil on canvas, 35 ½ x 35 ½ in.
Yale Center for British Art, Paul Mellon Collection

REFERENCES:
Malcolm Cormack, *The Paintings of Thomas Gainsborough* (Cambridge and New York, 1991), 52, no. 11; Malcolm Warner and Julia Marciari Alexander, with an introduction by Patrick McCaughey, *This Other Eden: Paintings from the Yale Center for British Art* (New Haven, 1998), 54–55, no. 15; Michael Rosenthal, *The Art of Thomas Gainsborough: "A Little Business for the Eye"* (New Haven and London, 1999), 127, 130.

Rococo, they have a gestural, almost anthropomorphic quality suggestive of an embrace. Interlocking trees recur in Gainsborough's drawings and paintings of this period and are particularly associated with images having to do with love and marriage. Here, the trees form a visual as well as a symbolic link between the husband and wife placed before them.

Although the painting appears rather naive in comparison with Gainsborough's mature work, it probably struck the artist's provincial Ipswich clientele as remarkably sophisticated. Throughout, it is marked by the artistic influences that Gainsborough had imbibed while living in London from 1740 to 1748. The sinuous lines and predominantly pastel palette reflect the decorative principles of French Rococo style, inculcated by his drawing master Hubert-François Gravelot. There is also an obvious debt to the small-scale outdoor portraits of his colleague Francis Hayman, whose eye for fashion detail Gainsborough matched in describing the ribbons and flounces of the women's clothing, calling particular attention to the fashionable straw hat that Mrs. Gravenor displays on her lap.

For all its artificiality Gainsborough's painting provides a remarkably convincing evocation of light and atmosphere. The bold juxtaposition of highlight and shadow on the silk gowns creates a shimmering appearance suggestive of a scene witnessed outdoors, an impression strengthened by the dappled fall of light and shadow on the ground and by the heavy atmosphere of the storm clouds moving in on the horizon. In the foliage of the tree and the sheaths of wheat, the light touch of Gainsborough's brush creates an impression of rustling movement, which animates the otherwise static figures.

RA

1. Philip Thicknesse, *A Sketch of the Life and Paintings of Thomas Gainsborough, Esq.* (London, 1783), 17.
2. William Whitehead, letter of November 16, 1758, quoted in Rosenthal, 1999, 167.

14

In the winter of 1759, Gainsborough moved to the fashionable spa town of Bath, where a steady influx of well-to-do visitors promised opportunities for patronage. Adopting a common strategy, he set out to paint a few local celebrities with the hope of luring potential customers to his new studio. His friend Philip Thicknesse volunteered to be one of the painter's "decoy ducks," as he put it,[1] but Gainsborough instead carried out this remarkable portrait of Ann Ford (1732–1824). The daughter of a judicial clerk, Ford had gained considerable fame both as a gifted singer and as a player of the viola da gamba and English guitar. Her personal beauty and emotional style fascinated audiences. "You would be desperately in love with her in half an hour," one of her admirers assured a friend in a letter of November 1758, "and languish and die over her singing as much as she does in performance."[2]

Ford gave a series of genteel Sunday concerts in 1760 at her home in Bath, playing alongside the Italian virtuoso Giusto Ferdinando Tenducci and other professional musicians. Soon after, she sought opportunities to perform in public. Despite being arrested twice at the behest of her father (who subscribed to the common view that such exposure was disreputable in a woman), she persevered in mounting a series of concerts in London during the spring of 1760. Her struggle for independence was partly motivated by the unwelcome attentions of the elderly Earl of Jersey, who had offered her £800 a year to become his mistress. On her return to Bath, she sought sanctuary at the home of her close friend Lady Elizabeth Thicknesse, the wife of Gainsborough's friend Philip Thicknesse (whom Ford herself would marry in 1762 following Elizabeth's death). It was presumably at that time, when Ann Ford's widely publicized troubles had reached their climax, that she sat to Gainsborough.

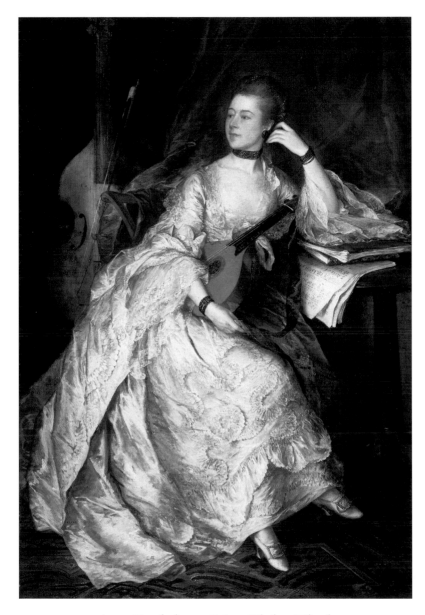

14 *Ann Ford, later Mrs. Philip Thicknesse, 1760*

Oil on canvas, 77 ½ x 53 in.
Cincinnati Art Museum, Bequest of Mary M. Emery

REFERENCES:
Ronald Paulson, *Emblem and Expression: Meaning in the Visual Art of the Eighteenth Century* (London, 1975), 206; Jack Lindsay, *Thomas Gainsborough: His Life and Art* (London, 1981), 53–54; Amal Asfour and Paul Williamson, *Gainsborough's Vision* (Liverpool, 1999), 112–15; Rosenthal, 1999, 167–79.

3. Wetenhall Wilkies, *A Letter of Genteel and Moral Advice to a Young Lady* (1740), quoted in Rosenthal, 1999, 167.
4. Mary Delany to Mrs. Dewes, letter of October 23, 1760, quoted in Augusta Waddington Hall, Lady Llanover, ed., *The Autobiography and Correspondence of Mary Granville, Mrs. Delany*, 3 vols. (London, 1861), 3:605.

His portrait captures both the headstrong self-confidence and the artistic passion that visitors to his studio would have associated with Ann Ford. She is seated in a complex, twisting pose, with her crossed legs extended to the right, her chest and shoulders pivoted toward the viewer, and her head turned to the left. The torsion of her body creates a series of serpentine lines that are echoed throughout the painting, most noticeably in the spiraling ornament of her dress and the scallop curves of the guitar in her lap and the viola da gamba on the wall behind her. The dynamism of the pose is further reinforced by the nervous energy of Gainsborough's brushwork, with slashing strokes of white and gray masterfully capturing the sheen of the satin gown. Glittering ornaments of jet, pearl, and diamanté further animate the painting with a sparkling glamour.

Gainsborough's preferred manner of commencing a portrait was to trace the figure directly on the canvas without much preliminary study. The unusual importance he attached to the present painting is attested to by the existence of drawings in which he gradually developed the complicated, twisting position in which Ann Ford appears. In its dashing self-confidence the pose recalls the portraiture of Anthony van Dyck, whom Gainsborough greatly admired (see no. 3). Van Dyck reserved such bold stances exclusively for men, however, invariably presenting women in gentler, less demonstrative attitudes. In daily life, too, English women avoided comporting themselves in the manner Gainsborough has adopted here. Indeed, eighteenth-century courtesy books specifically advised female readers against sitting with their legs crossed above the knee, because "such a free posture unveils more of a masculine disposition than sits decent upon a modest female."[3]

Gainsborough's intention was clearly to present Ann Ford in an eye-catching and provocative fashion, but some contemporary observers felt he had gone too far. One woman who visited his studio toward the end of October 1760 remarked to a correspondent, "I saw Miss Ford's picture—a whole length with her guitar, a most extraordinary figure, handsome and bold; but I should be sorry to have any one I loved set forth in such a manner."[4] The striking pose, vivacious paint handling, and unusual insistence on his sitter's musical authority make this one of Gainsborough's most daring portraits of a woman. Owned in the nineteenth century by the important British collectors Alfred de Rothschild and Charles J. Wertheimer, the portrait was later acquired by the philanthropist Mary M. Emery, widow of a wealthy Cincinnati entrepreneur. She bequeathed it to the Cincinnati Art Museum in 1927. It provides a stunning contrast to the more conventionally pretty images of women that collectors typically favored during the first decades of the twentieth century.

RA

15 Gainsborough was one of three painters who received a daunting commission from William, Lord Shelburne, during the late 1760s. Shelburne charged each to "exert himself to produce his *chef d'oeuvre*, as they were intended to lay the *foundation of a school of British landscapes*."[5] Rising to the challenge, Gainsborough executed this delicious woodland scene, which has long since been recognized as a pivotal work in his development as a landscape painter. It marks the first appearance of a theme to which the artist returned on several occasions: that

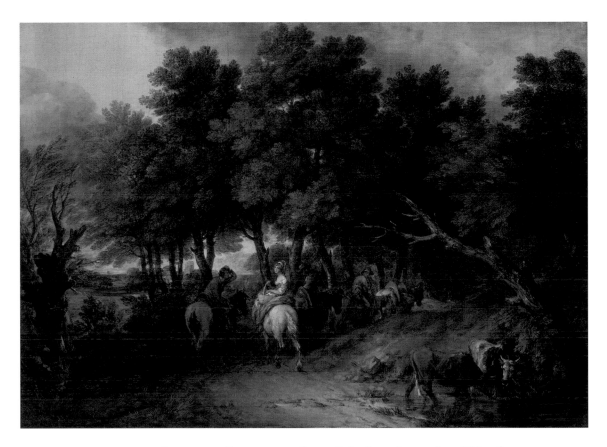

15 *Peasants Returning from Market through a Wood,* c. 1767–68

Oil on canvas, 47 ¾ x 67 in.
Toledo Museum of Art. Purchased with funds from the Libbey Endowment,
Gift of Edward Drummond Libbey, 1955

REFERENCES:
John Barrell, *The Dark Side of the Landscape* (Cambridge, 1980), 53–58; John Hayes, *The Landscape Paintings of Thomas Gainsborough*, 2 vols. (London, 1982), 1:104–6, no. 89; Michael Rosenthal, *English Landscape Painting* (Oxford, 1982), 58, 68; Paul Spencer-Longhurst and Janet M. Brooke, *Thomas Gainsborough: The Harvest Wagon*, exh. cat. (Birmingham Museums and Art Gallery, Birmingham, 1995), 12, no. 13.

of peasants going to (or returning from) market. Although his early interest in Dutch art remains apparent in specific motifs, such as the cattle drinking at the water's edge and the rugged path winding gently into the distance, Gainsborough's fluent brushwork, vigorous use of impasto, and rich palette reflect the greater influence of the seventeenth-century Flemish painter Peter Paul Rubens.

With rapid flicks of the brush, Gainsborough dabbed in the foliage of the trees, using a range of green and umber tones. Dashes of red and orange suggest the warm highlights of the sun—for example, in the bushes beside the chestnut horse and in the dead tree to its left. The same fluency and freedom are apparent in the rapidly sketched forms of the human figures and cattle, which the artist has captured convincingly with a minimal number of brushstrokes. The painting as a whole gains a sparkling, fresh atmosphere from the luminous opalescence of the morning sky, glimpsed through the dense screen of trees.

A splash of light on the foreground path and the emphatic gesture of the blasted tree at right direct our attention to a humorous incident that forms the focus of the painting. A pretty girl holding a basket of eggs and seated on a white horse turns to look directly at the viewer. In doing so, she ignores the befuddled horseman opposite her, who awkwardly doffs his cap. As in many of Gainsborough's depictions of rural life, he has drawn a marked distinction between the attractive, daintily dressed woman and the scruffy man who attends her. The tendency seems to reflect the comic pastoral mode developed in John Gay's immensely popular poem *The Shepherd's Week* (1714), in which pretty dairymaids and shepherdesses exude a fetching charm, while their male companions invariably appear as clownish oafs.

5. John Britton, *The Beauties of Wiltshire* (1801), quoted in Hayes, 1982, 431.

The literary analogy underscores the artificiality of Gainsborough's depictions of rustic life, which he pursued as a pleasurable escape from the drudgery of his fashionable portraiture practice.

In composition and handling *Peasants Returning from Market through a Wood* was one of the most impressive landscapes that Gainsborough had produced to date. It is fitting that he created it for Lord Shelburne, whose encouragement of landscape painting distinguished him from the vast majority of Gainsborough's patrons. It was engraved by Francesco Bartolozzi in 1802 but not exhibited publicly until 1887. Since coming to America in 1955, however, its appearance in exhibitions and publications has established it prominently within the canon of Gainsborough's landscape oeuvre.

RA

16 At a tender age Elizabeth Linley (1754–92) and her brother Thomas (1756–78) distinguished themselves as the most talented members of an exceptional family of musicians. From 1763 they performed in their father's concerts in the English resort town of Bath, and in January 1767 they made their London debut in a masque staged at Covent Garden. Audiences were dazzled by Elizabeth's brilliant singing and by Thomas's multifaceted performance, in which he played the violin, danced the hornpipe, and sang in the role of Puck. Unfortunately, neither sibling fulfilled his or her precocious promise. Elizabeth's career was cut short by her marriage to the playwright Richard Brinsley Sheridan in 1773, while Thomas's remarkable accomplishments as a violinist and composer were extinguished by his untimely

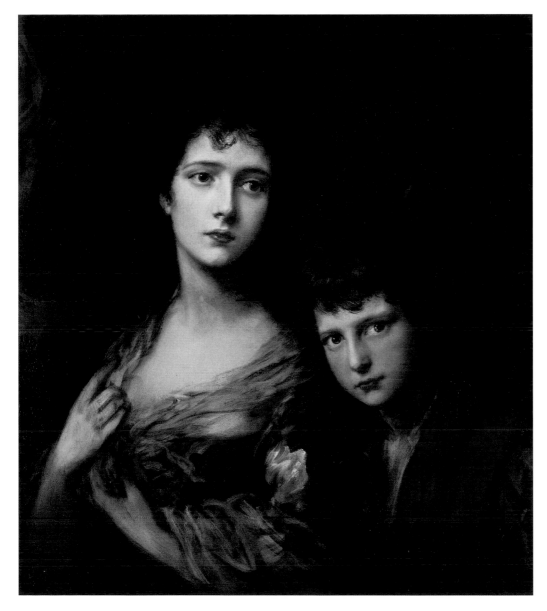

16 *Elizabeth and Thomas Linley*, 1768

Oil on canvas, 27 ½ x 24 ¼ in.
Sterling and Francine Clark Art Institute, Williamstown, Massachusetts

REFERENCES:
Ellis Waterhouse, *Gainsborough* (London, 1958), 103; Giles Waterfield et al., *A Nest of Nightingales*, exh. cat. (Dulwich Picture Gallery, 1988), 62, no. 3.1; Jean Strouse, "J. P. Morgan's Last Romance," *New York Review of Books* 46 (April 22, 1999): 44–47.

death by drowning at the age of twenty-two.

Gainsborough "lived in great intimacy" with the Linleys during the 1760s, undoubtedly drawn to the family by his own passion for music. He executed portraits of several family members but seems to have regarded the present painting in a rather different light. During the eighteenth century it was known as "A Beggar Boy and Girl," a title that masks the identity of the famous sitters, transforming them into the sort of waifs one often finds in the artist's "fancy pictures" of rustic cottage dwellers (see nos. 15, 19). The loosely painted drapery seems to show them dressed in ripped and ragged clothing, and the backdrop suggests that they stand in a dense forest. The composition may originally have been more extensive and elaborate than it now appears. In a letter to a friend, Gainsborough mentioned that he was working on "a large Picture of Tommy Linley and his sister."[6] Although the present painting cannot be described as large, its unusual proportions suggest that it may have been cut down from a bigger canvas.

Gainsborough's sentimental idealization of the Linley children and of rustic cottage life is particularly evident in his treatment of Elizabeth. Her windswept hair and plaintive, faraway gaze establish the portrait's mood of poetic romanticism. (For a later portrait of her on a grander scale, see fig. 10.) The flurry of Gainsborough's brushwork accentuates the emotional power of the painting but may also indicate the speed with which he worked. In the letter to a friend mentioned earlier, he remarked that Thomas was "bound for Italy at the first opportunity." Indeed, by early summer 1768, the boy was studying with the violinist Nardini and playing with Mozart, who was exactly his age. Mozart later remarked, "Linley was a true genius, and . . . had he lived, he would have been one of the greatest ornaments of the musical world."[7] In retrospect, the tragic

circumstances of the boy's early death enhance the tender vulnerability of his earnest gaze.

Perhaps out of affection for the sitters, Gainsborough kept *Elizabeth and Thomas Linley* until 1784, when he sold it to the 3rd Duke of Dorset. By the early twentieth century it was in the possession of the 3rd Baron Sackville, of Knole who began selling off family heirlooms in 1911 in order to raise badly needed cash. The first item sold was Gainsborough's Linley portrait. "Alas! Miss Linley is gone!" Lady Sackville noted in her diary. "We suppose some American will buy it eventually."[8] Sure enough, the painting sold to J. Pierpont Morgan, who had already bought a Reynolds portrait from Knole (see no. 30). Lady Sackville continued to regret the loss of *Elizabeth and Thomas Linley* and, during a romantic liaison with Morgan, unsuccessfully attempted to negotiate its return. Morgan bequeathed the painting to his son in 1913. Later it was sold to Robert Sterling Clark, heir to the Singer sewing machine fortune, who, with his wife Francine Clary Clark, founded the art institution in Williamstown, Massachusetts, that bears their names.

RA

EXHIBITED AT YALE ONLY.

6. Waterfield, 62.
7. Ibid., 13.
8. Strouse, 44.

17 There is no more famous British painting in America than Gainsborough's portrait of Jonathan Buttall (1752–1805). The portrait received acclaim from its first public appearance in 1770, when it was exhibited at the Royal Academy under the anonymous title *Portrait of a Young Gentleman*. By 1798 admiring British artists had nicknamed it *The Blue Boy*, and it has been known by that title ever since. Buttall was the son of

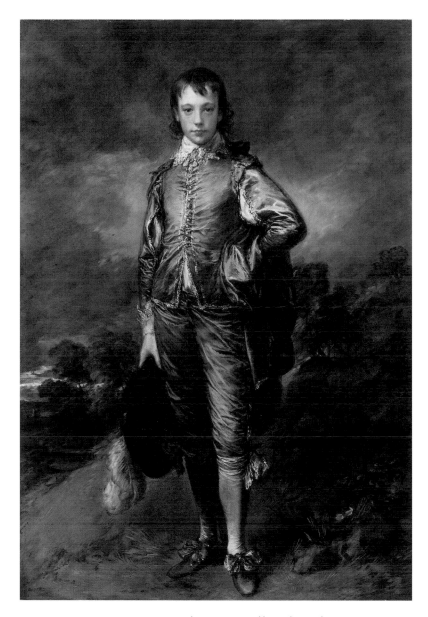

17 *Jonathan Buttall: The Blue Boy*, 1770

Oil on canvas, 70 ⅜ x 48 ¾ in.
The Huntington Library, Art Collections, and Botanical Gardens

REFERENCES:
William T. Whitley, *Thomas Gainsborough* (London, 1915), 309; William T. Whitley, *Artists and Their Friends in England, 1700–1799*, 2 vols. (London and Boston, 1928), 1:263–65; Robert R. Wark, *Ten British Pictures, 1740–1840* (San Marino, 1971), 29–41; Deborah Cherry and Jennifer Harris, "Eighteenth-Century Portraiture and the Seventeenth-Century Past: Gainsborough and Van Dyck," *Art History* 5 (September 1982): 298–99, 302, 305; Aileen Ribeiro, The *Dress Worn at Masquerades in England, 1730–90, and Its Relation to Fancy Dress in Portraiture* (New York and London, 1984), 211; Robyn Asleson, *British Paintings at The Huntington*, gen. ed. Shelley M. Bennett(New Haven and London, 2001), 104–11, no. 17.

9. The x-rays are reproduced and discussed in Asleson, 104, 106–7.

a prosperous London ironmonger who died in 1768, when the boy was just sixteen. Evidence suggests that Gainsborough painted him on a whim of his own, rather than as a formal commission, for x-rays reveal that the portrait is executed on a discarded piece of canvas that the artist had begun as a full-length portrait of an older man.[9] Over the next twenty years, Gainsborough and his sitter evidently developed a close relationship. Buttall was among a handful of friends whose presence Gainsborough specifically requested at his funeral in 1788.

The Blue Boy attests not only to Gainsborough's regard for Jonathan Buttall, but also to his admiration for Anthony van Dyck, the seventeenth-century Flemish painter who revolutionized British art while serving as Principal Painter in Ordinary to Charles I (see. no. 3). Since moving to the resort town of Bath in 1759, Gainsborough had made a conscious study of van Dyck's portraiture in nearby country-house collections. The consummately elegant poses, luxurious costumes, and bravura paint handling of van Dyck's portraiture provided Gainsborough with valuable lessons that he emulated in his own paintings. Here, Jonathan Buttall's brilliant blue satin suit, trimmed with silver galloon lace, is modeled on similar examples in van Dyck's portraiture, as is the boy's dashing stance, with one hand resting on his hip and his weight shifted casually to one side.

Gainsborough was hardly the first British artist to present a modern-day sitter in the historic trappings of van Dyck's era. Portraitists had been experimenting with this whimsical conceit since the 1730s, and there was a simultaneous vogue for "vandyke" dress at fashionable masquerade balls of the period. What sets Gainsborough's portrait apart from the others is the soulful poignancy of the boy's earnest gaze and the sheer wizardry of the brushwork. In the latter respect, Gainsborough has both captured and exceeded the splendor of van Dyck's own style. The shimmering satin of the blue suit and the amorphous atmosphere of the landscape backdrop were created with a flurry of energetic brushstrokes that resolve themselves at a distance into a convincing illusion.

The Blue Boy remained in Jonathan Buttall's possession until 1796, when financial difficulties forced him to sell the painting at auction. Sold again in 1802, it was purchased by the fashionable portrait painter John Hoppner, who produced a careful copy before selling it on to his patron and friend, Robert, 2nd Earl Grosvenor, later 1st Marquess of Westminster. Westminster and his heirs exhibited the portrait on ten occasions between 1814 and 1908, and the publication of at least four separate engravings added to its fame. In the first two decades of the twentieth century, *The Blue Boy* was probably the most coveted British portrait in private hands—a trophy many dealers and collectors sought to acquire. A media sensation erupted when the art dealers Duveen Bros. acquired the painting in 1921, and the commotion redoubled when the American railroad magnate Henry E. Huntington purchased it for a record sum of £182,200 ($728,000). A farewell exhibition at the National Gallery in London reportedly attracted 90,000 visitors, and large crowds also flocked to Duveen's gallery in New York, where the painting was shown before being sent to California to join Huntington's growing collection of great British paintings.

RA

EXHIBITED AT THE HUNTINGTON ONLY.

18 Gifted as a composer as well as a musician, Karl Friedrich Abel (1723–87) was probably best known during his lifetime as Europe's last virtuoso performer on the viola da gamba, ancient forerunner of the modern cello, noted for its softer, more textured sound. Abel was also Gainsborough's most intimate friend—"the man I loved from the moment I heard him touch the string," as the artist once said.[10] Numerous contemporary accounts attest to the profound effect that Abel's music had on Gainsborough, who studied under him and strove to emulate his emotive style of playing.

Gainsborough's portrait of Abel captures the qualities of intimacy and affection that characterized their friendship, but without sacrificing the dignity and stature demanded by the musician's professional eminence. The impressiveness of the painting owes much to the luxurious setting, with its tasseled velvet curtain and column, as well as the majestic size and full-length format of the canvas itself. Gainsborough employed a richer palette than usual, with vibrant shades of emerald, crimson, and sapphire in place of the subdued tertiary hues he generally favored. Abel's sober and rather old-fashioned brown wool suit gains additional glamour from the bravura splashes of gold darted about the figure—for example, in the shimmering satin vest, Brandenburg frogging, and galloon braid. Abel's commanding presence in this portrait reflects the formidable impression he made in actual life. A contemporary described him as "a tall, big, portly person, with a waistcoat under which might easily have been buttoned twin brothers."[11]

The richness, sobriety, and formality of Abel's presentation buttresses Gainsborough's portrayal of his friend as an intellectual composer rather than a virtuoso performer. He is shown seated at a writing table with his pen resting on the incomplete first bar of a new musical score, which it is possible to read as an *Allegro* movement. Cocking his head attentively to one side and casting his eyes upward with a keenly focused gaze, he seems to listen to music that exists for the moment only in his head. The lively, rather arch expression of Abel's face suggests something of the "allegro" character of the music he composes. The bright light illuminating his forehead has been likened to "the flash of inspiration."[12] For all its seriousness, the painting is not without humor, for the utter lethargy of the dog sleeping at Abel's feet provides a witty contrast to his master's mental alertness.

In 1777 Abel's portrait formed part of a superb array of pictures that Gainsborough exhibited at the Royal Academy of Arts, marking a watershed in his career. Several critics singled it out as the artist's finest contribution that year. One went so far as to call it "the finest modern portrait we remember to have seen."[13] Following Abel's death in 1787, Queen Charlotte acquired the portrait, and it thereafter passed through a number of important English collections, including that of George Francis Wyndham, 4th Earl of Egremont, Charles J. Wertheimer, and Lord Ronald Sutherland Gower. The painting first came to the United States in 1914, when Duveen Bros. sold it to the New York railroad owner George Jay Gould, who was acquiring an important collection of British paintings. Frequently exhibited, engraved, and copied, its price had multiplied by a factor of forty-six in a little over twenty-five years by the time Henry E. Huntington purchased it from Duveen in 1925.

RA

REFERENCES:
Michael I. Wilson, "Gainsborough, Bath and Music," *Apollo* 105 (February 1977): 107–10; Cormack, 120; Rosenthal, 1999, 90–93; Asleson, 92–100, no. 15.

10. John Hayes, ed., *The Letters of Thomas Gainsborough* (London, 2001), 164.
11. Henry Angelo, *Reminiscences*, 2 vols. (London, 1828), 1:184.
12. Cormack, 120.
13. "The Painter's Mirror," *Morning Post, and Daily Advertiser*, April 25, 1777, 4.

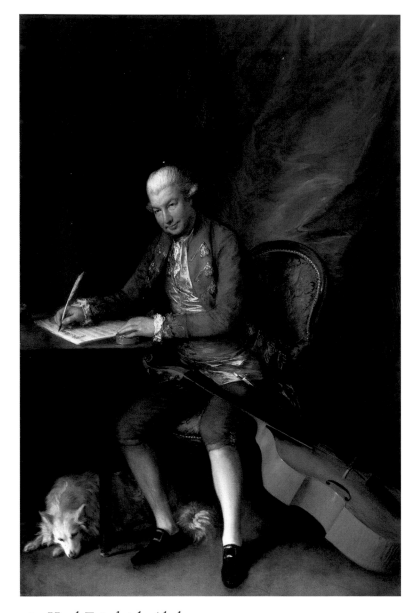

18 *Karl Friedrich Abel*, c. 1777

Oil on canvas, 88 ¾ x 59 ½ in.
The Huntington Library, Art Collections, and Botanical Gardens

19 *Cottage Door with Children and Woodcutter,* c. 1778

Oil on canvas, 48 ¼ x 58 ¾ in.
Cincinnati Art Museum. Gift in honor of Mr. and Mrs. Charles F. Williams by their children, 1948

REFERENCES:
Barrell, 70–72, 75, 76;
Hayes, 1982, 473–7, no.
121; Rosenthal, 1982,
58, 68; Asfour and
Williamson, 186–87.

19 Gainsborough's romanticization of the peaceful and pleasurable aspects of peasant life casts a golden glow over this cottage scene, one of several that the artist produced for his own enjoyment. Weary of the business of "face-painting," Gainsborough occasionally expressed a desire to "walk off to some sweet Village where I can paint Landskips and enjoy the fag End of Life in quietness and ease."[14] A friend who accompanied him on his rustic journeys recalled that the artist could be "severe and sarcastic, but when we have come near to cottages and village scenes, with groups of children, and objects of rural life that struck his fancy, I have observed his countenance to take on an expression of gentleness and complacency."[15]

Although Gainsborough began recording scenes of peasant families gathered outside their woodland cottages in the late 1760s, it was only after his 1774 move from Bath to London (where his distance from the countryside was greatest and the demands of his portrait practice most taxing) that he became deeply engaged in the theme as a vehicle for expressing the pleasurable sensations he associated with rural domesticity. Indeed, like other paintings of its kind, *Cottage Door with Children and Woodcutter* is entirely a studio production. It closely follows the design of a chalk-and-ink-wash drawing (H.R.H. The Duchess of Kent) in which Gainsborough fully anticipated such features as the lush, feathery textures of the foliage and thatched roof, as well as the skillfully designed figure composition.

In order to evoke the atmosphere of a sultry summer evening, Gainsborough very likely executed this painting by candlelight, a technique he developed in the 1760s. His fascination with strong contrasts of light and shadow inspired him, around 1781, to experiment with transparent paintings on glass plates,

lit from behind by candles. Analogous effects are seen here in the flickering lights that relieve the darkness of the foreground, and in the glowing sunset, depicted with thickly impasted strokes of yellow paint. The painting's rich palette, together with its dramatic effects of light and shade and the lush, vigorous handling of the foliage, all reflect Gainsborough's emulation of the Flemish painter Peter Paul Rubens.

A critic who admired *Cottage Door with Children and Woodcutter* at the Royal Academy exhibition in 1778 wrote wistfully, "We would forego the portion of pleasure we experience in viewing his portraits, for the ineffable delight we receive from his landscapes; and wish that he also would leave the one for the other."[16] The compliment was essentially rhetorical, for Gainsborough found scant patronage for his rustic landscapes and genre pictures. The present painting joined scores of others that lined the walls of his studio, remaining unsold at the time of his death. It was only in the late nineteenth century that such works began to rise in esteem. By the early twentieth century they ranked among the most highly desirable of Gainsborough's works and were avidly sought out by American collectors. *Cottage Door with Children and Woodcutter* was purchased in 1935 by Charles Finn Williams of Cincinnati, a founder of the Western and Southern Life Insurance Company. His children gave the painting to the Cincinnati Art Museum in 1948.

RA

EXHIBITED AT YALE ONLY.

14. Thomas Gainsborough to William Jackson, undated letter, quoted in Hayes, 2001, 68.
15. Uvedale Price, *Essays on the Picturesque*, 2 vols. (London, 1810), 2:368.
16. *General Advertiser*, April 30, 1778, quoted in Hayes, 1982, 475.

Richard Wilson

?1713–82

Landscape painter in the classical, Italianate tradition. Wilson began his artistic career as a portraitist; he devoted himself to landscape painting following a 1750–57 sojourn in Italy. He modeled his style on seventeenth-century Dutch and Franco-Italian landscape, a mode of art that held particular appeal for British connoisseurs. The literary, historical, and philosophical nuances of Wilson's paintings were especially gratifying to his well-educated and well-traveled patrons. His ambitious approach to the representation of natural scenery led the way in establishing landscape painting as an independent art form in Britain. In addition, Wilson's sensitivity to changing effects of light and atmosphere anticipated the naturalistic tendencies that would fully blossom in the works of John Constable. Wilson was a founding member of the Royal Academy in 1768, but demand for his work had declined by 1770. Alcoholism and dissipated habits caused him to squander his talents, and he produced little in the last decade of his life. Following his death in 1782, Wilson's imitators and pupils disseminated his style more widely, and his reputation steadily rose, along with the prices of his paintings. His status as a British "Old Master" was cemented by the retrospective exhibition of his work held at the British Institution in 1814.

20 During the seven years that Wilson lived in Rome, he filled countless sketchbooks with drawings of the Campagna and immersed himself in the classical tradition. On returning to England, he continued to produce landscapes of Italianate subject matter, in which he emulated the balanced compositions of the seventeenth-century Franco-Italian painters Claude Lorrain and Gaspard Dughet. *The White Monk* illustrates the satisfying sense of order that characterizes Wilson's paintings. Eye-catching motifs lead the eye through successive planes of receding space, mapping out a logical and well-paced recession into depth. From the immediate foreground, where the figures beneath the umbrella initially attract our notice, the eye moves on to the chapel on the precipice, which stands out starkly against the pale sky. From there our glance moves across the expansive plane to the castellated mountain in the distance. Linking devices, such as the branch propped against the boulder and the man on horseback, enhance the unity of the composition by visually connecting one plane with the next. The diversity of the figures themselves—the lovers under the umbrella, the slumped and solitary horseman, and the monks at their devotions in the distance—all add to the variety and interest of the scene.

Wilson often repeated his most popular landscape compositions, describing such designs as "good breeders."[1] The existence of more than twenty variations of this particular composition indicates that it must have been one of his best sellers. All of the versions appear to have been executed in England after the painter's return from Italy in 1757. Most of them were probably painted after 1765, when an engraving by James Roberts was published in *Views of Italy*. Because Wilson rarely dated his work, it is difficult to place the various versions of the composition chronologically, but stylistically the present picture seems to be among the earliest, and it is also among the most highly finished. Whereas most of the other versions depict a crucifix on the promontory in the

1. Thomas Wright, *Some Account of the Life of Richard Wilson, Esq., RA* (London, 1824), 33.

20 *The White Monk,* early 1760s

Oil on canvas, 26 x 31½ in.
Toledo Museum of Art. Purchased with funds from the Libbey Endowment,
Gift of Edward Drummond Libbey, 1958

left middle distance, Wilson here substitutes a gabled chapel. The setting of the painting is sometimes identified as Tivoli, but it is impossible to locate the scene with certainty, and it probably represents an imaginary or composite view. The evocative title *The White Monk* is a nineteenth-century invention, and Wilson's original title is unknown.

The early history of the painting is obscure, but in the nineteenth century it entered the collection of the 1st Viscount Leverhulme, a Liverpool industrialist who made his fortune in soap. It thereafter entered the Lady Lever Art Gallery, a public museum founded by Leverhulme. When the gallery deaccessioned the painting in 1958, it was purchased through Agnew & Sons by the Toledo Museum of Art.

RA

REFERENCES:
W. G. Constable, *Richard Wilson* (London, 1953), 227–30; David H. Solkin, *Richard Wilson: The Landscape of Reaction*, exh. cat. (Tate Gallery, London, 1982), 66–73, no. 103.

George Stubbs

1724–1806

The greatest painter working in the tradition of British sporting and animal art. He was born in Liverpool and spent his early career largely painting portraits in the north of England. In 1756 his growing interest in animal painting and scientific illustration led him to spend sixteen months making dissections and anatomical drawings of horses, the basis for his book The Anatomy of the Horse *(published in 1766). He worked in London from 1758 and in the early 1760s established a reputation as a painter of both horses and wild animals, attracting important patrons, including the Marquess of Rockingham. He painted portraits of successful racehorses for their owners, hunting and shooting subjects, and dramatic scenes of horses being attacked by lions. In these last, he attempted to forge a type of animal painting that possessed the high seriousness of myth and allegory. He pursued various experiments in painting technique and from about 1775 worked closely with the master potter Josiah Wedgwood to develop ceramic tablets on which to paint in enamel.*

21 Foaled in 1754, Lustre was a racehorse owned successively by the 3rd Duke of Ancaster and Frederick St. John, 2nd Viscount Bolingbroke, for whom he raced successfully in 1760–61. Known to his friends as "Bully," Bolingbroke was a famous figure in the world of racing, both as an owner and as a gambler. He was one of George Stubbs's most important early patrons, commissioning him to paint Lustre and at least seven other racehorse portraits. Another of them, *Turf, with Jockey Up, at Newmarket*, is also at the Yale Center for British Art.

The eighteenth century was a golden age for British horseracing and the painting of prized horses for their owners was already a well established practice in British art. To compare Stubbs's first works in this genre to that of his predecessors, chiefly John Wootton and James Seymour, is to see a stiff and prosaic tradition brought to life by a brilliant newcomer. The description he gives of a horse's stance and musculature is so clearly informed by anatomical knowledge—the sense of a skeleton, blood vessels, and a whole internal system not just observed but understood. This goes together with an impeccable feeling for design: the profile view was standard in portraits of horses, but in Stubbs's hands it takes on the order and refinement of classical relief sculpture. He was an accomplished portraitist of both equine and human subjects and, in a work such as *Lustre*, imparts to horse and groom a remarkable sense of character and communication.

Paul Mellon bought *Lustre* at a Sotheby's auction in 1970. The subject of a beautiful horse tended by a boy in an idyllic, green, English landscape went to the heart of his nostalgic Anglophilia; indeed his first painting purchase, long before he began his great British collection, had been Stubbs's *Pumpkin with a Stable-Lad* (also Yale Center for British Art). His passion for Britain and British art was intimately bound up with his passion for sport: from boyhood he was an accomplished horseman; from his student days a devotee of foxhunting and horseracing; and in later life a prominent owner-breeder of racehorses, including the great Mill Reef. Stubbs was his favorite British artist, and the Paul Mellon Collection at the Yale Center for British Art contains twenty-seven Stubbs paintings, as well as numerous drawings and prints.

21 *Lustre, Held by a Groom*, c. 1760–62

Oil on canvas, 40 ⅛ x 50 in.
Yale Center for British Art, Paul Mellon Collection

REFERENCES:

Judy Egerton, *Sport in Art and Books. The Paul Mellon Collection: British Sporting and Animal Paintings, 1655–1867* (Tate Gallery, London, for the Yale Center for British Art, 1978), 68, no. 68; Judy Egerton, *George Stubbs, 1724–1806*, exh. cat. (Tate Gallery, London, and Yale Center for British Art, New Haven, 1984), 68, no. 40; *George Stubbs in the Collection of Paul Mellon: A Memorial Exhibition*, exh. cat. (Yale Center for British Art, New Haven, 1999), 22, no. 5; John Baskett and Malcolm Warner, *The Paul Mellon Bequest: Treasures of a Lifetime*, exh. cat. (Yale Center for British Art, New Haven, 2001), 79.

Paul Mellon responded to Stubbs's horses not just as individual animals, but as archetypes of nature. As he once wrote, "I think he saw in the horse, in his alertness and muscularity, a way of representing life itself in all its movement, form, vitality, colour, strife, and mystery. His horses are alive and beautiful because they were in his soul; he saw them as symbols of many life forces rather than as mere conveyances, necessities, implements. Just as his paintings of lions, tigers, zebras, cheetahs and other wild animals glow with vibrant power, so his horses give off an aura of grace, transforming the perils of energy and wildness into a controlled sense of tense expectation."[1]

MW

22 The *Zebra* is possibly the first, and arguably the most beautiful, of the documentary studies of exotic species that Stubbs painted alongside his better known sporting pictures and fantastic scenes of horses attacked by lions. Typically, he brought to the subject the detailed anatomical knowledge he had gained through his dissections of horses, as well as habits of painstaking inquiry, observation, and drawing from nature. The result is an image of objectivity and precision, recording special characteristics of the animal, such as the particular backward lean of the ears, the dewlap on the underside of the neck, and the "gridiron" pattern of stripes on the back immediately above the tail. By comparison, the efforts of contemporary engravers to represent the zebra appear absurdly crude and conventional, showing merely a horse or donkey with stripes added.

This was the first zebra to be seen in Britain. From Stubbs's painting it can be identified as a Cape Mountain zebra, the smallest of the three distinct zebra types. It was brought from the Cape of Good Hope (South Africa) by Sir Thomas Adams, captain of HMS Terpsichore, for presentation to Queen Charlotte, who was a keen collector of unusual animals. In Noah's-ark fashion, Adams took on board a male and a female, but only this, the female, survived the voyage, arriving in Britain in the summer of 1762. The "painted African ass" (as it was sometimes called) was installed at Buckingham House, the royal residence recently bought by the queen and her husband George III, and became the object of much public interest. "This animal," the *London Magazine* of July 31, 1762, reported, "from her majesty's good natured indulgence, has been seen by numbers of people, and is now feeding in a paddock near her majesty's house." As a biographer of the queen later noted: "The Queen's she-ass . . . was pestered with visits, and had all her hours employed from morning to night in satisfying the curiosity of the public. She had a centinel and guard placed at the door of her stable . . . The crowds that resorted to the Asinine palace were exceeding great."[2] The zebra was the talk of the town, even the subject of a bawdy song entitled "The Queen's Ass." Later it was joined at Buckingham House by an elephant, and eventually it was moved to the menagerie at the Tower of London. It died on April 3, 1773, after which its skin was preserved, stuffed, and displayed with other animal curiosities in a touring exhibition.

By portraying the royal zebra against an obviously British rather than African landscape, presumably representing the park at Buckingham House, Stubbs underlines the idea of the scene as directly observed rather than imagined. Here is the animal just as it appeared to him and the rest of its British audience—incongruous almost to a comic degree, with its stripes acting as the opposite of camouflage. Surprisingly, he

1 Paul Mellon, Foreword to John Baskett, *The Horse In Art* (Boston, 1980), 7.
2. MacClintock, 4.

22 *Zebra*, 1762–63

Oil on canvas, 40 ½ x 50 ¼ in.
Yale Center for British Art, Paul Mellon Collection

REFERENCES:
Egerton, 1978, 74–5, no. 74; Egerton, 1984, 112, no. 77; Dorcas MacClintock, "Queen Charlotte's Zebra," Discovery 23, no. 1 (1992): 3–9; Malcolm Warner and Julia Marciari Alexander, with an introduction by Patrick McCaughey, This Other Eden: Paintings from the Yale Center for British Art (New Haven, 1998), 114–15, no. 42; George Stubbs in the Collection of Paul Mellon, 38–39, no. 19.

3. Paul Mellon, with John Baskett, Reflections in a Silver Spoon: A Memoir (New York, 1992), 281.

seems to have painted the work without a commission, whether from Queen Charlotte, George III, or any other interested party; he showed it at the Society of Artists exhibition in 1763, after which it remained in his possession throughout his life, appearing in his studio sale in 1807. Perhaps he always intended to keep the work with him, to serve as a kind of advertisement, recognizing such an entirely foreign, "virgin" subject as the ideal showpiece for his abilities as a naturalist-painter.

In the middle years of the twentieth century, the Zebra was for a time in a Connecticut collection, that of M. A. Hall. By 1960 it belonged to a British army officer, Colonel J. B. Donnelly: in October that year it appeared in an auction of his property, including furniture and household articles, at Harrod's in London. Paul Mellon heard about this unlikely source of a great Stubbs from his London adviser Basil Taylor. "We thought, 'Ah, a probable bargain,'" Mellon recalled in his autobiography, "but alas, others thought the same, and it wound up costing me twenty thousand pounds."[3] Mellon presented the work to the Yale Center for British Art, returning it to Connecticut, in 1981.

MW

REFERENCES:
Egerton, 1984, 116, no. 80; Richard Dorment, British Painting in the Philadelphia Museum of Art: From the Seventeenth through the Nineteenth Century (Philadelphia Museum of Art, 1986), 382–84, no. 107.

4. Dorment, 382.

23 Hound Coursing a Stag relates closely to a much larger composition painted by Stubbs in 1762, The Grosvenor Hunt (collection of the Duke of Westminster). The earlier canvas was commissioned by Lord Grosvenor and shows him and some companions hunting on his estate at Eaton Hall: they have pursued a stag to the edge of the River Dee and are watching from horseback as the staghounds splash through the water toward their prey, closing in for the kill. Though on land rather than in water, the stag in the present painting appears in exactly the same defensive position as the one in The Grosvenor Hunt, and the shape of its antlers is identical, suggesting that the artist may have used the same study for both works. The Philadelphia painting was probably executed shortly after The Grosvenor Hunt as a smaller-scale, more focused reworking of its central drama, the violent encounter of hound and stag. Here the audience of sporting gentlemen is unseen, and the stag is prey to a single greyhound.

The stag and hound seem almost to fuse together as a single element in the design; their forms rhyme with those of the landscape yet stand out more insistently, like the most deeply carved part of a relief sculpture. The translation of the classical relief form into painting, infusing it with color and life, was a leading idea of Stubbs's career as an artist and indeed of the burgeoning Neoclassical movement in European art at this time. As Richard Dorment has pointed out, Stubbs probably exhibited the Hound Coursing a Stag for the first time at the Society of Artists in London in 1763, where it was paired with one of his paintings of a lion attacking a horse (see no. 24).[4] Together they would have suggested variations on the theme of hunting, and perhaps the idea of sport as the civilized counterpart to violence in the wild.

The painting belonged to the 4th Viscount Midleton of Peper Harrow, Surrey, and may have been bought or commissioned from Stubbs by his father, the 3rd Viscount, who died in 1765. It passed by family descent to the 2nd Earl of Midleton, who sold it in 1945. It appeared in an auction at Parke-Bernet in New York in 1950 and has remained in American collections ever since.

MW

EXHIBITED AT YALE ONLY.

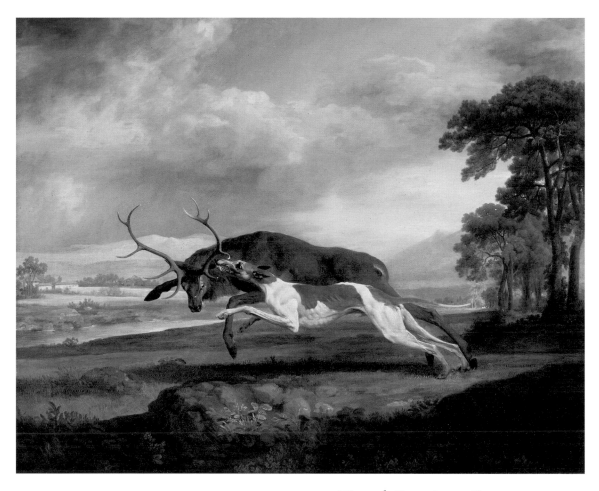

23 *Hound Coursing a Stag,* c. 1762–63

Oil on canvas, 39 ⅜ x 49 ½ in.
Philadelphia Museum of Art. Purchased with the W. P. Wilstach Fund, the John D. McIlhenny Fund,
and gifts (by exchange) of Samuel S. White 3rd and Vera White, Mrs. R. Barclay Scull,
and Edna M. Welsh, 1984

REFERENCES:
Robert R. Wark, "A
Horse and Lion Painting
by George Stubbs,"
*Bulletin of the Associates in
Fine Arts in Yale University*
22, no. 1 (1955): 1–6;
Basil Taylor, "George
Stubbs. The 'Lion and
Horse' Theme,"
Burlington Magazine 107
(February 1965): 86;
Egerton, 1984, 99,
no. 77.

24 From the early 1760s to the 1790s, Stubbs returned again and again to the theme of horses attacked by lions. In his hands the encounter takes on the elemental drama of a scene from myth, suggesting the struggle of good against evil, beauty against ugliness, civilization against savagery. The simple, relief-like design of the animal group brings this out in oppositions of form and tone: placed directly above the graceful hind leg of the white horse, for instance, the lion's leg reads like a dark, demonic mockery. Stubbs's essays in this imaginary, awe-inspiring (or "sublime") subject, far removed from the commissioned racehorse portrait, were central to his attempt to show that animal painting could rise to the seriousness and universality of high art. In some respects Stubbs's achievements in animal painting parallel those of Joshua Reynolds in portraiture and Richard Wilson in landscape, raising what was traditionally a "low" branch of painting to higher levels. Most of his horse-and-lion subjects show the same moment of attack as the present painting, others an earlier moment in the lion's stalking of its prey. In all, Stubbs treated the theme in seventeen known works, including paintings in oil and enamel, two engravings, and the model for a Wedgwood relief panel.

In his scenes of the lion's attack, Stubbs was offering a modern interpretation of the well-known classical sculpture of the same subject in the Palazzo dei Conservatori in Rome. Like the famous *Laocoön* group of struggling figures, to which it is in a sense an animal equivalent, this had been much admired since the Renaissance for its expressive power. Stubbs could have seen the work at first hand on a visit he made to Rome in 1754, or in any of numerous copies and reproductive engravings. In the present painting he introduces a greater sense of order and control to the design, despite the violence of the event, than exists in his classical source. The animal group appears flatter, almost like an emblem—typically, Stubbs tends toward the effect of relief work rather than sculpture in the round—and carefully unified as a composition of circular and oval lines. At the same time, he brings to the scene touches of modern, scientific naturalism: the painting of the horse is a kind of anatomy demonstration, designed to show how the equine body and face might contort if subjected to extremes of pain and fear. Stubbs's studies in the anatomy of the horse were the cornerstone of his career as an animal painter. For the lions in all the horse-and-lion works, he is said to have used drawings he made in Lord Shelburne's private menagerie at Hounslow Heath.[5]

Stubbs painted the present work as one of a pair: its companion piece (Walker Art Gallery, Liverpool) shows presumably the same white horse rearing back on seeing the lion emerge menacingly from the shadows. In this earlier episode the sky is largely clear; as the lion consummates the hunt, storm clouds thicken and darkness descends like a pall. The setting looms larger in the Yale painting than in the other horse-and-lion images: the horse's violent death appears as part of the wildness of nature as a whole. Stubbs based the landscape on the steep limestone formations at Creswell Crags in the English Midlands. The caves at Creswell Crags contained the remains of prehistoric animals, along with tools and weapons that were among the oldest signs of human life in Britain. With its primeval and savage associations, the place clearly appealed to Stubbs's imagination and features in a number of his paintings.

Horse Attacked by a Lion was bought from Percy Moore Turner by the Associates in Fine Arts at Yale University and presented by them to the Yale University Art Gallery in 1955.

MW

5. For discussions of the origins of Stubbs's horse-and-lion works, see Basil Taylor, "George Stubbs. The 'Lion and Horse' Theme," *Burlington Magazine* 107 (February 1965): 81–86, and Egerton, 1984, 90–99.

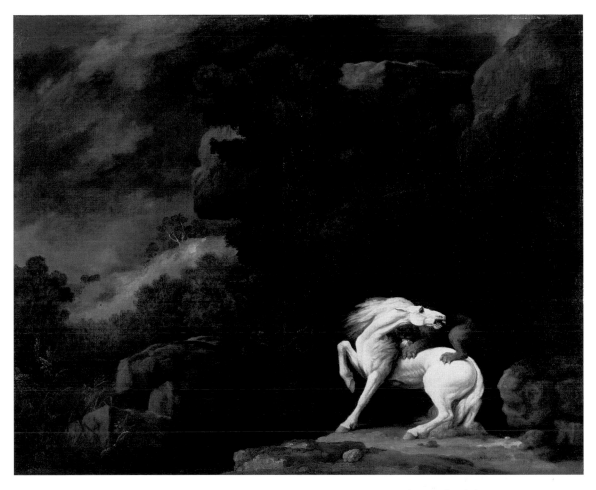

24 *Horse Attacked by a Lion*, 1770

Oil on canvas, 40 ⅛ x 50 ¼ in.
Yale University Art Gallery, Gift of the Art Gallery Associates

Johann Zoffany

1733–1810

German-born and trained, Zoffany was arguably the greatest painter of the conversation piece in eighteenth-century Britain. He began his career as a painter and engraver in Regensburg, Germany, but during the 1750s he absorbed the tenets and forms of Ancient and Renaissance art on travels in Italy. By 1760 he had left the Continent for England, where he was to make his name in the burgeoning genre of the conversation piece. In 1762 he made the acquaintance of David Garrick, the most famous actor in eighteenth-century England, who commissioned a number of portraits recording his various roles, his stage productions, and his property along the River Thames. Through Garrick's patronage Zoffany established his reputation and became one of the most sought-after artists of his day. Perhaps because of his nationality, in addition to his painterly abilities, he soon became a favorite artist of Queen Charlotte, also a German. In 1771 he painted what may be his most famous image, the group portrait of the members of the newly-founded Royal Academy (Royal Collection). At the queen's behest he left England for Italy in 1772, but not all the pictures he sent back pleased her; when he returned seven years later, he found his work largely out of favor. In 1783 he moved to India, hoping to find a steady clientele among the every-growing British community there; he returned to England a wealthy man in 1789.

25 This engaging conversation piece depicts the family of John Peyto-Verney, who acceded to his title of Baron Willoughby de Broke in 1752. The Barons Willoughby de Broke (pronounced "brook") had been granted their titles in the late fifteenth century and, by the eighteenth, had become one of the richest and most powerful families in England. In 1761 Lord Willoughby de Broke married Lady Louisa North, daughter of the Earl of Guilford, allying two of the most prominent families of the age. Lady Louisa's brother, Frederick, Lord North, was a leader of the Tory party; he held the posts of England's first Lord Treasurer, Chancellor of the Exchequer, and later Prime Minister. Lord Willoughby de Broke was active at court, where he held the post of Lord of the Bedchamber to King George III throughout his life.

Though apparently an informal scene, Zoffany's portrait acts as a record of the productive union of two aristocratic and political dynasties. Nearly all displayed in the same plane as if in a sculptural frieze, the figures interact with one another according to their prescribed family stations. Lord Willoughby de Broke stands at the apex of his familial pyramid, his head framed—almost in profile—against the plain wall behind him. As father, he gently but firmly chides his younger son George (born 1763), who naughtily swipes a piece of bread from the tea-table; his heir and namesake John (born 1762), as if playing at managing an estate, drags a toy horse behind him. Neither boy has yet been breeched, and each wears the characteristic dress of a toddler. The little girl, probably Louisa (born 1765), is clearly differentiated from her brothers by her pink sash and frilly bonnet; her physical proximity to her mother and position on top of the table places her firmly within the woman's domestic sphere. Lighthearted and instructive, the

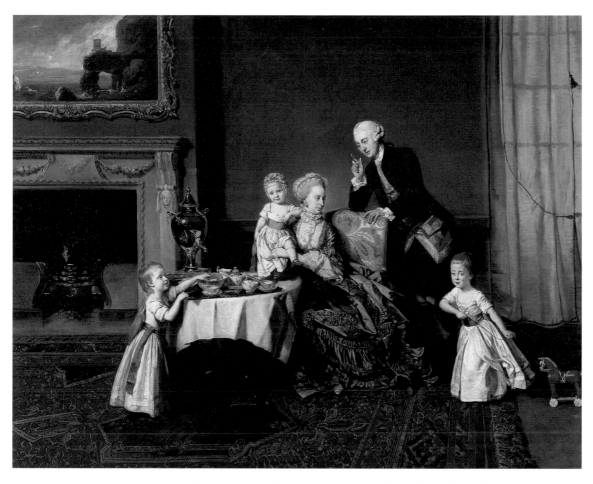

25 *The Family of John, 14th Lord Willoughby de Broke, 1766*

Oil on canvas, 39 ¼ in. x 49 ¼ in.
J. Paul Getty Museum, Los Angeles

REFERENCE:
Mary Webster, *Johan Zoffany, 1733–1810*, exh. cat. (National Portrait Gallery, London, 1976), 40, no. 35.

scene shows the various ways in which the aristocratic family functioned; the parents, according to Enlightenment beliefs, play and interact with their children but do not fail to instruct them in the proper codes and behavior of polite society. Only the girl breaks decorum, but her exuberant, childlike gesture actually serves to reiterate the social standing of the sitters: while the middle classes rigidly complied with codes of decorous physical conduct in their portraits, the ruling classes in England were privileged to diverge from such modes of behavior when they saw fit.

Whereas many conversation pieces depicted sitters in fictional locales that merely evoked specific places (see no. 33), here the family is seen in a recognizable setting: the breakfast room at their family seat, Compton Verney. In 1440 Henry VI had granted the lands and manor of Compton Murdak to Lord Willoughby de Broke's ancestor John Verney, dean of Lichfield, and successive generations had engaged in substantive renovations, additions, and expansions to the manor house and surrounding property. In 1762 Lord Willoughby de Broke commissioned Robert Adam, the most fashionable neoclassical architect of his day, to alter the house and the renowned landscape architect Lancelot "Capability" Brown to renovate the parkland and garden. By 1765 these projects were finished. Here the artist subtly refers to them by showing the shadows of the mullions of Adam's impressive arched windows through the curtains, which are drawn to prevent the morning light from streaming into the room. Writing of Compton Verney, the 19th Lord Willoughby de Broke described these apartments as having "an enviable southern aspect over the lawn, lake and woodland, while their sunlit walls used to afford a resting place to the [family portraits]."[1] The blank wall above the family may well be the spot this very portrait soon would occupy.

Overall, the portrait displays Lord Willoughby de Broke's fashionable but not showy taste as well as Zoffany's technical prowess: he paints the reflection of the room in the surface of the highly-polished silver urn and renders the silks, taffetas, and lace of Lady Louisa's dress in exquisite detail.

Zoffany's painting was recognized by Horace Walpole as a portrait of the Willoughby de Broke family when it was exhibited at the Society of Artists in 1769. It remained in the family collection until 1996, when the Getty Museum acquired it from the dealer Agnew's. As one of the newest acquisitions in the Getty's growing collection of British paintings, Zoffany's portrait is a spectacular example of the genre and a celebration of the privileged and leisured life of the landed aristocracy in Georgian England.

JMA

EXHIBITED AT THE HUNTINGTON ONLY.

1. Richard Greville Verney, *The Passing Years* (London, 1924), 6.

Benjamin West

🕭 1738–1820

History painter and portraitist, West was a seminal figure in the development of Neoclassicism and Romanticism in Britain. Born in rural Pennsylvania, he studied briefly in America and later in Rome (1760–63). He settled in England at the age of twenty-five and swiftly established a high reputation as a history painter. In 1771 West's sensational Death of General Wolfe *(National Gallery of Canada, Ottawa) established a new genre, the contemporary history painting. The following year he was appointed history painter to George III. Although West produced numerous portraits during his career, royal patronage enabled him to concentrate on subjects drawn from mythology, religion, literature, and history—one of the few artists in Britain to enjoy such opportunities. He succeeded Sir Joshua Reynolds as president of London's Royal Academy of Arts in 1792 and continued in that office, with a brief interruption, until his death in 1820. Although he never returned to America, his London studio effectively became a "school" for American painters who crossed the Atlantic in order to study the practical techniques and grand-manner conventions of British painting.*

26 Probably West's most beautiful painting, *Venus Lamenting the Death of Adonis* shows a milder aspect of his neoclassical manner than the scenes of pious fervor and impassioned action for which he is best known. The painting concerns the myth of Venus, goddess of love, who was pricked by the fatal arrow of her son Cupid and fell in love with Adonis, a mortal youth of remarkable beauty. In her absence Adonis went hunting and was gored by a wild boar. West represents Venus returning with Cupid in her chariot of swans to find her lover lying dead beside a pool of blood. The billowing clouds that descend from the upper left corner and sweep across the picture to the swans at far right suggest Venus's rapid descent from the heavens upon hearing the groans of her earthly lover. To the right of Adonis, West shows the red anemones that Venus created by mixing his blood with nectar.

West's interest in the subject was probably sparked in Florence, where he had copied a seventeenth-century Italian picture of the theme, then attributed to Annibale Caracci (Galleria Corsini, Florence). Soon after arriving in England, West executed a small version of *Venus Lamenting the Death of Adonis* in which the far more expansive landscape dilutes the impact of the central scene (private collection). In his final version West emulated his original Italian model by focusing more tightly on the figures, uniting Venus, Adonis, and Cupid in a continuous circle formed by their curving bodies. The juxtaposition of the three heads—Adonis in three-quarter view, Cupid full-face, and Venus in profile—charts a progression from death, through grief, to stoic resignation. Small but touching details, such as the crossing of Venus's and Adonis's hands, add to the pathos of the scene. West's study of ancient Greek and Roman relief sculpture is evident in the marmoreal pallor and precise outlines of the figures. Only the weeping figure of Cupid threatens to tip the picture into bathetic sentimentality. Otherwise, it is remarkable for its atmosphere of cool, austere neoclassical restraint.

West completed *Venus Lamenting the Death of Adonis* in 1768, as indicated by the inscribed date at lower right, and exhibited it at the Royal Academy the

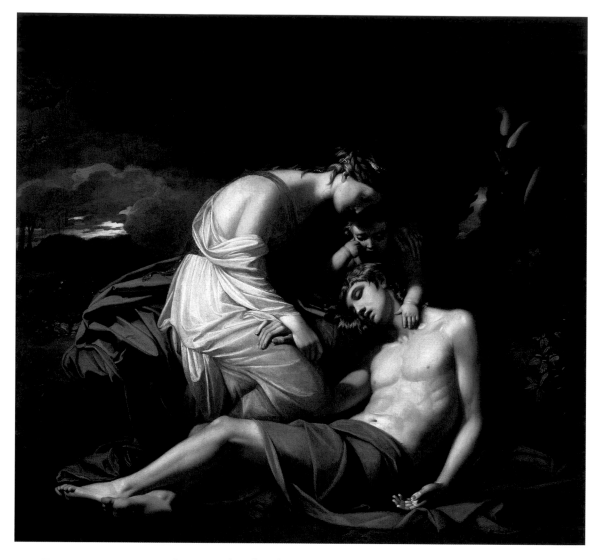

26 *Venus Lamenting the Death of Adonis*, 1768–1819

Oil on canvas, 62 x 68 in.
Carnegie Museum of Art, Pittsburgh. Purchase, 1911

following year. He had possibly carried out the painting for Sir William Young, Bart., who certainly owned it by 1771. The picture may have been intended to form a pair with West's group portrait of 1767 showing Young with his wife and infant in a neoclassical setting, dressed in antique drapery (private collection). The man, woman, and child united by death and grief in the present painting would have provided a bittersweet contrast to the group united by affection in West's portrait of the previous year.

Fifty years after it was first exhibited, *Venus Lamenting the Death of Adonis* was offered for sale at auction on March 23, 1819. Having passed through a number of collections, the painting was then in a dilapidated state and missing its frame. West was concerned by its poor appearance at the sale and began to repaint it in the last months of his life. He evidently cut several inches off both sides of the canvas, possibly in order to remove damaged areas. Although the painting is now almost square, Matthew Liart's engraving, published on December 13, 1771, shows a wider format. Heavily overpainted passages may also represent areas of damage that West addressed in 1819. The composition itself remains essentially unchanged, however.

After completing his work, West added the inscription *Retouched 1819* at lower left. Either then or at an earlier date, the painting acquired a third inscribed date of 1772. It seems unlikely that West simply forgot when the picture was painted, for in April 1819 he sought and received confirmation of its appearance in the 1769 Royal Academy exhibition. Moreover, the date printed on Liart's engraving would have indicated that the painting certainly predated 1771. It is possible that West reworked the picture in 1772 as well as in 1819, and that the perfected beauty that we now see reflects three campaigns of work over the course of half a century.

RA

REFERENCES:
Kathryn Cave, ed., *The Diary of Joseph Farington*, 16 vols. (New Haven and London, 1978–1984), 15:5346; Helmut von Erffa and Allen Staley, *The Paintings of Benjamin West* (New Haven and London, 1986), 44, no. 116.

Joseph Wright, known as Wright of Derby

1734–1797

Painter known equally for his landscapes, portraits, and subject pictures. Among the most brilliant and idiosyncratic artists of the eighteenth century, Wright displays in his art his commitment to the tenets of Enlightenment thought, at both the philosophical and scientific levels. His paintings often explore the subject of light and broadly fit into the tradition of tenebrist painting as it had been developed by seventeenth-century painters in Italy and the Netherlands; he is sometimes described as the "English Caravaggio" or, more often, the "English Rembrandt." His two-year sojourn in Rome in the early 1770s exposed him to the work of the Ancients as well as the Old Masters and cemented his predilection for classical subjects. Although he did work in London and Bath irregularly over the course of his career, he mainly lived and practiced in his native Derby, where he was an active member of the local intelligentsia; several of his friends and colleagues would become recognized leaders of the Scientific and Industrial Revolutions. He consistently maintained an artistic reputation in London and was elected an Associate of the Royal Academy in 1781; quarrels with members of that institution, however, denied him elevation to full RA status. Largely forgotten by later generations of artists—perhaps because of his provincial practice or his highly individual style—he and his work were not given their due critical recognition until the mid-twentieth century. Since then he has rightly come to be regarded as one of the most important painters of his time.

27 Between 1771 and 1773 Wright painted a number of variations on the theme of the blacksmith's shop and the related subject of iron forges. Among these, this painting most closely adheres to an idea that he recorded in one of his account books:

> *Two Men forming a Bar of Iron into a horse shoe— from whence the light must proceed. An Idle fellow may stand by the Anvil, in a time-killing posture . . . Horse Shoes hanging upon Ye walls, and other necessary things, faintly seen being remote from the light— Out of this Room, shall be seen another, in Wch a farier may be shoeing a horse by the light of a Candle. The horse must be Sadled and a Traveler standing by . . . This will be an indication of an Accident having happen'd, & shew some reason for shoeing the horse by Candle Light—The Moon may appear and illumine some part of the horse if necessary.*[1]

Although Wright clearly felt the need to provide plausible reasons behind the events depicted in his canvas, his composition is much more than a mere pictorial description of "an Accident having happen'd." Indeed, this is a composition redolent with allusions to religion and man's spirituality. By including men of all ages in the composition, he creates a modern-day treatment of the time-hallowed theme of the Ages of Man. Each of the two boys around the anvil is at a different stage of awareness of his future: the younger one shields his eyes while the elder watches with interest. The three smiths, in their prime, are easy and confident masters of their profession. By contrast, the older man in the corner sits idle, pensively clutching his stick. No longer an active participant, he can only engage in a "time-killing posture." Like the figures Wright's setting is a potent vehicle of meaning. Dilapidated and disused, the building in which the smiths work must have had a former life as a grand,

27 *The Blacksmith's Shop,* 1771

Oil on canvas, 50½ x 42 in.
Yale Center for British Art, Paul Mellon Collection

REFERENCES:
Benedict Nicolson,
*Joseph Wright of Derby:
Painter of Light*, 2 vols.
(London, 1968), 1:237,
no. 199; Judy Egerton,
Wright of Derby, exh. cat.
(Tate Gallery, London,
1990), 99–100, no. 47;
Malcolm Warner and
Julia Marciari Alex-
ander, with an intro-
duction by Patrick
McCaughey, *This Other
Eden: Paintings from the
Yale Center for British Art*
(New Haven, 1998),
80–81, no. 27.

possibly religious edifice, a fact hinted at by the angel carved in the spandrel of the arched doorway, the fluted pilasters, and the stone floors. It was not uncommon to find such structures—often once prosperous but now abandoned monasteries—adapted and used by local inhabitants.

Such a conflation of the everyday aspects of English daily life with allusions to headier notions of religion and man's place in the universe is the stuff of Wright's work. In this painting he creates a vision of workaday labor that calls to mind images of the Adoration of Christ, the glowing Christ Child replaced by the hot iron that the men themselves transform. These are modern-day heroes who honor their age-old profession through their commitment and skill, doing so with little pomp and no circumstance.

By the time of its first exhibition at the Society of Artists in 1771, *The Blacksmith's Shop* had already been sold; it had caught the eye of Lord Melbourne, who bought the painting for £150 while it was still "on the easel." It remained in Melbourne's family until it was acquired by Sir George Buckston Browne F. R. C. S., who presented it to the British Association for the Advancement of Science in 1929. Later it passed into the collection of the Royal College of Surgeons, from which Paul Mellon purchased it in 1964, later presenting it to the Yale Center for British Art. One of the first twentieth-century connoisseurs and collectors to recognize the extent and breadth of Wright's achievements, Mellon funded the first monograph on this artist's work, under the auspices of The Paul Mellon Foundation for British Art. *The Blacksmith's Shop* is included here not only for its inherent artistic merit, but also as a tribute to the eye and understanding of its last private owner.

JMA

1. Quoted in Egerton,
1990, 98.

28 Wright looked to the literary world of fables for the subject of this picture, painted shortly before he left England for Italy in 1773. An old woodsman, weary from his lifelong task of gathering and bundling faggots, has fallen to the ground and asked Death to end his suffering. Summoned, Death appears in the form of a skeleton, wielding over his shoulder the instrument of the man's destruction. Because Death is not imposing himself but responding to the man's wishes, he holds the arrowhead away from the man, giving him the choice to continue his life. Startled and frightened to find his wish come true before his very eyes, the man experiences a change of heart and wards off his demise, instead asking only for help in hoisting his bundle. The moral of the story—which Wright most likely took from a modern edition of Aesop's Fables or a recent English translation of Jean de la Fontaine's version of the same tale—is that it is "better to suffer than to die."

This is one of Wright's first forays into a subject picture set in an elaborate landscape. Previously several of his portraits had displayed his ability as a landscape painter, for instance his brilliant portrait of *Mr. and Mrs. Coltman* of 1771 (National Gallery, London). But the land around the portrait sitters had not been as integral to the subject of the composition nor as fully developed in itself as in this image. Here, by placing the figures in the foreground, he is able to use the sprawling landscape that surrounds them to convey meaning. The foliage and architecture in the middle ground echo the action in the foreground: the man is soon to become dilapidated like the building in ruins above him; the skeleton, the embodiment of Death, is also mirrored in the landscape as a dead tree, to which he is connected visually by the point of his arrow. Indeed, Death seems to be an organic form that rises out of the ground on which he stands.

28 *The Old Man and Death*, 1773

Oil on canvas, 40 x 60 in.
The Wadsworth Atheneum Museum of Art, Hartford, Connecticut.
The Ella Gallup Sumner and Mary Catlin Sumner Collection Fund

REFERENCES:
Nicolson, 1:243, no. 220;
Egerton, 1990, 83–84,
no. 38; "The Spirit of
Genius": Art at the
Wadsworth Atheneum, ed.
Linda Ayres, with intro-
ductory essays by
Eugene R. Gaddis and
Patrick McCaughey,
commentaries by Jean
Cadogan, et al. (New
York, 1992), 68.

Wright's detailed attention to the landscape attests to his desire to create pictures rooted in a real—or at least ostensibly accurate—depiction of nature. His sources were not only the sights and topography of Derbyshire (see also no. 27) but also the most up-to-date scientific descriptions of the human skeletal structure. For this picture he looked to Bernhard Siegfried Albinus's *Tables of the Skeleton and Muscles of the Human Body*, published in English in 1749, an edition of which belonged to one of his friends. Like *The Blacksmith's Shop* this picture transforms the stuff of real life into a powerful visual statement about the meaning of man's place in the natural world.

When this painting was exhibited as the sole work by Wright at the Society of Artists in 1774, the artist was in Rome and unable to champion its merits. Its fantastic subject matter and idiosyncratic treatment of the naturalistic landscape—in which the dabs of paint appear as if suspended on the canvas, seemingly still fresh—proved too much for its initial audiences. Wright wrote to his sister to make sure that "my picture is hung advantageously in the Exhibition . . . I have set 80 guineas upon it, but I would take 70 rather than not sell it."[2] As it happened, the picture remained in his possession and was not sold until after his death. It was first bought in 1810 by Sir R. Wilmot of Chaddesden for £84 and remained in the Wilmot collection until 1952, when the Wadsworth Atheneum became interested in it. On previewing the picture on behalf of the museum, the art historian Alec Clifton-Taylor reported that the work displayed "neither poetry nor visual imagination."[3] Despite this negative assessment the director C. C. Cunningham and curator of paintings Charles Buckley found the picture worthy of the museum's growing collection of British art and purchased it with funds from Ella Gallup Sumner and Mary Catlin Sumner. Thus the Atheneum brought to America one of the great paintings of the English Enlightenment.

JMA

2. Quoted in Nicolson,
1:243.
3. From a letter in the
picture file, Wadsworth
Atheneum.

Joshua Reynolds

ᔧᕰ 1723–92

Portraitist and first president of the Royal Academy, whose advocacy of grand-manner style and the supremacy of history painting transformed the conventions of British portraiture and elevated the status of the artist in England. Reynolds began his artistic training with an apprenticeship to Thomas Hudson (1740–43), and in 1749 he embarked on a two-year period of study in Italy. Unsuccessful in his attempts to gain royal patronage on his return to London, Reynolds nevertheless established a thriving portrait practice and rose to prominence within aristocratic and intellectual circles. His professional and social preeminence was secured by his selection as first president of the Royal Academy on its founding in 1768. Aspiring to raise portraiture to the level of high art, Reynolds consciously borrowed poses, compositions, and themes from classical sculpture and Old Master paintings. Admiration for the great art of the past also informs the aesthetic theories that he formalized in a series of presidential lectures delivered at the Royal Academy from 1769 to 1790.

29 Few English ladies would have consented to be painted as Reynolds shows his friend Frances Abington (c. 1737–1815) in this portrait. Leaning over the back of a chair in an informal pose generally reserved for men, she places a thumb in her mouth in a manner that today appears thoughtful or coy, but which eighteenth-century viewers would have considered extremely vulgar. The rationale for the pose is that Reynolds's sitter was an actress, and that she appears here in a specific role—that of "Miss Prue," the rural ingenue in the Restoration play *Love for Love* (1695) by William Congreve. It was as Miss Prue that Abington had cemented her successful return to the London stage in 1769 following a five-year absence in Ireland.

Abington's talent for comedy was reportedly best displayed while portraying women who were distinctly unladylike: "coquettes, hoydens and country girls."[1] Off stage, however, she had toiled assiduously to separate herself from that class of women. Born into poverty, she steadily worked her way up the social ladder, graduating from a flower-seller and street singer in the 1740s, to a prostitute by the early 1750s, before establishing herself as a leading London actress by the close of the 1760s. Along the way she became proficient in French and Italian and, through marriage to her music-master, acquired the requisite "Mrs." that lent respectability to an actress's stage name.

There is some irony in Reynolds's decision to portray Abington in terms of the very vulgarity that she had dedicated herself to eschewing. Exhibited at the Royal Academy in 1771 under the anonymous title *Portrait of a Lady*, the painting would immediately have been recognized as a likeness of the famous Mrs. Abington. However, it required discernment on the part of the observer to realize that her compromised behavior was not her own but that of a fictitious character. It says much for the publicity value of portraiture that Abington was willing to take the risk.

Like most seventeenth-century dramas staged in the eighteenth century, *Love for Love* was performed in present-day dress rather than historical costume. Actresses were generally responsible for selecting the clothing they wore on stage, and Abington was

1. H. Simpson and Mrs. C. Braun, *A Century of Famous Actresses, 1750–1850* (London, 1913), 116.

29 *Mrs. Abington as Miss Prue in "Love for Love" by William Congreve, 1771*

Oil on canvas, 30 ¼ x 25 ⅛ in.
Yale Center for British Art, Paul Mellon Collection

provided with a large budget for the purpose. She swiftly became a leader of fashion, vying with the peeresses of polite society in establishing the styles that all other women followed. In this portrait Reynolds shows her in an extremely fashionable pink gown with lace flounces, her powdered hair piled in the high, conical arrangement that had recently come into vogue. The black silk bracelets on her arms are an eighteenth-century revival of Jacobean style, intended to emphasize the delicacy and whiteness of the skin. Reynolds went to unusual lengths to ensure his sitter's glamorous appearance. Beneath one of Abington's appointments in his sitter book is the notation, "Ruffle for the Picture at 12 Alexander hair dresser Haymarket."[2] The arrangements may have been made at Abington's insistence; she could be a vain *prima donna* on occasion.

Reynolds seems to have made unusually speedy progress with this portrait, completing it in little more than a month. The last sitting occurred on April 6, 1771, just a few weeks before the opening of the Royal Academy exhibition. It is easy to appreciate Reynolds's eagerness to bring the painting before the public while his subject remained topical. A great enthusiast for the stage and a friend of many actors and actresses, he was acutely aware of the fickle nature of theatrical fame. While stars were in the ascendant, however, they brought valuable publicity to the artists who painted them. The startling pose and disconcerting gaze of *Mrs. Abington as Miss Prue* would have been certain to arrest all eyes.

Over the last two hundred years the intrinsic appeal of the portrait has proved more enduring than the fame of Frances Abington herself. The painting was in great demand during the nineteenth century, exhibited on five occasions and engraved twice. Sustained interest in the twentieth century resulted

in the appearance of *Mrs. Abington as Miss Prue* in ten public exhibitions. The painting remained in the hands of private English collectors during much of that time. It entered the Yale Center for British Art as a gift of Paul Mellon in 1977.

RA

30

The ingenuous qualities of children delighted Reynolds. Some of his most charming portraits are sympathetic depictions of the sons and daughters of the elite, in which childhood is idealized as a golden age of innocence and simplicity. Reynolds tended to paint only the faces of his youthful subjects while they sat squirming in his studio chair. The rest of the work was often done from body doubles: urchins whom he recruited from the streets of London and treated with far less deference than his paying customers. He also employed street children as models for imaginative subject pictures such as *Cupid as a Link Boy*. In such paintings Reynolds's romantic idealization of youthful innocence and purity tends to fall away, replaced by a far more complex and disturbing characterization of childhood.

Cupid as a Link Boy shows a sly wit that functions on a number of levels. Its principal irony lies in deifying a ragamuffin child as Venus's son, the god of love. In Reynolds's version, however, Cupid's wings are not borrowed from an angel, but from a bat, lending him a sinister appearance. Rather than a bow and arrows, he carries a flaming torch—an alternative emblem of romantic passion but treated by Reynolds as a graphic sexual symbol. He emphasizes the phallic appearance of the torch by means of its placement against the boy's body and its incorporation into his

REFERENCES:
J. F. Musser, "Sir Joshua Reynolds's Mrs. Abington as 'Miss Prue,'" *The South Atlantic Quarterly* (Spring 1984): 176–92; Nicholas Penny, ed., *Reynolds*, exh. cat. (Royal Academy of Arts, London, 1986), 246–7. no. 78; Malcolm Warner and Julia Marciari Alexander, with an introduction by Patrick McCaughey, *This Other Eden: Paintings from the Yale Center for British Art* (New Haven, 1998), 98–99, no. 35; David Mannings, *Sir Joshua Reynolds: A Complete Catalogue of His Paintings* (New Haven and London, 2000), 55–6, no. 29.

2. Penny, no. 78.

30 *Cupid as a Link Boy*, 1774

Oil on canvas, 30 ⅞ x 25 in.
Albright-Knox Art Gallery, Buffalo, New York. Seymour H. Knox Fund through special gifts to the fund
by Mrs. Marjorie Knox Campbell, Mrs. Dorothy Knox Rogers, and Mrs. Seymour H. Knox, Jr., 1945

obscene gesture, with his left hand grasping his upwardly thrusting right arm. Through these subtle hints Reynolds associates his Cupid not with love but with lust. Equally subversive is the artist's treatment of the child himself. His shadowy eyes appear dull and lifeless, lacking the twinkling glint of moisture that animates the gaze of Reynolds's more "respectable" young sitters. Neither child nor cherub, Reynolds's Cupid gives the impression of a dangerous little fiend.

There were reasons for characterizing a link boy in such a manner. In order to find their way through the poorly lit streets of eighteenth-century London, nocturnal travelers often hired boys to accompany them with lighted torches, known as "links." The smoky street scene behind Cupid in Reynolds's picture suggests the grim conditions that might call for a link boy, with only the feeble light of a single lamp in evidence. Beneath the lamp the figures of a man and woman melt into the gloom, reinforcing the painting's sexual connotations. Reynolds's first biographer, Edmond Malone, referred to this painting as the "Covent Garden Cupid," associating the child with a section of London notorious as a site of brothels and illicit assignations. Link boys themselves were popularly associated with crime. John Gay's *Trivia: or, The Art of Walking the Streets of London* (1716) contains the couplet, "Though thou art tempted by the linkman's call, / Yet trust him not along the lonely wall."[3] Indeed, under the cover of darkness many link boys turned to thievery, preying upon the very people who trusted them as guides. The treachery of link boys toward unsuspecting victims provides another analogy with Cupid, thief of hearts.

Reynolds painted *Cupid as a Link Boy* as a pendant to *Mercury as a Cut Purse* (The Faringdon Collection Trust, Buscot Park), in which a young pickpocket appears in the guise of the messenger of the gods. Both paintings, together with a third picture, *A Beggar Boy and His Sister*, were executed for John Frederick Sackville, 3rd Duke of Dorset, who paid Reynolds 120 guineas in November 1774 for "three Pictures of Blackguards."[4] The Duke of Dorset was by far the most prolific purchaser of Reynolds's fanciful subject pictures; ultimately eight of them would join a collection that also contained several Reynolds portraits and a history painting. However, the duke was perhaps better known as a collector of women than of works of art. By its sexual innuendo the present painting combines his two principal interests in a roguish yet sophisticated fashion.

Cupid as Link Boy became well known almost as soon as it left Reynolds's studio. A mezzotint by John Dean was published on August 15, 1777, and another engraving was made by Samuel William Reynolds in about 1820. The painting became a staple of British Old Master exhibitions, appearing at the British Institution in 1817, 1823, and 1840, and at the Royal Academy in 1875 and 1896. J. Pierpont Morgan probably saw the painting on a visit to Knole in 1875. Twenty years later he purchased it and eventually brought it back to the United States. Sharing the Duke of Dorset's reputation for combining picture-collecting with romantic intrigue, Morgan made an appropriate owner of the painting. By ironic coincidence his last affair was with Lady Sackville of Knole, the 3rd Duke of Dorset's great-granddaughter, whom Morgan met five years after purchasing *Cupid as a Link Boy*. By 1945 the painting was in the possession of the New York art dealers Knoedler & Co., from whom it was purchased by the Albright-Knox Art Gallery.

RA

REFERENCES:
Thomas Humphrey Ward and W. Roberts, *Pictures in the Collection of J. Pierpont Morgan at Princes Gate and Dover House*, 3 vols. (London, 1907), 1:unpag.; Penny, 33, 48, 264–65, no. 92; Martin Postle, *Sir Joshua Reynolds: The Subject Pictures* (Cambridge, 1995), 66, 72, 94–95; Mannings, 523–24, no. 2060.

3. Quoted in Ward and Roberts, unpag.
4. Penny, 265.

REFERENCES:
Esther Singleton, *Old World Masters in New World Collections* (New York, 1929), 346–47; Mannings, 401–2, no. 1564; Robyn Asleson *British Paintings at The Huntington*, gen. ed. Shelley M. Bennett (New Haven and London, 2001), 328–35, no. 72.

31 The charming air of informality in this portrait of Diana Sackville (1756–1814) provides a refreshing change from more static and serious representations of ladies of rank and fashion. Since the 1760s, Reynolds had been experimenting with the subtle relaxation of decorum in his grand-manner portraits. His aim was to create an air of casual elegance, long considered a hallmark of English aristocratic style. Reynolds achieved some of his most successful results by introducing a sense of spontaneous movement into his portraits. Here, he represents Sackville as if glimpsed in motion, walking through a wooded park flickering with light and shadow. The windswept tendrils of her hair add an impression of momentum to the figure, as does her unbalanced pose, emphasized by the arm thrown out before her, which seems to propel her body forward. The landscape is unusually well realized and contributes to the portrait's overall sense of naturalism.

The mirthful expression of Sackville's face (particularly her gleeful smile) is a striking aspect of the portrait. It deviates dramatically from the neutral expression found in most grand-manner portraiture and advocated in courtesy literature of the period. The expression was unusual enough to raise eyebrows when the portrait appeared at the Royal Academy in 1779. One critic thought it patently artificial, remarking, "This may be a good Likeness of a Lady of Fashion, for the Countenance is very expressive of Affectation."[5]

Reynolds's experimentation with informality in portraying Diana Sackville undoubtedly owed something to the fashionable negligence popularized by the young Duchess of Devonshire during the late 1770s. The youth of the man who commissioned this portrait probably also played an important role. At twenty-four, Sackville's fiancé, John Crosbie, 2nd Viscount Crosbie, was far younger than the vast majority of Reynolds's patrons, and presumably more appreciative of the chic air of insouciance that Reynolds developed in his future wife's portrait.

Diana Sackville first visited Reynolds's studio on September 9, 1777, and she sat five more times that month, with four final sittings in October and November. There was evidently some urgency to complete the painting before she changed her condition through marriage; the last sitting occurred on November 14, just twelve days before she and Viscount Crosbie were wed. The carefree disregard for status and propriety in Reynolds's portrait belies the cold practicalities behind the marriage it commemorated. In private letters, Crosbie alluded to the financial and social concerns motivating his match with a granddaughter of the Duke of Dorset. "My marrying in this manner will mortify the narrow, envious people of Kerry," he boasted to a friend, adding that his bride's £10,000 "is more than I thought her fortune would be, for the daughters of these great families have seldom more than six."[6]

During the late nineteenth century Reynolds's portrait of Diana Sackville hung in the saloon of the Crosbies' Irish seat, Ardfert Abbey. In 1890 it was purchased by the wealthy British brewer Sir Charles Tennant, 1st Bart., whose collection of important eighteenth-century British paintings provided a model for many Americans. It descended through the Tennant family until 1923, when heavy death duties prompted its sale to Duveen Bros. Within a few months of acquiring the painting, Joseph Duveen sold it to Henry E. Huntington, whose magnificent collection of British paintings in San Marino, California, was particularly strong in full-length portraits of beautiful young women.

RA

5. *St. James's Chronicle; or, British Evening Post*, April 24–27, 1779, 4.
6. Asleson, 333.

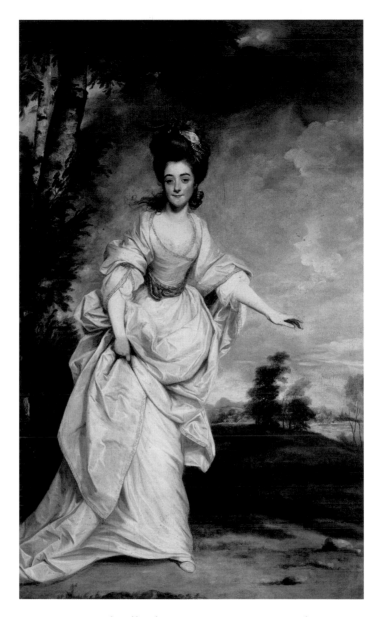

31 *The Hon. Diana Sackville, later Viscountess Crosbie, 1777*

Oil on canvas, 94 ¾ x 58 in.
The Huntington Library, Art Collections, and Botanical Gardens

REFERENCES:
Penny, 20, 60, no. 301;
Ronald Paulson, *Emblem
and Expression* (Cambridge, 1975), 91; Mannings, 148, no. 429.

32 It is remarkable that this swashbuckling portrait of George Coussmaker (1759–1801) remained unexhibited and unengraved during Reynolds's lifetime. In its sophisticated design and acute summation of character, it ranks among the artist's most effective portraits. Leaning against a tree with one leg crossed over the other and an elbow resting on a conveniently placed branch, Coussmaker is a study in casual confidence. Acknowledging the viewer's presence only obliquely with a partial turn of his head, he gazes down at us with cool impassiveness. Coussmaker's aloof manner contrasts with the violent action of his horse, which literally bows at its master's feet. The sweeping curve of the horse's neck, its flowing mane, and large, moist eye charge the painting with emotion that is echoed in the tumultuous, cloud-tossed sky and in the feathery brushwork used to depict the foliage. The exceptionally broad and robust handling evident throughout the painting reflects Reynolds's admiration for the Flemish painter Peter Paul Rubens. The overall consistency of technique suggests that Reynolds painted much of the portrait himself, rather than delegating large sections to his studio assistants (which was his usual practice and that of most eighteenth-century English portraitists).

Coussmaker served as a colonel in the Grenadier Guards, and his resplendent appearance here owes much to the visual impact of his regimental uniform, particularly the crimson coat with dark facings edged in gold braid. Reynolds has enhanced the dashing effect of the coat by employing a far more somber palette in the rest of the painting; the monochromatic setting provides a foil to the brilliant splash of red at its center. In addition, he has used the bold, angular cut of Coussmaker's coat to set up a series of converging diagonal lines that are echoed by other elements: the man's limbs; the neck, hoof, and bridle of the horse; and the slanted tree trunk. The web of intersecting lines helps to consolidate the three elements of man, horse, and tree as a tightly interconnected unit.

Despite the painting's appearance of effortless execution, Reynolds's sitter books record an unusually extensive number of appointments with Coussmaker, suggesting that the artist had difficulty pleasing his patron, or perhaps himself. Coussmaker's first recorded sitting was on February 9, 1782, and the same day he made a first payment of £100, half the value of the portrait. Thereafter, he seems to have had as many as twenty additional appointments with Reynolds between February and April. There are also as many as eight appointments recorded for Coussmaker's horse between late March and early April. Coussmaker made the second payment of £105 for the picture sometime between May 1782 and July 1783, by which date his portrait was presumably finished.

Colonel George Coussmaker descended in the family of the sitter's wife for over a hundred years. It was exhibited for the first time in 1813 and again in 1875, having been engraved the previous year. By then fairly well known, the painting was sold in 1884 to the important British collector Charles J. Wertheimer. Thereafter, it was acquired by William K. Vanderbilt, who bequeathed it to the Metropolitan Museum in 1920.

RA

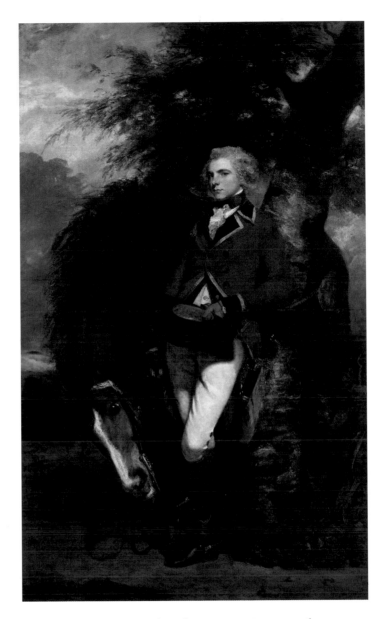

32 *Colonel George Coussmaker, 1782*

Oil on canvas, 93 ¾ x 57 ¼ in.
The Metropolitan Museum of Art, New York. Bequest of William K. Vanderbilt, 1920

Francis Wheatley

❧ 1747–1801

Painter and printmaker best known for his conversation pieces and series of engravings The Cries of London *(1792–95). Wheatley trained in London, and his early works were well received by his contemporaries in the Society of Artists. He was able to establish a relatively successful career as a portrait and subject painter, whose work followed closely that of the German painter Johann Zoffany, then working in London. Despite his continued success with patrons of the upper middle classes, Wheatley was forced to flee his creditors in 1779, escaping to Ireland, where he remained for four more years. Upon his return to London he began to work more frequently in the medium of prints, establishing a close relationship with the printseller John Boydell, whose most ambitious project was a gallery dedicated to works based on Shakespeare's plays. Wheatley's work from this later period—and especially his prints—won him once again great respect among his colleagues, and he was elected to the Royal Academy in 1791. Unfortunately, he was never fully able to escape his creditors, and his last years were dominated by ill-health and financial worries.*

33 Wheatley's portrait has generally been thought to show the Wilkinson family in the garden of their estate at Roehampton, southwest of London. Following the conventions of the ostensibly informal family portrait known as the "conversation piece," the artist shows his sitters enjoying a communal walk in a well-appointed and manicured garden that includes a garden pavilion, or "folly," whose Doric columns and neoclassical facade reflect the most current tastes in architectural design. The Wilkinsons, dressed in their finest, most up-to-date attire, are accompanied by their elegant dog, probably a whippet, one of the more popular breeds at the time.

Although Wheatley's portrait implies Mr. Wilkinson's ownership of the property surrounding them, the composition was probably worked up in the artist's studio after a few sittings, also in the studio, with each of the family members. Like nearly all of his contemporaries who painted conversation pieces, Wheatley frequently recycled the architectural props he used, thinly disguising them in each case by changing their features slightly: for instance, a Doric column would become Ionic, the orientation of the building would shift, or the dog would change from a greyhound to a spaniel. Although these elements turn up again and again in his portraits, they nevertheless give to each picture an aspect of stately grandeur and even convey a sense of place seemingly specific to the sitters. While the wealthiest sitters could summon an artist to their country seats, most of Wheatley's patrons were from the upper middle classes of London society; although some may indeed have owned country homes, they probably would not have gone to the trouble or expense of subsidizing their portraitist's journey there and back.

Just as it displays the Wilkinsons as a family whose sartorial and architectural tastes follow the fashions of their day, the portrait also demonstrates their knowledge and understanding of current Enlightenment philosophy about life and the pursuit of happiness. Mid-eighteenth-century European society considered it vital for families to spend time together enjoying the bounties of nature. The development of landscape gardening as an artistic form both echoed

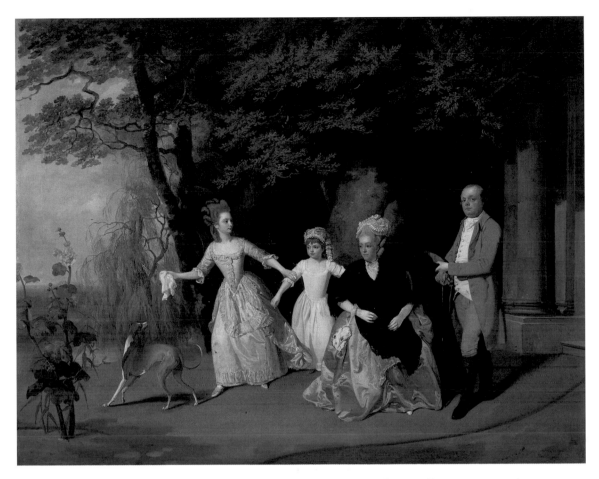

33 *The Wilkinson Family,* c. 1778

Oil on canvas, 40 ¼ x 50 ⅜ in.
The Detroit Institute of Arts. Founders Society Purchase, General Membership Fund

REFERENCES:
Francis Wheatley, RA, 1747–1801: Paintings, Drawings & Engravings, with an essay by Mary Webster, exh. cat. (Aldeburgh Festival and City Art Gallery, Leeds, 1965), 45, no. 96; *Romantic Art in Britain: Paintings and Drawings, 1760–1860*, exh. cat. (Detroit Institute of Arts and Philadelphia Museum of Art, 1968), 133–34, no. 75; Mary Webster, *Francis Wheatley* (London, 1970), 27, 123, no. 20.

and contributed to current beliefs that nature's beauties could be beneficial to both body and soul. The philosopher Jean-Jacques Rousseau's novel *Emile* was particularly influential on mid-eighteenth-century child rearing; it described the proper "Enlightenment" education of a child and was widely read in England during the 1760s. Books such as this promoted the idea that outdoor activity was critical to a child's mental and physical health and should be engaged in by parents and children together. Conversation pieces like *The Wilkinson Family* not only celebrated the wealth of the family depicted but also proclaimed the happiness of their life together.

This painting remained in the Wilkinson family collection until 1924 when it was sold through Leggatt Brothers. At that time it passed through the rooms of Tooth and Co., who may have been acting as the agent for the New York firm of Scott & Fowles. J. R. Aldred, a Long Island collector, purchased the work from Scott & Fowles and owned it from 1924 until 1946, when it was auctioned in a sale of his collection at Parke-Bernet. It returned once again to the rooms of Scott & Fowles, from which the Detroit Institute of Arts bought it in 1946, erroneously attributed to Benjamin West. Among the Institute's significant holdings of British art, this convivial family portrait is one of Wheatley's masterpieces, capturing not only the individual likenesses of the sitters but also their desire to be seen as a model eighteenth-century family.

JMA

EXHIBITED AT YALE ONLY.

Henry Fuseli

1741–1825

Painter of scenes of high drama from literature, history, and myth, often with erotic and supernatural elements. He was born Johann Heinrich Füssli, the son of a portrait painter in Zurich, Switzerland. After a brief career as a Zwinglian minister, he lived for periods in Berlin and London, pursuing studies in art theory and working as a translator. Encouraged by Joshua Reynolds, he decided to become an artist and spent the years 1770 to 1778 in Italy, where he immersed himself in the art of the past. He passionately admired the awe-inspiring, "Sublime" qualities of Michelangelo, whose work was to be his model for the rest of his career. He was back in Zurich in 1778–79 but from 1779 lived and worked permanently in London. He contributed paintings to Boydell's Shakespeare Gallery, a long-term commercial exhibition of paintings by British artists that were also published as a series of engravings. In 1799 he opened his own Milton Gallery in Pall Mall, a similar project but consisting entirely of his own works; it met with little success. Having been elected to the Royal Academy in 1790, he held the post of Professor of Painting from 1799 and Keeper from 1804.

34 *The Nightmare* is undoubtedly one of the most celebrated and familiar British paintings in an American collection. It suggests a fascination with mysterious and sinister forces, reveals dark regions of the artist's inner self, shows an element of obsession, and in all these things marks a key moment in the rise of the Romantic movement.

The creature squatting on the young woman's stomach is an incubus, an evil spirit supposed to rape its victims as they sleep and torment them with horrible dreams. Behind, a wildly caricatural, phallic-looking horse, its eyes luminous and bulging, thrusts its head through the bed curtains with a lascivious grin. This is presumably the incubus's steed, on whose back it rides through the dark in search of victims. As Nicolas Powell has pointed out in his monograph on the painting, there is no etymological connection between the words "nightmare" and "mare" meaning female horse.[1] On the other hand, the free, reason-defying association of things seems wholly in keeping with the subject.

Fuseli was a highly literary artist who normally based his paintings on stories from written sources: the plays of Shakespeare, the epic poetry of Milton, the myths and legends of the ancient world. Although the incubus is a being of legend, *The Nightmare* is not a scene from any particular story but the artist's own creation. In this respect it is like an enlarged, painted version of one of his erotic drawings, which, of course, he made for private consumption rather than public exhibition. Certainly its inspiration was deeply personal, arising out of frustrated passion. The object of Fuseli's passion was Anna Landolt, the niece of an intimate friend of his youth in Zurich, Johann Kaspar Lavater, the famous writer on physiognomy. Fuseli met her on his visit to Zurich in 1778–79. He had no chance of winning her—she was already engaged to another man—but this did not prevent him from pursuing her in his imagination and pouring out his feelings in letters to friends. In a letter to Lavater of June 16, 1779, for instance, he described a fantasy of making love to her: "Last night I had her in my bed with me—tossed my bedclothes hugger-mugger — wound my hot and

REFERENCES:
Nicolas Powell, *Fuseli: The Nightmare* (New York, 1973), passim; Gert Schiff, *Johann Heinrich Füssli, 1741–1825,* 2 vols. (Zurich and Munich, 1973), 496, no. 757; *Henry Fuseli 1741–1825,* exh. cat. (Tate Gallery, London, 1975), 122–23, no. 159.

1. See Powell, 56–59.

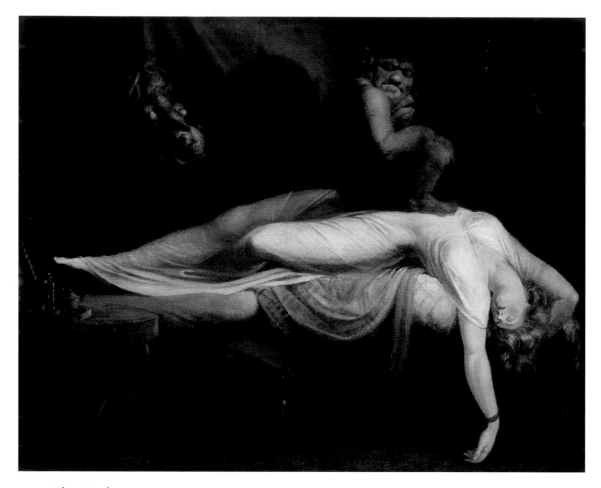

34 *The Nightmare*, 1781

Oil on canvas, 40 x 50 in.
The Detroit Institute of Arts. Founders Society Purchase, with funds from Mr. and Mrs. Bert L. Smokler, and Mr. and Mrs. Lawrence A. Fleischman

tight-grasped hands about her—fused her body and her *soul* together with my own—poured into her my spirit, breath and strength. Anyone who touches her now commits adultery and incest! She is *mine*, and I am *hers*."[2]

On the reverse side of the canvas of *The Nightmare* is the unfinished portrait of a fashionable young woman holding up her left hand as though drawing back a veil. The portrait has been identified as Landolt, and it seems highly likely that, at some level, Fuseli did indeed intend it to represent her.[3] The subject of the portrait and the victim of the nightmare on the other side of the canvas could well be one and the same young woman—although, as one would expect, the features are more generalized in *The Nightmare*. On the one side of the canvas appears the elegant and self-assured beauty, on the other a mind and body prey to torment. Privately, then, *The Nightmare* seems to have been another outpouring of Fuseli's desire for Anna Landolt, like the feverish letters about her that he wrote to his friends: a wish-fulfilling erotic fantasy in which he allowed the incubus in himself to have its way.

The Nightmare was exhibited at the Royal Academy in London in 1782 and established Fuseli's reputation in Britain. Through several variants on the composition that Fuseli painted after the present, prime version, as well as through reproductive engravings—three of which had been published by 1784—the image reached a wide audience. One measure of its fame was the number of caricatures and cartoons based on the composition that were published in the later eighteenth and nineteenth centuries.[4] In more recent times it has become not only Fuseli's best-known painting but almost an icon, familiar to many who would be unable to name the artist. With the heightened interest in the subconscious, dreams, and sexuality brought about by the rise of psychology, it has assumed a powerful modern resonance. As Nicolas Powell recounts, in 1926 a visitor noticed a reproduction of it hanging next to another of Rembrandt's *Anatomy Lesson* in Sigmund Freud's apartment in Vienna.[5] The painting has also been taken up and claimed as a precursor by avant-garde movements in art, including both Expressionism and Surrealism.

The Nightmare had crossed the Atlantic by 1950, when it was with the New York dealers Durlacher Brothers, an important source of British paintings for both public and private collectors at this time. It was purchased from them by the Detroit Institute of Arts in 1955.

MW

2. Quoted in Powell, 60.
3. The suggestion was first made by H. W. Janson in "Fuseli's Nightmare," *Arts and Sciences* 2 (Spring 1963): 22–28.
4. For some examples, see Powell, 18 and 81–83.
5. Powell, 15.

Gilbert Stuart

🖎 1755–1828

American portrait painter whose grand-manner style was profoundly influenced by the eighteen years he spent working in England and Ireland. Born in Rhode Island, the son of a Scottish immigrant loyal to the British Crown, Stuart journeyed to England just prior to the outbreak of the American Revolution in order to complete his art training. Following his 1775–82 apprenticeship with the American expatriate Benjamin West, Stuart began an independent portrait practice in London. He received positive notice for his ability to capture a convincing likeness but struggled to compete in a city teeming with professional portrait painters. In search of patronage, he moved to Ireland in 1786 but left for the United States seven years later with the intention of painting a portrait of George Washington that would establish his American reputation. The success of that portrait led to additional commissions, and he went on to paint five presidents among other prominent members of society. Stuart's portraits introduced America to the sophisticated grand-manner conventions that he had learned in Britain and the loose style of brushwork favored by British artists. Stuart spent the last thirty-five years of his life in the United States, where his example did much to raise the quality and status of portraiture.

35 Reflecting on his early years of struggle as a young American art student in London, Gilbert Stuart later recalled that he was "suddenly lifted into fame by the exhibition of a single picture."[1] The change in his fortunes was effected by this portrait of William Grant (d. 1821) of Congalton, Scotland, which Stuart sent along with three other portraits to the Royal Academy exhibition in 1782. It was the young artist's first full-length portrait, and the commission had caused him considerable trepidation. Although Stuart had already exhibited several paintings at the Royal Academy, his concentration on smaller formats had spawned the rumor that "he made a tolerable likeness of a face but as to the figure he could not get below the fifth button."[2] Moreover, as he was still working as a student and assistant to Benjamin West, he was uncertain of his capacity to carry out ambitious work of his own.

Stuart's inexperience and uncertainty are belied by his daringly original decision to represent Grant in the act of skating. Although many gentlemen indulged in this informal activity, no British artist had yet translated it to full-length portraiture. Those who saw Stuart's painting at the Royal Academy exhibition were duly impressed by its novelty. One appreciative viewer remarked, "One would have thought that almost every attitude of a single Figure had long been exhausted in this land of portrait painting but one is now exhibited which I recollect not before." He went on to characterize *The Skater* as "a noble portrait large as life . . . which produces the most powerful effect."[3]

According to a contemporary of Stuart, the unusual theme of the portrait came about by accident. When Grant arrived for his first appointment with the painter, he complained that the cold day was better suited for skating than sitting for a portrait. Daunted by his monumental task and prone to procrastinate, Stuart suggested that they postpone the sitting in order to take a turn on the ice. Grant reportedly proved no match for Stuart's superior skill; and, when the frozen river began to crack

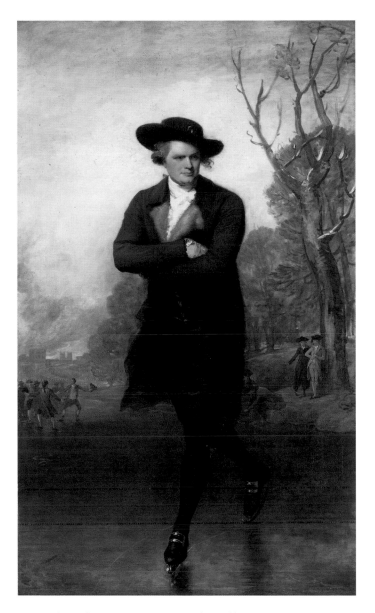

35 *The Skater (Portrait of William Grant)*, 1782

Oil on canvas, 96 ⅜ x 58 ⅛ in.
National Gallery of Art, Washington. Andrew W. Mellon Collection

REFERENCES:
William T. Whitley, *Gilbert Stuart* (Cambridge, 1932), 15, 31–36; Charles Merrill Mount, *Gilbert Stuart: A Biography* (New York, 1964), 69–74; William L. Pressly, "Gilbert Stuart's *The Skater*: An Essay in Romantic Melancholy," *The American Art Journal* 18 (1986): 43–51; Andrea G. Pearson, "Gilbert Stuart's *The Skater (Portrait of William Grant)* and Henry Raeburn's *The Reverend Robert Walker, D.D., Skating on Duddington Loch*: A Study of Sources," *Rutgers Art Review* 8 (1987): 55–70; Ellen G. Miles, *American Paintings of the Eighteenth Century* (Washington, 1995), 162–69.

1. Gilbert Stuart, quoted in Pressly, 43.
2. Whitley, 33.
3. Pressly, 44.

beneath them, he had to be pulled to safety while clinging to the painter's coattails.

Stuart's portrait removes any trace of ineptitude on Grant's part, imbuing him with an appearance of consummate grace and confidence. Stuart achieved this effect in the manner advised by Joshua Reynolds, president of the Royal Academy of Arts, by turning to the great art of the past for models. He based Grant's elegant pose on an antique statue used by many British artists, the Apollo Belvedere, a cast of which stood in Benjamin West's studio. Stuart modified the open, active gesture of the statue by placing Grant's arms in a more subdued, self-contained pose. The figure lacks the lively sense of motion that more established artists (such as Reynolds) occasionally brought to their grand-manner, full-length portraiture. It is the act of skating itself that creates an impression of motion.

By adopting a low vantage-point, Stuart made Grant appear all the more imposing, and by means of the prominent tree at right, he lent an impression of greater stability to the pivoting figure. Dabbed in with feathery strokes, the silvery-grey atmosphere of the landscape backdrop provides an effective foil to the imposing black figure, whose sober dress is relieved with only a few strokes of white, gray, and tan. Through all of these touches Stuart endows the mundane activity of skating with a classical air of authority. The strategy enabled him to sustain the dignified composure demanded by British decorum, while simultaneously infusing a fresh sense of vitality and informality into the static conventions of grand-manner portraiture—a further idea borrowed from the portraiture of Reynolds.

The Skater was displayed in an exhibition of Old Masters of the British School in 1878, where it attracted high praise, as it had when first exhibited in 1782. The painting remained with the descendants of William Grant in Scotland and England until 1950, when it was sold to the National Gallery of Art. From then on, exhibitions and publications have presented the portrait as a masterpiece of American painting, despite its signal debt to the traditions and sensibilities that Stuart imbibed in England.

RA

George Romney

ஃ 1734–1802

Painter of glamorous society portraits and romantic subjects drawn from literature, history, and mythology. After leaving school Romney worked for his father, a cabinet-maker and joiner in Cumbria, and only began his art career at the age of twenty-one, serving a two-year apprenticeship with the itinerant portrait painter Christopher Steele. Limited patronage in the north of England convinced Romney to move to London in 1762. He swiftly came to notice by winning prizes for history paintings in 1763 and 1765. He improved his credentials with a six-week visit to Paris during the autumn of 1764. Despite charging lower prices than many of his rivals, he was able to save enough money to fund a two-year tour of Italy from 1773 to 1775, during which he studied ancient sculpture and Old Master paintings. Returning to London at the age of forty-two, he purchased an impressive house and soon established an extensive portrait practice. Romney aspired to more imaginative forms of art, however, and in his leisure time he experimented with dramatic scenes from literature and mythology. Reclusive by nature, he refused to exhibit publicly after 1772 and never sought membership in the Royal Academy of Arts.

36 Glamorous portraits of fashionable women were Romney's specialty, but he was always at his most beguiling when painting Emma Hart (1765–1815), his muse and favorite model. Born the daughter of a humble blacksmith, Hart's exceptional beauty and irresistible charm launched a romantic career that raised her to the heights of British society before tumbling her into poverty and destitution. When she met Romney in 1782, she was the teenage mistress of the artist's friend, the Hon. Charles Francis Greville, who commissioned this portrait of his lovely paramour, along with several others. The relationship between Romney and Hart soon expanded well beyond the business of Greville's commissions, however. They shared a taste for theatricality, and during the years 1782–86 Hart often visited Romney's studio to enact impromptu dramatic performances while he sketched her. A frustrated history painter forced to make his living as a society portraitist, Romney relished these opportunities to pursue imaginative subject matter with a singularly inspiring model.

An air of theatricality enlivens the present portrait as well. The highly original pose represents the sitter playfully transforming her expensive straw hat into a makeshift bonnet by pulling the stiff brim down about her ears. The improvisation lends a rustic, pastoral air to her appearance, which she plays up by lowering her chin and gazing in exaggerated innocence from beneath the hat's shadow. The pose allows Romney to capture not only Emma Hart's womanly beauty, but also the childlike whimsy and coquettishness of a girl still in her teens. The geometric patterns created by the position of her arms and the folds of her drapery recur in several of Romney's paintings of this period, as does the dashing exuberance of his brushwork, which suggests the speed and energy with which he painted.

36 *Emma Hart, later Lady Hamilton, in a Straw Hat,* c. 1782–84

Oil on canvas, 30 x 25 in.
The Huntington Library, Art Collections, and Botanical Gardens

Romney held onto this painting for some years while waiting for the impoverished Greville to pay for it. In 1788 he finally presented it to his friend as a gift. The portrait had already become well known through an engraving by John Jones, published on December 29, 1785, with the inscribed title *Emma*. When a writer for the *World* newspaper visited Romney's studio in 1787, he observed a dozen portraits of Hart but was particularly struck by the one "with the hat tied under her chin."[1] The woman herself had long since left London. As a matter of economy, Greville had bundled her off to his uncle, Sir William Hamilton, British envoy at Naples, whom she married in 1791. Like Romney, Hamilton encouraged Hart's innate theatrical ability, and under his tutelage she gained international renown for the "Attitudes" she performed in imitation of classical painting and statuary.

In 1924 Duveen Bros. acquired this painting from the heir of Alfred de Rothschild, the prominent British financier and collector. Joseph Duveen already intended the painting for the collection of Henry E. Huntington, whom he assured in a letter of April 25, 1924, "any exaggeration of its beauty, quality and importance is impossible."[2] Although Huntington had not committed to purchasing the painting, Duveen sent it to his house in San Marino, California, along with an employee to hang it. The ploy worked, and Huntington bought the painting for an even larger sum than Duveen had initially asked. The romantic history of Emma Hart and her relationship with Romney made such portraits particularly attractive to American collectors. Henry Clay Frick had purchased Romney's portrait of her "as Nature" in 1904 (fig. 40), and Duveen sold Huntington a second Romney portrait of her in 1926.

RA

REFERENCE.
Robyn Asleson, *British Paintings at The Huntington*, gen. ed. Shelley M. Bennett (New Haven and London, 2001), 424–27, no. 92.

1. Quoted in William T. Whitley, *Artists and Their Friends in England, 1700–1799* (London and Boston, 1928), 89.
2. Institutional archives, Huntington Library.

Thomas Lawrence

❧ 1769–1830

Painter of romantic and official portraits in the Grand Manner. Enormously talented from a young age, Lawrence was essentially self-taught. He gained early renown for his remarkable facility in making pencil portraits of elegant travelers at his father's coaching inn. In the summer of 1787, Lawrence settled permanently in London. Initially specializing in pastel portraits, he turned almost exclusively to oil painting following a few months' study at the Royal Academy Schools. The glamorous and vivacious full-lengths he exhibited in the 1790s secured his preeminence among the younger generation of painters. In the late 1790s and early 1800s financial embarrassment and the demands created by his own runaway success caused him to undertake an excessive number of commissions. Studio assistants became increasingly important to his practice, and it was they who completed the 200 portraits that remained unfinished at the time of his death. Knighted in 1815, Lawrence went to Vienna in 1818 as envoy of the Prince Regent with a prestigious commission to paint the victorious allies in the Napoleonic Wars. Following an instructive visit to Rome, he returned to England in March 1820. During his absence he had been elected president of the Royal Academy. Lawrence's art changed with the times, and his later works reflect a nineteenth-century penchant for sentimentality.

37 Comedy was the forte of the actress Elizabeth Farren (c. 1759–1829), who succeeded Frances Abington (see no. 29) as the great comic star of Drury Lane theater in London. The daughter of George Farren, an apothecary and surgeon who later turned to acting, Farren performed with other members of her family in provincial theaters before making her London debut in 1777. Despite her humble origins she excelled in playing aristocratic and fashionable ladies. In her case life imitated art; after attracting the attentions of the 12th Earl of Derby, Farren entered into a discreet but widely known courtship that lasted until the death of the earl's wife in March 1797. Two months later she married her devoted paramour, becoming the Countess of Derby.

Enormous popular interest in Elizabeth Farren, both on and off the stage, made the present portrait an important plank in the establishment of Lawrence's fame. He was just twenty-one in 1790 and had arrived in London only three years earlier. Devoted to the theater, he had haunted the stages of Bath as a boy and often astonished visitors to his father's inn by performing well-rehearsed set pieces. His portrait of Farren conveys many of the features that Lawrence and other theatergoers had come to associate with her: great beauty, glamour, and vivacity. Crucially, however, Lawrence has divested her of any association with the stage itself. Walking through a well-groomed landscape, wearing a stunning fur-edged cloak of white satin over a chiffon dress, with a fur muff trailing from her gloved hand, she might be any great lady taking a stroll through the grounds of her estate. Only the coy and slightly flirtatious informality with which Farren engages the viewer—inclining her head and parting her lips to reveal a flash of white teeth—suggests that Lawrence's subject is perhaps not to the manor born.

37 *Elizabeth Farren, later Countess of Derby,* 1790

Oil on canvas, 94 x 57 ½ in.
The Metropolitan Museum of Art, New York. Bequest of Edward S. Harkness, 1940

REFERENCES:
Esther Singleton, *Old Masters in New World Collections* (New York, 1929), 420; Kenneth Garlick, *Sir Thomas Lawrence: A Complete Catalogue of the Oil Paintings* (London, 1989), 87–88, no. 294; Kenneth Garlick, *Sir Thomas Lawrence: Portraits of an Age, 1790–1830*, exh. cat. (Art Services International, Alexandria, Virginia, 1993), 54–55, no. 18.

The flattering terms in which Lawrence painted Elizabeth Farren were probably dictated by the sitter and Lord Derby, who commissioned the painting. Their anxieties about the compromised social position that she occupied as an actress were revealed during the exhibition of the painting at the Royal Academy in the spring of 1790. Farren complained to Lawrence that the exhibition catalogue listed the picture as "Portrait of an Actress" rather than "Portrait of a Lady." The artist had in fact submitted the painting under the latter title, but instant recognition of the lovely celebrity must have caused someone else to retitle it. Farren also informed Lawrence of her friends' criticism of his depiction of her: "One says it is so thin in the figure, that you might blow it away—another that it looks broke off in the middle."[1] Sensing that her public image was being sacrificed to her portraitist's professional interests, she added: "In short, you must make it a little fatter at all events diminish the bend you are so attached to, even if it makes the picture look ill, for the owner of it is quite distressed about it at present." The courtly painter probably made the requested changes, although contemporary references to Farren's excessive thinness suggest that his original depiction was more accurate than she cared to acknowledge.

Despite Farren's misgiving her portrait created a sensation at the Royal Academy. It was hung near Joshua Reynolds's portrait of Elizabeth Billington, the star of Covent Garden, whom the venerable painter depicted in a ponderous, grandiose manner, floating on clouds in the guise of St. Cecilia. The brisk naturalism and spontaneity of Lawrence's painting cut through such pretensions like a gust of fresh air. Reynolds reportedly acknowledged as much, declaring to Lawrence, "In you, Sir, the world will expect to see accomplished what I have failed to achieve."[2]

1. Singleton, 420.
2. Garlick, 1993, 54.

The fame of *Elizabeth Farren* was secured by its mass reproduction in a stipple engraving by Francesco Bartolozzi, first published in 1792 and reissued after Farren's marriage in 1797 and again in 1803. A stipple engraving by C. Knight was published in 1813, and another appeared in 1823. The painting's celebrity grew through frequent exhibition during the latter half of the nineteenth century and in the first years of the twentieth. Its purchase in about 1906 by J. Pierpont Morgan was therefore a considerable coup. The painting was later acquired by the philanthropist Edward S. Harkness, heir to the Standard Oil fortune, who bequeathed it to the Metropolitan Museum of Art in 1940.

RA

38 Many young men in eighteenth-century Britain sat for their portraits on the occasion of completing or commencing a new stage in their educations. Arthur Atherley (1772– 1844) probably sat to Lawrence at the age of eighteen as he was about to leave Eton College. There was then a tradition among departing Etonians of commissioning a "leaving portrait" that would be given to the headmaster and remain at the school as a kind of memorial. *Arthur Atherley* is not a leaving portrait, but Lawrence would later be called upon to paint several of them. He very likely owed some of those commissions to the success of this painting, which he exhibited as *Portrait of an Etonian* at the Royal Academy in 1792. The portrait was immediately engraved and became well known.

Lawrence shows Atherley standing before an extensive landscape prospect, with Eton College Chapel visible in the distance at lower right. With his

38 *Arthur Atherley*, c. 1790–91

Oil on canvas, 49 ½ x 39 ½ in.
Los Angeles County Museum of Art, William Randolph Hearst Collection

REFERENCES:
Garlick, 1989, 141,
no. 50; Garlick, 1993,
26–27, no. 4.

right arm akimbo and his lowered left hand doffing his top hat, Atherley assumes a pose of relaxed confidence that gains an element of bravura from the startling intensity with which he meets our gaze. His pose essentially reverses that assumed by sixteen-year-old Jonathan Buttall in Thomas Gainsborough's famous painting *The Blue Boy* (no. 17), which seems to have been fairly well-known within artistic circles during the late eighteenth century. Lawrence initially may have contemplated a still closer resemblance between the two paintings: an oil study once believed to be Gainsborough's sketch for *The Blue Boy* but now identified as Lawrence's study of Atherley's head (private collection) indicates the artist's original intention of depicting the boy in a blue coat.

The differences between *Arthur Atherley* and *The Blue Boy* are as revealing as their similarities, however. Lawrence followed Gainsborough in placing his subject before a murky, atmospheric backdrop, but his instinctive theatricality (also evident in his substitution of a red coat for a blue one) led him to lower the horizon line behind Atherley so that he appears to stand at a commanding height, with storm clouds billowing behind him. The towering figure entirely dominates Eton Chapel, which we can almost imagine him scooping up with a flick of his hat. The heightened emotional tone of the portrait compensates for its reduced format, so that even at half-length, Atherley projects a presence as commanding as Buttall's in Gainsborough's full-length.

Eton has always prided itself on attracting Britain's elite and on incubating the talents of the nation's future leaders. These ideas are implicit in Lawrence's conception of Atherley as an Etonian. Through theatrical aggrandizement of his subject, Lawrence more than hints at Atherley's great expectations. His revelation of the man within the boy probably underpins the success of the portrait and of the engraving made from it. Lawrence was in an excellent position to portray a young man of precocious talent and ambition; he was, after all, only three years older than Atherley himself. Yet he had already painted the queen of England, and was spoken of as a future president of the Royal Academy.

Arthur Atherley grew up to become a banker and also pursued a political career as a staunch member of the Whig party. He served as Member of Parliament for Southampton on three occasions: 1806–7, 1812–18, 1831–33. Lawrence's portrait descended through Atherley's family until the first decades of the twentieth century. In 1928 it was purchased by the Californian newspaper tycoon William Randolph Hearst, who gave it to the film star Marion Davies. The painting was purchased from her for the Los Angeles County Museum in 1947.

RA

39 Since the early twentieth century Lawrence's portrait of eleven-year-old Sarah Goodin Barrett Moulton (1783–95) has been best known by the sitter's nickname, "Pinkie." The portrait was commissioned by Sarah's maternal grandmother, Judith Barrett, following the child's departure from Jamaica in 1792 to be educated in England. "I become every day more desirous to see my dear little Pinky," Barrett wrote to a relation in London in 1794, "but as I cannot gratify myself with the Original, I must beg the favor of you to have her picture drawn at full length by one of the best Masters, in an easy Careless [i.e., carefree] attitude."[3] Although still in his early twenties, Lawrence had already established himself as "one of

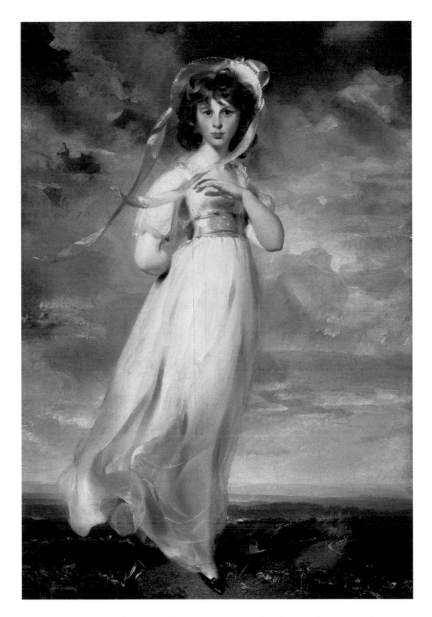

39 *Sarah Goodin Barrett Moulton: "Pinkie,"* 1794

Oil on canvas, 58 ¼ x 40 ¼ in.
The Huntington Library, Art Collections, and Botanical Gardens

REFERENCES:
Philip Kelley and
Ronald Hudson, "New
Light on Sir Thomas
Lawrence's "Pinkie,"
Huntington Library Quarterly 28 (1965): 255–61;
Robert R. Wark, *Ten
British Pictures, 1740–
1840* (San Marino, California, 1971), 59–65;
Garlick, 1989, 241, no.
580; Marcia Pointon,
*Hanging the Head: Portraiture and Social Formation in Eighteenth-Century
England* (New Haven
and London, 1993),
200–2; Robyn Asleson,
*British Paintings at The
Huntington*, gen. ed.
Shelley M. Bennett,
(New Haven and London, 2001), 242–48,
no. 50.

3. MS. letter, Eton College, quoted in Kelley
and Hudson, 255.
4. The x-rays are reproduced and discussed in
Asleson, 242, 245.

the best Masters" of his day, with a particular gift for romantic representations of children (see no. 38). The artist's election to the Royal Academy of Arts on February 10, 1794, undoubtedly helped to secure the commission for Sarah Moulton's portrait shortly thereafter.

Lawrence represented his young subject in a vitally unstable pose, seemingly perched on the brink of a precipice, pivoting on a single pointed toe. With her hair tousled by the breeze and her skirts swirling about her, she appears to embody the dynamism and freshness of the cloud-tossed sky behind her. In this respect Lawrence's portrait expresses the theoretical unity between children and the natural world—an idealistic notion popularized earlier in the eighteenth century by the French philosopher Jean-Jacques Rousseau. Lawrence achieves this impression without sacrificing the air of polite civility that Sarah had journeyed to England to acquire. Her arms and feet are positioned gracefully, suggesting that the girl is shown in the midst of a genteel dance step.

At the age of eleven, Sarah had reached an awkward transition, not quite a child anymore, but not yet a woman either. The ambiguity caused Lawrence some difficulty in this portrait. X-rays reveal that he initially represented her with the squat proportions of a child. He later added a section of canvas at the bottom of the painting in order to elongate the lower anatomy and create a more elegant silhouette, a flattering trick that he often employed in his glamorous portraits of adult women (see no. 37).[4]

Lawrence postponed delivery of this portrait in order to display it in the Royal Academy exhibition that opened on May 1, 1795. Sadly, his subject had died of consumption just a week earlier, on April 23, one month after her twelfth birthday. This tragic circumstance was probably not widely known at the time, and the portrait appears to have excited little comment at the Royal Academy. Subsequent exhibition at the British Institution in 1856 occasioned only slightly more notice. The portrait's relative obscurity as late as 1857 is indicated by the low price of £93 placed that year on the entire art collection owned by Edward Moulton-Barrett, Sarah's younger brother (and father of the poet Elizabeth Barrett Browning), who had inherited *Pinkie* along with other family portraits.

In the early twentieth century *Pinkie's* fame increased dramatically as a result of its appearance in two public exhibitions in 1907 and 1908. When sold by the Moulton-Barrett family in 1910, it commanded a price of £40,000. In 1926 the art dealers Duveen Bros. acquired *Pinkie* for nearly £80,000, the highest price ever paid for a British painting at auction. After another public exhibition in 1926, Duveen sold the painting to Henry E. Huntington—to the great irritation of rival American collector Andrew W. Mellon, who tried unsuccessfully to acquire it for himself, saying that the girl reminded him of his own daughter. *Pinkie's* cult status was confirmed in 1928, when the painting was reproduced on Cadbury's chocolate tins. That was only the first of many popular uses of the portrait, which is now firmly established as an icon of British art.

RA

EXHIBITED AT THE HUNTINGTON ONLY.

40 This vivacious double portrait provided Lawrence with one of the great popular successes of his late career. His sitters were Emily Calmady (1818–1906) and her sister Laura Anne (1820–94), the eldest children of Charles Biggs

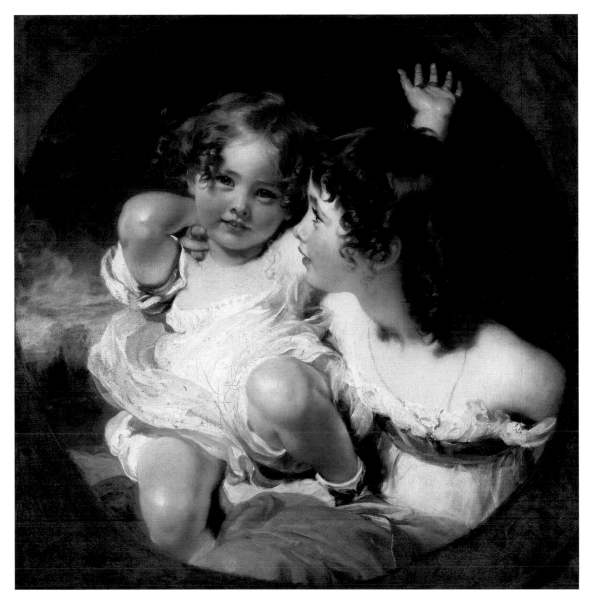

40　*The Calmady Children,* 1823–24

Oil on canvas, 30 ⅞ x 30 ⅛ in.
The Metropolitan Museum of Art, New York. Bequest of Collis P. Huntington, 1925

REFERENCES:
D. E. Williams, *The Life and Correspondence of Sir Thomas Lawrence*, 2 vols. (London, 1831), 2:332–46; Garlick, 1989, 161, no. 152; Garlick, 1993, 36, no. 9.

Calmady of Langdon Hall, Devon. Their mother had taken the girls to Lawrence's studio during a visit to London in 1823. The artist was sufficiently intrigued by the idea of painting them that he lowered his usual price of £650 to £150. Delighted with the portrait upon its completion in 1824, Lawrence went so far as to sign the canvas with his initials—something he had done on only five other occasions, he told the girls' mother. As a further indication of his pride in the painting, Lawrence took it to Windsor Castle in 1824 to show the king. Its appearance at the Royal Academy exhibition that spring inspired lavish praise. The following year *The Calmady Children* accompanied Lawrence to Paris on an official visit to paint Charles X. Color lithographs of the portrait were reportedly "very widely circulated throughout the provincial towns and were to be seen in the farmhouses."[5] The painting was also engraved in line by G. T. Doo in 1832, and Samuel Cousins produced a mezzotint in 1835 bearing the inscription "Nature."

Cousins's inscription sheds light on the interpretation given to Lawrence's painting in the early nineteenth century and helps to account for its phenomenal popularity. The painting exemplifies the romantic idealization of childhood as an uncorrupted state of nature, a view popularized in the late-eighteenth century by the writings of Jean-Jacques Rousseau. Lawrence had translated this ideal to his children's portraiture from early in his career, in *Pinkie* for example (no. 39). During the 1820s, however, his sentimental and romantic approach to the representation of children reached its zenith.

In order to convey the childlike qualities of the Calmady girls, Lawrence represented them in "natural" positions that no grown woman would ever adopt in her portrait. The elder child turns impulsively to gaze at her sister, who squirms free of her embrace, raising both arms and thrashing her legs. The churning folds of her dress accentuate the impression of restless movement. In addition, by placing the figures so shallowly within the picture plane, Lawrence redoubled their apparent energy and immediacy, creating the impression that the flailing arms and legs of the younger girl and the projecting shoulder of her sister are about to burst through the canvas into our own space. The disordered dress and spontaneous movements of the children are meant to strike the viewer as charmingly true to life.

For all its apparent naturalism, however, Lawrence's painting is also extremely artificial. He has given the girls an appearance of exaggerated sweetness: polishing their skin to a marmoreal smoothness; heightening the rosy carnation of their cheeks and cupid's-bow lips; emphasizing the sheen of their glossy ringlets and the sparkle of their heavily lashed eyes. His idealization of the physical features of Emily and Laura Anne Calmady encourages our interpretation of the children as universal types of cherubic innocence. To reinforce this interpretation, Lawrence modeled the composition on sixteenth- and seventeenth-century paintings of the infant Christ and St. John the Baptist. The round (*tondo*) format deliberately invokes associations with well-known Renaissance prototypes, such as Raphael's *Madonna della Sedia* of c. 1512–14 (Palazzo Pitti, Florence). Despite the fact that Lawrence portrays two particular children, his idealized characterization encourages a more generalized, typological reading of the girls as embodiments of the refreshing vitality and lack of artifice associated with nature. By subtly alluding to the venerated prototypes of Christian art, he raises the artistic pretensions of the painting still further, ennobling his sitters to a kind of iconic status.

Lawrence's approach to *The Calmady Children*

5. Williams, 345.

proved extremely effective in expanding the painting's potential audience beyond those acquainted with the specific children represented. The picture sustained its fame through repeated exhibition in London in 1830, 1862, and 1872. Sometime after 1886 *The Calmady Children* was acquired by the railroad titan Collis P. Huntington of New York, who bequeathed it to the Metropolitan Museum of Art in 1900. It formally entered the museum's collection in 1925, following the death of his widow. Today, the painting remains one of Lawrence's best known works, often reproduced in posters, greeting cards, and other popular forms.

RA

EXHIBITED AT YALE ONLY.

Henry Raeburn

1756–1823

Portrait painter known for the dashing character of his brush-work and for his facility in seizing on the personality and appearance of his sitters. Raeburn apparently learned to draw and paint in watercolors while executing jewelry designs and perhaps portrait miniatures during his apprenticeship to an Edinburgh engraver from 1772 to 1778. Marriage to a wealthy widow, Ann Leslie, in 1780 enabled him to pursue a painting career. In 1784 he left his family in Scotland in order to spend two months studying in London with Joshua Reynolds. In 1786 he returned to Edinburgh, where he established an independent portraiture practice. By 1798, when he built himself a new studio, he was considered the leading portrait painter in Scotland. In 1812 Raeburn was elected president of the Associated Society of Artists in Edinburgh, where he had been exhibiting since 1809. He had also exhibited regularly at the Royal Academy, where he was elected an Associate in 1812 and a full Academician in 1815. He was an honorary member of the American Academy of Fine Arts in New York (1817) and the Academy of Art of South Carolina (1821). In 1822 he was knighted by George IV during the king's ceremonial visit to Scotland.

41 Although the exact circumstances of the commission are unknown, this portrait was clearly intended to portray David Birrell (1757–1800) in connection with his service in the East India Company. At the time he sat to Raeburn, Birrell was beginning his second decade in the company, and the artist accordingly represented him in his officer's uniform, in a commanding stance that signals his authority. Birrell had joined the East India Company as a cadet in 1778, around the age of twenty. In the same year he progressed to the rank of cornet and then to lieutenant. In 1796 he was promoted to captain in the company's Bengal Cavalry, and he rose to major in June 1799. He died of cholera the following year at Fatehgarh in Uttar Pradesh. As Birrell spent so much of his adult life in the East Indies, the question arises as to when he could have visited Raeburn's studio in Edinburgh. He was on furlough from the East India Company between January 16, 1789, and September 27, 1793, and it was probably then (as the stylistic qualities of this portrait confirm) that he sat to the painter.

The dramatic impact of *Captain David Birrell* owes much to the romantic landscape backdrop, churning with clouds and stunning splashes of sunlight. The directness of Birrell's gaze and the solidity of his locked-arm stance lend him an appearance of stability and calm in the midst of the swirling, amorphous atmosphere that surrounds him. Raeburn has enhanced the figure's impression of towering self-confidence by assuming a low vantage point in relation to his subject. In order to achieve that effect, he often placed his sitters on an elevated platform in his studio so that he could paint them at the height their completed portraits would assume when hung on the wall.

Raeburn made no preparatory drawings for his portraits but set to work directly on the canvas, blocking out the main lines of the composition in broad strokes. Having no training in anatomy, he painted only the appearances that were presented to his eye without analyzing the structures that lay beneath them. In the portrait of Birrell, we see him

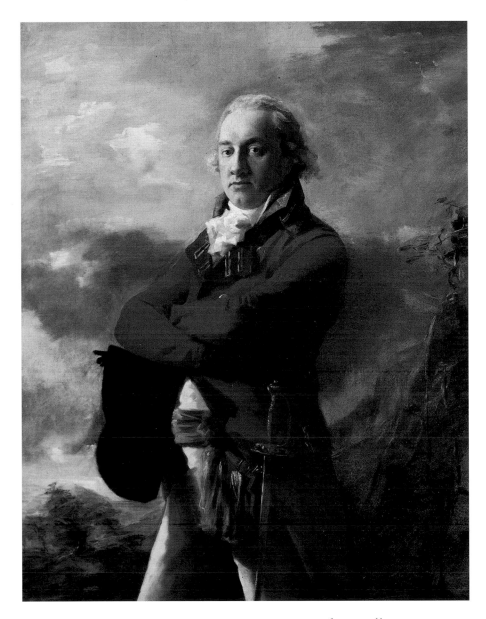

41 *Captain David Birrell*, c. 1790–93

Oil on canvas, 50 x 40 in.
Morehead Planetarium, The University of North Carolina at Chapel Hill

REFERENCES:
James Grieg, *Sir Henry Raeburn, R.A.* (London, 1911), 40; Duncan Thomson, *Raeburn*, exh. cat. (National Galleries of Scotland, Edinburgh, 1994), no. 15.

defining form almost entirely through bold contrasts of chiaroscuro. Dramatic illumination from the upper left corner of the canvas bathes that side of Birrell's face and body in intense light, while the opposite side recedes into shadow. Certain elements, such as the sword hanging at his side, are defined almost exclusively by the sparkling highlights that bounce off their surfaces. In other passages subtly applied half-tones modulate the stark transitions from highlight to shadow.

Raeburn's spontaneous technique and acute eye enabled him to work with astonishing speed. Robert Louis Stevenson penned an insightful assessment of his art a century after the present painting was executed: "He looked people shrewdly between the eyes, surprised their manners in their face, and had possessed himself of what was essential in their character before they had been many minutes in his studio. What he was so swift to perceive, he conveyed to the canvas almost in the moment of conception."[1]

On Birrell's death his portrait passed to his brother, also in the service of the East India Company, and remained with his family until the first decade of the twentieth century. The painting's exhibition on four occasions between 1903 and 1911 and its reproduction in several magazines made it fairly well known by the time it entered the collection of Marshall Field in Chicago, sometime before 1939. In 1950 it was acquired by John Motley Morehead, a native North Carolinian of Scottish descent, who was then forming a collection of art (chiefly Scottish, English, Dutch, and Flemish portraits) in tribute to his recently deceased wife and her artistic interests. The collection still hangs in the Genevieve B. Morehead Memorial Gallery at the University of North Carolina, Chapel Hill.

RA

1. Robert Louis Stevenson, "Some Portraits by Raeburn," in *Virginibus Puerisque and Other Papers* (London, 1881), 221.

EXHIBITED AT YALE ONLY.

42 Raeburn had a gift for capturing the charming characteristics of children and for elevating them to an iconic level through his romantic and idealizing manner of presentation. The bravura brushwork and sentimental mood of this portrait of young Quentin McAdam (1805–1826) illustrate the principal strengths of Raeburn's style. The boy towers before an atmospheric landscape backdrop, dressed for outdoor activity with a whip in one hand and his hat in the other. The physically ennobling treatment lends the child an air of authoritative gravity, while the dramatic illumination imbues him with a radiant aura. Thrusting his hips to his right and shifting his weight onto his standing leg, the boy assumes a pose of dashing nonchalance. The confidence suggested by his pose is undercut, rather touchingly, by the trusting ingenuousness of his direct gaze and slightly parted lips. Tilting his head to one side and looking earnestly out of the picture, he makes a beguiling appeal to the viewer.

The subject of the portrait was the grandson of John McAdam of Craigengillan, Ayrshire, a wealthy landowner and agricultural improver, as well as an early supporter of the poet Robert Burns. In 1786 Burns addressed a rhymed epistle "To Mr. McAdam of Craigengillan, in answer to an obliging letter he sent in the commencement of my poetic career." Quentin McAdam's father (and namesake) committed suicide in the year of the boy's birth, and young Quentin himself died in tragic circumstances, aged just twenty-one.

The poignant combination of confidence and vulnerability in this portrait seems appropriate to Quentin McAdam's personal circumstances. However, such qualities are fairly typical in late-eighteenth- and early-nineteenth-century British portraits of male

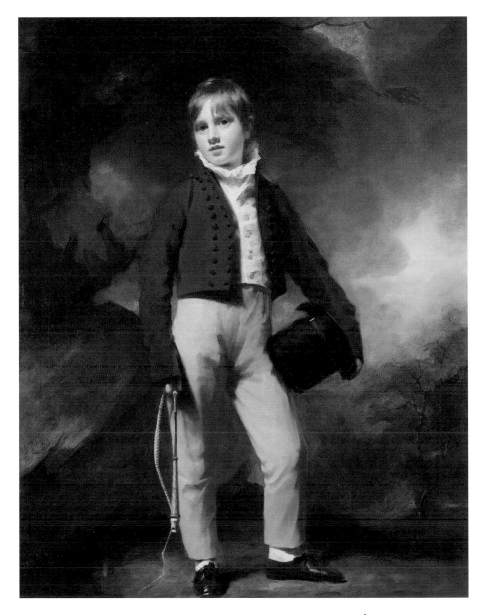

42 *Quentin McAdam,* c. 1812–17

Oil on canvas, 61 x 47 in.
Yale Center for British Art, Paul Mellon Collection

REFERENCES:
Esther Singleton,
*Old Masters in New
World Collections* (New
York, 1929), 416; W. R.
Valentiner, *Unknown
Masterpieces in Public and
Private Collections* (New
York, 1930), no. 101.

children and adolescents (see no. 17). The mood of such portraits reflects the idealization of childhood as a quasi-sacred, idyllic stage of human development, inspired by the writings of the French philosopher Jean-Jacques Rousseau. By calling attention to Quentin McAdam's emulation of adult dress and behavior while simultaneously underscoring his youth, Raeburn's portrait invokes a melancholy consciousness of the ephemerality of the child's golden state of innocence.

In the last decades of the nineteenth century, Raeburn's sweetly sentimental portraits of children became highly sought after among British and American collectors. As a result the prices of such paintings increased at an astonishing rate. *Boy with Cherries*, for example, auctioned by Raeburn's executors for £252 in 1877, sold for £310 in 1888, and for £2100 in 1901. During that period the present portrait was scarcely known, having hung for more than a century at Camlarg, the dower-house of Craigengillan. In 1926 it was purchased by Thomas Agnew & Sons, who sold it to the American advertising impresario and self-made millionaire Alfred W. Erickson. Thereafter, *Quentin McAdam* was lauded as one of Raeburn's masterpieces. Following the death of A. W. Erickson's widow in 1961, the painting was acquired at auction in New York City by Paul Mellon, who gave it to the Yale Center for British Art in 1981.

RA

John Constable

✤ 1776–1837

Landscape painter who profoundly influenced the history of British art through his faithful representation of transient qualities of light and atmosphere. The son of a prosperous farmer and mill owner in East Bergholt, Suffolk, Constable balked at joining the family business but remained deeply committed to his home terrain. He learned the rudiments of landscape composition by studying contemporary watercolors and Old Master paintings in the collection of the connoisseur Sir George Beaumont. In 1799 he enrolled in the Royal Academy Schools and dabbled briefly in religious painting and portraiture. Around 1809 he resolved to immerse himself in the scenery of his native Stour Valley. His direct, personal response to nature resulted in a pioneering approach to landscape. Having exhibited at the Royal Academy to little effect since 1802, he created a sensation in 1819 with the first of six large-scale views along the Stour (his "six-footer" canvases). He was elected an Associate of the Academy within months. The three paintings he exhibited at the Paris Salon in 1824 garnered instant acclaim, securing him a gold medal and the enthusiastic praise of young French painters. In England, however, he continued to suffer neglect, and it was not until 1828 that he was elected a full Academician.

43 Constable hinted at the circumstances behind this painting in a letter of October 25, 1814, in which he informed his correspondent, "I have almost done a picture of 'the Valley' for Mr Fitzhugh—(a present for Miss G. to contemplate in London)."[1] "Miss G." was Philadelphia Godfrey, who had grown up as Constable's neighbor in East Bergholt, Suffolk. She was to leave the Stour Valley and settle in London following her marriage to Thomas Fitzhugh on November 11, 1814. As a wedding present her fiancé commissioned Constable to create a memento of the countryside surrounding her childhood home. The painter had carried out a similar project fifteen years earlier, producing four drawings of Stour Valley scenery prior to another neighbor's marriage and departure from Suffolk. He would later provide at least one more bride with a pictorial reminder of home terrain (see no. 47).

Constable was pursuing his career in London when he received Fitzhugh's commission. Having recently resolved to work more closely from nature, he traveled to the Stour Valley in early autumn 1814 to carry out the picture. After selecting the prospect that he wished to paint, he captured the lay of the land in a small, rapidly executed oil study, completed in a single sitting on September 5 (Leeds City Art Galleries, Temple Newsam House). Over the next several weeks he made numerous oil studies and pencil sketches in which he continued to analyze the general topography while also refining specific details, such as the laboring figures and the cart and horses. The unusually large number of preparatory studies attests to Constable's sense of the painting's importance as his first major landscape commission.

Constable moved on to the final canvas while still in Suffolk, evidently continuing to paint outdoors. In order to ensure the consistent appearance of light and shadow, he limited himself to working on the picture during the morning hours, turning his attention to an afternoon scene later in the day. The result is an entirely convincing evocation of light and atmosphere, with the distant prospect of Dedham

1. R. B. Beckett, ed., *John Constable's Correspondence*, 6 vols. (Ipswich, 1964), 2:134–35.

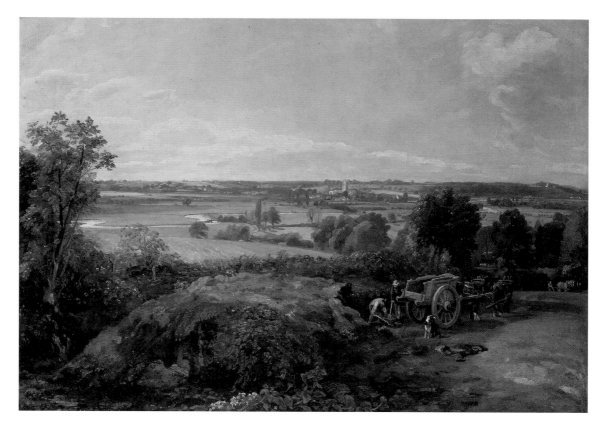

43　*The Stour Valley and Dedham Church, 1814–15*

Oil on canvas, 21 ¾ x 30 ¾ in.
Museum of Fine Arts, Boston. Warren Collection, William Wilkins Warren Fund

village seen through a veil of aerial mist. In response to critical complaints of negligence, Constable had been striving for a more fastidious level of finish in his work. The present painting abounds in exquisitely observed details, such as the carefully articulated vegetation in the immediate foreground, the equipage of the horses, and the smoke rising from the chimneys of Dedham. The artist's fine touch never appears labored, however, remaining fresh and fluid throughout. Certain elements, such as the cart and horses, may have been finished indoors with the aid of sketches. He often used such drawings for more than one painting, and in fact the dog shown turning his head to the right also appears in *The Wheatfield*, which Constable began painting in 1815 (no. 44).

Like most of Constable's landscapes, *The Stour Valley and Dedham Church* is peopled with agricultural laborers who inflect the scene with a moral quality, suggesting prosperity and diligent toil. The precise nature of their activities has aroused considerable comment. Eschewing such conventional landscape motifs as foraging peasants and shepherds tending their flocks, Constable has depicted laborers excavating a large dunghill in preparation for autumn manuring. Searching for meaning in this unusual motif, scholars have interpreted it as everything from a Christian symbol of rebirth to a "ribald" reference to the bride's fecundity. It seems most likely, however, that the artist merely documented the agricultural activity that he happened to witness while at work on the painting. By its very earthiness and lack of romanticism, the vignette reflects the strength of Constable's redoubled commitment to naturalistic fidelity.

The Stour Valley and Dedham Church was among eight paintings that Constable contributed to the Royal Academy exhibition in 1815. Thereafter, the painting presumably remained with Philadelphia Fitzhugh until her death in 1869. Through channels that remain obscure, it was acquired sometime between 1885 and 1900 by the American collector James McLean, becoming one of the first paintings by Constable to find a permanent home in the United States. McLean's heir sold the painting in 1948, when it was acquired by the Museum of Fine Arts, Boston.

RA

44 In the fields and waterways of his native Stour Valley in rural Suffolk, Constable found subject matter that would occupy him for much of his career. Early on, he resolved not to imitate the conventional formulas of landscape composition, but rather to create "a pure and unaffected representation" of the Suffolk countryside, based on laborious preliminary studies made outdoors.[2] *The Wheatfield* almost certainly results from the artist's early experimentation with an even more rigorous form of naturalism, in which the final canvases themselves were brought outside in order to be painted directly from nature. The method enabled Constable to capture the exact fall of light and shadow and the optical effects of weather and atmosphere, as well as the characteristic activities of agricultural life.

Constable's narrow geographic range is indicated by the fact that he depicts the same field in the foreground of this painting that appears in the previous year's *The Stour Valley and Dedham Church* (no. 43). Shifting his vantage point further west, so that the village of Dedham lies beyond the left edge of the composition, he provides a more expansive view of the field, opening onto a sweeping panorama of the Vale of Dedham in the distance. X-rays of the

REFERENCES:
John Barrell, *The Dark Side of the Landscape* (Cambridge, 1980), 148–51; Ronald Paulson, *Literary Landscape: Turner and Constable* (New Haven and London, 1982), 130–32; Michael Rosenthal, *Constable: The Painter and His Landscape* (New Haven and London, 1983), 14, 78–87; Leslie Parris and Ian Fleming-Williams, *Constable*, exh. cat. (Tate Gallery, London, 1991), no. 74; Graham Reynolds, *The Early Paintings and Drawings of John Constable*, 2 vols. (New Haven and London, 1996), 1:205, no. 15.1.

2. Beckett, 2:32.

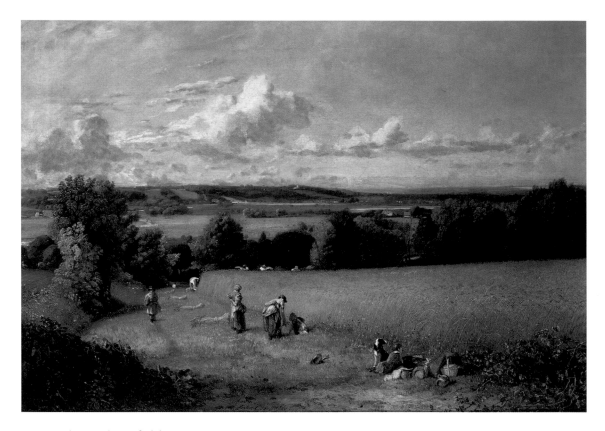

44 *The Wheatfield, 1815–16*

Oil on canvas, 21 ⅛ x 30 ⅜
Sir Edwin and Lady Manton

painting indicate that Constable altered the composition radically as he worked and that he had originally contemplated an entirely different view of the vale. The changes suggest that he skipped the preliminary stage of formalizing his ideas in an oil study (as he did prior to painting *The Stour Valley and Dedham Church*) and instead developed the composition spontaneously on the canvas.

Constable painted much of *The Wheatfield* during the month of August 1815. In a letter of August 27 he informed his fiancée, "I live almost wholly in the feilds [sic] and see nobody but the harvest men."[3] The previous autumn he had witnessed laborers preparing the ground for sowing wheat; in the present painting he documented the harvesting of that very same crop. Closest to the viewer, he represents a group of women and children gleaning the sheaves left behind by the male harvesters, whom we see working in the distance. Constable studied the individual figures in a series of pencil studies (Musée du Louvre, Paris), which may have assisted him later in the year while he refined the details of the canvas in preparation for the Royal Academy's spring exhibition.

As part of the finishing process, Constable worked over the picture with fine touches of a stiff, granular paint that stands up from the surface of the canvas. The highlights add to the textured effect of the brushwork and create an impression of shimmering light and movement. The ultimate appearance surprised those who associated Constable with a less polished style of handling. A reviewer who saw the painting at the Royal Academy in 1816 remarked that the artist had gone "from extreme carelessness . . . to the other extreme, and now displays the most laboured finish."[4] When Constable exhibited *The Wheatfield* again, in 1817 at the British Institution, the picture won praise from another critic who asserted that its "beautiful" color and general effect provided "a close portraiture of our English scenery."[5] Thereafter, *The Wheatfield* disappeared from view until the late 1980s, when it was finally traced to a private American collection. The painting returned to the public eye as part of an exhibition of Constable's work held at the Tate Gallery, London, in 1991. Its reappearance after some 175 years has shed valuable new light on the artist's early working methods.

RA

EXHIBITED AT YALE ONLY.

45 Dedham Mill was located on the Stour River near Constable's childhood home of East Bergholt, Suffolk. It was one of the mills operated by his father, and as a boy he had worked there himself. Beginning in about 1809, Constable explored the artistic possibilities of the site in a series of on-the-spot sketches that provided the basis for an initial version of *Dedham Lock and Mill*, probably painted in 1818. While on display at the British Institution in 1819, the painting found a purchaser, and a few months later Constable was elected an associate of the Royal Academy. Those successes evidently gave him the confidence to produce two additional versions of *Dedham Lock and Mill* as commercial speculations. Proudly signaling his rise above the ranks of provincial artists, Constable added the location "London" to his signature in the present painting, which is the second version. His naturalistic mode of landscape painting still faced considerable resistance, however, and despite his sanguine expectations, neither the present painting nor the third version found purchasers during his lifetime.

Constable's work on the subject of Dedham Lock

REFERENCES: Michael Rosenthal, *Constable: The Painter and His Landscape* (New Haven and London, 1983), 95–97; Leslie Parris and Ian Fleming-Williams, *Constable*, exh. cat. (Tate Gallery, London, 1991), 511, no. 76; Reynolds, 1996, 1:215–16, no. 16.1; Judy Crosby Ivy, *Constable and the Critics, 1802–1837* (Woodbridge and Rochester, 1991), 71–72, 76.

3. Beckett, 2: 149.
4. *Repository of Arts* (June 1816), quoted in Ivy, 71.
5. Ivy, 72.

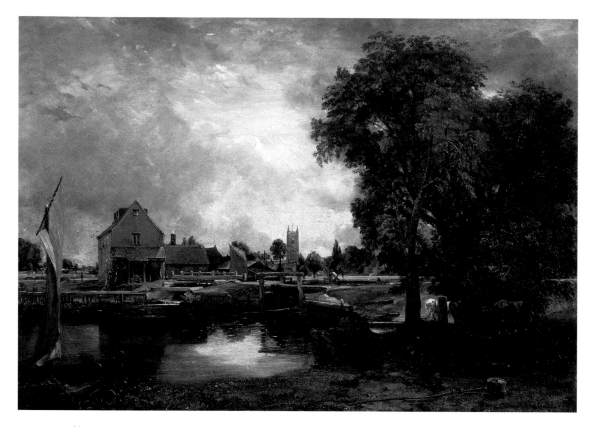

45 *Dedham Lock and Mill*, 1820

Oil on canvas, 21 ½ x 30 ½ in.
The Currier Gallery of Art, Manchester, New Hampshire. Currier Funds, 1949

and Mill over the course of a decade charts his gradual move away from spontaneous outdoor painting to a more deliberate process of analysis and refinement in the studio. All three versions of the painting follow the arrangement laid out in his original on-the-spot sketches, using a screen of towering trees at right as a foil to the open landscape prospect at left. Beyond the reflective water of the canal, we see Dedham Mill with the lock beside it and the tower of Dedham Church rising in the distance. To increase the interest of the scene and draw the eye into space, Constable added several figures in the middle distance, including the conversing pair to the left of the mill and the man bending over the lock.

Constable continued to refine and improve on the composition after transferring the design of his original picture to the present canvas. Rather than produce an exact replica, he elaborated on the subject with a number of impromptu alterations. Most importantly, in the left foreground he added a sailing barge that is absent in the first version. The diagonals of the boat and its sail break up the severe rectilinearity created by the horizontals of land and water and by the vertical lines of the trees. Visible *pentimenti* around the bottom of the sail indicate that the boat was an afterthought, added after the artist had already painted the rippling water of the canal. Constable made additional refinements in the third version of the painting, transferring the rope that is attached to the mooring-post in the present work to the towing-horse that we now see grazing freely beneath the trees.

Fidelity to natural effects and local topography had nothing to do with Constable's changes, which were dictated solely by his desire to hone the painting's pictorial organization. Through such analysis and revision he translated the facts of the Suffolk countryside into an idealized construction characterized by order and tranquility. In this way he reformulated a subject of rather limited, personal interest and produced a universally accessible evocation of rural England. Constable's increasingly ambitious treatment of the scenes of his youth culminated in his "six-footer" canvases, in which he conferred an epic grandeur on Stour Valley scenery (see no. 46). His use of the natural world to convey intimations of sentiment and mood made him a pioneer of the nascent Romantic movement.

After Constable's death his daughter gave *Dedham Lock and Mill* to Jane Spedding, whose father had been Constable's solicitor. Over a century later the painting was brought to the United States by M. Knoedler & Co. of New York, who sold it to the Currier Gallery in 1949.

RA

46 While at work on *View on the Stour near Dedham*, Constable confided to a friend, "I should paint my own places best—Painting is but another word for feeling. I associate my 'careless boyhood' to all that lies on the banks of the Stour."[6] The statement attests to the intimate connection between Constable's art and the Suffolk countryside in which he grew up. In this painting and a handful of others, Constable's deep-seated love for the scenes of his youth inspired him to depict the seemingly unremarkable landscape of the Stour Valley on a monumental scale normally reserved for the noble subject matter of history painting.

Constable exhibited six of these large Stour Valley canvases, known as his "six-footers," between 1819 and

REFERENCES: Rosenthal, 115; Graham Reynolds, *The Later Paintings and Drawings of John Constable*, 2 vols. (New Haven and London, 1984), 47–48, no. 20.11; Malcolm Cormack, *Constable* (Cambridge, 1986), 106–10; Parris and Fleming-Williams, 189, no. 95.

6. Beckett, 6:76–79.

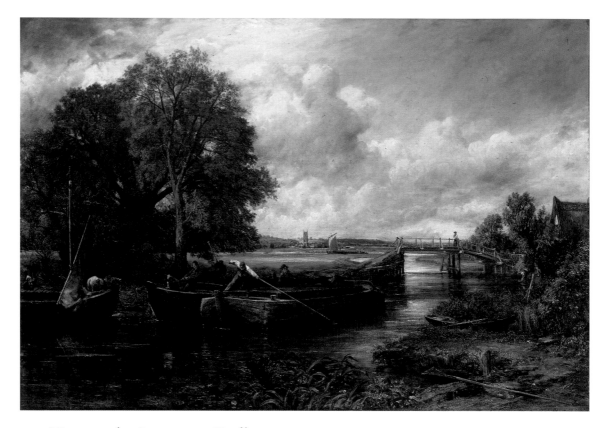

46 *View on the Stour near Dedham,* 1822

Oil on canvas, 51 x 74 in.
The Huntington Library, Art Collections, and Botanical Gardens

1825. Here, in the fourth painting in the series, he shows the Stour wending its way from Flatford Lock (located out of view beyond the far left edge of the canvas), past Flatford Bridge, toward the town of Dedham, whose church tower rises in the distance. The area had been the site of Constable's intense study from 1802 to 1817, when he immersed himself in on-the-spot drawings, oil sketches, and finished paintings that recorded the familiar terrain under varying conditions of light, weather, and season. His open-air studies provided the raw data on which Constable relied years later while painting the Stour from the remote, urban setting of his London studio.

The ostensible focus of *View on the Stour near Dedham* is the strenuous labor of the men and boys on the central barge. However, the artist's real subject is the atmosphere and mood of the place. Apart from the shifting clouds of the sky, which prefigure changes in light and weather, the landscape suggests utter stillness and calm. Measured recession into depth is charted by successive bands of light and shade along the ground, and by the serpentine course of the river from the lower left edge of the canvas all the way to the horizon. Animal and human figures peripheral to the central action are motionless, held in a state of suspended animation. The melding of ephemerality and stillness in this painting reflects the goal underlying much of Constable's art, which, in his own words, was "to give 'one brief moment caught from fleeting time,' a lasting and sober existence."[7]

View on the Stour near Dedham remained unsold at the close of the 1822 Royal Academy exhibition, but in April 1824 it was purchased (with two other paintings, one of them Constable's famous *Hay Wain*, now in the National Gallery, London) by the Paris art dealer John Arrowsmith for a total of £250. In August 1824 the picture was exhibited at the Paris Salon—hung high on the wall, on the mistaken theory that the artist's rugged brushwork required distance to be viewed properly.[8] It was later moved "to a post of honor," where fascinated observers could appreciate "the richness of the texture—and the attention to the surface of objects."[9]

The 1822 Salon proved a watershed for French artists allied with the goal of naturalism. Eugène Delacroix later attested to Constable's impact on this movement, describing him as "the father of our landscape school."[10] Many American collectors (such as George A. Lucas of Baltimore) valued Constable's paintings for their influence on the history of painting in France, for his broken brushwork and ephemeral effects of light and atmosphere ultimately bore fruit in Impressionism, Pointillism, and other modern art movements. For other collectors, however, Constable represented the quintessential English landscape artist, and the Suffolk terrain he immortalized has long been known as "Constable Country."

The art dealer Joseph Duveen had been endeavoring to acquire *View on the Stour near Dedham* as early as 1922, when he first mentioned it to Henry E. Huntington. "With the Turner [no. 53] and [Gainsborough's] 'Cottage Door,'" he assured Huntington, "it would form a trio of the three greatest landscapes possessed by any private collection in the world."[11] Duveen at last acquired *View on the Stour near Dedham* in 1925 on the death of its owner. Having laid the groundwork three years earlier, he sold it to Huntington within a matter of weeks.

RA

REFERENCES:
Beckett, 6:87, 89; Rosenthal, 136–41; Reynolds, 1984, 1:xiv, 99–100, no. 22.1; Ivy, 48–49, 92–97; Robyn Asleson, *British Paintings at The Huntington*, gen. ed. Shelley M. Bennett (New Haven and London, 2001), 58–64, no. 8.

7. "Introduction," *Various Subjects of Landscape, Characteristic of English Scenery . . . from Pictures Painted by John Constable*, R.A. (London, 1833), unpag.
8. Ivy, 48–49.
9. Beckett, 6:185.
10. Quoted in Michel Florisoone, "Constable and the 'Massacres de Scio' by Delacroix," *Journal of the Warburg and Courtauld Institutes* 20 (1957): 180.
11. Joseph Duveen to Henry E. Huntington, letter of May 24, 1922, institutional archives, The Huntington.

REFERENCES:
Reynolds, 1984,
1:56–57, 117–19, no.
23.2, 173–74; Asleson,
54–58, no. 7.

 The sparkling light and palpable sense of atmosphere in this painting demonstrate Constable's ability to capture naturalistic effects on canvas. Although he generally painted such landscapes in his London studio, he invariably based them on studies made out of doors, directly from nature. In the summer of 1820, he spent a highly productive three weeks with the family of Dr. John Fisher, bishop of Salisbury, a friend and early supporter of the artist. During that visit Constable produced numerous outdoor sketches, including a view of Salisbury Cathedral from the southwest, as it appeared from the garden of the Bishop's Palace (private collection). Pleased with the sketch, the bishop eventually commissioned a large painting of the same scene, which Constable embellished with figures in the middle distance, representing the bishop pointing out the cathedral spire to his wife, with one of their daughters advancing toward them, holding a parasol (Victoria and Albert Museum, London).

The present painting is a reduced-scale version of that earlier *Salisbury Cathedral from the Bishop's Grounds*, which Constable exhibited at the Royal Academy in 1823. After the close of the exhibition, the bishop asked Constable to carry out this smaller version as a wedding present for his daughter Elizabeth, who had just become engaged to the attorney John Mirehouse. Writing to the artist on August 3, the bishop explained, "She wishes to have in her house in London a recollection of Salisbury; I mean, therefore, to give her a picture."[12]

Although Constable and the bishop shared many interests and ideas, there was one subject on which they strongly disagreed. Constable's belief that the sky constituted the chief "Organ of sentiment" in a landscape painting led him to make innumerable outdoor studies of clouds under varying weather conditions.[13] The bishop loathed the active, cloud-choked skies that Constable introduced into his pictures, viewing them only as harbingers of rain. Consequently, in his commission of August 3, he specified that the present painting should have "a more serene sky" than Constable had depicted in his original version.[14] The bishop remained dissatisfied with the sky that Constable eventually did paint and, according to his daughter, asked that the artist alter the present painting by inserting a "small piece of blue sky" in order to make the picture "more suitable [as a] marriage gift."[15] X-rays confirm alterations in the cloud patterns, and microscopic analysis reveals several passages of blue pigment applied over an original application of darker paint.

The changes in the sky account for just a few of the alterations that Constable made to this painting after initially hanging it in Elizabeth Mirehouse's London house in October 1823. He continued to fuss over the picture over the next three years and only gave it up under duress in 1826, several months after the bishop's death. Part of Constable's difficulty may have been caused by the unusual amount of architectural detail required by the cathedral itself, which he delineated with uncharacteristic precision. He was evidently pleased with the final result and confided to a friend, "It is wholly a new picture and very pretty."[16]

The personal associations of this painting endowed it with special meaning for the Mirehouse family. They retained it for over 125 years before selling it at Christie's in 1952. The London art dealers Thos. Agnew & Sons purchased the painting at that auction and sold it on to The Huntington, where it remains one of the most important acquisitions made by the institution in the decades following Henry E. Huntington's death.

RA

12. Beckett, 6:125.
13. See Beckett, 6:74.
14. Beckett, 6:125.
15. From a MS. note found inserted between the canvas and the stretcher when the painting was cleaned in 1952 (Huntington curatorial file).
16. Beckett, 6:213.

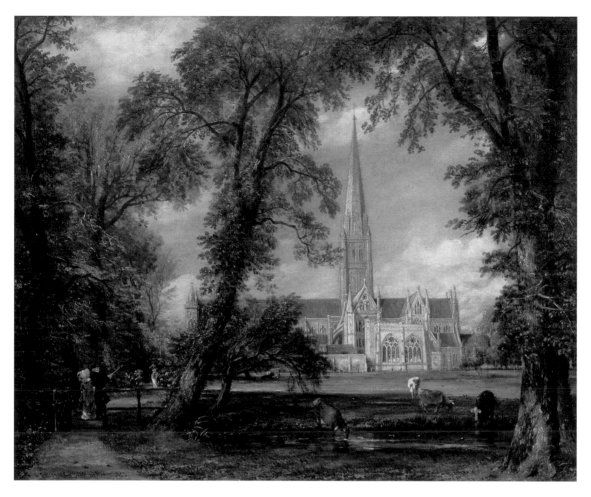

47 *Salisbury Cathedral from the Bishop's Grounds, 1823–26*

Oil on canvas, 24 ¾ x 29 ⅞ in.
The Huntington Library, Art Collections, and Botanical Gardens

48 The ruins of the thirteenth-century Hadleigh Castle stand on the northern shore of the Thames estuary, overlooking the stretch of water known as the Nore, where the river meets the open sea. Constable shows the view looking southeast from the castle, with the tower of St. Clement's, Leigh-on-Sea, further along the near shore, the shoreline and hills of Kent in the distance opposite, and the town of Sheerness on the far right. He first visited this spot in 1814 and wrote admiringly of the view in a letter to his fiancée Maria Bicknell: "At Hadleigh there is a ruin of a castle which from its situation is really a fine place—it commands a view of the Kent hills the nore and the north foreland & looking many miles to sea." In the same letter he mentions a walk on the beach at nearby Southend-on-Sea, remarking that he was "always delighted with the melancholy grandeur of a sea shore."[17] He made a rough drawing of the scene at Hadleigh in a sketchbook, and this was to serve as the basis for the present large exhibition picture, painted some fifteen years later—one of the series of "six-footers" that the artist considered his most important contributions to the art of landscape painting. A small oil sketch for the composition was bequeathed to the Yale Center for British Art by Paul Mellon in 1999, and a sketch on the same scale as the final painting is in the Tate Collection in London.

When Constable first showed *Hadleigh Castle* at the Royal Academy exhibition of 1829, he had the following lines from James Thomson's poem *The Seasons* printed in the catalogue:

> *The desert joys*
> *Wildly, through all his melancholy bounds*
> *Rude ruins glitter; and the briny deep,*
> *Seen from some pointed promontory's top,*
> *Far to the dim horizon's utmost verge*
> *Restless, reflects a floating gleam.*

The association of ruins with desolation and melancholy was by this time a commonplace of art and literature. Constable's great contemporary J. M. W. Turner, for instance, used the same passage from *The Seasons* for the view of the ruined Dunstanburgh Castle that he showed at the Royal Academy in 1798 (National Gallery of Victoria, Melbourne), another morning scene after a stormy night. In the Romantic imagination ruins were awe-inspiring, or "sublime," because they suggested the shortness of human life as against the passage of the ages and showed the ravages visited by time upon even the sturdiest works of mankind; they were a *memento mori*, a symbol of universal decay. Through his choice of viewpoint in *Hadleigh Castle*, Constable sets his ruins against a scene full of the grandeur and power of nature: the flow of the mighty river toward the infinite "briny deep," the drama of morning sunlight bursting through clouds. There has been a storm in the night, and the craggy remains of the castle appear as though lashed by wind and rain, perhaps even struck by lightning. The theme of the Romantic ruin flourished in American art as well as British, and *Hadleigh Castle* in particular seems to have inspired a number of paintings of ruined towers by the American landscape painter Thomas Cole.

Beyond its general significance as an image of transience, there is little doubt that Constable thought of *Hadleigh Castle* as autobiographical. His beloved Maria, whom he married after a long engagement in 1816, died of consumption in November 1828. He was left desolate and depressed, a ruin of a man—he used this metaphor himself—for the rest of his life. "Hourly do I feel the loss of my departed Angel," he wrote in December 1828. "I shall never feel again as I have felt. The face of the world is totally changed to me."[18] He began *Hadleigh Castle* in January or

17. Reynolds, 1984, 199.

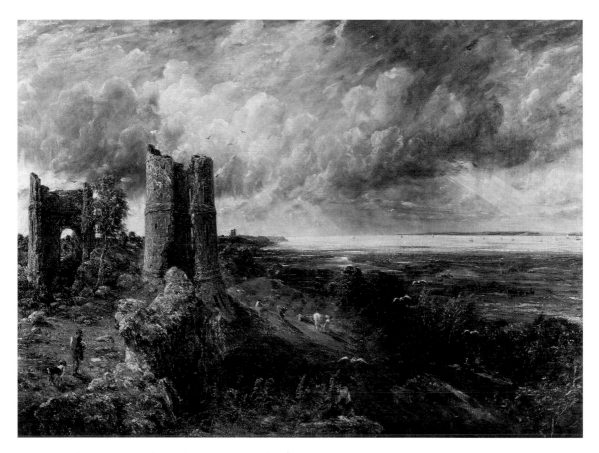

48 *Hadleigh Castle, The Mouth of the Thames—Morning after a Stormy Night,*
1829

Oil on canvas, 48 x 64 ¾ in.
Yale Center for British Art, Paul Mellon Collection

REFERENCES:
John Walker, *Self-Portrait with Donors: Confessions of an Art Collector* (Boston and Toronto, 1974), 188–89; Malcolm Cormack, "In Detail: Constable's *Hadleigh Castle*," *Portfolio* (Summer 1980): 36–41; Louis Hawes, "Constable's *Hadleigh Castle* and British Romantic Ruin Painting," *Art Bulletin* 65, no. 3 (September 1983): 455–70; Reynolds, 1984, 199–200, no. 29.1; Malcolm Warner and Julia Marciari Alexander, with an introduction by Patrick McCaughey, *This Other Eden: Paintings from the Yale Center for British Art* (New Haven, 1998), 146–47, no. 59.

February 1829; and it seems likely, given his deep grief and abiding Christian faith, that he would have thought of this view from ruins to distant open sea as a view, in spiritual terms, from grief toward consolation. The sunbursts and "floating gleam" on the horizon suggest the light of heaven and the bereaved's hope of reunion in the afterlife, while the Nore, between river and sea, serves as an image of the passage from earthly to eternal realms.

Hadleigh Castle was unsold in the artist's lifetime and appeared in his sale in 1838. By the 1950s it was in the collection of Countess László Széchenyi (Gladys Moore Vanderbilt, daughter of Cornelius Vanderbilt) in Washington, D.C. The director of the National Gallery of Art, John Walker, had hopes that the work might eventually come to the gallery and was disappointed when the Countess sold it to the London dealer Agnew's. Paul Mellon bought it from Agnew's in 1961. In the Mellon Collection at Yale it serves as a natural counterpart to Turner's *Dort* (no. 50) and the centerpiece to one of the greatest Constable collections in the world, which includes some sixty of his paintings as well as numerous drawings and watercolors.

MW

18. Hawes, 456.

Joseph Mallord
William Turner

ᘒ 1774–1851

Romantic landscape and seascape painter. Turner made his name in the early 1790s as a topographical watercolorist. Throughout his life he made extensive sketching tours in Britain and on the Continent, visiting Wales for the first time in 1792, France and Switzerland in 1802, and Italy in 1819–20. He made his debut as a painter in oils at the Royal Academy exhibition of 1796. He was elected a Royal Academician in 1802 and remained a staunch supporter of the RA throughout his career. From 1812 he showed some of his paintings at the RA exhibitions with lines from his own poem "Fallacies of Hope." Turner was technically brilliant and enormously ambitious, and his work addresses such themes as the fate of empires, the vanity of human endeavor, and the transience of life. Throughout his work there are self-conscious allusions to his predecessors in landscape painting, the Dutch masters of the seventeenth century and Claude Lorrain. The oils and watercolors of his middle to late career, from the 1820s onward, suggest a world in spectacular dissolution, and some of his last paintings treat subjects of a visionary nature.

49 The story of Aeneas and the Sibyl is from the sixth book of Virgil's *Aeneid*. The Trojan hero and his men have landed on the Italian coast at Cumae, near Naples, which is famous as a shrine to the god Apollo. Here Aeneas consults the Sibyl, Deiphobe, who serves as the god's priestess and prophetic mouthpiece. He knows that within the sacred precincts there is an entrance to the underworld and begs the Sibyl to take him down to the nether regions to see the shade of his dead father, Anchises. The Sibyl tells him of a tree in a neighboring grove that bears a golden bough; if he breaks this off and takes it as an offering to the queen of the underworld, Proserpine, it will protect him from the perils of the journey. She leads him to a cave near Lake Avernus—named from the Greek for "birdless," since its hellish vapors supposedly killed any birds flying overhead. He makes sacrificial offerings to Proserpine and Pluto; then he and the Sibyl make their descent into the underworld, carrying the golden bough. In the Elysian Fields Aeneas meets the shade of his father, who shows him the souls of his descendants as yet unborn, the line of kings, consuls, and emperors who will rule the future Rome. As the story of a hero who braves the unknown, leaving Apollo's realm of light and sun to follow his destiny in that of Stygian gloom, this was the kind of classical legend that appealed most powerfully to the Romantic imagination.

Turner shows the Sibyl holding aloft the golden bough, gesturing toward the lake, and calling upon Aeneas to follow her: "Now, Trojan, take the way thy fates afford; / Assume thy courage, and unsheathe thy sword" (from the translation by Dryden, which Turner probably used). A couple of his men and a priest are making a burnt offering, presumably part of the sacrifices to Proserpine and Pluto. In the shadows to the right, a foretaste of the darkness of the underworld, the relief carved on a piece of fallen masonry represents the parallel story of the twelfth labor of Hercules, in which the hero descends into the underworld to bring back the monstrous three-headed guard-dog Cerberus. The view over the lake

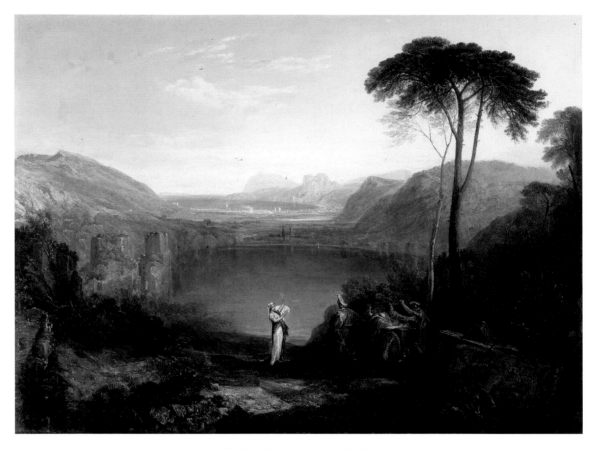

49 *Lake Avernus: Aeneas and the Cumaean Sibyl*, 1814–15

Oil on canvas, 28 ¼ x 38 ¼ in.
Yale Center for British Art, Paul Mellon Collection

is from the north side looking south. The ruins on the edge of the lake to the left were believed in Turner's time to be an ancient temple of Apollo but are in fact Roman baths. The large building in the distance on the right is the Castle of Baiae, and the island visible on the horizon is Capri. The fall of light indicates late afternoon or early evening: Aeneas prepares to enter the darkness of the underworld just as darkness encroaches on the world above.

As the second version of a picture of more or less the same size, painted in about 1798, this is a rare instance of Turner's repeating himself.[1] He had never seen Lake Avernus (he was to make his first visit to Italy in 1819–20) and based the first version on a topographical drawing by Sir Richard Colt Hoare of Stourhead, Wiltshire. Hoare was a lover of Italy and the Antique and as a child had watched his grandfather Henry Hoare create the magnificent classical gardens at Stourhead with their lake and temples—including one dedicated to Apollo. As well as providing the drawing, Hoare may actually have commissioned the first version of *Lake Avernus*, probably to hang as a pendant to a view of Lake Nemi by Richard Wilson that was already at Stourhead: the canvases are close in size; they deal with related subjects—Lake Nemi was associated with Apollo's sister Diana—and the Turner was obviously intended as an imitation of Wilson's style.[2] The chain of events is a matter for speculation, but we know that Hoare did commission this, the second version, and that it did hang as a pendant to the Wilson at Stourhead. Perhaps there was an exchange in which Turner took back the first version—which would explain why it was in his studio at his death and became part of the Turner Bequest (Tate Collection). Certainly the second version represents the artist more impressively than the first; with its brighter palette and

wonderfully subtle effects of aerial perspective, it typifies his artistic development around the middle of his career.

Paul Mellon purchased the work in 1963, from the London art dealers Gooden and Fox. It was one of his inaugural gifts to the Yale Center for British Art on its opening in 1977.

MW

50 Turner visited Dordrecht (sometimes known as Dort) during his tour of the Netherlands and the Rhine in the summer of 1817; he was there for only a day and a half but made numerous pencil sketches, and these served as the basis for the present work. The city is seen from the north, from a point on the river Noord, which connects it to Rotterdam; the skyline is dominated by the Groote Kerk, or Church of Our Lady. The direction of the light shows that it is morning. The becalmed packet is more precisely a market-boat or "beurtschip"; the one that sailed between Dordrecht and Rotterdam was traditionally called "De Zwaan" and flew a flag with the emblem of a swan as shown here. While awaiting a change in the wind or tide, the passengers are buying food and drink from enterprising local people in rowing boats.

Ever matching himself against other landscapists, both ancient and modern, Turner painted the Dort as a tribute-cum-challenge to the seventeenth-century Dutch master Aelbert Cuyp. The allusion is especially apt, since Dordrecht was Cuyp's birthplace, and the black-capped painter in the rowing boat may be meant as a tongue-in-cheek portrait of him. The contrasting of dark elements against luminous sky and water in the work are distinctively Cuyp-like,

REFERENCES:
Martin Butlin and Evelyn Joll, *The Paintings of J. M. W. Turner*, rev. ed., 2 vols. (New Haven and London, 1984), 135–36, no. 226; Gerald Finley, "Love and Duty: J. M. W. Turner and the Aeneas Legend," *Zeitschrift für Kunstgeschichte* 55 (1990): 388–89; Malcolm Warner and Julia Marciari Alexander, with an introduction by Patrick McCaughey, *This Other Eden: Paintings from the Yale Center for British Art* (New Haven, 1998), 88–89, no. 31.

1. See Butlin and Joll, 24–25 (no. 34).
2. For the Wilson, see David Solkin, *Richard Wilson: The Landscape of Reaction*, exh. cat. (Tate Gallery, London, 1982), 192–93 (no. 77).

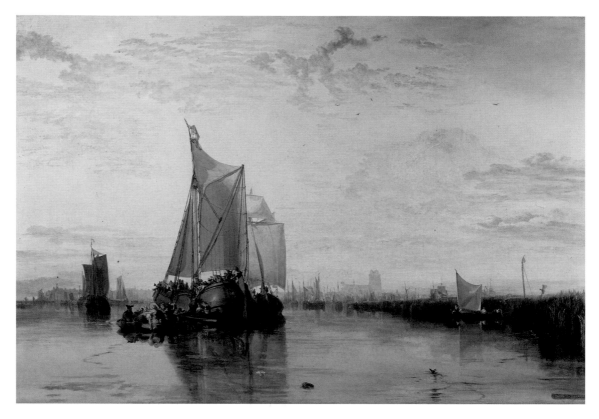

50 *Dort or Dordrecht: The Dort Packet-Boat from Rotterdam Becalmed, 1817–18*

Oil on canvas, 62 x 92 in.
Yale Center for British Art, Paul Mellon Collection

recalling in particular that artist's painting of *The Maas at Dordrecht*, then in the collection of the Duke of Bridgewater. Turner may also have referred to *The Rotterdam Ferry*, then in the collection of the Earl of Carlisle, from which he could have borrowed the swan design on the flag. (Both these Cuyps are now in American collections, respectively the National Gallery of Art and the Frick Collection.) In subject, composition, and scale Turner's painting also plays competitively off a near-contemporary work, Augustus Wall Callcott's *Entrance to the Pool of London* (Earl of Shelburne)—itself an homage to Cuyp—which Turner had admired at the Royal Academy exhibition of 1816.[3]

Turner measured himself up against Cuyp and Callcott quite knowingly, expecting the informed viewer to call them to mind and, of course, to judge the winner of the contest to be Turner. In most respects it is. The thrill of space, light, and distance that he conveys in such a work, his mastery of atmospheric perspective, are surely unmatched in the history of painting. Much of this comes from the details: his handling of the Groote Kerk, for instance, imparts quite magically the effect of elaborate stonework seen at a certain distance in a certain light—even the suggestion of details as yet unseen, blended together in the golden haze, that would emerge as we approached more closely. The conjuring of effects of distance was the artist's chief motive in the work, and it is surely no accident that its subject, a becalmed boat, is all about being at some distance from a destination. The incident of the boat also draws attention to the great calmness of the scene as a whole. On a symbolic level, moreover—given Turner's abiding interest in the fate of nations and the rise and fall of empires—it may represent the economic and political state of the Netherlands,

glorious in the age of Cuyp but now in the doldrums.

The painting was bought from the Royal Academy exhibition of 1818 by one of Turner's leading patrons, Walter Fawkes of Farnley Hall, near Leeds in Yorkshire. As a later watercolor of Turner's shows, it hung over the fireplace in the drawing room at Farnley, with the light falling from the left as it does in the scene. It remained at Farnley more or less without interruption until purchased by Paul Mellon from Fawkes's descendants in 1966; it was brought to Mellon's attention as a possible acquisition by his friend John Walker, director of the National Gallery of Art.[4] The *Dort* was the jewel in the crown of Paul Mellon's inaugural gift to the Yale Center for British Art in 1977 and remains the centerpiece of its paintings collection.

MW

EXHIBITED AT YALE ONLY.

REFERENCES:
Malcolm Cormack, "'The Dort': Some Further Observations," *Turner Studies* 2, no. 2 (Winter 1983): 37–39; Butlin and Joll, 102–4, no. 137; Warner et al., insert, n. p.

51 Staffa is a small, uninhabited island in the Hebrides, off the west coast of Scotland. The place is famous for its many caves and for its strange, columnar formations of purple-gray basalt. It was already a much visited attraction when Turner went there in the summer of 1831, taking a tourist paddle-steamer much like the one in his painting. Fingal's Cave was the largest of the caves on Staffa; discovered by chance by Joseph Banks in 1772, it was named for a central character in the poems of Ossian. These were supposedly the writings of a third-century bard, a Celtic Homer, but in fact a modern pastiche of northern myths and legends composed by their "translator" James Macpherson. The Ossianic poems were wildly popular and the main fuel for Romantic ideas of

3. See David Blayney Brown, *Augustus Wall Callcott*, exh. cat. (Tate Gallery, London, 1981), 78–79, no. 15.
4. See John Walker, *Self-Portrait with Donors: Confessions of an Art Collector* (Boston and Toronto, 1974), 187–88.

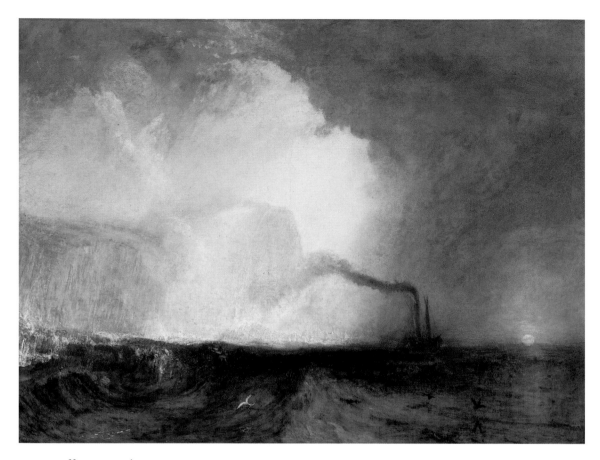

51 *Staffa, Fingal's Cave, 1831–32*

Oil on canvas, 36 x 48 in.
Yale Center for British Art, Paul Mellon Collection

Scotland until superseded by the poems and novels of Walter Scott.

Fingal was a hero of superhuman proportions, almost a force of nature, for whom an awe-inspiring cave on an island lashed by the sea would seem a fitting habitation. To the Romantic imagination, the cave also carried an aura of mystery and spirituality, like the temple of some primeval Ossianic religion, a natural cathedral. Walter Scott took up this imagery in his poem "The Lord of the Isles," likening the noise of the sea to resounding organ music:

Where Nature herself, it seemed, would raise
A Minster to her Maker's praise!
Not for a meaner use ascend
Her columns, or her arches bend;
Nor of a theme less solemn tells
That mighty surge that ebbs and swells.
And still, between each awful pause
From the high vault an answer draws.

Turner visited Scott on his way north; he had this passage in mind when he painted *Staffa* and quoted the last four lines in the catalogue when the work was shown at the Royal Academy exhibition of 1832. Although Scott was describing the inside of the cave and Turner's view is from a distance, the general idea of waves echoing among rocks and elements responding to one another suits the painting well: storm clouds arch over the island as though imitating its outline; the cliffs take on an orange-pink tinge from the light of the setting sun. Against all this sublime natural drama, the man-made element in the scene, the paddle-steamer, appears dwarfed— suggesting the familiar Romantic and Turnerian idea of mankind at the mercy of fate.

Staffa was the first painting by Turner to enter an American collection. In 1845 Colonel James Lenox of New York commissioned the artist C. R. Leslie to approach Turner on his behalf and spend up to £500 on a painting. Turner's immediate response to the idea of Americans buying his work was typically cantankerous: "No, they won't come up to the scratch." But he finally relented and parted with *Staffa*, which had remained unsold since first exhibited in 1832. In a letter to Lenox written soon after the painting had reached New York, Leslie reported a conversation in which Turner asked how Lenox liked the work, to which Leslie replied, "He thinks it indistinct." Turner has been widely misquoted as responding defiantly, "You should tell him that indistinctness is my *forte*," but the letter actually reads "indistinctness is my fault." In any case Lenox soon overcame his reservations about the painting, writing to Leslie, "Burn my last letter, I have now looked *into* my 'Turner' and it is all that I could desire."[5]

The son and heir of a wealthy merchant and real estate investor, James Lenox was one of the greatest of New York's early collectors and the first serious collector of British art in the States. In addition to Turner, the British artists represented in his collection included Reynolds, Gainsborough, Raeburn, and Constable. Ranging widely in his tastes and interests, Lenox was to buy a set of twelve large Assyrian reliefs for the New-York Historical Society (they are now at the Brooklyn Museum of Art). He also formed the largest private collection of Bibles in the States, including the first Gutenberg Bible to cross the Atlantic, and in 1870 founded the Lenox Library, later to become the cornerstone of the New York Public Library.

Staffa was one of the many and various treasures James Lenox gave the Lenox Library in the 1870s. As such it passed into the collections of the New York Public Library, from which it was auctioned at Parke Bernet, New York, in 1956. It was bought by the

REFERENCES:
Henry Stevens, *Recollections of James Lenox and the Formation of His Library* (New York, 1951), 40–43; Adele M. Holcomb, "'Indistinctness is my fault:' A Letter about Turner from C. R. Leslie to James Lenox," *Burlington Magazine* 114 (August 1972): 557–58; Butlin and Joll, 198–99, no. 347; Edmund D. Pillsbury, "Paul Mellon as Collector and Patron of British Art: Selected Painting Acquisitions, 1976–1980," *Essays in Honor of Paul Mellon, Collector and Benefactor*, ed. John Wilmerding (National Gallery of Art, Washington, 1986), 259; Warner et al., 148–49, no. 60; *Art and the Empire City: New York, 1825–1861*, ed. Catherine Hoover Voorsanger and John K. Howat, exh. cat. (Metropolitan Museum of Art, New York, 2000), 97–98.

5. See Stevens, 40–43, and Butlin and Joll, 199.

London dealer Agnew's, from whom it was bought in turn by the Honourable Gavin Astor, later Lord Astor of Hever. Paul Mellon bought the work from Astor in 1977, the year in which the Yale Center for British Art opened, with a view to strengthening the representation of Turner's later work in the Center's collection.

MW

REFERENCES:
Butlin and Joll, 206–7, no. 357; Alison McQueen, "Private Art Collections in Pittsburgh: Displays of Culture, Wealth, and Connoisseurship," in *Collecting in the Gilded Age: Art Patronage in Pittsburgh, 1890–1910,* exh. cat. (Frick Art and Historical Center, Pittsburgh, 1997), 75–76; Warner et al., insert, n.p.

52 Wreckers were gangs who scavenged debris and goods from wrecked ships, often luring them to their destruction by setting false lights near dangerous rocks. The theme of shipwreck was a lifelong fascination of Turner's. In an age when sea travel was full of perils, there was no sight more immediately disturbing. It demonstrated the awe-inspiring power of nature and, for Romantic and pessimistic sensibilities such as Turner's, the ultimate helplessness and ignominy of mankind. Later he was to tell the story of a terrible storm in which he himself was almost shipwrecked: instead of going below decks, he had the sailors lash him to the mast so that he could experience the full fury of the elements and afterwards recorded his impressions in the swirling *Snow Storm—Steam-Boat off a Harbour's Mouth* (Tate Collection).

Here the vessel in difficulties on the bleak Northumbrian shore is a two-masted sailing ship, seen in the distance near the center of the composition. Although the title states that the steam-boat to the right is "assisting," it seems clear that the time for this is past and the ship lost; indeed the implication is that the wreckers in the foreground are already dragging in the remains. The castle in the background is identifiable as Dunstanburgh. Turner made a number of drawings at Dunstanburgh on an early sketching tour and made the castle the subject of one of his first oil paintings, exhibited at the Royal Academy in 1798 (National Gallery of Victoria, Melbourne); later he also painted a watercolor of the scene (Manchester City Art Gallery), which was published as an engraving in his series of *Picturesque Views in England and Wales.* In *Wreckers* the castle introduces another of the recurrent themes of his work, the ruin as a symbol of transience: the tempestuous sea and sky may be more spectacular in their destructiveness, but time makes a wreck of everything.

Turner exhibited *Wreckers* at the Royal Academy in 1834 and the British Institution in 1836. The work was much admired, and the painter Thomas Sidney Cooper considered that "in thought and fancy it stands unparalleled even by other works of his own."[6] It remained unsold until 1844, however, when it was bought from Turner by one of his most avid and important patrons, the whale-oil merchant Elhanan Bicknell. It was later in the collection of Sir John Pender. In 1899 the work was bought from the dealer Knoedler by the Pittsburgh iron manufacturer Alexander McBurney Byers and his wife Martha; the price was reported as $50,000.[7] Alexander and Martha Byers were among Pittsburgh's most distinguished collectors; they were also the first to take a serious interest in British painting of the Golden Age, leading the way for younger Pittsburgh collectors including Henry Clay Frick and Andrew W. Mellon. *Wreckers* remained in the possession of Byers family descendants until 1978, when it was bought by Paul Mellon for the Yale Center for British Art.

MW

EXHIBITED AT YALE ONLY.

6. Quoted in Butlin and Joll, 207.
7. See McQueen, 76.

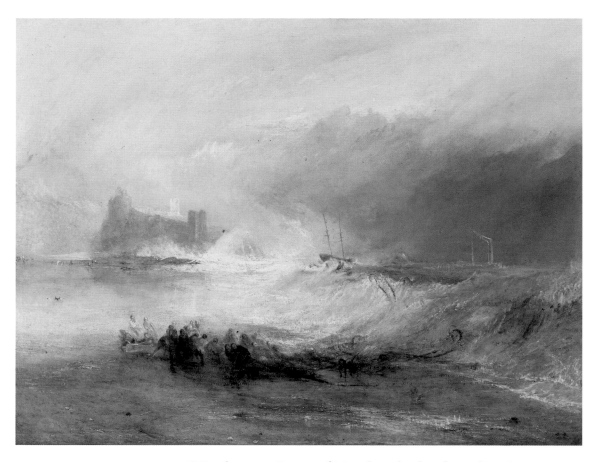

52 *Wreckers—Coast of Northumberland, with a Steam-Boat
Assisting a Ship off Shore,* c. 1833–34

Oil on canvas, 36 x 48 in.
Yale Center for British Art, Paul Mellon Collection

53 Fascinated by light and atmosphere, Turner found abundant subject matter in Venice. Comprised of a series of islands connected by bridges and canals, the city is dominated by sky and water—a combination that produces magical effects of color and luminosity. Such effects are fully exploited in this painting of the principal Venetian waterway, the Grand Canal, seen with the celebrated Rialto bridge in the distance. Turner based the painting on pencil sketches he had made on the spot during a visit to Venice in 1819. He took considerable liberties with fact, however, in order to emulate the traditions of Venetian view-paintings, which often show the city transformed by pageantry. Here, colorful banners festoon the buildings, and floating platforms accommodate crowds of richly dressed onlookers.

The magnificence of Venetian festivals made the city a particularly popular destination for British travelers on the Grand Tour of Europe. In an era before photography, many of them purchased topographical paintings of Venice as souvenirs. Although Turner's approach is fundamentally imaginative and poetic, his painting of the Grand Canal is equally calculated to evoke the dazzling array of images and ideas experienced by British tourists in Venice. Rather than document the present-day appearance of the city, Turner borrowed features from several well-known historical pageants in order to suggest the inexhaustible richness of the city's eventful past. By creating a composition in which there is no single focus for the eye, he sought to induce an exhilarating experience of the Sublime, dazzling the viewer with an impression of unfathomable grandeur and profusion.

When Turner exhibited this painting at the Royal Academy in 1837, he employed a lengthy title borrowed from Shakespeare: "Scene—a street in Venice. 'Antonio. Hear me yet, good Shylock. *Shylock*. I'll have my bond.'—*Merchant of Venice*, act iii, sc. 3." Without the title, it would be easy to overlook Shakespeare's relevance to this scene of Venetian pageantry. Closer scrutiny reveals a vignette from *The Merchant of Venice* inserted unobtrusively into the lower right corner of the painting, where the moneylender Shylock can be seen dangling a pair of scales and demanding his pound of flesh from Antonio. Turner's desire to associate this painting with Shakespeare's play is easily understood, for English-language guidebooks invariably related Venetian topography to the fictitious events of *The Merchant of Venice*. Moreover, many commentators shared the view (expressed in a guidebook of 1831) that "Venice and the Venetians, but for Shakespeare, Lord Byron, and a few eminent native painters would, long ere this, have been all but forgotten."[8] In succeeding years Turner's spectacular paintings of Venice would reinforce England's deep cultural impress on the city, as would the Venetian writings of the Victorian art critic John Ruskin, Turner's great champion and an early owner of the present painting.

Sold by Ruskin in 1872, *The Grand Canal* passed through a few English collections before selling to the Duveen firm in May 1922. Joseph Duveen immediately offered the painting to the American Henry E. Huntington, emphasizing that its size and unusual vertical format would complement a painting that Huntington had purchased from him a month earlier, Thomas Gainsborough's *The Cottage Door*.[9] Upon receiving a lukewarm response from Huntington, Duveen appealed to a higher authority. "There is only one question which I would like to ask you, if I may," he wrote, "and that is, does Mrs. Huntington like the picture? Because, if Madame does, then I shall not dispose of it until you have both seen it."[10] An

8. Richard Hollier, *Glances at Various Objects, during a Nine Weeks' Ramble through Parts of France, Switzerland, Piedmont, Austrian Lombardy, Venice, Carinthia, the Tyrol, Schaffhausen, the Banks of the Rhine, and Holland* (London, 1831), 143.
9. Joseph Duveen to Henry E. Huntington, letter of May 24, 1922, institutional archives, Huntington Library.
10. Joseph Duveen to Henry E. Huntington, letter of June 9, 1922, institutional archives, Huntington Library.

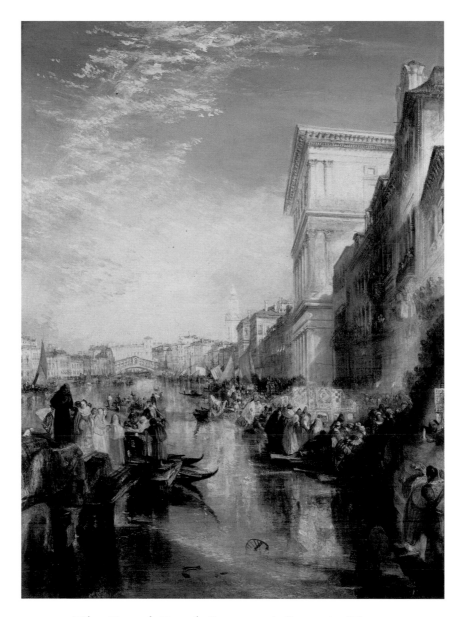

53 *The Grand Canal: Scene—A Street in Venice, c.* 1837

Oil on canvas, 59 ¼ x 44 ¼ in.
The Huntington Library, Art Collections, and Botanical Gardens

REFERENCES:
Robert R. Wark, *Ten British Pictures, 1740–1840* (San Marino, 1971), 123–34; Butlin and Joll, 219-20, no. 368; Robyn Asleson, *British Paintings at The Huntington*, gen. ed. Shelley M. Bennett, (New Haven and London, 2001), 458-61, no. 101.

important collector in her own right, Arabella Huntington had been instrumental in initiating the decade-long relationship with Duveen that enabled her husband to assemble an unparalled collection of British grand-manner paintings. It was presumably with her blessing that Huntington ultimately purchased *The Grand Canal* in November 1922.

RA

Richard Parkes Bonington

✺ 1802–28

British Romantic landscape painter who lived and worked largely in France. In 1817 his family moved to Calais and in 1818 to Paris, where they established themselves as lace merchants. Bonington became a pupil of the Neoclassical painter Antoine-Jean Gros and a friend of the young Eugène Delacroix, with whom he shared a studio for a time. He made his name in the early 1820s with his watercolors and lithographs of landscapes, port scenes, and monuments in northern France, the result of frequent sketching tours. At the same time he became more ambitious as an oil painter, exhibiting a large beach scene with fishermen unloading their catch at the Paris Salon of 1824. He also painted historical and literary costume pieces in the fashionable "troubadour" style. In 1826 he visited Italy, after which he exhibited a number of Italian subjects, especially views of Venice. In 1828, suffering from sunstroke and exhaustion, he developed a serious pulmonary disease and died, a month before his twenty-sixth birthday.

54 Bonington stayed in Venice for several weeks in April–May 1826, traveling there with his aristocratic friend and patron Charles Rivet. He worked hard during the visit, making many pencil drawings to use later as the basis for finished watercolors and paintings, sometimes sketching in watercolor or oil on the spot. He and Rivet also studied and copied masterpieces of Venetian art in the Accademia and other collections. The present painting is among the most exquisite of the outdoor (or "plein-air") oil sketches, showing three fifteenth-century palazzi that face Santa Maria della Salute, near the entrance to the Grand Canal.

To the tradition of the Venetian view established by Canaletto and others in the eighteenth century, Bonington brings a shimmering vision of the place, a concern with fugitive effects of atmosphere and light rather than the definition of masses and spaces. In his plein-air sketches the city seems to float, both on the water and in the air. Whereas the earlier view-painters show busy throngs of people, Bonington tends to play down the human presence and create a mood of stillness. In the present work, for instance, only the linens airing on the balconies give any sense that the three palaces are inhabited.

The fragile, melancholy Venice that emerges from Bonington's views had its counterpart in the writings of Romantic travelers, both French and British. Indeed it was almost a commonplace among writers on Venice to describe the city as a near-ruin, to contrast its present-day dilapidation to its former glory, and to ponder its decline as a great *memento mori*. One of these was Antoine Valery, who visited Venice for the first time just a month after Bonington's departure. "There is a soft and melancholy pleasure," he wrote in his account of the city, "in gliding amid those superb palaces, those ancient aristocratic dwellings …

1 Antoine Valery, *Historical, Literary and Artistical Travels in Italy*, trans. C. E. Clifton (Paris, 1839), 160, quoted in Noon, 58.

54 *The Manolesso-Ferro, Contarini-Fasan, and Contarini Palaces, Venice,* 1826

Oil on millboard, 14 ½ x 18 ¾ in.
Richard L. Feigen, New York

which are the memorial of so much power and glory, but are now desolate, shattered or in ruins."[1]

As Patrick Noon has pointed out, what makes Valery especially interesting is that he knew Bonington's views, compared them to Canaletto's, and felt that they captured the "desolation" of modern Venice:

> The paintings of Canaletto have so familiarized us with the harbor, the squares, and monuments of Venice that when we penetrate into the city itself, it appears as if already known to us. Bonington, an English artist of melancholy cast, has painted some new views of Venice, in which is most perfectly sketched its present state of desolation; these, compared with those of the Venetian painter, resemble the picture of a woman still beautiful, but worn down by age and misfortune."[2]

The association of Venice with faded glory and transience also informs the Venetian views painted by J. M. W. Turner in the 1830s and 1840s. Turner greatly admired Bonington and was probably influenced by him in adopting Venice as a major theme in his work (see no. 53).

The Manolesso-Ferro, Contarini-Fasan, and Contarini Palaces, Venice was bought by its present owner at Christie's in 1987 and now forms part of the finest collection of Bonington's work in private hands.

MW

REFERENCE:
Patrick Noon, Richard Parkes Bonington: 'On the Pleasure of Painting', exh. cat. (Yale Center for British, New Haven, 1991), 213, no. 97.

2 Valery, 143, quoted in Noon, 58.

Edwin Landseer

1802–73

Romantic painter of animal subjects and scenes of Scottish rural life. Landseer's father and four of his siblings were artists, and his own talent emerged precociously. As a boy he studied with the history painter Benjamin Robert Haydon and at the anatomy school run by the surgeon Sir Charles Bell. He entered the Royal Academy Schools at the age of fourteen and within two years was exhibiting at the Academy and enjoying financial and critical success. He was elected an Associate in 1826 and a full Academician in 1831. Landseer first visited Scotland in 1824 and habitually returned in the autumn to hunt and sketch. Well-read and possessed of great personal charm, he was welcomed into the highest social circles. He became a great favorite of Queen Victoria, whom he met in 1837, the year of her accession. She commissioned him to paint her dogs and other pets as well as members of her family. She granted him a knighthood in 1850. Landseer's mental and physical health had begun to deteriorate in 1840, when he suffered a nervous collapse. Remarkably—despite bouts of depression, paranoia, and alcoholism—he succeeded between 1857 and 1866 in producing four monumental bronze lions for the base of Nelson's column in Trafalgar Square—a major work in an entirely new medium for him. It is equally remarkable that the mentally unstable artist was offered the presidency of the Royal Academy in 1866, a responsibility that he sensibly declined.

55 The ptarmigan is a type of grouse found in the rocky hilltops of the Scottish Highlands. In the winter the bird's plumage turns white, allowing it to camouflage itself against the snow. Landseer had observed ptarmigan during his autumn visits to Scotland, where he often joined hunting parties. He and his friend the actor Charles Mathews went on one such expedition near Glen Feshie in September 1833. "[We] set off on our shaggy ponies with the intention of shooting our way over the mountain tops to the glen," Mathews recalled. "After a most fatiguing ascent we reached the ptarmigan hills, where the party dispersed in various directions in quest of game."[1] Landseer had probably explored those same hills the previous autumn in connection with the present painting, which he exhibited at the British Institution in the spring of 1833.

Landseer's phenomenal popularity during the nineteenth century rested on his knack for investing animals with a semblance of human intelligence and emotion. That fanciful and sentimental aspect of his work has diminished his present-day reputation, distracting attention from his sheer technical brilliance as a painter. *Ptarmigan* provides a compelling example of Landseer's artistic virtuosity. The painting is essentially a study in white, in which a wide range of tones is enlisted to depict the snowy birds on the ice-encrusted hilltop. In the foreground Landseer maps the protrusions and crevices of the gnarled rock with subtly modulated pigments ranging from warm browns to cool blues. Reserving the purest whites for the birds themselves, he accentuates their appearance of dazzling brightness by means of contrasting accents of black and red. At a glance the foreground conveys an impression of meticulously detailed finish, but Landseer's paint handling is actually free and expressive. A veil of thick white scumbling,

55 *Ptarmigan*, c. 1832-33

Oil on canvas, 19 ¾ x 26 in.
Philadelphia Museum of Art. The Henry P. McIlhenny Collection,
in memory of Francis P. McIlhenny, 1986

REFERENCES:
John Canaday, *Mainstreams of Modern Art* (New York, 1959), 142; Richard Ormond, *Sir Edwin Landseer*, exh. cat. (Philadelphia Museum of Art, Philadelphia, 1981), 79–80, no. 37.

applied with short, brisk dabs of the brush, is chiefly responsible for creating the illusion of minutely rendered texture. The soft, downy feathers of the birds are painted very differently, with fluent strokes of smooth, thin paint.

Landseer deliberately raised the emotional tone of *Ptarmigan* by inserting the distant view of soaring mountain peaks. The impressive setting lends an air of epic grandeur to what is essentially a still-life study, thus ennobling the suffering of the bloodied bird struggling in agony at the center of the painting. The stark disjunction between the intensely immediate foreground and the remote background enhances the dramatic character of the scene. Only the soaring birds in the middle distance at right bridge the vertiginous gap between near and far.

Ptarmigan is one of at least seven pictures of game birds that Landseer painted in the early 1830s for William Wells, a shipbuilder, sportsman, and collector of Old Master and contemporary paintings. Wells's house, Redleaf in Kent, was a gathering place for artists, and Landseer made it his home-away-from-home. On Wells's death in 1847, his collections passed to his nephew, who contributed the present painting to a retrospective exhibition of Landseer's art held at the Royal Academy in 1874. The painting was also included among sixty-five works by Landseer shown at the Grosvenor Gallery in 1890, and it appeared again in Landseer exhibitions held at the Royal Academy in 1961 and at the Tate Gallery and the Philadelphia Museum of Art in 1981–82. *Ptarmigan* was by then owned by Henry P. McIlhenny, a chairman and former curator of the Philadelphia Museum of Art, who left the painting to the museum on his death in 1986.

RA

1. Charles Dickens, *Life of Charles J. Mathews* (1879), quoted in Ormond, 79.

John Martin

1789–1854

Romantic painter best known for his visions of spectacular and supernatural events, often scenes from the Bible, sometimes featuring elaborate and fantastic architectural perspectives. He worked first as a glass- and ceramics-painter. He made his name at the Royal Academy exhibition of 1812 with one of his first attempts at large-scale oil-painting, Sadak in Search of the Waters of Oblivion *(St. Louis Art Museum), in which the Romantic hero struggles through an awe-inspiring mountain landscape. This and further evocations of the "Sublime," both paintings and mezzotint prints, caught the popular imagination, and Martin became one of the most celebrated artists of his day; through the prints in particular, his fame spread beyond Britain to the Continent of Europe and the United States. He achieved his greatest critical and financial success in 1821 with the exhibition of* Belshazzar's Feast *(private collection) at the British Institution. In his last years he painted a triptych of vast canvases on the theme of the* Last Judgment *(Tate Collection).*

56 *Pandemonium* was inspired by the lines in John Milton's *Paradise Lost* in which the poet describes the erection of Satan's golden palace in Hell. Satan stands like a tower above his massed legions of rebel angels as, with supernatural speed, they mine and melt the gold, cast the palace whole in an underground foundry, then raise it up:

> *Anon out of the earth a Fabric huge*
> *Rose like an Exhalation, with the sound*
> *Of Dulcet Symphonies and voices sweet,*
> *Built like a Temple, where* Pilasters *round*
> *Were set, and Doric pillars overlaid*
> *With Golden Architrave*

In Martin's vision of the scene the palace appears as a monumental hybrid of ancient and modern. It recalls the sinful, "fallen" city of Babylon—as reconstructed by Martin himself in his paintings of Belshazzar's Feast and other Babylonian subjects—and at the same time nineteenth-century London. It looms over the volcanic fires of hell like a diabolical parody of buildings along the Thames, perhaps Somerset House or the planned Houses of Parliament, and Christopher Newall has plausibly compared it to Carlton House Terrace.[1] Certainly the lamps along its terrace resemble modern gas lamps.[2] Martin was deeply concerned about the vice and uncleanliness of contemporary industrial cities and devised ambitious, never-to-be-realized plans for improving London's water supply and sewage system. In *Pandemonium* he seems to be drawing parallels between Hell, Babylon, and the modern metropolis.

The painting is an oil version of Martin's two mezzotint prints of the same subject, the first published in his collection of illustrations to *Paradise Lost* in 1825, the other in a larger format as a single print in 1831. The main changes he made between the mezzotints and the painting were to remove Satan's

REFERENCES:
William Feaver, *The Art of John Martin* (Oxford, 1975), 165–66; Christopher Newall, *The Victorian Imagination*, exh. cat. (Bunkamura Museum of Art, Tokyo, et al., 1998), 167; Andreas Blühm and Louise Lippincott, *Light! The Industrial Age, 1750–1900: Art, Science, Technology and Society*, exh. cat. (Van Gogh Museum, Amsterdam; Carnegie Museum of Art, Pittsburgh, 2000), 128–29.

1. Newall, 167.
2. See Blühm and Lippincott, 128.

56 *Pandemonium*, 1841

Oil on canvas, 48 ½ x 72 ½ in.
The FORBES Magazine Collection, New York

wings and clothe him, and to elaborate upon the architecture of the palace. He showed the painting at the Royal Academy exhibition of 1841, paired with the contrasting heavenly subject of the *Celestial City and River of Bliss* (private collection), also from *Paradise Lost*. It remains in its original frame with serpent and dragon ornaments, which Martin himself designed.

The work of John Martin has enjoyed an American following since the artist's own lifetime and had a considerable influence on American Romantic landscape painters such as Thomas Cole. One of a number of major examples of his work in the States, *Pandemonium* represents him at full strength in arguably the foremost American collection of British art of the Victorian period. The FORBES Magazine Collection began with a miscellany of paintings, kinetic art, Fabergé objects, and presidential autographs assembled in the 1950s and 1960s by its publisher, Malcolm Forbes. The idea of adding Victorian art as a major emphasis of the collection came from Malcolm Forbes's son, Christopher Forbes. His imagination fired by pioneering books on the subject by Graham Reynolds and Jeremy Maas, he approached his father on the matter in 1969. "It was the growing number of acquisitions in the Impressionist field that prompted my suggestion that the Magazine would do better to collect a less-sought-after aspect of the nineteenth century. Why pay huge prices for less than first-rank works of a school at the peak of its popularity, when major examples of Victorian painting were fetching less than the sales tax on a third-rate Pissarro?"[3]

Despite some reservations, his father gamely agreed, and Christopher Forbes proceeded rapidly to build a varied and representative Victorian collection. He set himself the rule that, to be included, any

prospective new acquisition "must have been exhibited at the Royal Academy during Queen Victoria's reign, or be a study for or replica of a painting which was."[4] A selection of works from the FORBES collection of Victorian paintings was exhibited at the Metropolitan Museum of Art, New York, and the Art Museum, Princeton University, in 1975. Through his collecting and further exhibitions Christopher Forbes has continued to champion the cause of Victorian art in the United States. *Pandemonium* was a relatively recent acquisition, bought in London in 1994. Before that it had belonged to successive generations of the family of George Whiteley, who bought it at the sale of its original owner, Benjamin Hick of Bolton, in 1843.

MW

3. Christopher Forbes, *The Royal Academy (1837–1901) Revisited: Victorian Paintings from the Forbes Magazine Collection*, exh. cat. (Metropolitan Museum of Art, New York; Art Museum, Princeton University, 1975), Preface, 3.
4. Ibid.

John Everett Millais

1829–96

Founding member of the Pre-Raphaelite Brotherhood and, in the 1870s and 1880s, the most popular painter in Britain. A child prodigy, he entered the Royal Academy Schools at the age of eleven and made his debut at the RA's annual exhibition at sixteen. He and his friend and fellow student William Holman Hunt developed radical ideas about the state of British art and formed the "P. R. B.," with other like-minded young artists, in 1848. The group dedicated themselves to treating serious subjects as naturally and truthfully as possible, in meticulous detail, rejecting the conventions of ideal beauty. In the 1860s Millais's style of painting loosened, and the artistic heroes of his later career were to be the painterly Old Masters, especially Frans Hals, Diego de Velasquez, and Joshua Reynolds. In 1885 he was created a baronet, and in the last year of his life he was elected President of the Royal Academy.

57 *Ferdinand Lured by Ariel* was Millais's first attempt at painting an outdoor scene in accordance with Pre-Raphaelite principles. The subject is from Shakespeare's *The Tempest* (Act I, Scene II). Ferdinand, son of the King of Naples, is teased by the sprite Ariel with the false news that his father has perished in the shipwreck that has landed them on Prospero's island. Ariel is carried through the air by fantastic bats ("On the bat's back I do fly") and holds a seashell to illustrate his story. When Millais showed the painting at the Royal Academy exhibition of 1850, the following lines from the play appeared in the catalogue:

Ferdinand *Where should this music be? I' the air or the earth?*

Ariel *Full fathom five thy father lies;*
Of his bones are coral made;
Those are pearls that were his eyes:
Nothing of him that doth fade
But doth suffer a sea-change
Into something rich and strange.
Sea nymphs hourly ring his knell.
 Burthen, *ding-dong.*
Hark! Now I hear them,—Ding-dong, bell.

Millais painted most of the background to the scene during the summer of 1849 while staying with his friend and patron George Drury at Shotover Park, near Oxford. In a letter to William Holman Hunt from Shotover he wrote: "The landscape I have painted in the Ferdinand for the name of an Artist is *ridiculously elaborate*. I think you will find it very minute, yet not near enough so for nature. To paint as it ought to be it would take me a month a weed—as it is, I have done every blade of grass and leaf distinct."[1]

As a Pre-Raphaelite Millais was determined to paint with meticulous attention to detail and respect for the individuality of each object. He would use friends and relatives as models and try to paint their features precisely as he saw them, resisting the temptation to adapt them or improve upon nature. For the figure of Ferdinand, which he painted in the studio on his return to London, the model was his fellow Pre-Raphaelite Frederic George Stephens. "In one lengthy sitting Millais drew my most

1. University of British Columbia Library, Vancouver, Special Collections Division.

57 *Ferdinand Lured by Ariel,* 1849–50

Oil on panel, 25 ½ x 20 in.
The Makins Collection

REFERENCE:
Leslie Parris, ed., *The Pre-Raphaelites*, exh. cat. (Tate Gallery, London, 1984), 74–75, no. 24.

un-Ferdinand-like features with a pencil upon white paper, making, as it was, a most exquisite drawing of the highest finish and exact fidelity," Stephens later recalled.

My portrait was completely modeled in all respects of form and light and shade, so as to be a perfect study for the head thereafter to be painted. The day after it was executed Millais repeated the study in a less finished manner upon the panel, and on the day following that I went again to the studio in Gower Street … From ten o'clock to nearly five the sitting continued without a stop, and with scarcely a word between the painter and his model. The clicking of his brushes when they were shifted in his palette, the sliding of his foot upon the easel, and an occasional sigh marked the hours, while, strained to the utmost, Millais worked this extraordinarily fine face. At last he said, 'There, old fellow, it is done!' … For me, still leaning on a stick and in the required posture, I had become quite unable to move, rise upright, or stir a limb till, much as if I were a stiffened lay-figure, Millais lifted me up and carried me bodily to the dining-room, where some dinner and wine put me on my feet again. Later the till then unpainted parts of the figure of Ferdinand were added from the model and a lay-figure.[2]

For both the costume and the pose of Ferdinand, Millais referred to a plate in Camille Bonnard's *Costumes Historiques* showing the dress of a "Jeune Italien" about the year 1400. The preliminary portrait-study mentioned by Stephens is now in the collection of the Yale Center for British Art.

While Millais was still working on *Ferdinand Lured by Ariel*, the art dealer William Wethered made some kind of undertaking to buy it; later he went back on this, objecting to the strange greenness of Ariel and the bats and wishing they were "more sylph-like."[3] He had probably been expecting the coyly erotic creatures that were the stock-in-trade of the Victorian fairy-painter. In spite of this setback, Millais still managed to sell his picture, before sending it in for the Royal Academy exhibition, to the collector Richard Ellison.

By 1897 *Ferdinand Lured by Ariel* belonged to the prominent late-Victorian collector Henry Makins; it has remained in the Makins family ever since, a star work in one of the most important collections of Pre-Raphaelite art still in private hands. The collection passed in succession to Henry Makins's son, Brigadier-General Sir Ernest Makins, M.P., to his grandson, Sir Roger Makins (later created Lord Sherfield), and most recently to his great-grandson, Christopher Makins; all three have been active collectors who have added important works to the collection (see also Millais's *A Huguenot*, no. 58).

Sir Roger Makins, a diplomat, had strong American connections: his wife Alice Brooks Davis was American, and he served at the British Embassy in Washington on three tours of duty, latterly—from 1953 to 1956—as Ambassador. On his death in 1996, his son Christopher Makins brought most of the collection to the U.S., where he has lived for thirty years. This aroused some controversy in Britain. In 1998 Lord Lloyd-Webber and others, including the Conservative Party spokesman on cultural affairs, alleged that the Government had made a "secret deal" to grant export licenses that would enable Christopher Makins to sell masterpieces such as *Ferdinand Lured by Ariel* and *A Huguenot* abroad, perhaps to the Getty Museum or another wealthy American collection. The allegations were never substantiated. In 1999 the other major Millais in the Makins Collection, *Mariana*, was accepted from Lord Sherfield's estate in lieu of inheritance taxes; it is now in the Tate Collection, London.

MW

2. John Guille Millais, *The Life and Letters of Sir John Everett Millais*, 2 vols. (London, 1899), 1:84–87.
3. See William Michael Rossetti, *The Pre-Raphaelite Brotherhood Journal*, ed. William E. Fredeman (Oxford, 1975), entry for January 12, 1850, 42.

58 This scene of star-crossed love and religious heroism is set at the beginning of the notorious Massacre of Saint Bartholomew's Day. Over a period of several days from August 24, 1572, French Roman Catholics led by the duc de Guise slaughtered thousands of Huguenots (Protestants) in Paris. Millais shows a Catholic girl trying to persuade her Huguenot lover to save himself by binding around his arm the white cloth that is to be the Catholics' means of identification. He resists, preferring to die rather than deny his faith. The source for the story was the opera *Les Huguenots* by Meyerbeer, which had been performed to acclaim at Covent Garden every season since 1848. In a scene in a Huguenot churchyard, the Catholic heroine Valentine tries in vain to tie the white cloth on the arm of her lover, Raoul de Nangis, a Huguenot nobleman. He refuses her entreaties, she embraces Protestantism, and they marry. In the opera's final scene they both die in the massacre, unknowingly killed by Valentine's own father.

Millais paints the lovers' moment of truth in a style that insists on its own truthfulness. Flouting the rules of composition, he takes mere background material, things such as a wall, plants, and flowers, and observes them from life with degrees of focus and fidelity that demand the viewer's scrutiny. The idea is both to invest the image with a feeling of unedited fact, and to force every part to come alive with the possibility of symbolic meaning. Since the species of plants and flowers are carefully identified, they can be read according to the Victorian language of flowers: the ivy clinging to the wall for "dependence," the Canterbury bell in the lower left for "constancy," the nettles and nasturtiums in the lower right for "pain" and "patriotism." The half-destroyed flower at the Huguenot's foot foreshadows the violence of the massacre. The old wall suggests both the idea of the lovers as penned in, with no escape from the horrors to come, and at the same time the fateful religious barrier between them.[4]

The work was begun during the time Millais shared lodgings with his friend William Holman Hunt at Worcester Park Farm, near Ewell, south of London. After completing the background to his *Ophelia* (Tate Collection), Hunt recalled, he thought of painting a subject based on the line "Two lovers whispering by an orchard wall" from Tennyson's poem "Circumstance," and duly began work on the wall. Hunt told him that he found such self-contained love scenes lightweight and uninteresting and urged him to switch to a subject of moral significance. Eventually Millais thought of the scene from Meyerbeer's opera.[5] "Sat up till past twelve," he wrote in his diary on October 16, 1851, "and discovered first-rate story for my present picture."[6] Millais's diary contains many detailed references to his work on the background to *A Huguenot*, done mostly inside a makeshift hut at his chosen piece of wall, between that date and December 5.[7]

Following his usual practice, Millais painted the figures from models in his London studio. The model for the head of the Huguenot was the fifteen- or sixteen-year-old Arthur Lemprière, a friend of the Millais family. The Huguenot's body was painted at least partly from a professional model named Child, and the model for the Catholic girl was the young Irish beauty Anne Ryan, also a professional; she was dark-haired but Millais painted her as blond. Shortly before it was finished Millais sold the work for £250 to the dealer David Thomas White, who almost immediately sold it to B. G. Windus.[8] The work was Millais's first popular success. The anti-Catholic implications of the subject may well have struck a

REFERENCES:
Parris, 98–9, no. 41; Malcolm Warner, et al., *The Victorians: British Painting, 1837–1901*, exh. cat. (National Gallery of Art, Washington, 1997), 70–71, no. 10.

4. For a detailed account of the imagery of *A Huguenot* and its considerable influence, see Susan Casteras, "John Everett Millais 'Secret-Looking Garden Wall' and the Courtship Barrier in Victorian Art," *Browning Institute Studies* 13 (1985): 71–98.
5. See William Holman Hunt, *Pre-Raphaelitism and the Pre-Raphaelite Brotherhood*, 2 vols. (London, 1905), 1:282–83, 285, 289–90.
6. Millais, 1:125.
7. See Millais, 1:125–34, 141–44.
8. See Millais, 1:163–64.

58 *A Huguenot, on Saint Bartholomew's Day, Refusing to Shield Himself from Danger by Wearing the Roman Catholic Badge, 1851–52*

Oil on canvas, 36 ½ x 24 ¼ in.
The Makins Collection

chord at a time of general fear among Protestants at the spread of Catholic influence in Britain, the so-called Papal Aggression. The picture was the talking point of the Royal Academy exhibition of 1852 and attracted largely favorable reviews, almost all dwelling on the emotional subtleties of the couple's expressions. In 1856 it was published as an engraving; this was highly successful too, spreading the fame of the image on both sides of the Atlantic.

The painting made its first transatlantic crossing in 1954, after being bought through Agnew's in London by George Huntington Hartford II, the A&P supermarket heir. Developing a taste for Victorian art at a time when it was deeply unfashionable, Hartford bought other outstanding works of the period, including Burne-Jones's *Laus Veneris* (Laing Art Gallery, Newcastle upon Tyne). In 1963 he built the Gallery of Modern Art at 2 Columbus Circle in New York, where a pioneering Pre-Raphaelites exhibition was held in the following year. *A Huguenot* featured in Hartford's sale at Christie's in 1972, where it was bought for the Makins Collection by Christopher Makins (for further details on the Makins Collection, see no. 57).

MW

EXHIBITED AT YALE ONLY.

59 Millais painted this small oil sketch from nature during the summer holiday he and his brother William spent in Scotland with the great critic John Ruskin, a formidable champion of the Pre-Raphaelite cause, and his wife Effie Ruskin. During the holiday Millais painted most of the background to a portrait of Ruskin standing by a waterfall in Glenfinlas in the Trossachs (private collection). Millais had already painted Effie Ruskin in the historical painting *The Order of Release, 1746* (Tate Collection). In Scotland, left alone together for much of the time as Ruskin worked on a series of lectures, he and Effie became close friends. She seems to have confided in him her unhappiness in her marriage to Ruskin, and by the end of that rainy summer they had fallen in love. In the following year Effie obtained an annulment of her marriage to Ruskin on the grounds of non-consummation, and in 1855 she and Millais were married.

The Millais-Ruskin party reached the village of Brig o' Turk, where they were to stay, on July 2, 1853. Having chosen the setting for the portrait of Ruskin, Millais painted this study of another waterfall, lower down the glen, by way of preparation for the larger work to come. The woman sewing on the right is Effie, wearing the brown "Linsey wolsey" dress and green jabot that were her everyday wear at Brig o' Turk. When the work was begun, Millais, his brother, and the Ruskins were staying at the New Trossachs Hotel. Ruskin wrote to his father from there on July 8, 1853: "We have been out all day again sitting on the rocks—painting and singing and fishing … Millais himself is doing a bit for practice … beautiful thing it will be when done."[9] On July 9 they moved into lodgings with the schoolmaster Alexander Stewart and his wife. Writing from the Stewarts' on the 10th, Millais told his old friend Harriet Collins: "Every day that is fine we go to paint at a rocky waterfall and take our dinner with us. Mrs. Ruskin brings her work and her husband draws with us. Nothing could be more delightful …I am painting at present a fall about a mile from this house."[10] The work was first exhibited at the Liverpool Academy in 1862, under the title of *Outdoor Study*.

Waterfall in Glenfinlas is now part of the Samuel and

9. Mary Lutyens, *Millais and the Ruskins* (London, 1967), 64.

10. Ibid., 68.

59 *Waterfall in Glenfinlas,* 1853

Oil on panel, 9⅜ x 13⅛ in.
Delaware Art Museum, Wilmington. Samuel and Mary R. Bancroft Memorial, 1935

Mary R. Bancroft Collection at the Delaware Art Museum in Wilmington, one of the principal collections of Pre-Raphaelite art in the States. Samuel Bancroft, Jr. was a Quaker industrialist; he and his brother ran a Wilmington cotton mill established by their English-born father. Bancroft was well read in English poetry and had some contact with British literary and artistic circles on visits to England in the 1880s. He began his art collection in 1890, when he bought Dante Gabriel Rossetti's painting *Water Willow*. In the following years he continued to buy works by Rossetti and other Pre-Raphaelite painters, including Burne-Jones, and enlarged his house, Rockford, to accommodate the growing collection. His mentor in the formation of the collection was the British artist, collector, and dealer Charles Fairfax Murray, himself a member of the Pre-Raphaelite circle. Bancroft was offered Millais's *Waterfall in Glenfinlas* by Agnew's for the first time in 1906, then again in 1908. "I do not think I care for *The Running Water*—at least at the price," he wrote to Gerald Agnew on December 3, 1908. "It is too geological, as it were!"[11] He finally bought the work in 1911, after some negotiation, along with another Millais oil sketch—a portrait of a Scottish girl that he painted at Brig o' Turk while finishing the portrait of Ruskin in the summer of 1854. These were among the last acquisitions Bancroft made before his death in 1915. His collection was donated by his estate to the Wilmington Society of the Fine Arts, the predecessor of the Delaware Art Museum, in 1935.

MW

REFERENCES:
Allen Staley, *The Pre-Raphaelite Landscape* (Oxford, 1973), 48, 51, 150; Rowland Elzea, *The Pre-Raphaelite Collections of the Delaware Art Museum* (Delaware Art Museum, Wilmington, 1984), 72–73; Parris, 115, no. 55; *Millais: Portraits*, exh. cat. (National Portrait Gallery, London, 1999), 84–87, no. 17.

11. Elzea, 73.

James McNeill Whistler

🜸 1834–1903

Painter of portraits and "Nocturnes," and a leading figure in the British Aesthetic Movement. Although he always considered himself an American, Whistler lived in the United States for only fourteen years and during the remainder of his life resided alternately in Paris and London, with sojourns in virtually every country in continental Europe. While pursuing his art training in France, he came under the influence of avant-garde artists such as Gustave Courbet, and in England, too, he gravitated toward controversial and progressive figures, such as the poet Algernon Swinburne and the painters Albert Moore and Dante Gabriel Rossetti. Under their influence he began to explore analogies between music and painting in portraits and genre pictures, to which he often appended musical titles. Having produced many paintings of the Thames, along with seascapes in South America and France, Whistler began to develop his Nocturnes in the late 1860s. In these atmospheric and ethereal paintings, the details of land, sea, and sky melt into harmoniously arranged bands of color. Their startling minimalism elicited sharp criticism from John Ruskin, whom the artist sued for libel in 1878. Bankrupted by the trial, Whistler went to Venice, where he produced visionary etchings and pastels. He served briefly as president of the Society of British Artists in 1886 and garnered numerous international awards in the last years of his life.

60 Throughout his British career Whistler produced extraordinary views of the river Thames, discovering hidden beauty along London's industrialized, sometimes shabby waterfront. Soon after settling in London in 1859, he initiated a set of Thames etchings and also began to paint a series of images of contemporary life along the river. The present painting depicts a Bohemian gathering at the Angel Inn in Rotherhithe, on the south side of the Thames, with the dense tangle of ships' masts and ropes all but obscuring the district of Wapping on the opposite shore. It was with this painting that Whistler hoped to establish his reputation in England and beyond. In a letter to a friend in France, he described it as the "picture on which I set all my hope and which should become a masterpiece."[1]

The decade of the 1860s was a period of intense work and frustration for Whistler as he struggled to develop a personal style. Many of the canvases that he initiated at that time took several years to complete; others were never finished at all. *Wapping* bears the date 1861 in the lower right corner, but the artist actually struggled with the painting for an additional three years. It was not the complex setting that caused him difficulty; in fact, he made few changes to the background following his first outdoor painting sessions at the Angel Inn. Rather, it was the figures that frustrated the artist's progress. He originally intended to depict a provocative scene of working-class sexuality, with a scantily clad woman with flaming red hair mocking the advances of a sailor. As Whistler repeatedly scraped down and repainted the canvas, however, his conception of the figural group changed. He ultimately produced quite a different scene, in which the physical isolation of the figures creates an impression of pensiveness and emotional

60 *Wapping,* 1860–64

Oil on canvas, 28 x 40 in.
National Gallery of Art, Washington. John Hay Whitney Collection, 1982

REFERENCES:
Andrew McLaren
Young, Margaret F.
MacDonald, Robin
Spencer, *The Paintings of
James McNeill Whistler*
(New Haven and Lon-
don, 1980), 14-15, no.
35; Robin Spencer,
"Whistler's Subject
Matter:'Wapping'
1860–1864," *Gazette des
Beaux-Arts* 100 (October
1982): 131–42; Malcolm
Warner et al., *The Vic-
torians: British Painting,
1837–1901*, exh. cat.
(National Gallery of
Art, Washington, 1997),
110-11, no.27; Robert
Wilson Torchia et al.,
*American Paintings of the
Nineteenth Century. Part
II* (Washington, 1998),
233–38.

1. Letter to Henri
Fantin-Latour, undated,
before July 1861, quoted
in Warner, 110.

detachment. When the painting appeared at the Royal Academy in 1864, it was criticized for the lack of resolution in the foreground figures. However, by evoking a vague mood, rather than depicting a specific narrative, Whistler anticipated the abstract concerns of the nascent Aesthetic Movement.

Equally suggestive of an interest in abstraction is the painting's emphasis on geometric patterns. Rapid strokes of warm color map the tracery of crisscrossing ropes and masts in the middle distance, while in the foreground the darker and more emphatic lines of the railing and ladder anchor the composition with an impression of solidity. Whistler's critics assumed that the artist's spontaneous, sketchy style resulted from impatience and carelessness. Quite the opposite was true, however, for he actually worked hard to give his paintings an effortless appearance— a lesson he had learned from the French avant-garde painters with whom he associated in Paris prior to settling in London. *Wapping* marks an important step in Whistler's transition from the realism that he had pursued in France under the influence of Courbet to the more atmospheric Nocturnes that he produced in England during the late 1860s and 1870s.

Following its appearance at the Royal Academy exhibition in 1864, *Wapping* was shown in New York in 1866 and at the Exposition Universelle in Paris in 1867, where it was included in the United States section. Soon after, the painting was purchased by Thomas DeKay Winans of Baltimore, who had accompanied Whistler's father to Russia in 1844 to begin construction of a railroad line between Moscow and St. Petersburg. In 1854, shortly before leaving America for Paris, Whistler had worked briefly for the Winans Locomotive Company in Baltimore, and his half-brother married into the Winans family. *Wapping* remained in that family until about 1923. It was purchased in 1928 by the twenty-three-year-old John Hay Whitney, who had inherited a fortune from his father the previous year. On Whitney's death in 1982, the painting was given to the National Gallery of Art.

RA

Frederic Leighton

ᴢ 1830–96

Classical subject painter, portraitist, and sculptor who did more to raise the stature of British art, both domestically and internationally, than any artist since Joshua Reynolds. His cosmopolitan style was formed while traveling throughout Europe with his peripatetic family. After studying art in Frankfurt, Rome, and Paris, he settled in London in 1859 and swiftly established his reputation as a rising talent. Elected an Associate of the Royal Academy in 1864, he became a full Academician in 1868 and Academy president a decade later. A leading figure in the revival of classical interests in British art, Leighton produced paintings remarkable for their monumental forms, brilliantly designed compositions, and fastidious finish. Having produced clay models as an aid to his painting practice, he began to pursue sculpture in its own right during the 1870s, and his innovative style proved highly influential. Leighton balanced hard work in his studio with ambitious travels to the Near East and North Africa, where he produced sparkling outdoor oil sketches of scenery. In honor of his contributions to British art, he was created a baronet in 1886 and raised to the peerage in the last year of his life, the first artist to receive that distinction.

61 Although Leighton is best known as a painter of classical idylls, he also produced numerous portraits and was particularly successful in his sweetly sentimentalized images of children. His dramatic presentation of fifteen-year-old Mary Theodosia (May) Sartoris (1845–1925) in this early portrait differs markedly from the artist's subsequent representations of young girls. Emulating such icons of British children's portraiture as *The Blue Boy* and *Pinkie* (nos. 17, 39), Leighton endows the portrait with an epic majesty that ennobles his adolescent subject. As in those earlier portraits, the child meets our eyes with a gaze of disconcerting directness. Her pale, alabaster skin, set off by the shadowy frame of her hat, causes the large, dark eyes to appear all the more arresting. Set against an impressive landscape backdrop, the beautiful yet vulnerable face takes on an air of high seriousness.

The appearance of precocious maturity in *May Sartoris* is enhanced by the girl's elegant and luxurious clothing. Dressed for a walk in the country, she wears riding apparel consisting of a black velvet jacket over a deep green-blue velvet skirt, set off by a large plumed hat, scarlet sash, white lace collar, and puffed sleeves. The reminiscence of seventeenth-century "van Dyck" dress in the style of the hat and lace collar provides a further connection with *The Blue Boy*, which had attracted great notice when exhibited in London in 1856. Leighton's knack for creating beautiful patterns of drapery is evident in the swags, bunches, and folds of the skirt and in the pooling fabric of the oversized shirtsleeves. His love of rich materials is expressed through fastidious attention to the glossy highlights of the ostrich plumes and the black satin bonnet worn beneath the hat.

Leighton painted this portrait for the sitter's mother, the former opera singer and hostess Adelaide Sartoris, who was descended from the illustrious Kemble theatrical dynasty. Blessed with hereditary talent, May herself was later to become a talented amateur actress and singer. After meeting Leighton in Rome in 1853, Adelaide Sartoris became his closest female friend and loyal supporter, while he

61 *May Sartoris*, c. 1860

Oil on canvas, 59 ⅞ x 35 ½ in.
Kimbell Art Museum, Fort Worth, Texas

became almost a fixture of the Sartoris household. This enabled him to produce many informal portraits of family members. In 1854 he made a drawing of May (Bolton Art Gallery); in the following year he contemplated delaying his departure from Rome in order to carry out portraits of the girl and her mother, but May's portrait appears to have been deferred for another five years. Leighton remained fond of his young subject, whose lovely features he depicted on several subsequent occasions.

The present portrait was probably painted at Westbury House, Hampshire, where the Sartoris family moved in 1859, and where Leighton was again a frequent visitor. The autumnal landscape in the background seems to have been based on outdoor oil sketches that Leighton carried out while in Hampshire. He delighted in making such sketches while traveling abroad, but it was an activity that he rarely had leisure to pursue in England. Here, he has treated the landscape in a somewhat abstract fashion, as a pattern of broadly simplified forms. Beyond the felled tree trunk the ground rises steeply to the uppermost edge of the canvas in a succession of layered planes. Intersecting diagonal lines organize the space and are echoed by the striking red scarf and the whip held in the girl's hand. In contrast to the convincing three-dimensionality of the figure, the background has a flat appearance, and the radically compressed space produces the optical illusion of projecting the figure forward so that she appears to walk straight out of the canvas. The effect is enhanced by the subdued palette of the landscape, which provides an effective foil to the strong colors employed in the figure. In particular, the red scarf and the brilliant white sleeves and collar strike the eye with considerable force.

May Sartoris remained in the sitter's family for many years, eventually passing to her granddaughter. It was not exhibited publicly until 1897 and then attracted little notice. Since its acquisition by the Kimbell Art Museum in 1964, however, it has become established as one of Leighton's most recognizable and appealing portraits. It provides compelling evidence of the enduring taste for grand-manner painting in England.

RA

REFERENCES:
Kimbell Art Museum, *Catalogue of the Collection* (Fort Worth, Texas, 1972), 188–90; Leonée and Richard Ormond, *Lord Leighton* (London, 1975), 45, 121, 153, no. 62; Christopher Newall, *The Art of Lord Leighton* (Oxford, 1990), 32–35; Stephen Jones, Christopher Newall, et al., *Frederic Leighton, 1830–1896* (Royal Academy of Arts, London, 1996), 120-22, no. 20.

Edward Burne-Jones
1833–98

Painter of melancholy, dreamlike scenes from medieval legend and classical myth, a leading figure in the Aesthetic Movement. While a student at Oxford he admired paintings by the Pre-Raphaelites, and after settling in London he met Dante Gabriel Rossetti, who gave him some informal lessons in painting—apparently the only training he received. In 1861 he helped his friend William Morris to establish his celebrated decorative arts firm, to which he was to contribute hundreds of designs for stained glass, tapestries, embroidered hangings, tiles, and other objects of applied art. Most of his early works, which show the strong influence of Rossetti, were in watercolor and bodycolor. From about 1870, however, he worked increasingly in oil, developing a mature style much indebted to his study of Italian Renaissance art. He achieved sudden fame when eight of his paintings were shown at the first Grosvenor Gallery exhibition in 1877.

62 With its beautiful, impassive figures, dreamy inaction, frankly decorative character, and unresolved suggestions of narrative, *Le Chant d'Amour* points the "aesthetic" direction in which advanced British painting was moving in the 1860s and 1870s. A young knight, a member of King Arthur's Round Table perhaps, listens to a fair damsel playing on a portable organ at twilight. It is Cupid who is working the bellows, his eyes closed because love is blind; apparently the knight has fallen for the beautiful musician, and we can only guess what pleasures and pains his love will bring him. The title comes from the refrain of an old Breton song: "Hélas! Je sais un chant d'amour, Triste ou gai, tour à tour" (Alas! I know a song of love, Sad or happy, by turns).

The work is an homage to the painters of the Venetian Renaissance. The theme of making and listening to music in the outdoors, the suggestion of the sound of running water and the promise of love in the air, the almost palpable atmosphere, and the slight feeling of strangeness about the whole composition, are Burne-Jones's response to such paintings as Giorgione and Titian's *Fête Champêtre* (Louvre, Paris). The white satin dress of the woman playing the organ suggests that he may also have had in mind Titian's *Sacred and Profane Love* (Borghese Gallery, Rome). Some idea of what the Venetians meant to Burne-Jones and his friends in the Aesthetic Movement, including his mentor Rossetti, can be gained from the writings of Walter Pater. In *The Renaissance* (1873), Pater wrote of Giorgione and his followers as the epitome of musicality in art, bearing out his famous principle that "All art constantly aspires towards the condition of music." By this he meant that Giorgione's art was aesthetically pure, that he achieved a beauty like that of music by making subject matter and form inseparable, free from the demands of storytelling and morality:

In the school of Giorgione, the perfect moments of music itself, the making or hearing of music, song or its accompaniment, are themselves prominent as subjects … men fainting at music; music at the pool-side while people fish, or mingled with the sound of the pitcher in the well, or heard across running water, or among the flocks … In these, then, the favourite incidents of Giorgione's

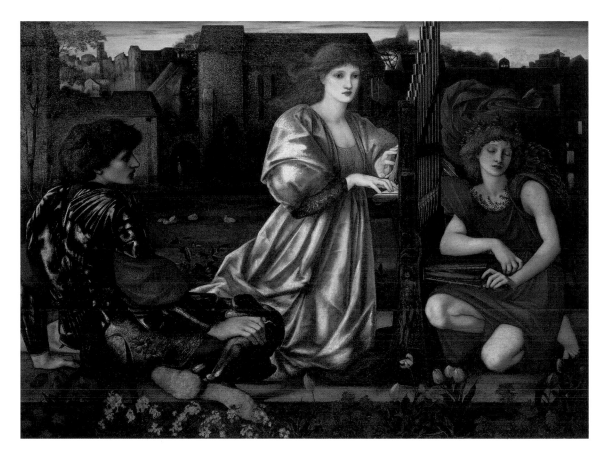

62 *Le Chant d'Amour*, 1868–77

Oil on canvas, 45 x 61 ⅜ in.
The Metropolitan Museum of Art, New York. The Alfred N. Punnett Endowment Fund, 1947

REFERENCES:
Leslie Parris, ed., *The Pre-Raphaelites*, exh. cat. (Tate Gallery, London, 1984), 227–29, no. 149; Malcolm Warner et al., *The Victorians: British Painting, 1837–1901*, exh. cat. (National Gallery of Art, Washington, 1997), 141–42, no. 38; Stephen Wildman and John Christian, *Edward Burne-Jones: Victorian Artist-Dreamer*, exh. cat. (Metropolitan Museum of Art, New York, 1998), 212–14, no. 84.

1. Walter Pater, *The Renaissance. Studies in Art and Poetry* (London, 1910), 150–51.
2. From the *Galaxy*, August 1877, in *The Painter's Eye: Notes and Essays on the Pictorial Arts by Henry James*, ed. John L. Sweeney (Cambridge, Massachusetts, 1956), 144.
3. From the *Nation*, May 23, 1878, in Sweeney, 163.

school, music or the musical intervals in our existence, life itself is conceived as a sort of listening—listening to music, to the reading of Bandello's novels, to the sound of water, to time as it flies.[1]

The evocation of music in a painting such as *Le Chant d'Amour* shows a characteristic interest in synesthesia, the pleasing of aural and visual senses at the same time. But it also serves as a sign of allegiance to music as the model for all the arts.

Burne-Jones first designed the group of young woman, organ, and Cupid about 1863, as part of the decoration of a piano given to him and his wife as a wedding present (Victoria and Albert Museum); as a scene of love and music, it was certainly suited to this purpose. He added the knight and the landscape background when he expanded the scene in an independent watercolor of 1865 (Museum of Fine Arts, Boston). This was bought from him by his most important patron, William Graham, the Liberal M.P. for Glasgow, who afterwards commissioned him to paint the present large oil, his definitive version of the subject. As Burne-Jones worked on the oil, the subject seems to have lost its original marital connotation and become associated in his mind with Maria Zambaco, with whom he was having a love affair: it appears as an illumination in the missal she is shown holding in one of his portraits of her (1870; Clemens-Sels-Museum, Neuss). After William Graham's death the painting passed to Joseph Ruston and afterwards to Thomas Henry Ismay, both of them prominent British collectors; it remained in Ismay's family until the 1940s, and was bought by the Metropolitan Museum in 1947.

One of Burne-Jones's most sensitive admirers was Henry James, who considered him the outstanding British artist of his time. James wrote of his work: "It is the art of culture, of reflection, of intellectual luxury, of aesthetic refinement, of people who look at the world and at life not directly, as it were, and in all its accidental reality, but in the reflection and ornamental portrait of it furnished by art itself in other manifestations; furnished by literature, by poetry, by history, by erudition."[2] When *Le Chant d'Amour* was shown at the Grosvenor Gallery exhibition of 1878, James wrote a review in which he described "the beautiful, rapt dejection of the mysterious young warrior" and remarked that the painting "looks at first like some mellow Giorgione or some richly glowing Titian," bearing "the stamp of the master for whom the play of colour is a freedom, an invention, a source of thought and delight."[3]

MW

EXHIBITED AT YALE ONLY.

63 One of Burne-Jones's favorite sources of subject matter throughout his career was the poetry of Geoffrey Chaucer. In 1858, as a wedding present for his friend William Morris, he decorated a wardrobe with a scene from *The Canterbury Tales* (Ashmolean Museum, Oxford), and the last great collaboration between him and Morris was the lavishly ornamented "Kelmscott Chaucer," published in 1896. The present painting shows a scene from *The Romaunt of the Rose*, an allegory of courtly love based on the thirteenth-century French *Roman de la Rose*. (Today scholars attribute only part of the *Romaunt* to Chaucer; in Burne-Jones's time it was thought to be entirely by him.) The story takes the form of a dream, in which the poet imagines himself as a Pilgrim in quest of his lady's love. Led by the God of Love, the amorous Pilgrim finally arrives at a secret garden in which he finds the perfect love he seeks, symbolized by a beautiful rose.

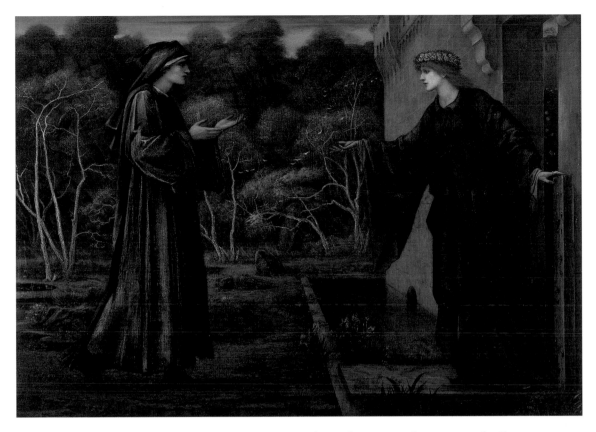

63 *The Pilgrim at the Gate of Idleness,* 1884

Oil on canvas, 38 ¼ x 51 ⅝ in.
Dallas Museum of Art. Foundation for the Arts Collection, Mrs. John B. O'Hara Fund

REFERENCE:
Wildman and
Christian, 180–87,
no. 78.

In the present painting the Pilgrim has discovered the entrance to the garden and is welcomed inside by the figure of Idleness, whom Burne-Jones paints just as she is described in the poem, dressed in green, with white gloves, and a garland of roses in her hair. Some *pentimenti* in the landscape background suggest that he wished to make the space between the Pilgrim and Idleness as clear and simple as he could, to direct the viewer's attention to the eye contact and hand gestures by which they communicate. The growth of weeds around the moat and atop the garden wall suggests the neglect that comes from idleness, while the fruits glimpsed through the gate hint at its pleasures. The themes of the quest for love and the pleasures of idleness are typically Burne-Jonesian. Though highly industrious in his many and various activities as an artist, Burne-Jones was one of the chief creators of that mood of dreamy lassitude that pervades the art of the Aesthetic Movement. In *Le Chant d'Amour* (no. 62), *The Pilgrim at the Gate of Idleness*, and many other pictures, he presents idleness not as a vice but as the handmaiden of love and beauty. This was the Aesthetic response to the religion of labor, preached by Thomas Carlyle, that had been accepted with cult-like devotion by most middle-class Victorians and celebrated in earlier Victorian art, most resoundingly in Ford Madox Brown's great Pre-Raphaelite manifesto-painting, *Work* (Manchester City Art Gallery).

The Pilgrim at the Gate of Idleness is a reprise of a design the artist had made some ten years earlier, part of the scheme of interior decorations provided by Morris & Company for Rounton Grange in Yorkshire, home of the industrialist Isaac Lowthian Bell. For the dining room at Rounton Grange, Burne-Jones and William Morris devised an embroidered frieze showing various scenes from *The Romaunt of the Rose*. Burne-Jones supplied drawings for the figures, Morris designed a background of stylized briar roses, and the embroidery was carried out over a period of eight years by their patron's wife and daughter. Burne-Jones often reused his decorative designs as the bases for independent paintings. In this case the grandest result was a monumental canvas of *Love Leading the Pilgrim*, begun in 1877 and completed in 1896–97 (Tate Collection). The present, smaller work was painted in 1884 for the Glasgow collector William Connal, who in 1889 commissioned the artist to adapt another of his Rounton Grange designs, *The Heart of the Rose*, as a companion piece on the same scale. *The Pilgrim at the Gate of Idleness* later belonged to the Maharajah of Jamnegar and was bought by the Dallas Museum of Art in 1996.

MW

EXHIBITED AT YALE ONLY.

Albert Moore

❧ 1841–93

Leading figure in the Aesthetic Movement, who used the classically draped female figure as a vehicle for exploring abstract pictorial concerns. Essentially self-taught, Moore was deeply influenced by his study of Greek and Japanese art. Together with his friend James McNeill Whistler, whom he met around 1865, Moore experimented with a progressive new approach to painting, excluding conventional subject matter and emotion in order to concentrate on the arrangement of line, form, and color. Moore's early architectural work led to his development of a geometric system of proportion that he employed in designing his compositions. His conservative critics complained of the monotony of his work, failing to appreciate that it was the abstract properties, rather than the ostensible subject, that engaged him in each of his pictures. His unconventional art, outspoken opinions, and disregard for social proprieties also offended the sensibilities of many of his colleagues, who actively prevented his election to the Royal Academy, although his paintings regularly appeared there. From 1877 Moore's delicately colored and gracefully composed pictures figured among the principal attractions of the newly founded Grosvenor Gallery. Plagued by ill health exacerbated by the grueling demands of his painting process, Moore gradually began to soften the rigorous thematic limits that he had initially imposed on his art. His last works demonstrate an awakening interest in emotion that was cut short by his death at the age of fifty-two.

64 Despite its unusually descriptive title, *The End of the Story* exemplifies Moore's almost total suppression of narrative, anecdote, and meaning in his paintings. Rejecting the fundamental conventions of Victorian art, he chose instead to pursue his own independent exploration of the abstract formal properties responsible for beauty. Before beginning work on the final canvas, Moore refined and perfected every detail of his composition. In preliminary drawings and oil sketches he accommodated the figure and every other element of the painting to an underlying geometric armature developed specifically for the picture in hand. His arrangement of colors on the canvas also followed a predetermined, abstract pattern. In perpetual pursuit of ideal beauty, Moore often continued to revise his ideas even after a painting was "finished." In a second version of *The End of the Story* (private collection), he made subtle alterations in the drapery patterns and color scheme.

The elegantly disposed drapery and the idealized facial features of the woman in *The End of the Story* attest to Moore's analysis of classical Greek sculpture. He also derived many formal principles from the art of Japan, the Near East, and other cultures. The rationale for his eclecticism was his belief in the essential formal unity of all beautiful things—a central tenet of the Aesthetic Movement, of which Moore was a leading figure. The anthemion device with which he signed all his paintings (and which appears in the woven rug at lower right) alludes to this principle of unity, as the motif occurs in the art of diverse civilizations.

Moore considered classical drapery the most beautiful clothing that ever existed, and he made use of it for that reason only. However, literal-minded critics often treated his paintings as if they were

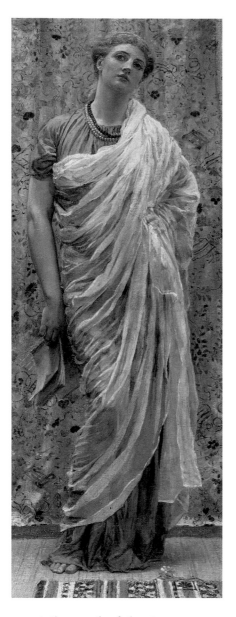

64 *The End of the Story*, 1877

Oil on canvas, 34½ x 12⅞ in.
Etheleen Staley

illustrations of classical history, and they were dumb-founded by such seemingly anachronistic details as the Liberty of London fabric in the background of *The End of the Story* and the bound volume held by the woman. Moore included such details in his paintings in order to make clear that his intentions were aesthetic, not archaeological.

The End of the Story was one of three paintings that Moore exhibited in 1877 at the inaugural exhibition of the Grosvenor Gallery, founded as a progressive alternative to the more conservative Royal Academy. An art critic for the *Times* praised "the painter's characteristic grace of line and subtle charm of delicate arrangement of colours" but, rather perversely, complained that "there was too much naturalism in the drawing of the arm."[1] Other critics were more hostile, provoked by Moore's acute attention to exclusively "artistic" values at the expense of more traditional pictorial concerns. It is now recognized that Moore's conception of art in terms of abstract, formal qualities was well in advance of his time, anticipating some of the principal concerns of twentieth-century Modernism.

Undeterred by Moore's deviation from the main-stream, a limited coterie of patrons kept up a steady demand for his paintings, which he produced slowly and in small number after several months of exhaustive preparation. *The End of the Story* was purchased by William Kenrick, a wealthy Birmingham manufacturer, politician, and philanthropist. It was brought to New York in the early 1960s by the English collector and art dealer James Coats, who specialized in Victorian paintings. He later sold the painting to the Canadian philanthropist Joseph M. Tannenbaum of Toronto. After thirty years in Canada *The End of the Story* returned to New York when it was acquired by the present owner in 1997.

RA

REFERENCES:
Alfred Lys Baldry, *Albert Moore: His Life and Works* (London, 1894), 47, 103; Robyn Asleson, *Albert Moore* (London, 2000), 137–38, 144–45, 168.

1. *Times*, May 1, 1877, 10.

John Singer Sargent
❧ 1856–1925

Painter of glamorous portraits and sparkling landscapes. Sargent was born in Florence, Italy, the son of a Philadelphia surgeon who had retired to Europe. He enjoyed a cosmopolitan youth, traveling throughout the Continent, learning several languages, and touring museums. From 1870 to 1873 he attended classes at the Accademia delle Belle Arti in Florence and in 1874 entered the Paris atelier of Charles-Emile-Auguste Carolus-Duran, while also attending drawing classes at the Ecole des Beaux-Arts. From 1877 he exhibited regularly at the Paris Salon. His reputation as a portraitist of daring originality reached a crisis point in 1884 when his audacious portrait of Virginia Gautreau (Madame X) scandalized fashionable Paris and lost him numerous portrait commissions. Sargent had visited and worked in England several times since 1881; when his Paris career foundered, his friend Henry James encouraged him to settle in London, which he did in 1886. The technical brilliance of his paint handling, the inventiveness of his compositions, and his insight into personal character brought him several triumphs at the Royal Academy during the 1890s. He was elected an Associate of the Academy in 1894 and a full Academician in 1897. He continued to live and work in England until his death.

65 Still reeling from the scandal unleashed by *Madame X* (Metropolitan Museum of Art, New York), the controversial portrait he was then exhibiting at the Paris Salon, Sargent was grateful to leave France in June 1884 to take up several commissions for the Vickers family in England. "It will be pleasant getting to London and especially leaving Paris," he confessed to the novelist Henry James. "I am dreadfully tired of the people here and of my present work."[1] Soon after his arrival Sargent went to stay at Beechwood, near Petworth, Sussex, the home of Albert Vickers, a director (and later chairman) of the Sheffield armaments firm that bears his family's name. Sargent's hostess was the former Edith Foster (d. 1909), Albert Vickers's second wife and the subject of the present portrait.

Edith Vickers's daughter later recalled that her mother had actively collaborated on the concept of this portrait, personally "inventing" the gray dress in which she appears. With its low-cut, pointed, and lashed bodice worn over a full-sleeved shift, the costume is clearly not that of the 1880s, and its vaguely historical style may have been intended to suggest the era of the seventeenth-century Spanish painter Diego de Velasquez. Sargent had a great admiration for Velasquez, whose paintings he had copied in Madrid in 1879. Here, he emulates Velasquez's tendency to set dark figures against shadowy backdrops, relieving the gloom with a few strategically placed flashes of white: the jeweled ornament in the woman's hair, the streaks of white shift glimpsed between her bodice lacings, and—most strikingly—the drooping petals of the magnolia blossom. The monochromatic palette enabled Sargent to explore subtle harmonies of grays, blacks, and umbers.

The artist may have begun *Mrs. Albert Vickers* during his initial visit to Beechwood in the early summer of 1884. He returned in October, and was still at work on the canvas late in the month, when Henry James informed a mutual friend that he was in Sussex "painting the portrait of a lady whose merits as a model require all his airy manipulation to be

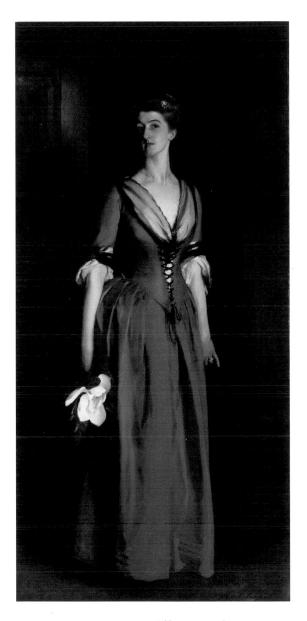

65　*Mrs. Albert Vickers*, 1884

Oil on canvas, 82 x 39 in.
Virginia Museum of Fine Arts, Richmond. The Adolph D. and Wilkins C. Williams Fund

REFERENCES:
Trevor Fairbrother, *John Singer Sargent* (New York, 1994), 62; Marc Simpson, *Uncanny Spectacle: The Public Career of the Young John Singer Sargent* (New Haven and London, 1997), 122, no. 28; Richard Ormond and Elaine Kilmurray, *John Singer Sargent: The Early Portraits*, 2 vols. (New Haven and London, 1998), 1: 133-35, no. 132.

expressed (in speech)."[2] Conscious of the painting's importance in establishing Sargent's professional footing in England, James added, "I trust it is a happy effort and will bring him fame and shekels here." In all, Sargent produced five portraits of Edith Vickers and her family in 1884. These included an informal painting of his host and hostess seated at the dinner table, a work he exhibited at the New English Art Club in 1886 (Fine Arts Museums of San Francisco), and a study of their children watering lilies in the garden at Beechwood (Flint Institute of Arts, Michigan), a subject that anticipated his famous *Carnation, Lily, Lily, Rose* of 1885–86 (Tate Collection). Also in 1884 Sargent painted three portraits for Albert Vickers's brother, Col. Thomas E. Vickers of Sheffield.

Sargent exhibited the present portrait as *Madame V* at the Paris Salon in 1885, together with a group portrait of Col. Vickers's three daughters (Sheffield City Art Galleries). After the disastrous scandal at the previous year's Salon, he reported that the two portraits painted in England had "rather retrieved me."[3] A few reviews likened *Mrs. Albert Vickers* to *Madame X* and to the work of Velasquez, but one critic was struck by an eerie quality in the painting, observing, "The young woman in gray, emaciated, elongated, wraithlike, whom he places before an armoir, holding in her elongated fingers a white magnolia flower, has all the unreal and mysterious character of the heroines of his compatriot Edgar Poe. Do we not see here the Ligeia or the Morella of the *Tales of Mystery and Imagination?*"[4] The painting was well received at the Royal Academy in 1886, although most British critics considered Sargent's style too flashy and "clever." However, while asserting that his pictures were little more than sketches, a critic for the London *Times* acknowledged that the painter nonetheless

captured "the truth about his sitters, and that no further touches could put more life or more character into face or form or accessories."[5]

The positive reception of his paintings sealed Sargent's decision in 1886 to relocate his portraiture practice to London. "There is perhaps more chance for me there as a portrait painter," he had speculated in September 1885.[6] Indeed, he gradually established a flourishing career in England. Although he derived a great portion of his commissions from the titled tier of British society, in many other paintings he continued to confer an aristocratic elegance on wealthy industrialists such as the Vickers family.

Mrs. Albert Vickers was purchased by the Virginia Museum of Fine Arts, Richmond, in 1992.

RA

1. Simpson, 122.
2. Ormond and Kilmurray, 134.
3. Ibid., 130.
4. Simpson, 144.
5. Ormond and Kilmurray, 135.
6. Ibid., 130.

William Holman Hunt

❧ 1827–1910

Founding member of the Pre-Raphaelite Brotherhood and the foremost religious painter of the Victorian period. While a student at the Royal Academy Schools Hunt became friends with John Everett Millais and Dante Gabriel Rossetti, with whom he founded the "P. R. B." in 1848. Hunt was probably the most earnest and morally-minded believer in the Pre-Raphaelite principle of truth to nature and throughout his career painted with a meticulous attention to detail combined with intricate symbolism. In 1854 he left London on the first of a series of visits to the Holy Land, where he gathered material for the topographically and archaeologically accurate treatments of biblical subjects that made his name. His two-volume autobiography, Pre-Raphaelitism and the Pre-Raphaelite Brotherhood, *appeared in 1905.*

66 *The Lady of Shalott* is based on Alfred Tennyson's poem of the same title. The story is set in the days of King Arthur and the Knights of the Round Table, though largely the poet's own invention rather than an actual Arthurian legend. Alone in her castle, the Lady weaves into a magic web images of people passing on the road to Camelot, where Arthur has his court. She is under a curse and may only look at them in a mirror. She meets her fate when one day she sees Sir Lancelot riding by in all his splendor and turns from her mirror to look at him directly:

Out flew the web and floated wide;
The Mirror crack'd from side to side;
"The curse is come upon me," cried
The Lady of Shalott

She goes down to the river, boards a boat, and floats downstream, singing her swansong. By the time she reaches Camelot, she has died. "She has a lovely face," remarks Sir Lancelot, unaware he has caused her death. "God in his mercy lend her grace, / The Lady of Shalott."

Hunt made a drawing of the Lady with the curse coming upon her as early as 1850 and later made an illustration of the same episode for the illustrated edition of Tennyson's poems published by Edward Moxon in 1857. When Tennyson saw the illustration, he felt that Hunt had treated his poem too freely and upbraided him for placing the Lady inside her loom when the poem describes her leaving it, and for showing her hair wildly tossing above her when the poem makes no mention of this. Hunt reminded him of the challenges of representing in a single image an idea developed over a number of pages of poetry.[1] Despite Tennyson's objections he was pleased with his illustration, and returned to it almost thirty years later as the basis for the present painting.

For Hunt the story was an allegory of the dire consequences of turning away from duty and yielding to worldly temptations, in some senses an Arthurian version of the Fall of Man, with the Lady as Eve. The "stormy east-wind" of the poem blows through her chamber making a great plume of her hair and frightening away the doves of peace that settled by her as she worked. Her weaving unravels, irrevocably ruined like her life, and she is tangled in its threads like an insect in a spider's web. What remains of the weaving shows not the passers-by of the poem, but an allegory of King Arthur and his court. In the

1. See William Holman Hunt, *Pre-Raphaelitism and the Pre-Raphaelite Brotherhood* (London, 1905), 2:124–25.

66　*The Lady of Shalott*, 1886–1905

Oil on canvas, 74 x 57 ½
Wadsworth Atheneum Museum of Art, Hartford, Connecticut. The Ella Gallup Sumner Collection Fund

patch of sunlight immediately to the right we see the pure Sir Galahad offering the king the Holy Grail on his shield, and to the left the impure Sir Lancelot kissing the king's fingers; it is Lancelot who, through his affair with Queen Guinevere, will bring about Arthur's downfall. The convex mirror in which the "real" Sir Lancelot appears, brandishing his sword, is a distant recollection of the famous *Arnolfini Marriage Portrait* by Van Eyck, a work greatly admired by the Pre-Raphaelites at the National Gallery in London; the pattens in the lower right of the painting probably derive from the same source.

The decoration of the Lady's chamber is not only a remarkable, fantastical essay in art nouveau, but also a dense symbolic accompaniment to the main action. The silver lamp to the right is ornamented with owls near the top and sphinxes at the bottom to suggest the light of wisdom triumphing over mystery and fear; now that the Lady has succumbed to temptation, the light has been extinguished, blown out by the wind. The relief in the oval panel to the right of the mirror represents the mythic hero Hercules picking the golden apples in the garden of the Hesperides, one of his twelve labors; to reach them he has to slay the serpent Ladon, who guards them, and he picks them as the Hesperides, or "daughters of evening," sleep beneath the tree. Hunt gives Hercules a halo to mark him as a pagan counterpart or "type" of Christ, his victory over the serpent being a parallel to Christ's victory over sin. The panel on the other side of the mirror shows the Virgin Mary praying over the Christ Child. Hercules in his valor and the Virgin in her humility are both exemplars of duty; they act as thematic foils to the Lady of Shalott, who personifies its dereliction. To show the global and cosmic significance of the event, Hunt designed the posts of her loom to represent the elements of water, earth, and air, and the reliefs on the upper parts of the wall to represent the heavenly "music of the spheres." The carvings in the floor around the posts show the eternal struggle of life, evolving from primitive sea creatures devouring each other on the left, to fighting mammals and men in the center, to the tools of peace and war on the right.

Typically, Hunt worked on *The Lady of Shalott* over a number of years, between 1886 and 1905, when it was exhibited at the gallery of Arthur Tooth and Sons in London. By the later 1890s his eyesight had seriously deteriorated; for the rest of his career he relied on assistants, and parts of the present work were executed under his direction by Edward Hughes. The painting is in a grandiose frame designed by Hunt himself on the pattern of an Italian Renaissance altarpiece. The frieze above is decorated with a fuming casket inscribed SPES ("Hope"). The inscription alludes to a classical parallel to the Lady of Shalott's story, the myth of Pandora's box. In order to punish the human race for the theft of fire by Prometheus, Jupiter ordained that when Pandora opened her box, all the evils of the world should fly out, leaving only Hope inside.

Despite the efforts of a committee formed to campaign for its purchase for the British nation, *The Lady of Shalott* remained in the artist's possession until his death. In 1961 his granddaughter Elisabeth Burt offered the work at Christie's, where it sold for 9,975 guineas, a record price for a Pre-Raphaelite painting. The buyer was the John Nicolson Gallery, New York, from which the Wadsworth Atheneum purchased the work in the same year. It was a remarkably bold and unfashionable acquisition for an American museum at this time, when the reputation of British art of the Victorian period was at a low ebb on both sides of the Atlantic. The work remains probably the most important Pre-Raphaelite painting in the United States.

MW

EXHIBITED AT YALE ONLY.

REFERENCES:
Leslie Parris, ed., *The Pre-Raphaelites*, exh. cat. (Tate Gallery, London, 1984), 249–50, under no. 168; *Ladies of Shalott: A Victorian Masterpiece and Its Contexts*, exh. cat. (Bell Gallery, List Art Center, Brown University, Providence, Rhode Island, 1985); Malcolm Warner, et al., *The Victorians: British Painting, 1837–1901*, exh. cat. (National Gallery of Art, Washington, 1997), 96–98, no. 18.

Lawrence Alma-Tadema

❧ 1836–1912

Prolific painter and watercolorist most famous for his detailed reconstructions of the ancient world. Although born in Holland and enjoying patronage throughout Europe and America, Alma-Tadema became a fixture of the London art world in the 1860s. He settled permanently in England in 1870, became a British citizen in 1873, and was elected to the Royal Academy in 1876. His fastidiously researched paintings of daily life in ancient Rome and Greece were initially inspired by his study of the Parthenon sculptures at the British Museum during a visit to London in 1862, and by his honeymoon trip to Rome, Naples, and Pompeii in 1863. He returned to Italy on several occasions, often gathering information and ideas at archaeological excavation sites. During his lifetime Alma-Tadema's historical genre paintings figured among the chief attractions at any public exhibition in Britain, Europe, or the United States. They brought him a steady flow of commissions and a succession of international honors, including a knighthood bestowed by Queen Victoria in 1899. In his late career he translated his archaeological and historical knowledge to the London stage, designing costumes and stage scenery for theatrical productions of classical dramas and Shakespearean plays.

1. Plutarch, *Moralia*, quoted in *The Exhibition of the Royal Academy of Arts* (London, 1887), no. 305.

67 Amphissa was a city near Mount Parnassus in northern Greece. In the fourth century BC it joined with Delphi in a holy war against Phocis. Six centuries later Plutarch recounted in his *Moralia* the courageous compassion of the women of Amphissa, who risked their own army's hostility in order to aid a group of Phocian maenads (followers of the god Dionysos) who had strayed into the Amphissan agora during a night of religious frenzy. "Being weary, and unconscious of danger, they lay down in the market-place and slept. When the wives of Amphissa heard this, they hastened to the spot, fearing lest the Thyades [maenads] should suffer insult or injury: and standing round the sleepers, waited till they had awakened, then tended them and gave them food."[1] The obscure episode gained new prominence in 1875, when George Eliot made use of it in her novel *Daniel Deronda*.

In this monumental painting Alma-Tadema captures the moment of the maenads' awakening. As they revive to various states of consciousness, the revelers receive the gracious ministrations of the women of Amphissa, whose polite gestures of hospitality would not be out of place in a Victorian drawing room. The only evidence of the riotous behavior of the night before is provided by the maenads' leopard-skin cloaks, ivy wreaths, and tambourines. Otherwise, the painting is remarkable for its suggestion of utter peace and quiet, conveyed by the stillness of the figures and the silvery atmosphere that envelops the scene.

By focusing on the moral virtue of the women of Amphissa, rather than the orgiastic frenzy of the maenads, Alma-Tadema has domesticated the exoticism of the ancient past, presenting it in terms that his contemporary audience could understand. As such, the painting exemplifies his belief that classical antiquity differed from the modern era only in

67　*The Women of Amphissa,* 1887

Oil on canvas, 48 x 72 in.
Sterling and Francine Clark Art Institute, Williamstown, Massachusetts

REFERENCES:
Vern G. Swanson, *The Biography and Catalogue Raisonné of the Paintings of Sir Lawrence Alma-Tadema*, exh. cat. (London, 1990), 233–34, no. 68; Jennifer Gordon Lovett and William R. Johnston, *Empires Restored, Elysium Revisited: The Art of Sir Lawrence Alma-Tadema*, exh. cat. (Sterling and Francine Clark Art Institute, Williamstown, Massachusetts, 1991), 96–97, no. 37; Edwin Becker et al., eds., *Sir Lawrence Alma-Tadema*, exh. cat. (Van Gogh Museum, Amsterdam, 1996), 232–33, no. 68.

externals, and that in more fundamental respects past and present civilizations were united by common human nature. Appropriately, when *The Women of Amphissa* was exhibited at the Royal Academy in 1887, it was the element of familiarity that struck a chord with critics. One wrote approvingly, "Archaeology for once, at least, is made subordinate to art, and in the waking wanderers, as well as in their ministering protectors, we have a series of elaborate studies, not of costume and pose, but of sentiment and emotion."[2]

Despite the critic's disparaging allusion to archaeology, it was in fact Alma-Tadema's meticulous reconstruction of the physical reality of the ancient world that most fascinated his contemporaries. Through scrupulous archaeological research he endeavored to document the mundane experiences of Greek and Roman life down to the finest detail, bringing a palpable sense of realism to the most arcane subjects. *The Women of Amphissa*, for example, provides a pictorial treatise on ancient Greek diet, with tables and serving trays laden with eggs, poultry, honeycomb, and cucumbers. In the background fish and shells are shown hanging out to dry in the sun. The fascination of such elements is enhanced by the minute detail in which Alma-Tadema renders them. The artist himself often encouraged his admirers to views his paintings through the lens of a magnifying glass.

Following exhibitions at the Royal Academy and the Manchester Institution in 1887, *The Women of Amphissa* was shown at the Exposition Universelle in Paris in 1889, where it won a gold medal. Although Alma-Tadema's works flooded the United States during the late nineteenth and early twentieth centuries, his reputation was in decline by 1920, and only about fifteen of his paintings were purchased by

Americans between that date and 1960. One of the few collectors who did sustain an interest in Alma-Tadema was Sterling Clark, who acquired a small painting, *Hopeful*, in 1937. The Sterling and Francine Clark Art Institute purchased *The Women of Amphissa* in 1978. Today the artist's work is enjoying a resurgence of interest among collectors in both America and Britain.

RA

2. *Illustrated London News*, May 7, 1887, quoted in Lovett and Johnston, 97.

Gwen John

1876–1939

Painter of portraits (chiefly of women) and interiors character-
ized by a soft, tone-on-tone technique and intimate mood. John's
work bridged the aesthetic divide between the art worlds of Lon-
don and Paris during the early decades of the twentieth century.
She attended London's Slade School of Fine Art in 1895 and left
for Paris in 1898 to study with James McNeill Whistler. She
returned to London from 1899 to 1903, but in the following year
she settled in Paris, which remained her professional base for the
rest of her career. During her first ten years in Paris, John sup-
plemented her income by working as an artist's model, posing for
the sculptor Auguste Rodin among others. In 1913 she converted
to Roman Catholicism and thereafter produced many delicate,
small-scale depictions of nuns. However, subject matter was of
less importance to her than the formal qualities of her paintings.
She became increasingly intrigued by contemporary art and
Modernist theories in the last years of her career. Often doubtful
of her achievements, she was reluctant to sell her paintings and
exhibited in London and Paris with considerable trepidation.
Nevertheless, her paintings received acclaim, especially in Eng-
land, and a solo show of her work was held at New Chenil Gal-
leries in London in 1926.

68 Haunting in its bleak intensity, this paint-
ing shares with much of Gwen John's work
a charged psychological atmosphere and a
spare, almost abstract aesthetic. Visually, it is one of
her most striking portraits. The mottled green
backdrop accentuates the luminous blue of the sit-
ter's large, moist eyes and provides an effective foil to
her white dress, set off by a black bow and sash. The
painting evokes an unsettling mood of vague dis-
quiet. The painfully thin woman, whose stiff posture
lends a brittle quality to her attenuated arms and
neck, meets our eyes with an expression that mingles
sadness with a hint of suspicion or hostility. The
weariness conveyed by her sloping shoulders and
flaccid hands contributes to the pathetic but entirely
unsentimental characterization.

Gwen John undertook this painting around Sep-
tember 1909, when she was living in fairly straitened
circumstances in Paris. She rarely indulged in the
luxury of hiring professional models, generally paint-
ing from herself or from friends. Nevertheless, with
uncharacteristic extravagance she spent fifteen pounds
on sittings with Fenella Lovell, the woman represented
here, and even took her out to dinner. They had some
things in common. Lovell, like John, was a British
woman living in Paris and supporting herself as an
artist's model. John's brother Augustus and her lover
Auguste Rodin were among the artists for whom
Lovell had posed. Yet, whereas John was intensely
private, Lovell was extraordinarily flamboyant. In
order to enhance her appeal within the Bohemian art
world, she masqueraded as a gypsy, borrowing the
name Lovell from a well-known Romany tribe in
Britain and adopting Romany dress and language. In
both the present portrait and a nude variation painted
concurrently with it, John stripped away the romantic
aura in which her model liked to cloak herself and re-
presented her in a brutally stark manner.

By February 1910 the painter had grown dis-
enchanted with her vain and insincere subject,
confiding in a friend, "it is a great strain doing Fenella.
It is a pretty little face but she is *dreadful*."[1] Three

68 *Girl with Bare Shoulders*, 1909–11

Oil on canvas, 17 ¼ x 10 ¼ in.
Museum of Modern Art, New York. A. Conger Goodyear Fund, 1958

months later antipathy goaded John into a course of action as uncharacteristic as her decision to hire Lovell in the first place. Overcoming her usual reluctance to exhibit, she decided to send *Girl with Bare Shoulders* and another painting to London to be exhibited that spring at the New English Art Club. "Why I want to send two paintings," she informed a correspondent, "is because I may then sell one and then I shall pay what I owe her [Lovell] and never see her again."[2]

By choosing to exhibit the paintings in England rather than Paris, John revealed her sustained sense of connection with the British art world. Indeed, between 1908 and 1911 she contributed to four London exhibitions, and her work was included in several other shows of contemporary British painting held between 1910 and 1914. She did not contribute to a Paris exhibition until 1919. Perhaps she felt that her quiet interiors and understated, introspective portraits had closer affinities with British art than with contemporary French painting. Certainly the pictures she sent to London fared extremely well. Of the six works she submitted to the New English Art Club during the 1910–14 period, buyers snatched up all but one: *Girl with Bare Shoulders*.

Even then, it was the artist's own interference that prevented the painting from selling. The New York attorney John Quinn had offered to purchase both of her contributions to the 1910 New English Art Club exhibit and had already sent a check for *Girl with Bare Shoulders* when he received John's letter of July 28, 1910, informing him, "I have been a long time trying to decide whether I should send it and now I have decided not to send it. People say it is so ugly I am sure it is."[3] Despite this inauspicious introduction Quinn became an ardent collector of Gwen John's work, acquiring some twenty of her paintings and eighty drawings prior to his death in 1924.

Antipathy for Fenella Lovell may have contributed to John's dissatisfaction with *Girl with Bare Shoulders*. When her brother Thornton returned the painting to Paris in December 1910, she informed a friend, "I shall finish that when I have the energie [sic]. It was silly of me to send it, it looks dreadful I think though I have not dared to look at it yet."[4] She seems to have continued to work on the painting until April 1911, but it remained unsold during her lifetime. In 1946 it was included in the Gwen John memorial exhibition held at London's Matthiesen Gallery. The painting's acquisition by the Museum of Modern Art attests to the ultimate recognition of John's significance within the history of early twentieth-century art.

RA

REFERENCES:
Mary Taubman, *Gwen John: The Artist and Her Work* (Ithaca, 1985), 115; Cecily Langdale and David Fraser Jenkins, *Gwen John: An Interior Life* (New York, 1986), 83, no. 13; Cecily Langdale, *Gwen John* (New Haven, 1987), 35–36, 41, 45, 139, no. 20; Allison Thomas, *Portraits of Women: Gwen John and Her Forgotten Contemporaries* (Cambridge, 1994), 124; Alicia Foster, *Gwen John* (Princeton, 1999), 33–39.

1. Langdale, 1987, 139.
2. Ibid.
3. Taubman, 115.
4. Ibid.

Walter Sickert

✺ 1860–1942

Central figure in the development of British Impressionism and an innovator in the expressive use of paint and the adoption of challenging contemporary subject matter. Born in Munich, Sickert immigrated to England with his family in 1868. After briefly pursuing an acting career, he attended London's Slade School of Fine Art from 1881 to 1883. Thereafter, he became the pupil and studio assistant of James McNeill Whistler, who encouraged him to subordinate subject matter to the purely formal and aesthetic qualities of his work. From 1885 Sickert spent long periods working in Dieppe, where he followed developments in modern French art. In 1889 he co-organized a "London Impressionists" exhibition. He was a pivotal figure in several groups formed for the exhibition and discussion of progressive art, including the Fitzroy Street Group (1907–11) and the Camden Town Group (1911–14). Sickert gained notoriety for his depictions of the shabby and sordid world of the urban underclass and for his evocations of the gaudy atmosphere of the music hall. He also produced etchings, published articles on art, and instructed countless students. He was elected president of the Royal Society of British Artists in 1927, and became a Royal Academician in 1934 (having been elected an Associate ten years earlier) but resigned in 1935. He retired from painting in 1940.

69 Among Sickert's many female friends and disciples, the most significant were probably two expatriate American painters, Ethel Sands, a noted London *saloniste*, and her companion Anna (Nan) Hope Hudson (1869–1957), whom Sickert represents in this stunning portrait. Sickert's voluminous correspondence with the two women during 1907–16 constitutes an invaluable source of information on his art theories and techniques—information ostensibly offered as advice to his correspondents but with expectation of future publication. Committed to the dissemination of his progressive ideas and practices, Sickert simultaneously wrote numerous articles of art criticism and organized several private schools of art instruction. The most influential and successful of the schools, Rowlandson House, provided the setting for Nan Hudson's portrait, in which she stands before a light-filled window in a paneled room. Sickert probably painted the portrait soon after opening Rowlandson House early in 1910. During the four years that it remained in operation, the school provided him with an influential platform for inculcating his views on art.

Miss Hudson at Rowlandson House demonstrates one of the central tenets of Sickert's art theory: that an artist must adopt a detached and impersonal attitude toward his subject in order to observe and record dispassionately the objective appearances presented to the eye. With that in mind, he had dissuaded Hudson and Ethel Sands from painting one another, warning that their personal emotions and tastes would inevitably hamper their pursuit of abstract formal qualities. "There is a constant snare in painting what is part of your life," he advised them. "You cannot avoid with yourself or another artist or a member of your own house or family a spoken or silent dialogue which is *irrelevant* to *light and shade*

69 *Miss Hudson at Rowlandson House,* c. 1910

Oil on canvas, 36 x 20 in.
The Phillips Collection, Washington, D.C. Bequest of Ethel Sands, 1966

REFERENCES:
Wendy Baron, *Sickert* (London, 1973), 118, no. 318; Wendy Baron, *Miss Ethel Sands and Her Circle* (London, 1977), 78.

irrelevant to colour."[1] Striving for his ideal of detachment in the present portrait, Sickert submerged his friend's face in shadow, entirely sidestepping the issue of likeness. Her jaunty stance—hips swung to one side, chest thrust forward, one arm akimbo—conveys a vivid impression of personality, as does her stylish dress and rather rakish, oversized hat. However, Sickert seems far less interested in directly representing her than in documenting her effect on the light-filled interior. Her reflection in the polished tabletop and her shadow on the light-splashed floor provide indirect portraits of the shadowy figure standing before the window.

Sickert's fascination with the effects of light is revealed throughout the painting but perhaps most strikingly in the chromatic patterns of the reflective table top. Splashes of pale blue, maroon, pink, and rust shatter the solid form into a mosaic of color, creating, at a distance, an almost liquid impression of shimmering light. Sickert laid the various pigments cleanly side by side, often in heavily impasted brushstrokes, with minimal blending. The eye instinctively integrates the broken, textured colors into a cohesive unity, but their distinctness produces an ocular vibration, so that the entire picture seems to scintillate. Rectilinear background features such as the paned window and paneled wall provide the dazzling scene with crucial structural stability. Their geometric regularity also provides a foil to the dramatic curves and angles of Hudson's body. Sickert worked out these complex arrangements in a number of preparatory drawings before translating the design to canvas.

Sickert may have painted more than one portrait of Nan Hudson. In a letter of 1910, he wrote that in another picture, he intended to capture "more portrait, and less effect, I mean light on the face."[2] His letters also indicate that he encouraged her to present a particularly stylish appearance, urging her to "come in some 'creation' you fancy yourself in because I fancy you in anything."[3] Despite the artist's misgivings about the portrait's excessive emphasis on "effect," it evidently pleased Hudson, who kept it for the next forty-seven years. It was apparently exhibited publicly only once, in 1938. On Hudson's death the painting passed to her companion Ethel Sands, who bequeathed it to the Phillips Collection in Washington, D.C., the city in which Nan Hudson grew up.

RA

1. Baron, 1973, 181.
2. Ibid., 359.
3. Ibid.

Duncan Grant

1885–1978

All of his long life Duncan Grant was associated with the Bloomsbury Group. He was a cousin of Lytton Strachey, the biographer and historian, and from 1915 until her death in 1961, he lived with Vanessa Bell, the artist and elder sister of Virginia Woolf. Although Grant was a convinced homosexual, the deep alliance he formed with Bell sustained them both. They established households and studios, most notably at Charleston, a Georgian farmhouse in Sussex that became a celebrated meeting place for the Bloomsbury group. Grant was trained in a conventional manner at the Westminster School of Art and later at the Slade School of Art. Through his friendship with Roger Fry and Clive Bell and the influence of the two remarkable Post-Impressionist exhibitions organized by them in 1910 and 1912, he developed a lifelong commitment to modern French painting.

70 Forty-six Gordon Square was the home to which Vanessa Bell moved her two brothers, Thoby and Adrian, and her sister Virginia in 1904 following the death of their oppressive father, Sir Leslie Stephen. In this house the Stephen family began to hold their "Thursday evenings," the first meetings of those writers, artists, and intellectuals who became known as the Bloomsbury Group. The setting for this animated still life thus lies in the very heart of Bloomsbury. The artificial flowers that appear in the composition, made by Grant, Bell, and others at the Omega Workshops, are equally singular emblems of Bloomsbury.

Part of the mission of the Omega Workshops was to make objects of daily use beautiful, relatively inexpensive, and widely available. Artificial paper or cloth flowers were a prime example of this endeavor. They were made from scraps of material left over from other enterprises at the workshop. These Omega flowers—so symbolic and characteristic of the workshop—now survive only in still-life paintings by Grant, Bell, and Roger Fry.

Bloomsbury was a strangely domesticated group. They met in each other's houses, and a large portion of their paintings depict interior settings, still lifes, or the garden at Charleston, where Vanessa Bell and Duncan Grant spent much of the latter part of their lives. The group prized conversation, argument, and the exchange of opinions and ideas as the true marks of friendship and civility—hence the importance of relaxed and intimate domestic settings, where such interchanges could happen freely.

Richard Shone, a leading art historian of the Bloomsbury group, has singled out this still life as one of Grant's "most spontaneously self-revealing."[1] Modern French painting, and Henri Matisse in particular, had liberated Grant's art from its roots in Edwardian realism. Color, its fluidity and inherent pictorial dynamism, became an essential part of his art. The rapidity and impetuousness of the brushwork and the moment-to-moment changes in hues, the strong contrast of warm and cool colors rather than dark and light, make it one of his most engaging and forward-looking paintings. There is even a hint of the painterly abstraction of Wassily Kandinsky, whose work was becoming generally known at this time. The still life is given a precise setting in the room, poised on a crowded mantelpiece, itself a favorite device of the Bloomsbury artist. The freedom with which Grant works his motifs pushes the painting toward a lyrical

1. Shone, 117.

70 *Omega Paper Flowers on the Mantelpiece, 46 Gordon Square, c. 1914–15*

Oil on canvas, 21 ¾ x 29 ⅞ in.
Mellon Financial Corporation, Pittsburgh

abstraction that he rarely attained again.

The years between the first Post-Impressionist exhibition in 1910 and the last years of World War I brought the art of Bloomsbury to its high-water mark. Paintings like this still life convey a sense of excited discovery—not simply an imitation of French manners—on the part of the painter as he produces the work. Although Grant would come to know considerable public success in the 1920s, he never surpassed the brilliance of his work from about 1912 to 1918.

Omega Paper Flowers on the Mantelpiece, 46 Gordon Square has a distinguished provenance. Duncan Grant gave it as a wedding present to Adrian Stephen, younger brother of Vanessa Bell and Virginia Woolf, and his bride Karin Costelloe, the stepdaughter of Bernard Berenson. It was sold to the Mellon Financial Corporation in Pittsburgh in 1984 by the London art dealer Anthony d'Offay, who was one of the first to champion Grant's work in the 1970s and mount exhibitions of his and other Bloomsbury artists, helping to foster a revival of their reputations. At the Mellon Financial Corporation it forms the centerpiece of a small but distinguished collection of modern British painting.

PMcC

REFERENCES:

The Omega Workshops: Alliance and Enmity in English Art, 1911–1920, exh. cat. (Anthony d'Offay Gallery, London, 1984), no. 60; Richard Shone, *Bloomsbury Portraits: Vanessa Bell, Duncan Grant and their Circle*, rev. and expanded ed. (London, 1993), 127, 195; Richard Shone, *The Art of Bloomsbury: Roger Fry, Vanessa Bell and Duncan Grant*, exh. cat. (Tate Gallery, London, 1999), 117, 123–24, no. 50.

Ben Nicholson

❧ 1894–1982

The most eminent practitioner of abstract painting in Britain. The son of two distinguished artists, Sir William Nicholson and Mabel Pryde, he was well connected by birth within the British art world. His first marriage to Winifred Roberts ended messily when he formed a new association with the eminent sculptor Barbara Hepworth. Although both marriages were to end in divorce, these women played key roles in Nicholson's development. In the 1930s, together with Henry Moore, Paul Nash, Hepworth, and others, Nicholson forged an English avant-garde with close connections to advanced art in Paris. Hepworth and Nicholson settled in St. Ives, Cornwall, at the outset of World War II and were the central figures in that remarkable school of British artists who successfully combined advanced artistic interests with a distinctive feeling for the Cornish landscape. After World War II Nicholson enjoyed fame and fortune. He was included in a succession of British Council touring exhibitions and from the early 1950s held regular exhibitions at Durlacher Brothers in New York, as well as exhibiting regularly in London. From 1958 to 1971 he lived and worked in Switzerland with his third wife, Felicitas Vogler.

71 The 1930s were an exciting if embattled decade for modern British art. Four major artists—Paul Nash, Henry Moore, Barbara Hepworth, and Ben Nicholson—led a vanguard of younger painters, sculptors, and architects who shared a profound sympathy with the most recent artistic developments in Paris. Where the Bloomsbury group had a romantic infatuation with all things French, these artists knew and participated in the evolving French avant-garde. Nicholson was the most persistent of British artists in connecting with the leading members of the School of Paris, including Georges Braque, Jean Arp, Constantin Brancusi, Piet Mondrian, and the founders of the Abstraction-Création group, Jean Hélion and Auguste Herbin. So close were his contacts with Abstraction-Création that he and Barbara Hepworth were invited to join the group—a rare distinction for British artists. But the most significant of the connections was with Mondrian. Nicholson met him in 1933 and visited his studio the following year. Although Nicholson was already convinced of the necessity of abstract art as a logical outcome of Cubism, Mondrian's accomplishment, self-possession, and certitude encouraged and ensconced him in his abstract tendencies. Mondrian's belief in the spiritual properties of abstract art—reconciling opposites in human nature through the kinetic balance of non-representational forms—struck an equally deep chord in Nicholson, who from the 1920s onwards had been deeply interested in the doctrines of Christian Science.

If Mondrian and other practitioners of abstract painting in Paris in the 1930s were one source of inspiration to Nicholson, his burgeoning relationship with Barbara Hepworth was another. They began to work together shortly after meeting in 1931 and would share studios for the next fifteen years or so. Hepworth's carving tools suggested a new way of working on a painting. Carving and chiseling the forms from wood panels gave painting an increasingly object-like quality at a time when terms like "objective" and "concrete" were almost synonyms for abstract.

The climax of these tendencies came in the white

71 *Two White Forms (White Relief)*, 1935

Oil on panel, 20 ½ x 29 in.
Private Collection

REFERENCES:
Jeremy Lewison, *Ben Nicholson*, exh. cat. (Tate Gallery, London, 1993), 44–52, 218; Charles Harrison, *English Art and Modernism, 1900–1939* (New Haven and London, 1994), 263–65; Sarah Jane Checkland, *Ben Nicholson: The Victorian Circles of his Life and Art* (London, 2000), 126 ff.

reliefs that Nicholson began to make in 1934, of which the present work is a particularly beautiful, austere, and important example. The solid, tactile quality of the reliefs was important to Nicholson for a number of reasons, aesthetic and otherwise. On the back of one of them he inscribed, "Please hang in strong side light," which would emphasize the articulation of the planes. The play of light and dark counteracted the ethereal quality of the overall whiteness and gave the work a dynamic quality: however severe the forms, they were animate.

The object-like quality of the white relief also served the deeper "spiritual" intent of the work. An important theme in early abstract art, stemming particularly from Mondrian and the De Stijl movement, was a belief that abstraction revealed a higher, spiritual order that lay hidden in the quotidian world of appearance and experience. To make the highest spiritual order palpable required paring down the means of art to the simplest, most elemental forms and colors. For Mondrian it meant the use of primary colors in black and white grids; for Nicholson it meant the abolition of color and the elevation of the picture surface into solid, tactile forms.

Part of the originality and aesthetic power of *Two White Forms (White Relief)* lies in the surefooted way it works between painting and sculpture. An abstract painter like Nicholson, closely associated with both Moore and Hepworth, and keenly aware and interested in the work of Arp and Brancusi on the Continent, saw that sculpture in the early 1930s offered a challenge to painting. Sculpture seemed to have achieved a more radical morphology, departing further from conventional forms and subjects than painting had. How could the painter absorb these sculptural lessons into his own medium? The white reliefs were Nicholson's answer. The impact of

Hepworth is particularly strong in this work. The circle on the right-hand side is surely reminiscent of the holes with which she pierced her sculpture in the early 1930s, later influencing Moore to do likewise. The piercing of the stone revealed the "inner light" of the material itself. It was akin to the spiritual revelation of a "hidden order" in the world of appearance. Nicholson makes his circle a receding plane, going into the ground—in contrast to the rectangle on the left-hand side, which projects forward. The feminine/masculine interchange of the receding/projecting forms is both profound and satisfying.

Two White Forms (White Relief) was first acquired by J. R. M. Brumwell, whose family had been neighbors of Nicholson and his first wife Winifred when they lived in Dulwich and were among his earliest collectors and patrons. It was exhibited in October 1935 at the last exhibition of the "Seven and Five" Group at the Zwemmer Gallery. In 1988 it entered a West Coast collection devoted to modern British art—probably the most comprehensive collection of its kind, either public or private, ever to be formed in the United States.

PMcC

Stanley Spencer

❧ 1891–1982

Stanley Spencer is readily identified as the visionary artist of Cookham, a village in the Thames Valley some thirty miles west of London: in Cookham he would set the procession to Calvary; in Cookham churchyard, the Resurrection of the Dead. Yet for all his idiosyncrasy, Spencer's career was representative of an artist of his generation. From 1907 to 1912 he trained with Henry Tonks at the Slade School of Fine Art, where his gifted contemporaries included David Bomberg, C. R. W. Nevinson, William Roberts, and Edward Wadsworth. During World War I he enlisted as a medical orderly and later as an infantryman, seeing action in Salonika, Greece. Between the wars he enjoyed considerable success and acclaim. His scheme of mural decorations in the Sandham Memorial Chapel at Burghclere, painted from 1927 to 1932, remains the finest example of sustained narrative painting in modern British art. Spencer became an Associate of the Royal Academy in 1932, only to resign three years later when two of his pictures were rejected. Shadowing his growing success was the breakup of his marriage to Hilda Carline and his bizarre infatuation with Patricia Preece. World War II brought him an important commission from the War Artists' Advisory Board to record shipbuilding on the Clyde at Port Glasgow. After the war he rejoined the Royal Academy as an Associate and in the last year of his life received a knighthood.

72 In January 1935 Stanley Spencer was recuperating from two operations to remove kidney stones. He was debilitated, and some of his larger promised commissions had failed to materialize after the successful completion of the Sandham Memorial Chapel at Burghclere. To help him in this difficult time, his patron Sir Edward Beddington-Behrens, a wealthy financier, secured him a commission worth £400 from Mr. Charles Boot, a builder, to produce a large painting for his boardroom on the theme of building. Because of his ill health Spencer chose to paint two slightly smaller paintings instead, *The Builders* and *Workmen in the House*. In the event, Boot disliked both paintings and refused to pay. An embarrassed Beddington-Behrens bought *The Builders* for £200; *Workmen in the House* remained with Spencer until bought by his solicitor, Wilfrid Evill, in 1937. Spencer showed both paintings at the Royal Academy's summer exhibition of 1935, the occasion on which the rejection of two of his other paintings moved him to resign his Associateship.

Spencer's remark that among his works "the secular pictures have religious associations and the religious ones secular associations" is vividly borne out by *The Builders*. It is ostensibly a genre scene, yet the figures move with a sacramental solemnity. Two of the figures are removing a template from an arch, an image Spencer recalled from the installation of his canvases in the upper register of the Sandham Chapel. The hod carriers, derived from his memory of a Cookham builder, Fairchild's, may refer back to one of the aborted commissions, a *Tower of Babel* subject, for which a small sketch remains. The whole scene is bathed in bright sunshine; this falls crisply from left to right across the composition and gives a clue to the overall theme of the work, which is renewal.

REFERENCES:
Kenneth Pople, *Stanley Spencer, A Biography* (London, 1991), 315-18, 338-39; Keith Bell, *Stanley Spencer: A Complete Catalogue of the Paintings* (London, 1992), 435-36, no. 169; Fiona MacCarthy, *Stanley Spencer: An English Vision*, exh. cat. (The British Council and The Hirshhorn Museum and Sculpture Garden, Washington, 1997), no. 21.

72 *The Builders*, 1935

Oil on canvas, 44 x 36 ⅛ in.
Yale University Art Gallery. Given Anonymously

Index of Artists

Alma-Tadema, Lawrence, no. 67
Bacon, Francis, nos. 74, 75
Bonington, Richard Parkes, no. 54
Burne-Jones, Edward, nos. 62, 63
Canaletto (Giovanni Antonio Canal), no. 11
Constable, John, nos. 43–48
Devis, Arthur, no. 12
Dyck, Anthony van, no. 3
Freud, Lucian, no. 80
Fuseli, Henry, no. 34
Gainsborough, Thomas, nos. 13–19
Grant, Duncan, no. 70
Hockney, David, no. 79
Hogarth, William, nos. 7–9
Holbein, Hans, no. 1
Hunt, William Holman, no. 66
John, Gwen, no. 68
Landseer, Edwin, no. 55
Lawrence, Thomas, nos. 37–40
Leighton, Frederic, no. 61
Lely, Peter, no. 4
Martin, John, no. 56
Millais, John Everett, nos. 57–59
Moore, Albert, no. 64
Nicholson, Ben, no. 71
Peake, Robert, no. 2
Raeburn, Henry, nos. 41–42
Ramsay, Allan, no. 10
Rego, Paula, no. 78
Reynolds, Joshua, nos. 29–32
Riley, Bridget, no. 77
Romney, George, no. 36
Sargent, John Singer, no. 65

Saville, Jenny, no. 81
Scott, William, no. 76
Siberechts, Jan, no. 6
Sickert, Walter, no. 69
Soest, Gerard, no. 5
Spencer, Stanley, nos. 72–73
Stuart, Gilbert, no. 35
Stubbs, George, nos. 21–24
Turner, Joseph Mallord William, nos. 49–53
West, Benjamin, no. 26
Wheatley, Francis, no. 33
Whistler, James McNeill, no. 60
Wilson, Richard, no. 20
Wright of Derby, Joseph, nos. 27–28
Zoffany, Johann, no. 25

Photographic Credits

©2001, Courtesy of The Art Institute of Chicago, All Rights Reserved, figs. 3, 20

©2001 Artists Rights Society (ARS), New York/DACS, London, fig. 19; nos. 68, 69, 71, 72, 73

©2001 Estate of Francis Bacon/Artists Rights Society (ARS), New York, nos. 74, 75

Courtesy of Ivor Braka, Ltd., nos. 73, 75, 78, 79

©Carnegie Museum of Art, Pittsburgh; Museum purchase, Photograph by Peter Harholdt, 1994, no. 26

Courtesy of the Witt Library, Courtauld Institute, London, fig. 8

©The Detroit Institute of Arts, nos. 33, 34

©Enoch Pratt Free Library, Baltimore, Maryland. Photograph by Allan Sprecher, no. 5

The FORBES Magazine Collection, New York, ©All Rights Reserved, no. 56

©Lucian Freud, no. 80

©1978 Estate of Duncan Grant, courtesy Henrietta Garnett, no. 70

©David Hockney, fig. 20; no. 79

Courtesy of The Huntington Library, Art Collections, and Botanical Gardens, San Marino, California, figs. 8, 9, 12, 41 nos. 10, 17, 18, 31, 36, 39, 46, 47, 53

©2001 Museum Associates/LACMA, no. 38

The Makins Collection/Bridgeman Art Library, nos. 57, 58

Copyright of His Grace the Duke of Marlborough, fig. 5

Courtesy of the Massachusetts Historical Society, figs. 21, 22

©The Metropolitan Museum of Art, fig. 38; nos. 2, 4, 32, 37, 40, 62

Courtesy, Museum of Fine Arts, Boston. Reproduced with permission. ©2000 Museum of Fine Arts, Boston. All Rights Reserved, fig. 14; no. 43

©2001 The Museum of Modern Art, New York, nos. 68, 77

©Board of Trustees, National Gallery of Art, Washington: figs. 2, 10, 39; nos. 3, 35 60

©Paula Rego, no. 78

©2001 Bridget Riley. All rights reserved. Courtesy Karsten Schubert, London., no. 77

©The Saint Louis Art Museum, St. Louis, fig. 1

©Jenny Saville, no. 81

©Estate of William Scott RA, no. 76

©Sterling and Francine Clark Art Institute, Williamstown, Massachusetts, nos. 16, 67

©Virginia Museum of Fine Arts. Photo: Ron Jennings, no. 65

Richard Caspole, Yale Center for British Art, figs. 4, 13, 17, 19, 27; nos. 6, 7, 11, 13, 21, 22, 24, 27, 29, 42, 48, 49, 50, 51, 52, 79